André Bazin on Adaptation

The publisher and the University of California Press Foundation gratefully acknowledge the generous support of the Robert and Meryl Selig Endowment Fund in Film Studies, established in memory of Robert W. Selig.

André Bazin on Adaptation

Cinema's Literary Imagination

EDITED AND WITH AN INTRODUCTION BY
DUDLEY ANDREW

Deborah Glassman and Nataša Ďurovičová, translators

UNIVERSITY OF CALIFORNIA PRESS

University of California Press
Oakland, California

Excerpted from *Écrits complets*, André Bazin (author),
Hervé Joubert-Laurencin (editor), © 2018 Éditions
Macula.

Library of Congress Cataloging-in-Publication Data

Names: Andrew, Dudley, 1945- editor, writer of
 introduction. | Glassman,
Deborah, translator. | Ďurovičová, Natasa, translator.
Title: André Bazin on adaptation : cinema's literary
 imagination / edited and with an introduction by
 Dudley Andrew ; Deborah Glassman and Nataša
 Ďurovičová, translators.
Description: Oakland, California : University of
 California Press, [2022] | Includes index.
Identifiers: LCCN 2021032897 (print) | LCCN 2021032898
 (ebook) | ISBN 9780520375802 (cloth) | ISBN
 9780520375819 (paperback) | ISBN 9780520976252 (ebook)
Subjects: LCSH: Bazin, André, 1918–1958. | Film
 adaptations—History and criticism. | Motion
 pictures—France—History and criticism.
Classification: LCC PN1998.3.B39 A53 2022 (print) |
 LCC PN1998.3.B39 (ebook) | DDC 791.43/6—dc23
LC record available at https://lccn.loc.gov/2021032897
LC ebook record available at https://lccn.loc
 .gov/2021032898

31 30 29 28 27 26 25 24 23 22
10 9 8 7 6 5 4 3 2 1

Contents

Preface

In 1967, thousands of us Anglophone film enthusiasts were knocked sideways when the University of California Press brought out a slim pink volume, Andre Bazin's *What is Cinema?* Its eleven essays remain the core of what we later realized was a mountain of articles and ideas whose grandeur is just starting to be revealed. Five of the articles came from "Le cinéma et les autres arts," volume two of *Qu'est-ce que le cinéma?*, the four-part collection Bazin assembled on the eve of his death. Thus Bazin, and his first English translator, Hugh Gray, understood that exploring cinema's rapport with literature, theater, and painting was not a diversion but essential to his quest. In a Canadian retranslation of a selection of Bazin's French volumes, four of these texts reappear.[2] Anyone who cares about Bazin's master question must know his two-part "Theater and Cinema"; his "For an Impure Cinema: in Defense of Adaptation" (aka "In Defense of Mixed Cinema"); and his "*Journal d'un curé de campagne* and the Stylistics of Robert Bresson," an essay Gray declared to be "the most perfectly wrought piece of film criticism" ever written.[3]

These constitute Bazin's most deliberate, considered, and consequential formulations on the rapport of film and literature.[4] The sixty-plus articles gathered here pursue that rapport across his career.

Cinema's "literary imagination," as I call it, naturally coalesces around the question and practice of adaptation. My introduction describes how Bazin's sensitivity to this cinematic realm grew into carefully formulated theoretical reflections, but only after he had reacted to a great many types of adaptation. Although literature has always funded cinema, Bazin started out as a twenty-six-year-old critic at a particularly rich moment, for in Autumn 1944 a phalanx of Hollywood films began pouring into Paris behind the liberating G.I.s. One of the first pieces he published noted that among these were an inordinate number of adaptations of currently prominent authors, some of whom (William Faulkner, Ernest Hemingway) were even active in the film industry. He inevitably compared Hollywood's approach to adaptation to that of France, where, during the Occupation, the stately "Cinema of Quality" had taken root very much under the sway of the nineteenth-century novels it so often used as sources. About half of my selections precede 1950, a year of hiatus and ill health for Bazin that he used to deepen his reflections on what today we call "comparative arts" and prepare the core articles mentioned above. This was also just when he co-founded *Cahiers du cinéma* and immediately upped the stakes on the question of adaptation with his article on Bresson's *Journal d'un curé de campagne*. That remarkable instance made him even more vigilant in monitoring adaptations, for he was convinced that cinema could greatly mature in such interaction, even though he realized that most adaptations are reactive, if not reactionary, with producers literally banking on the reputation of famous novels.

Film producers are even more likely to rely on well-known plays, as these have already been broken down into scenes with dialogue and settings that can be conveniently taken whole or modified. Moreover, plays have been tested in front of an audience. Bazin penned scores of reviews dealing with films adapted from plays and devoted his lengthiest essay to the theater-cinema rapport. But the questions he posed there, involving issues of acting, space, architecture, and the co-presence of players and audience, are sufficiently distinct that I have sidelined them for the moment, hoping later to edit a companion to this volume. Thus, "literature" here refers mainly to prose fiction; in this context, Bazin routinely thought about cinema through narrative categories such as image, voice, tense, narration, interiority, and description. Sharing these categories, the two art forms—to use his analogy—pass the baton back and forth in a cultural relay race, with cinema starting later but running faster. In mid-century, Bazin believed these were unquestionably the most consequential art forms, attracting both popular and highly educated audiences, the way theater had done in Elizabethan England, or as poetry has done for centuries in Persia.

And so when writing about films that evoke literature, Bazin could expect a large and diverse readership. This anthology provides many examples of the criticism he produced several times a week for Paris's most popular newspaper, *Le Parisien libéré,* and regularly for the more urbane weeklies *L'Observateur* and *Radio-Cinéma-Télévision,* and the monthlies *Esprit* and *Cahiers du cinéma.* You will also find a piece he wrote for a university broadside and one for the publicity rag of the film industry, as well as a couple for sophisticated literary journals. Remarkably, his views seem consistent over the course of fifteen years; they also seem consistently pitched to the intelligence and imagination of his readers

no matter their background, although one can hear him inflect his style as he switched from one assignment and periodical to another. For he frequently reviewed the same film two or three and occasionally four times, without, mind you, repeating many of the same phrases or points. I've selected two reviews each for three of the adaptations in this collection, to enable not just a binocular look at his ideas but a chance to watch his prose adjust itself ever so slightly to fit the venue.

Bazin did not imagine anyone would read his ideas about a film in more than one periodical. And he certainly had no expectation that these reviews would be passed down for later generations to examine. His preface to *Qu'est-ce que le cinéma?*, written days before his death, exudes modesty:

> Of the mass of pages my pencil has blackened day after day, most are good only for lighting a fire; some may have had a bit of value in terms of the state of the current cinema when they came out but scarcely have any retrospective interest today. I eliminated them because the history of criticism is in itself a minor thing, and a specific review or critique (of a film) interests nobody, not even the critic himself, except as an exercise in humility.[5]

That winnowing process left him, he continued, the sixty-four articles that he did find worth preserving, including the seven that form volume two of *Qu'est-ce que le cinéma?*. However, for once, Bazin's judgment was off. As I bring back reviews that he turned out overnight or in the course of a busy week—reviews, in some cases, about films that are forgotten and difficult to locate today—each seems precious. In aggregate, these sixty-two articles clarify the history, achievements, and possibilities of the two art forms he rightly took to be the most significant of the century. They also illuminate a writer of dazzling

intelligence as they trace an unbroken, sinuous line of thought from first to last.

. . .

It is important to know where these selections come from and what has governed the translation decisions, including the notes that aim to bring them to the Anglophone public in the best possible form.

In fewer than fifteen years Bazin produced an astonishing number of articles—close to three thousand—which were finally brought together in two volumes in December 2018 as his *Écrits complets* (Éditions Macula). The editor, Hervé Joubert-Laurencin, arranged Bazin's output chronologically, publishing the articles as they originally appeared in newspapers, magazines, monthly journals, and anthologies. He corrected errors of spelling and date, and added a few clarifying footnotes to supplement Bazin's occasional ones. Retained in this translation are some of Joubert-Laurencin's notes, and all of Bazin's, while I have added many of my own so as to assist the English-language reader, though I stopped short of turning this volume into a commentary. If Bazin makes an apparent factual error not caught in the French edition, inserted beside it is the telltale "[*sic*]." Except for the addenda, all but a few of these pieces appear here in English for the first time. We approached these few afresh, just as we did the rest, aiming for the kind of consistent tone in the English that Bazin gave to everything he wrote in French.

Do not imagine that this volume constitutes anything like his total output on the subject. With a degree in literature from the École normale supérieure, Bazin inevitably kept in mind cinema's relation to that art. More important, as my introduction

tries to establish, he believed that, at mid-century and fifty years into its evolution, cinema's immediate future was intricately tied up with literature. In France, at least, the two forms needed each other and ought to be thought of together.

To think of film and literature together required a vocabulary that challenges today's translators and scholars. Bazin was a leading voice, though by no means the only one, to insist that such freighted terms as "auteur" and "écriture" be applied at key moments to cinema as well as literature. The former term has become so common that it no longer requires italics in English publications. I do italicize *découpage,* one of three other key terms of postwar film analysis that, along with "montage" and "mise en scène" have recently been explored philologically by a triumvirate of film scholars in a book that takes those terms for its title.[6] The last two words, equally French in origin, are left in Roman font, because Bazin, like others from his generation and in ours, took both to be standard, if complex, notions, montage often thought of as "editing" and mise en scène as "staging," coming as it does from theater. Bazin would adjust his sense of these terms to the circumstance of the film or topic about which he was writing. With *découpage,* however, he was more aggressive, effectively promoting it as the preproduction mental layout of a film's master visual idea that includes many registers (a scene's spatial design, the angle and movement of the camera, the depth of field covered, the positioning of actors, the composition of colors or chiaroscuro, etc.). Despite the root of the term ("couper"), *découpage* never means "cutting" to him, except insofar as an entire film can be conveniently discussed when it is broken down, or cut, into discrete scenes. This French word has begun to enter the English glossary of film terms. Like those in the French film industry, Bazin employed the phrase "*découpage tech-*

nique" to specify the final text handed to production personnel, translated here as "shooting script."

Perhaps the most persistent and problematic term encountered in these pages concerns the various ways the French refer to a film's "director." Bazin even discusses this problem in a pedagogical text—one of the lessons in his "Petite école du spectateur" (Little school of the spectator). In the postwar fight for artistic standing, and with the notion of the "auteur" often in play, certain critics—and soon the editorial staff of *Cahiers du cinéma*—wanted to distinguish a "metteur en scène" from a "régisseur" or a "réalisateur." In the 1940s, Bazin was relatively indifferent to which term should be used; he mainly employed "metteur en scène" where we would say "director." But later on, his protégé François Truffaut raised the stakes of these terms, reserving "auteur" for cineastes who effectively take charge of and stamp an entire project, while demoting "metteur en scène" to characterize those who do their best simply to put onto celluloid in the most convenient way possible whatever scripts they are handed. Several of Bazin's articles in this collection were written between 1953 and 1955, when he was in intense dialogue with Truffaut, and it is therefore likely that his use of "metteur en scène" was pointed, and so should not be rendered "director," even if that feels right in English.

There are plenty of other French terms that carry different valences in that language than in English, an effect referred to in translation circles as "false friends." Particularly frequent, and often troublesome because it is spelled the same in both languages, is "intelligent," which in French can carry a connotation of abstraction and dry rationality, and so is only intermittently laudatory. Other words, like "récit," have relatively specific meanings in French ("novella," though also "narrative") but less

so in English, while "romanesque" can mean both "novelistic" and "romantic" depending on context. And on the rare occasions when the context doesn't point the way, Bazin's French term is placed in brackets beside the English. In coming to terms, so to speak, with the abundant instances of linguistic ambiguity, we have not made it easy on ourselves or the reader, but for good reason: the fertility of Bazin's ideas comes alive in the furrows dug by his prose.

Even as a journalist working swiftly and under constraints, Bazin shows himself to be a gifted writer with a naturally classical style. Fond of wordplay and paradox, he is devilishly difficult to bring across even when his points are clear, for he compresses into a single sentence as many relevant elements of his argument as possible. Rather than paraphrase him so as to make his points slip readily into the reader's ken, the translators have done their utmost to retain the feel of his syntax, striving to ride the rolling wave of his thought until it culminates at the end of a sentence or paragraph. The English reader's attention is demanded no less than was that of the original French reader; Bazin lets you know he is composing his prose with deliberation. And there should be genuine pleasure in watching (hearing) him organize his points, arrange his metaphors, and adjudicate the oppositions that his keenly analytical mind loved to pinpoint, even while reviewing the most minor of films. The fact that many of these reviews needed to be dashed off in an evening makes his intricate prose all the more remarkable.

• • •

Anticipating several types of prospective readers, we have clustered the sixty-two articles—some but a few paragraphs in length—into three parts. Part One, "Adaptation in Theory,"

should awaken the expectations of those wanting to see Bazin's film theory in action or from a new angle, as well as those concerned with the history and theory of adaptation. Another set of readers, students and aficionados of French literature, will turn instead to the pieces grouped at the ends of Part Two on recent fiction and Part Three on pre-twentieth-century literature. In deciding to organize this large bundle of articles, and to do so in such a manner, I have disrupted the chronological order in which they were written. An Appendix restores this order by listing the articles' item numbers in the *Écrits complets,* from number 43 on *The Human Comedy,* published early in 1945, to number 2656 on Maupassant's *Une vie,* which appeared in mid-October 1958. Readers ought to encourage some nearby university library to purchase the two-volume French set so Bazin can be sampled in his own language, while our English renditions of difficult passages can be verified or challenged.

Each part is prefaced by a text that justifies its contents. Along with the two crucial essays in the Addendum, the pieces grouped in Part One show Bazin speculating at his most deliberate on the nature of adaptation and on medium specificity. In the past couple of decades, adaptation studies has grown into a burgeoning subdiscipline. Sometimes linked to translation sudies and intermedia, it can be found in academic programs of literature, film, and media. Bazin's pieces concentrated in this section should have an immediate and long-term impact on the discourse rife in the ever-growing number of books, journals, conferences, and courses on the theory and practice of adaptation.

Part Two shows Bazin coming to, or applying, his ideas about film and literature through his daily and weekly criticism of films that showed up on the screens of Paris. He approached films based on the books of current and recent authors with

particular attention, believing that the public did the same. It is immediately apparent that he expected a great deal from adaptations of writers who were still settling into—or unsettling—contemporary culture; these were likely to exhibit both more social friction and more stylistic creativity than adaptations of novels already sanctified as classic. A subsection shows Bazin interacting with films of French writers of his own day, from the dying literary aristocrat André Gide to the teen phenomenon Françoise Sagan.

Part Three collects Bazin's views of what is effectively a genre of classic cinema: adaptations of esteemed, mainly nineteenth-century novels. These often elaborate homages are designed to reflect glory, or at least respectability, back onto a film industry that has to some extent been built upon them. The French subsection this time stands as a near checklist of the national canon as well as a repertoire of the directors and actors charged with firming up French cinema through the august presentation of that canon. Our final translated piece is one I take to be summary: in "French Cinema faces Literature," Bazin recognizes that while it may seem most appropriate for cinema to take on subjects coming straight from its own cinematic imagination, adapting novels is nevertheless prior "proof of a maturity and mastery that make everything possible." I would say the same of Bazin: we may naturally prioritize his wide-open speculations on documentary, animation, and other specifically cinematic forms, but his maturity and mastery as a critic make everything else possible, and these qualities are on display in the articles contained here, all of which serve cinema as it in turn serves literature.

. . .

A final note on titles of Bazin's articles and the films he writes about. While the translators and I have tried assiduously to bring into English Bazin's French sentences in the way he wrote them, the titles of his articles are another matter. I have felt at liberty and licensed to rework them. First, it is by no means clear that Bazin came up with these titles; sometimes, perhaps most of the time, they were in the hands of the editors of the periodicals for whom he wrote. Many of his columns in *Le Parisien libéré* are simply headed "Le film de la semaine" (This week's film). Even without that justification, the Table of Contents needs to identify, to some extent, what each article takes up. And so wherever appropriate, the titles invoke the names of recognized novels, authors, and filmmakers. The article titles as they originally appeared are in each case identified at the end of each article.

My protocol for handling the titles of French films and novels, on the other hand, is quite the reverse. I have kept these strictly in French, often with the English title in parenthesis after its initial appearance in this book. Having bristled when reading French critics who render, for instance, Hitchcock's *Vertigo* as *Sueurs froides,* I would find it bizarre to have Bazin refer to Carné's *Le Jour se lève* as *Daybreak*. Most other titles are given in English, including those from non-French foreign languages, unless they are conventionally known in the United States in the original (e.g., *I vitelloni*). An index of all films mentioned furnishes the English equivalent of foreign titles.

NOTES

1. André Bazin, *What is Cinema?*, vol. 1, trans. Hugh Gray (Berkeley: University of California Press, 2013 [1967]).

2. André Bazin, *What is Cinema?*, trans. Timothy Barnard (Montreal: caboose Press, 2009).

3. Gray, *What is Cinema?*, 7. It was Gray who shortened "Pour un cinéma impur: défense de l'adaptation" to "In Defense of Mixed Cinema."

4. Bazin's early and brilliant theoretical foray into this topic, "Adaptation, or The Cinema as Digest," has been available in English as the lead essay in *Film Adaptation,* ed. James Naremore (New Brunswick, NJ: Rutgers University Press, 2001). Our retranslation eliminates certain of its discrepancies with the original French text.

5. Bazin, "Avant-Propos," in *Qu'est-ce que le cinéma?*, vol. 1: *Ontologie et langage* (Paris: Éditions du Cerf, 1959), 8.

6. Laurent Le Forestier, Timothy Barnard, and Frank Kessler, *Montage, Découpage, Mise en scène: Essays on Film Form* (Montreal: caboose Press, 2021).

Acknowledgments

Ever since 1995, when my daughter Nell, with financial assistance from Colin MacCabe at the British Film Institute, photocopied the lion's share of André Bazin's articles, I have wanted to be in a position to learn what he knew about—and felt about—the adaptation of literature to cinema. Around Christmas 2019, that opportunity became feasible when I received the *Écrits complets*, which Hervé Joubert-Laurencin had managed to organize, edit, and publish through the prestigious Macula Press. This required an heroic effort on his part, meticulously carried out, while representing a bold publication risk by Macula's director Véronique Yersin. Macula gave Bazin the superb care he deserves. His abundant, surprising, yet always consistent ideas are now available to those who read French.

The Centre Nationale du Livre understood the value of bringing Bazin's beliefs about literature and adaptation to readers of English, when it supported this translation with a generous grant, later matched by the Frederick W. Hilles Publication Fund of Yale University. I am grateful to both not just for the

awards but for their recognition of the crucial, undervalued role of translation in the furthering of ideas in a world that is not nearly so global as some assume. These two prize committees were surely impressed that the book would come out through The University of California Press, which had first brought Bazin into English decades ago and whose record of publishing the very best film scholarship is unrivaled in the United States. Among the largest of academic publishing houses, it goes by a familiar name to me, a comfortable and friendly one, appearing frequently in my emails and cellphone logs: Raina Polivka. Thank you, Raina, for your enthusiasm and encouragement, as well as the care and efficiency with which you made certain the book passed smoothly through gestation to birth. Thank you especially for your perspicacious advice that resulted in decisions about the shape, format, and even the title that emerged.

Let me eagerly signal my occasional but crucial exchanges about translating Bazin with Jacques Aumont, Timothy Barnard, Colin Burnett, Timothy Corrigan, Kamilla Elliott, Jean-Michel Frodon, Alice Kaplan, Thomas Leitch, Naghmeh Rezaie, Sally Shafto, Anni Shen, Robert Stam, Noa Steimatsky, and Jeremi Szaniawski. It is not by happenstance that four of my closest friends, Angela Dalle Vacche, Sam Di Iorio, Steven Ungar, and Jiwei Xiao, are close to Bazin as well, and to the topic of this anthology. I was gleeful when I encountered conundrums that needed their consultation, for it made for long and entertaining conversations. The impeccable Dana Benelli, long a friend and ever a film historian, extracted the book's useful and reliable index. A younger friend and colleague, even more directly tied in his own work to this project, Tadas Bugnevicius insisted on, then constructed, the appendix and the title index; it was he who pored over the two articles translated by Hugh Gray so that I

could update them. Tadas poured over my prose as well, saving me from imprecise formulations, not to mention outright errors. His remarkable knowledge of French literature and French cinema made him the book's ideal pre-reader. I await the books he will surely write.

André Bazin on Adaptation: Cinema's Literary Imagination deserves a long and prominent life because of the significance, scope, and quality of the ideas that run through it, but also because of its exceptional and exceptionally self-conscious translation. Deborah Glassman and Nataša Ďurovičová delivered the substance of this book. They translated, debated, and repeatedly retranslated each article, and then they conferred with me evening after evening, in scores of lengthy Zoom sessions. I do not expect a comparable collaborative effort has ever been expended on any translation in our field. While arduous and inevitably contentious, these sessions became an electrifying dialogue with Bazin himself, with his way of seeing, thinking, and especially writing. The friction of dialectic that is implicit in translation, in criticism, and in argumentation warmed us during a year of social sequestration. Bazin's love of words and concepts, which is perhaps greater than his love of images, spilled into the work of these two translators until it became literally vivacious. Just as every translated word—each one in this book—has been measured, then rethought in relation to the overall sense of what was meant, so I offer two carefully chosen words to them: Thank you.

Introduction

André Bazin's Position in Cinema's
Literary Imagination

DUDLEY ANDREW

More than forty years ago, I inadvertently put my foot into what
Mary Ann Doane, soon to be a distinguished film scholar,
warned me was the swamp of adaptation, when I composed an
under-researched article that has kept me trudging intermit-
tently onward ever since.[1] That article has many problems, but it
did properly stake out the two principal directions one could
take in this unmapped zone: semiotics and sociology. The
former avoids history and encompasses media specificity
(including media overlap), narratology, comparative stylistics,
registers of equivalence, and degrees of fidelity. The latter deals
with periods and movements in multiple arts; the varied incar-
nations and remediations of overriding themes, situations, and
characters; the national promotion or censorship of topics; com-
parative reception and the fluctuating force of fandom, etc. Both
directions demand general reflection and specific case studies.
In 1980, emerging from a decade of semiotics and narratology, I
held the banner of the sociological alternative high so it could at
least be recognized. Actually I was unknowingly contributing to

a wave that turned the leading edge of adaptation studies away from analyzing pairs of texts (novels into films) and toward cultural studies. I urged broad but controlled research into how literary texts and movements have been appropriated and exploited by producers and consumers in various times and places, and how, sometimes, there has been a reverse flow from film back to literature. The impact of the text, not its inviolability, counts for social history. Then cultural studies came to completely dominate the humanities, and I flinched to see original works of literature left unprotected from roving bands of critics who applauded while books and plays I considered masterworks were manhandled in ways alleged to be relevant, challenging, or simply postmodern. Eventually I published an about-face called "The Economies of Fidelity" in a collection neatly titled *True to the Spirit*.[2] Fidelity, I argued, cannot be pushed brusquely aside. It may be overvalued, but it remains a value for all that, and one not to be dismissed even in cases when it is flagrantly traduced.

Evidently, I don't know where I stand, apparently trudging in both directions. But I take heart, since André Bazin had done the same, though in his case with a plan and in full awareness. He knew that a social history of the arts alongside technological and stylistic knowledge of both literature and cinema must accompany, perhaps tacitly, any worthwhile examination and assessment of those many moments when these media collide in adaptation. Adaptations are not curiosities, constituting a niche genre. They are crucial for the health and growth of both fiction and film. They also open up for the critic and the public a glimpse into the (semiotic) workings of both forms and into the sociology of cultural production.

Bazin treated cinema's rapport with literature, what I call its "literary imagination," as the necessary complement to its rap-

port with reality. His most famous essay, "The Ontology of the Photographic Image," anchoring his realism, appeared in print in 1945, a few months before his equally intricate piece on André Malraux's *Espoir* came out in *Poésie.* There Bazin dared to suggest that Malraux's film could be taken on a par with his novel, because, as he would state three years later in "Cinema as Digest," it is effectively its twin and it doesn't matter which was the first to come out of Malraux's head. Even if they drift down different streams of cultural history—one literary, the other cinematic—they share the DNA of this auteur's style. "Cinema as Digest" put the new medium in its place, that is, situated it among the arts as these have evolved in Western culture since the Middle Ages. This kind of historical-cultural investigation was essential to Bazin's quest to discover "What is Cinema?," just as were his ideas about the medium's specificity in the essay on photography's ontology. Certain that, *pace* Jean-Paul Sartre, "Cinema's existence precedes its essence,"[3] Bazin recognized the need for an ontogeny of the medium that would complement its ontology.[4] Both types of investigation demand a scrutiny of cinema's stylistic resources, such as he provided in the Malraux example and many of his film reviews. As those reviews intermittently demonstrate, cinema's ontogeny involves an evolution in which it grew out of, and in symbiosis with, literature.

COMPARING NOVELS AND FILMS VIA AESTHETICS AND SOCIOLOGY

Generally considered a narrow concern by today's "Film and Literature" scholars, fidelity stands out prominently in Bazin, because, in cases where the original work is well known, it has been prominent with film producers and audiences. Few care

about fidelity when the source is generic, as in a mystery novel, even a very good one by, say, Georges Simenon, since audiences and producers are looking for the novel to engender a film with equivalent suspense and cleverness, whether or not it departs from what Simenon wrote.[5] Classic literature and best sellers are different. In a manner of speaking, they form a genre in which fidelity plays a role, just as spectacle plays a role in historical films. Not every historical film need be spectacular, just as not every adaptation need be faithful to the text, but audiences and producers will ask themselves about deviations from the norm. All things being equal, fidelity is a good norm, Bazin repeatedly argues, beneficial to both art forms; but it is not inviolable. Indeed, fidelity's priority is historically relative once you look at adaptation as an endemic, unavoidable practice throughout Western civilization. Adopting Malraux's art historical purview (*The Museum Without Walls* came out in 1947), Bazin goes back to the Middle Ages before fidelity was prized, when stories and images from the Bible and the lives of the saints funded works in many media, as these aimed to edify all classes in a homogeneously Christian society. He ventured that cinema finds itself in an analogous situation today, since it, likewise, addresses all classes with codified genres that repeat a limited range of stories and images. Just as medieval people seldom pointed to individual artists when encountering sculptures, stained-glass windows, illustrated manuscripts, or plays, most viewers do not take the films they watch to be the brainchildren of directors. Credits disperse "authority" for films beneath the studio logo. Audiences during the classic period—and still today—generally assume films come simply from some national or international entertainment industry, for which "Hollywood" often serves as a colloquial shorthand.

In the twentieth century, the audience for cinema, unlike for the other arts, except perhaps architecture, was massive and indiscriminate. The entranced crowds inside the picture palaces that were built between the two world wars thus resemble the faithful of the Middle Ages who filled cathedrals to listen to homilies, gaze at statues and stained glass, and worship together. Spectacle, stories, instruction, and communion (with their fellow beings as much as with Christ) constituted a weekly ritual for multitudes, then and now. Yet most critics talk about films as if they were modeled on nineteenth-century aesthetic notions of private contemplation of works, each produced by individual genius.

Of course, the arts have greatly changed since the thirteenth century. Anonymous mystery plays evolved into dramas published by playwrights with names like Shakespeare, Racine, Ibsen, and Cocteau. Paintings, which are now experienced mainly on the walls of museums rather than churches, carry the name of the artist, if not on the actual canvas, then on a label next to it. But cinema, the newest art, resembles the medieval situation; attention to the creator is less pervasive. From the 1920s to the 1960s, the French public to which Bazin belonged frequented what was known as "le cinéma du samedi soir," often without knowing the title of the film they would see, let alone its auteur. They attended the movies in the way so many of them did Mass the following morning, perhaps ignorant of which priest was officiating. In any case, his name was incidental to the ritual, as were the names of those responsible for the weekly spectacle at the local movie theater. This suggests that, as Fredric Jameson might put it, films may be an essentially "modern" form of representation, but they carry residual aspects from the feudal mode of production.[6]

By the same token, keeping Jameson's view in mind, certain popular films in the classic era also point to, or contain in

embryo, indicators of the fictional arts of postmodern culture in late capitalism. Actually, Bazin prophesied in 1951 that cinema was mortal and could be expected to morph into something quite different before too long,[7] so we can imagine that were he alive at the dawn of the twenty-first century (making him eighty-two had he lived), he would have written energetically about cinema's somewhat diminished but still important place in "convergence culture," where it is situated among anime, manga, and video games. Although he was writing about the classic era of cinema, Bazin could have had twenty-first-century digital culture in mind when he argued for "the birth of a new aesthetic middle ages whose cause is the masses' rise to power (or at least their participation in it) and the emergence of an artistic technology corresponding to that rise." Our historical myopia seldom keeps in view anything prior to the Romantic age, when individual genius was prized above all else. And this myopia has led to the distorted and "entirely *modern* notion of the inviolability of a work of art, for which the critics are largely responsible."[8]

Although he would not have known it, here Bazin edges close to Walter Benjamin. Benjamin demoted the creative writer by upholding the premodern storyteller, who performed traditional tales to attentive listeners in the public square, as opposed to the nineteenth- and twentieth-century cliché of the novelist scribbling in his garret or typing in his solitary office expecting to be read by individuals singly in their rooms.[9] Both Bazin and Benjamin sense that the technological arts (this would include radio, cinema, and television, as well as new media) serve as today's public square, where rosters of writers, adapters, producers, and show runners spin versions of familiar plots and characters that are adjusted to be relevant to their presumptive audience. Bazin found Hollywood vigorous because, unlike the

weaker French film industry, its studios spawned genres which, no matter who was responsible, continued to spew stories that audiences greeted familiarly. Indeed, familiar genres are best defined by family resemblance. Bazin went even further, believing that, at base, cinema has operated in the mode of 'myth' whenever it recycles, updates, combines, parodies, or modifies the fictional situations that a culture has found fertile.[10] By definition, myths are fundamentally unauthored.

The adaptation of famous novels might be considered a genre of a special type, where the films resemble not one another, as is the norm in genres, but their accomplished older literary siblings. Even when this appears ludicrous (Bazin pointed often to the travesty of Ernest Hemingway in Sam Wood's 1943 *For Whom the Bell Tolls*), he did not think this damaged the revered author—quite the reverse. Hemingway stands to gain readers and respect, which is just what Bazin, an ardent student of literature, was glad to see. And so he eagerly wrote about adaptations of novels he had read or had heard about, even though most were thin soup compared to the meaty novels on whose fame and inspiration they drew. When a film comes preadvertised as adapted from a noted book or author, fidelity is a topic one cannot avoid.

Should Bazin, then, be included among those critics he mentioned as responsible for the shortsighted, "modern" view of cultural history that stretches back only to the nineteenth century and its devotion to the author-as-genius? The nineteenth century was critical to cinema, he agreed, but in a most material way. When cinema was struggling to walk, it was lifted on the backs of literature and theater through adaptation and imitation, and propelled quickly toward maturity as an artistic force in culture. Cinema's production practices and business protocols emulated those of theater, while its subject matter frequently came directly

from the novels and short stories of the past several generations. Adapting fiction was essential to cinema's ontogenesis. Adaptation was not something to discredit or approve, because it was a fact of cinema's existence. Rather, Bazin aimed to understand its chemistry, including what he called, after Sartre, the "chyle" produced by cinema's digestion of masterpieces.[11] Chyle may sound distasteful, but, as a kind of sap, it has great metabolic value!

Ontology and ontogeny: Bazin's relentless pursuit of both kept him from dogmatism; it also kept him current and keeps him so. Hence the return in our digital age of his ruminations on cinema's congenital realism. Hence also the pertinence of his ideas about adaptation for today's convergence culture in which cinema is blending into a media stream. Just as Daniel Morgan argued that Bazin's strict ontology of photography's link to visible reality supported the various realisms he elaborated in his criticism,[12] so I argue that his insistence on the value of fidelity in adaptation still permitted him numerous defensible attitudes toward its presence in all sorts of cultural productions. He promoted what he called "fidelité vivante."[13] In both domains, realism and adaptation, an axiom can fund several lines of reasoning and lead to arguments defending distinct, even opposed, cases in film history. The evolution of technology, genres, and styles, not to mention the unpredictability of sheer genius in certain filmmakers, has demonstrably delivered alternative types of adaptations and will inevitably do so in the future. Bazin's chief ideas, however, remain relevant throughout. They helped him assess what he found in varied cases across a dozen years, and they can help us do the same. Fidelity takes on multiple values when placed within an ecology of cinema as comprehensive as is Bazin's.

Such scope should feel refreshing to Anglophone students of film who first learned how to deal with adaptations from follow-

ers of George Bluestone's 1957 *Novels into Film*. Of course, a concern with this topic predated Bluestone by half a century; it is effectively as old as cinema itself, and as popular. Émile Zola was still alive in 1902 and so probably saw the four-minute *Les Victimes de l'alcoolisme* that Ferdinand Zecca made from *L'Assommoir*. Just six years later, Albert Capellani directed a version ample enough at thirty-six minutes to boast that novel's title. Before World War I, Capellani would go on to grander projects in this genre: *Anna Karenina*; *Les Misérables* (a serial in seven hourlong episodes); and the terrific *Germinal,* shown integrally at two and a half hours in 1913. I imagine that terms like "fidelity," "propriety," and perhaps even "equivalence" laced the conversations of spectators pouring out of the theaters and into cafés after seeing *Germinal,* and that newspaper reviews of the film's literary ambition were debated. Decades later, Bluestone's book, published by an academic press, lifted the topic out of the cafés and newspapers, making it something to interrogate in classrooms and at conferences. Books and anthologies on the subject have followed, encouraged by publishers who keep their eye on secondary school and college curricula. For the longest time, most textbooks followed Bluestone, with chapters dedicated to comparing the film versions of important literary works taught to undergraduates.

But as with food, fashion, and music, views about adaptation, including "theories" as well as tastes, are widespread, and we shouldn't listen only to those whose expertise has been sanctioned by a PhD. Dedicated critics, writing about their regular encounters with adaptations, might tell us something more immediate and truer. Best of all would be the popular critic boasting a serious stake in literary creation or a background in its study. In the classical era, the models were James Agee in the

United States, Graham Greene in the United Kingdom, and in France, preeminently, André Bazin.

LITERATURE: THERE AT THE OUTSET OF BAZIN'S APPROACH TO CINEMA

Bazin became a daily critic writing for a huge public only when a stutter cost him the teaching post he anticipated after reaching a top level of literary study at an École normale supérieure. And so you might expect, and amply find, references to literary issues, to authors, and to adaptation throughout his corpus. I have argued that Bazin's career might be split in about 1950, when tuberculosis took him out of circulation for fifteen months.[14] The 1940s Bazin focused on realism, while the 1950s Bazin turned more toward cinema's cultural relations, specifically its place among the arts. But having now read his complete works, I find this clear symmetry smudged. Starting out as a twenty-five-year-old critic, he was convinced that he was chronicling a crucial development from the classic era to a modern one, with Jean Renoir, Orson Welles, and the Italian neorealists spearheading change. If he were right, a modern drift should also be felt in many standard films as well. Why not look for changes in adaptations, for instance, generally a conservative, even reactionary genre? And, indeed, a number of the ideas about film's relation to the novel that he formulated in his reviews of the 1940s contributed, I now believe, to his understanding of realism and the modernist moment, just as, in the 1950s, ideas about cinema's ontological realism would continue to pollinate his discussions of adaptation.

Bazin was consistent, but he also kept learning from the films that he went to see week after week. Riffling through the first years of *Le Parisien libéré*, you find in August 1946 a brief piece,

"Roman et cinéma," placed just beneath, so as to extend, his review of John Ford's *How Green Was My Valley*, a beautiful film taken from Richard Llewellyn's six-hundred-page best seller. Bazin tells his readers to expect more adaptations of well-known novels from Hollywood, where the "general tendency in American cinema" had begun to change. Rather than simply mining them for their characters, plots, and titles, Hollywood promised "to double the literary work with an equivalent cinematographic one by preserving the complexity and subtlety of the novelist's art."[15] Whether or not they succeeded, this ambition shamed standard French adaptations such as the 1946 *L'Idiot.* Despite his prestidigitations, screenwriter Charles Spaak badly digested eight hundred pages of often philosophical prose into a ninety-three-minute period melodrama. Merely stringing together the novel's famous scenes, the director, Christian-Jaque, evacuated Dostoevsky's angst.[16] Sets, costume, plot, and dialogue are not enough, Bazin lamented, as was made clear when, playing Prince Myshkin, Gérard Philipe, still a neophyte, struggled awkwardly to convey the novel's depth with facial gestures.

Meanwhile, less than a month after Charles de Gaulle marched through the Arc de Triomphe, Bazin mentions that Lewis Milestone's 1939 *Of Mice and Men* was on its way. Though it wouldn't be until Christmas 1946 that he would see it, John Steinbeck's name forecast a writers' era, in which he, along with Erskine Caldwell, Hemingway, and William Faulkner, were putting pressure on Hollywood to do well by their novels.[17] Bazin's colleagues at *Esprit*, Roger Leenhardt and the brilliant Claude-Edmonde Magny, said the same. In what Magny called "The Age of the American Novel,"[18] these writers, who had learned many literary techniques from cinema, might now be in a position to give back to Hollywood the kind of maturity in

subject matter and the suppleness of style that would, in the best prognosis, result in a more sophisticated public and ultimately a more discriminating, sensitive, and reflective citizenry.

This hope was both confirmed and deflated when *The Human Comedy* appeared in Paris just two months after the Germans had been driven out. On the one hand Bazin was disappointed that William Saroyan's lightweight tale had to be the first work of literary cinema to reach Paris from Hollywood; he would have preferred an adaptation of a challenging story by Steinbeck, Faulkner, or Hemingway. He reasoned that the distributors were coddling the French who surely needed something uplifting after four years of Occupation, and Saroyan's rather saccharine optimism served as a good will gesture from the liberators. What it contained was less like literature than like propaganda and public relations. On the other hand, *The Human Comedy* was unmistakably a writer's film. Saroyan had published his novel in 1943, adapting it from his original screenplay that linked wholesome anecdotes of daily life in a small town during wartime. The novel came out as a Book of the Month club selection in March 1943, just as Clarence Brown's film premiered with Mickey Rooney in the lead. While recognizing the director's track record, Bazin could feel Saroyan in the voice-over narrating from beyond the grave and hovering benevolently above the town. The novelist's omniscience dominates the limited perspectives of the camera, cinema benevolently acquiescing to literature rather than usurping it. Brown (plus what he would later call "the genius of the system") helped a worthy writer express himself in two forms, prose and celluloid, reaching two different publics and gratifying those fans ready to relish their Saroyan twice over. Neither the novel nor (especially) the film may be exceptional; but that didn't diminish Bazin's enthusiasm for a growing trend:

Until now, the fidelity of an adaptation (when it was of any concern at all) was generally limited to the plot and to the characters' psychology. At the very most, it extended to what is conventionally referred to as "atmosphere." Fidelity tends to penetrate even further today, it seems, going so far as to give us a complete equivalent, in its form and substance, of the written novel. This was an entirely natural development from a sociological perspective. Roger Caillois[19] perceived this very clearly when he pointed out that cinema is something of a functional relay of the novel.... Clarence Brown's art wasn't applied only so that the *découpage* would retain Saroyan's descriptive impressionism; in his selection and enhancement of the actors and through the plasticity of his cinematography, he was also able to recreate the novelist's aesthetic universe.[20]

Significantly, these observations were provoked by a current best seller rather than by a classic. Cinema had long ago found standard ways of bringing classic novels to the screen, but recent fiction, often featuring innovative narrative techniques like those in *The Human Comedy*, requires flexibility. Bazin's review of Billy Wilder's *The Lost Weekend* goes further, by noting at the outset that for once it was a film that made a book famous, occasioning a "Modern Library Edition" in 1948 and perhaps sparking the 1946 French translation that the publisher, René Julliard, astutely brought out just before the film's Paris premiere.[21] Bazin came to that premiere having read the book. This allowed him to appreciate Wilder's achievement in turning an "anti-cinematic novel of interior monologue" into a film that he believed should forever dispel doubts about cinema's capacity for subtlety. To probe his character, Wilder never considered facile effects like superimpositions but relied on his "icy skill in mise en scène." Better than the novelist, "the camera makes it possible to deduce [the hero's] feelings much as radar detects the position of an invisible transmitter.... The glass of liquor, the

wet rings it leaves on the counter, the typewriter, the hundred other objects present in Don Birnam's mind, take on in the film a hallucinatory importance they do not have in the novel." Bazin had claimed in his "ontology essay" that the photographic image "is a really existing hallucination," so he applauds Wilder for accomplishing on film what the novelist only dreamed of doing.

Adaptations like this, being contemporaneous with their sources, have a chance to appear on equal footing with another form of the "same" story. *Of Mice and Men* alerted Bazin to this possibility. Although he abhorred the film's music and sentimentality, he turns to it at the end of "Cinema as Digest." Steinbeck's title, he writes, could refer to three popular forms of a single subject: his 1937 novella, the stage production by George S. Kaufman that same year, and the film directed in 1939 by Milestone. Anyone looking up *Of Mice and Men* a hundred years hence, Bazin says, "would find himself in the presence not of a novel from which a film and a play were 'drawn' but of a single work in three art forms, a sort of three-sided artistic pyramid where nothing would sanction a preference for one or the other side."[22]

Bazin nails down this conclusion by citing *Espoir,* novel and film, those twins that gestated alongside one another. Twins being rare, he had made the most of this example in his early essay on Malraux's style, which defined terms he would use again and again. First, he carefully distinguished Malraux's *subject* (the solidarity of those who fight fascism) from the two artistic *forms* encasing it. These forms (film and prose-narrative) can be scrutinized for their differences, because a single *style,* one that belongs to Malraux alone, inhabits both. It is the latter term, style, that commands Bazin's attention. The author and the auteur in this case being the same, any disparity we feel in experiencing these works is due to the forms in which they appear, their media. For instance,

Malraux's famous ellipses make tremendous demands on viewers of the film who face the ineluctable progression of an experience that unrolls without interruption, whereas readers of his novel control the pace of their experience, even thumbing back through pages that were not well understood the first time. Metaphor functions differently, too, because cinema's literalness opposes the abstraction of language. Bazin's suspicion of both ellipsis and metaphor comes up intermittently throughout his writings and puts him out of step with other critics of the time and of today. He was ready, however, to grant Malraux whatever he liked, as this polymath was able to pull off a double success, being equally adept in both art forms, and because his particular style (elliptical, external, and concrete, yet replete with correspondences between man and nature) activated the resources of both.

As Malraux's novel and film face each other like two hemispheres of a global object, there runs between them an axis of creation that reaches to the poles governing adaptation: the *aesthetic* or semiotic pole of equivalence in style and the *sociological* pole of artistic function. Malraux's style might be paramount in Bazin's 1945 essay in *Poésie,* but by the time he wrote "Cinema as Digest" in 1948, it was Malraux's ambitious cultural reach that drew his attention. For the previous year when the novelist brought out *The Museum Without Walls,* he had spread out on its pages hundreds of reproductions of paintings, sculptures, and tapestries. Created in many forms throughout the ages and around the world, these are reproduced in equivalent size and laid out in black and white for comparison. Malraux made this "digest" of art history available to the masses who couldn't afford to travel to museums. Genius and style remained paramount for Malraux and would always be in the back of Bazin's mind, but in 1948 both men lobbied for cultural dissemination over artistic aura. Threads

of style invisibly stitch together the story of art. Malraux and Bazin wanted that story to reach all publics, uniting the human community. This was precisely Bazin's mission as he introduced films to union workers in Paris, parishioners in provincial towns, denizens of culture in Algeria, and students in Germany. Mixing art forms, adaptations also brought peoples together, though not necessarily in harmony. For values are at stake, aesthetic and cultural values that are at variance in every adaptation.

When Bazin was composing "Cinema as Digest," the most controversial example before him was *Le Diable au corps* (*Devil in the Flesh*, 1947), Claude Autant-Lara's scandalous version of Raymond Radiguet's even more scandalous 1923 novel about a teenager (Gérard Philipe) who has a passionate affair with the lonely wife (Micheline Prèsle) of a soldier at the front. Such an adaptation risked outraging the literati (in its aesthetic dimension) and much of the public (its sociological aspect) due to Radiguet's seemingly dispassionate, almost casual attitude for which the calculating producers, as well as their hired scriptwriters, Jean Aurenche and Pierre Bost, found substitutions that succeeded in stretching the limits of censorship without incurring a ban. Bazin recognized here a compound problem: a single subject that appeared not just in different art forms but in different social milieux, separated by a quarter century. From one postwar to another, France had undergone changes in mores as well as in literary style. While presumably somewhat more permissive regarding sexuality, the cinema had still not caught up with the way a twenty-year-old author could so provoke the middle class in 1923. To explain how this apparently successful adaptation by professionals had nevertheless made him "suffer," Bazin, in an unlikely but brilliant move, pressed hard on the term "transformation":

Aurenche and Bost's work consisted of "transforming" (in the sense of an electric transformer) the novel's voltage. In the film, the aesthetic energy remains virtually intact, but is distributed differently to meet the exigencies of a cinematic optic; despite Aurenche and Bost's successful transformation of the original's enormous amorality into an almost too obvious morality, the public still found it difficult to accept.

This is a stupendously fertile analogy. Aurenche and Bost literally change the "form" of the subject matter (the characters and situations), "trans-forming" it from prose to motion pictures and recorded sound. But as with the homonymous apparatus, the adaptation takes the electrical current flowing at full power in the novel (220 volts, let's say) and reduces it for their film to 110 volts, or whatever level best functions for what engineers call an "equivalent circuit." Radiguet's high-voltage novel, in other words, required a step-down process to drive a film that needed to operate at a cooler temperature. What would have happened, Bazin asks, had Jean Vigo adapted Radiguet? The match in anarchic temperament between writer and director would have resulted in so little transformation, or step-down, that "the public would never have seen his film because the reality of the book would have scorched the screen."[23] The cultural circuits would have been overtaxed. By extension, Bazin says something about cinema's relation to literature in 1948: the "circuit" of cinema "distribution" may be "equivalent" to that of the "circuit" that delivers novels to us, but it turns out to be more delicate, requiring careful monitoring or censorship.

Timothy Corrigan salutes "Cinema as Digest" for taking a cultural studies approach to a topic that by default had been conducted via comparative textual analysis.[24] Like many of today's cultural critics, Bazin showed himself most interested in

the "refraction" of known works into various forms and media where the vicissitudes ("obstructions" is Corrigan's word) of production and reception expose the values at stake in each instance. Before his serious bout with tuberculosis, Bazin was an indefatigable cultural activist, paid by a communist organization, "Travail et Culture," determined to extirpate elitism. When publishing on adaptation in the daily *Le Parisien libéré*, he was equipping his readers (and there may have been more than a hundred thousand of them) with a way to take hold of and use, or question, the values of powerful literary works, even as these are truncated, filtered, adulterated—in short, digested—in their screen versions.

ÉCRITURE CINÉMATOGRAPHIQUE

In the first half of 1948, and while preparing to advance the rather sociological "Cinema as Digest," Bazin also stepped up his aesthetic and semiotic concerns by referring increasingly to cinematic language. Whereas in the 1945 *Espoir* essay he had shown "style" operating across two different sign systems, now, after encountering the works of Wilder, William Wyler, and especially Welles, he was ready to raise the stakes. Their styles, as different as they were, indicated the development of a genuine language that brought cinema close to the novel. Hence, the clever title of the article "Roger Leenhardt has Filmed a Novel he never Wrote." Bazin declared that this auteur had achieved in his *découpage* a cinematic "phrasing" and "syntax" reminiscent of "French literary classicism." Paradoxically, Leenhardt's classical literary formation required him to peremptorily throw over classical film editing, and this put him in the company of Renoir, Malraux, and Welles, whom Bazin dubbed a "nouvelle avant-

garde." Thus, in the first month of 1948 Bazin implies that a literary approach to cinema could be cutting edge. Two months later Alexandre Astruc broadcast this term and these directors far and wide in his manifesto: "Naissance d'une nouvelle avantgarde: la caméra-stylo."

> From today onwards, it will be possible for the cinema to produce works which are equivalent, in their profundity and meaning, to the novels of Faulkner and Malraux, to the essays of Sartre and Camus. Moreover, we already have a significant example: Malraux's *L'Espoir*, the film which he directed from his own novel, in which, perhaps for the first time ever, film language is the exact equivalent of literary language.[25]

Astruc followed Bazin here (also in mocking the "idiotic transformations" of Balzac and Dostoevsky that have served as literary cinema), although he had himself mentioned the idea of a new cinematic avant-garde some months before, claiming, with Welles and Robert Bresson in view, that "There are no more *poètes maudits*. Malraux stated this and it's true. Now instead we have *cinéastes maudits*."[26] Welles became the emblem of the *cinéaste maudit*, after *Macbeth* made him a pariah in Hollywood. Although Jean Cocteau adored *Macbeth*, the weight of Laurence Olivier's *Hamlet* smothered it at the 1948 Venice Festival. Bazin spent hours there consoling its director and laying out his and Cocteau's plans for a new ciné-club, Objectif 49, just then getting started. Objectif 49 would lead in less than a year to the Festival du Film Maudit, with Welles designated head of jury. Then, early in 1950, six months after that festival, Bazin published his brief but revolutionary monograph on Welles, with a substantial introduction by Cocteau.[27] At mid-century and just as Bazin fell dangerously ill, this publication marked a new plateau in film aesthetics.

To have reached the level of sophistication evident in many of this book's formulations required the numerous preliminary approaches Bazin and Astruc had ventured, starting already in 1945 where they had alternated columns at *Poésie* and at *L'Écran français*. They both repeatedly addressed the new novelistic cinema presaged by Malraux and Welles. The month before he published his manifesto on "la caméra-stylo," Astruc had singled out Welles' long takes as making possible what novels provide: "sentences that describe a situation only through temporal perspective."[28] This pithy remark summarizes the defense of *Citizen Kane* that Bazin had penned in February 1947 in *Les Temps modernes* at the generous invitation of Sartre. There Bazin countered Sartre's notorious dismissal of the film by comparing Welles to the philosopher's favorite writers. Bazin claimed that Welles did for *écriture cinématographique*, what Gustave Flaubert, André Gide, and Albert Camus did when shaping verbal tenses into ways of seeing the world. While authors like these didn't invent the French language; they knew how to turn it into personal style. Declaring that *Citizen Kane* was indebted to John Dos Passos—indeed, was equal to his novels—Bazin asserted that "the mutual influence that literature and cinema have on each other ... does not diminish the uniqueness of their respective means of expression."[29] Compared to the "puerile" adaptations that French directors were turning out in their "quasi-uniform" language, "Welles, Wyler, or Preston Sturges don't adapt; they write and rewrite their stories in film language and never doubt thereby to achieve, each in his own way, the artistic revolution required, just as James Joyce, for instance, managed to do it in literature."[30]

And so, a year in advance of Astruc's "la caméra-stylo," Bazin's "The Technique of Citizen Kane" mobilized the vocabulary that both these critics, leading a phalanx of others, started to employ

to break through a fossilized conception of adaptation and of cinema itself. Leenhardt stood right beside them. Indeed, he may well have been first: he had been first in praising *Espoir,* first in recognizing a new American cinema based on current fiction, and first in demoting spectacle in favor of film language.[31] He had presented one of his documentaries at Bazin's ciné-club in 1943 and then mentored Bazin as his replacement as the journal's film critic when *Esprit* began to publish again after the war. He was a kind of godfather to him, just as Sartre was to Astruc. These names ricochet back and forth alongside the names Malraux, Cocteau, Bresson, and, less often, Jacques Becker, Jean Grémillon, and René Clément.[32] This group came together late in 1948 at Objectif 49, which Bazin coordinated with Astruc's help. Leenhardt, Bresson, and Cocteau shared the honor of being president. They proudly oversaw the projection and discussion of works that were the opposite of predigested classics. Bazin now was directly encouraging and promoting new films, the way publishers of presses do with the works of authors. Welles, Bresson, Roberto Rossellini, Cocteau, Leenhardt, and Grémillon took the stage in front of the Paris literati. Through their films and their discussions, they demonstrated a concept that was more than an analogy: *écriture cinématographique.*

While it had some currency during the 1920s,[33] this term came to the fore in Bazin's *Citizen Kane* essay, where he rebukes Sartre's nasty characterization of Welles as a bluffer whose precious style was, in fact, too literary for Sartre, reminding him of "certain elite New York poems," which smelled of "l'écriture d'artiste."[34] Bazin, instead, salutes Welles for working as a novelist does, though in a new medium. He praises him not for inventing techniques that were available to him the way French was available to Camus, but for his choice of a personal *écriture cinématographique.*[35]

This is a far bolder expression than the common "cinematic style" or "cinematic language." To say that an auteur writes in cinema blasts open the conception of the film-literature rapport. Less than a year later, he lifted Rossellini alongside Welles, claiming that both had arrived at an equivalent in filmic expression of the progressive American novel (which, it should be said, Sartre had done so much to promote).[36] With *Paisà* as with *Citizen Kane*, we are outside the realm of adaptation yet within a conception of the film as *recit*. This is why Leenhardt could be said to have filmed a novel he never wrote, for he was, precisely, "un écrivain du cinéma." His "cinematic sentences" carry a personal rhythm, just as, for Bazin and Astruc, the long takes (sentences) in Welles and Renoir are thoughtful, and carry thought.[37]

The growth of Bazin's enhanced conception of film style is apparent when the February 1947 "Technique of *Citizen Kane*" is set beside his monograph on the director that came out exactly three years later. Dos Passos comes up in both texts; so, too, does Welles' counterintuitive move away from theatrical spectacle and toward a novelistic conception of film. But something new and quite specific to cinematic grammar appears in the book. On page fifty-four he baptizes a term, "le plan sequence" (the sequence shot). He defines it as "this new unit in film semantics and syntax"[38] that Welles required to articulate his vision. In constructing *Citizen Kane* in a novelistic manner, and in adapting both the *Magnificent Ambersons* and *Macbeth* so as to preserve the ambiguity of the dark worlds in which their characters dwell, Welles altered for good the language of the cinema. Of course Bazin recognized that Welles was part of a trend toward modernization visible in other filmmakers who aimed to write cinema the way auteurs write fiction. But it was Welles who made Sartre, Astruc, and so many others take note. For his struggle in

the making of these films and then in the skirmishes over them once they were made, was, Bazin implies, a battle evident on screen in the grammar of cinematic language and narration. Bazin's book declared Welles and cinema victorious.

The book equally established the ascendency of a critical vocabulary capable of articulating this evolution in cinema. Bazin's deployed the key term of that vocabulary "l'écriture cinématographique" with swelling confidence after 1947. One reason for its sudden rise to prominence at just this time may have come from an undeclared ally: Roland Barthes.[39]

ROLAND BARTHES AND BAZIN

In the summer of 1947 Barthes came onto the Parisian intellectual scene with an article, "Le Degré zéro de l'écriture," that would grow into his first book six years later. It received so much response that *Combat* quickly published his follow-up piece[40] Articulating a modern form of French writing that prized neutrality over expressiveness, Barthes drew his examples from authors (Camus, Sartre, Jacques Prévert, Raymond Queneau), dear to Bazin and Astruc. Except for Camus, these men also happened to write scripts, something Barthes mentions in conjunction with Sartre.[41] The article's title and these four authors could have caught Bazin's eye, or more certainly Astruc's, as he regularly published in *Combat*. Bazin, I speculate, may well have been stimulated to think of the history of film in the way Barthes discusses the mutating idea of literature that each epoch presents to its authors. The neutral style was Barthes' response to Sartre's just-published "The Situation of the Writer in 1947," which demoted poetry in favor of committed journalism and fiction.[42] Barthes offered a way to appreciate authors whom Sartre actually

approved by refiguring the "style of the journalist" so as to escape Sartre's binary categories. Neutral writing made possible a "third way," to produce a kind of literature other than politically committed tracts and allegories, on one side, and idealist bourgeois effluent on the other. There was room, he wrote, for contemporary authors, through productive disengagement, to keep their distance from the often difficult subjects they take up. Camus, Queneau, and Prévert, not to mention Sartre, are identified as fulfilling a promising enterprise to represent the world without "any secret, that is to say in an indifferent style, or rather an innocent style. Thus in *L'Étranger*, for example, Camus has obtained a style of absence which nearly achieves an ideal absence of style."[43]

Like Barthes, the leftist but wary Bazin felt hemmed in by Sartre as the Cold War began. Not wanting to endorse Soviet Socialist Realism or dismiss all American productions, Bazin held out hope that Hollywood would dial back ostentation and represent both the material and the moral worlds with the ambiguity that existentialism found everywhere in the postwar period. A few American directors like Wilder in *The Lost Weekend*, along with an entire school of Italian neorealists, had arrived at a version of what Barthes called *écriture blanche* in relation to Camus and *écriture parlé* in relation to Queneau and Prévert, where literature was made without literary style. Bazin undoubtedly discussed this with his colleagues at *Esprit*, Leenhardt and Magny. The latter's book, *The Age of the American Novel*, linking Camus both to Hemingway and to cinematic style, was published just after Bazin's "Technique de Citizen Kane" (which she cites) and just before Barthes' "Le Degré zéro de l'écriture." So Bazin would have read Barthes' discussion of the neutral style with Magny and the cinema in mind.

In fact, the neutral style comes up in Bazin just a few months after Barthes' *Combat* pieces, when in the third paragraph of his

two-part "William Wyler, Jansenist of Mise en Scène," he writes, "If we were to try to describe the mise en scène of *The Best Years of Our Lives* on the basis of its 'form,' we would have to give it a negative definition. All its energies are aimed at doing away with itself."[44] To recognize that Bazin here is channeling the literary ideas around him, and doing so outside the issue of an adaptation, one need only look again at his review of Leenhardt's "non-adaptation" that appeared just a week before the Wyler essay. Here he dwelt on this "écrivain-cinéaste's style," on his disengagement and responsibility, issues crucial to "Le Degré zéro de l'écriture." One can hear Barthes' vocabulary when Bazin writes *"L'écriture cinématographique* rediscovers ... the paradoxical agreement of clarity with the truth of concrete observation, this syntax of lucidity that also typifies French novelistic classicism."

Whether or not Bazin and Barthes read each other, their ideas traveled along parallel paths. Three years older than Bazin, Barthes was slower to make his way. Before he had published anything substantial, and as he was leaving the sanatorium where he, too, spent time recovering from tuberculosis, he likely encountered Bazin's "Ontology of the Photographic Image" (which he cites in *Camera Lucida*) and certainly "Le Mythe du cinéma total," since it came out in Georges Bataille's journal *Critique* and took up one of Barthes' constant topics, myth. A couple of Bazin's articles, such as the 1946 "Entomologie de la pin-up," adopt the form Barthes would make famous in *Mythologies*. Later on, Bazin's most incendiary article, "Le cinéma sovietique et le mythe de Staline," resonates with Barthes' anti-Stalinist Marxism and at just the moment, summer 1950, when Barthes was reassessing his relation to both Sartre and Camus during their terrible dispute.[45] Purportedly this article made Bazin notorious in the office of *Esprit*, where it was published and where Barthes would soon be a presence, launching

his "Mythologies" in a series of four brief articles there. If they didn't meet at *Esprit*, then they likely did at *L'Observateur*, where Barthes served as theater critic and Bazin as film critic. On a few occasions they addressed the very same subject (CinemaScope, Garbo, *On the Waterfront*).[46] In addition, both men exchanged views on the topic of myth with Edgar Morin, another anti-Stalinist Marxist. While mythology is usually thought of as the magma out of which literature arises in history (the Greek myths funding Homer's epics), both Barthes and Bazin instead recognize myth as a postliterate condition. "Novels are the wombs of myth," wrote Bazin.[47] Frankenstein, Quasimodo, and Emma Bovary are alive in the vocabulary and in the subconscious of people who have never read Mary Shelley, Victor Hugo, or Flaubert.

Exploring the interrelation of myth, literature, cinema, and history, and doing so in a politically tense cultural arena ruled by Sartre, both men adopted a terminology to skirt the master's rigid binary distinction between language (public, unchanging) and style (private). Barthes' historically sensitive term "écriture," lines up well with Bazin's term "form," which Barthes also uses extensively in relation to responsibility. These are codified ways of expressing oneself in a medium. In Barthes' literary sphere, the unity of classical literature broke, he argued, into a spectrum of options ("écritures") from which writers after Flaubert could choose. Bazin found cinema to be going through a similar, though delayed, maturation and diffusion. He sensed the classical becoming the modern, with the latter splitting into numerous options that he called "forms"; these, in turn, support various "styles." In 1951, he wrote:

> Sound cinema, having reached the end of, or at least a plateau in, its formal evolution, is reflecting—perhaps for the first time—on its true formal problems. Such a cinema cannot evade any longer the

decisive importance of style: that is, the fundamental state of the art where every technique is completely responsible for what it expresses, or every form is a sign, and where nothing is really said without its being couched in the necessary form.... To speak of "form" in this new sense is the very opposite of an analysis of subject matter.[48]

In bringing up the "responsibility" inherent in the choices of technique, Bazin comes very close to Barthes, for whom the author adopts an available form or *écriture* as suitable—indeed, as necessary—for what needs to be expressed in a personal style. Both critics squeeze from Sartre's ethics of choice a third term, *écriture* (form). What Susan Sontag wrote in her preface to the English translation of *Le Degré zéro de l'écriture* applies to cinema's auteurs: "Sartre has suppressed the fact that the choices made by writers always face in *two* directions: toward society and toward the nature of literature itself.... The writer's choice—which amounts to 'a way of conceiving literature'—is a matter of 'conscience, not of efficacy.'"[49] Barthes and Bazin were sensitive to literature and cinema as institutions that could change. They championed artists (e.g., Jean Cayrol and Alain Robbe-Grillet for Barthes; Bresson and Agnès Varda for Bazin) who were ushering in something new in the history of these art forms and who were doing so in a flat style.

BAZIN THE THEORIST OF ADAPTATION, TRUFFAUT THE CRITIC

In Spring 1951, just at the end of his stay in the sanatorium, Bazin was healthy enough to prepare at a distance his first contributions to the newborn journal, *Cahiers du cinéma*. Issue three contains his magnificent essay on Bresson's *Journal d'un curé de campagne*. Soon after, he composed "Pour un cinéma impur," the

supremely influential overview of the novel-film relation that benefited from his months of quiet retreat.[50] He was able to draw on these two carefully formulated articles whenever the issue of adaptation arose in the busy years that followed. In fact, the topic arose almost immediately in his discussions with François Truffaut. For in the months between these two publications, Bazin helped extricate this unpredictable youth from a military prison in Coblenz, where he was being held for desertion. Barely twenty, Truffaut moved into the attic at the Bazin home, residing there for more than two years.[51]

Right away he set to work on the article that would make his name, "A Certain Tendency of the French Cinema." Well over a year in gestation, its argument turns on adaptation, and its central example comes from *Journal d'un curé de campagne*. Needless to say, it was revised in dialogue with Bazin, first around the dinner table, then starting in Spring 1953 in the office of *Cahiers du cinéma* where Truffaut was given the chance to write reviews. He wrote a lot of them, and he often disagreed with his benefactor. He adored Max Ophüls, for example, while Bazin found that the excessive ornamentation of *Le Plaisir* smothered the clean lines of Guy de Maupassant's short stories. On the other hand, Truffaut despised Autant-Lara and his scriptwriters, Aurenche and Bost, for manhandling and simplifying Colette's beguiling *Le Blé en herbe*,[52] whereas Bazin indulged the film's "uncertain fidelity," explicitly calling out his young friend for remorselessly vilifying the adaptors of *La Symphonie pastorale* and *Le Diable au corps*: "I am well aware that François Truffaut disagrees with them; but he is wrong." Still, even before Truffaut's piece appeared, Bazin, surely under the younger critic's influence, had written, "*La Symphonie pastorale* and *Le Diable au corps*... now seem timid."[53] In light of Bresson's recent masterwork, these films no longer looked dar-

ing. Still, he acknowledged their historical importance in lifting the ambition of the practice of adaptation just after the war.

What he could not forgive was a perceived lack of ambition among those who now controlled French cinema, and in this Truffaut egged him on. In a merciless paragraph, written in March 1953, Bazin characterizes the recent track record of the national cinema, declaring that "French cinema had nothing to be proud of when it came to its young directors... [for] their very first films already concealed all the concessions, all the subterfuges of their success, dexterous but shoddy. What to expect from this generation other than a confirmation of all that is most detestable in a certain French cinema 'of quality'?" Bazin then voices revived hope: "At long last, here are two films and two young people worthy of the art they exemplify with fervor and intelligence."[54] He had just seen *Les Crimes de l'amour*, the title of a program of paired forty-five minute adaptations from the Romantic era by first-time directors: Astruc's *Le Rideau cramoisi* (*The Crimson Curtain*) and Maurice Clavel's *Mina de Vanghel*.

Having spent years around Astruc, Bazin would always support him, even in his stylistic excesses and miscalculations. Later, reviewing Astruc's version of Maupassant's *Une vie*, he dubbed him "an authentic auteur projecting his vision of the world in cinema as legitimately and as personally as does a painter or a writer."[55] Still, there are consequences to taking liberties with one's sources, as Astruc always did: "We have the right to be more demanding when it comes to creative infidelity than we have to honest, respectful mediocrity." Citing Bresson as the model, Astruc fails to measure up.

With *Mina de Vanghel*, Clavel comes closer to that model, paradoxically thanks to a most effective use of "creative infidelity" to the Stendhal novella he took on. Clavel dared to invent

voice-over commentary, attributing it to Stendhal himself. Bazin found this ingenious. Prose fiction is not just fair game for the cinema; if dealt with as Clavel has done, fiction can be materialized.

> An adapter's job is not to "extract" a story or an action from the literary work, no matter how faithful it might be to the events and characters, but rather to replace the original with a total equivalent, a new aesthetic microcosm in which the action proper and even the protagonists' psychology, enter only in an almost secondary role in the same way as do the clouds, the sounds of men or animals, or the appearance of things—as the coordinates of a metaphysics.[56]

Bresson is again the model, as Bazin must have been thinking of the sounds of rain and windshield wipers, or images of the barren trees and of spilt wine, by which Bresson situated the written fictions of Diderot and Georges Bernanos.[57] In Clavel's case, Stendhalian language is voiced alongside real people, animals, and things; thus reality ties down the novelist's psychology and morality, so that the entirety forms an integral cinematic world. As a writer, Stendhal had to put one thing after another—a character's thoughts following the description of a nearby setting or the speech of another character—but Clavel was able to stage all this simultaneously, including the characters, the objects, the sounds among them, and a voice reflecting on the moment. If he invented some new Stendhalian commentary (infuriating literary scholars), it was to properly balance and synchronize this universe, to make it equivalent to the one that Stendhal had composed as a sequence of sentences page after page. *Mina de Vanghel,* the novella as much as the character, thereby passed into a new form, and was trans*form*ed.

Compared to innovative adaptations like these, the predictable machinery of Aurenche and Bost was disappointing in Bazin's eyes, and completely anathema to Truffaut, who called *Le Blé en*

herbe, Le Diable au corps, and *Le Rouge et le Noir* "the worst kind of matinee theater."[58] Bazin, too, found *Le Rouge et le Noir* perfunctory: "What lack of imagination in the mise en scène! Not a single gesture surprises us, dramatic intention included. We need only compare it to the lovers' movements in the apartments in [Astruc's] *Le Rideau cramoisi.*"[59] But he gave Autant-Lara credit for focusing less on the action than on the characters' reactions, managing to show them maturing across this long film, and thus to possess something of the density by which Stendhal made them so memorable. Still, unlike Astruc, Autant-Lara would never be an auteur. On this, Bazin concurred with Truffaut.

A director on whom they never concurred, one known throughout the 1950s for his adaptations, was René Clément. Indeed Clément caused a rift within the ranks of *Cahiers du cinéma.* The journal's founders, Bazin and Jacques Doniol-Valcroze, along with Pierre Kast, praised his intelligence, technical wizardry, precision, and esprit de corps. He had joined Objectif 49 and attended the Biarritz festival, where Bazin had interviewed him at length. His published opinions were close to Bazin's, both of them decrying the stultifying atmosphere of the studios and star system, and upholding *Paisà* as the new model of what cinema should become.[60] However, the young Turks at *Cahiers* found that he betrayed these ideals, when his so-called assets made him dispassionate, intellectual, cynical, and ready to compromise. His films exhibited little personal vision, even as his budgets kept increasing. They declared Clément a lackey of the industry.

Originally tagged to be France's answer to Italian neorealism, by 1950 Clément produced only adaptations, culminating at the very end of the decade, and after Bazin's death, in the international and critical hit *Plein Soleil (Purple Noon,* from a Patricia Highsmith novel), which *Cahiers* did its best to discredit as a New

Wave look-alike.[61] Truffaut's dismissal was retrospective. Once he had accepted Aurenche and Bost as scriptwriters in 1949, Clément showed his true colors. Truffaut denigrated even *La Bataille du rail* as a mere imitation of *Espoir*, whereas Bazin extolled the film when it landed Clément the Best Director award at the inaugural Cannes Festival in 1946. The fact that Clément also directed Cocteau's *Belle et la bête* that same year showed his stylistic range and technical resources. How could you not expect great things from him? Bazin felt vindicated when *Jeux interdits* (*Forbidden Games*) won an Academy Award, a New York Film Critics Circle Award, and the Venice Golden Lion, while *Monsieur Ripois* took the Jury Special Prize at Cannes in 1954.[62]

We know Bazin preferred adaptations from recent rather than classic fiction, and, except for *Gervaise* from Zola's *L'Assommoir*, all Clément's fifties films came from books that were in the news, like Marguerite Duras' *Barrage contre le Pacifique*. *Jeux interdits* was particularly interesting to Bazin because its genesis exposed the cultural circulation system within which a subject gathers strength and interest as it is passed from medium to medium. François Boyer had written this Occupation tale as a film script while completing his training at the newly established French film school, IDHEC (Institut des hautes études cinématographiques), in 1946. Clément was a teacher at the school, but declined to purchase an option on the script. Discouraged, Boyer transformed his virtual film into a short novel, *Jeux inconnus*. It sold but three hundred copies in 1947, but somehow found its way into English as *Secret Games*, taking off in the United States, even appearing in the *Reader's Digest*.[63] Clément was now convinced to go forward with the project, but as a forty-minute segment in a three-part omnibus film, until producer Robert Dorfman let the film grow to feature length.

The virtues of the film derive from this complicated gestation. First of all, Aurenche and Bost raised their level because they adapted not Boyer's novel but the rejected 1946 script.[64] That script, Bazin hints, owes a great deal to the "behaviorist" tone of much recent American fiction. Perhaps this is why the novel was popular in the U.S. market. Bazin charts a relay in which the vogue in France for American fiction led to a French film script, reworked into a French novel, which rebounded from its American translation back to the French film script it had once been, resulting in a successful movie that won an Oscar in Hollywood.

Throughout all versions Boyer's dialogue evidently remained intact; Bazin praises it as pure, though often shocking, like the children themselves. Clément's nearly anthropological manner of observing the fantasy life of children puts the moralism of the adults in its place. His "technical objectivity" provides a place, a physical situation, for Boyer's dialogue. Whereas on the printed page it comes fast, line following line without descriptions of the speakers, the same dialogue on screen is emitted in a genuine rural location and from the mouths of two children from whom we can't take our eyes. Keeping his own expressiveness in check, Clément outdoes Boyer thanks to the poetry not just of the dialogue but of the untutored acting of the child performers, something no novel can provide. Bazin was incredulous that so many critics excoriated Clément for ridiculing the peasants and religion and for offering what they took to be a cynical view of childhood.[65] Perhaps like the adult peasants, these critics would prefer the children to speak and behave differently. But Clément has given his characters (and actors) genuine independence. If they are amoral, then the film is amoral too, and so much the better.

Surprisingly, France's most talented realist director had contemplated cushioning *Jeux interdits* with a gentle scene to open and then close the film, in which the boy reads a book to the little girl through whose imagination the story would then unfold.[66] Projecting the child's point of view this way, these scenes would account for the harsh light directed at the adults and would have softened the cruel final shot of the little girl abandoned at an orphanage. But Clément, or his producer, was right to discard these scenes even after they had gone to the expense of shooting them. For *Jeux interdits* may be taken from a novel, as its credits, appearing on turning pages, indicate, but it is not a "reflective novel" like *Le Silence de la mer* or *Journal d'un curé de campagne*, whose credit sequences include a hand turning the first pages of the actual novel (in the case of *Le Silence de la mer*) or of the *curé*'s handwritten journal. Moreover, in both cases voice-over narration signals throughout that these are fictions set in the past. Whereas, without a spoken narrative voice, *Jeux interdits*, Bazin wrote, emulated a novel by Caldwell, direct and objective.[67] And so the film starts abruptly with the horrendous spectacle of the frantic exodus from Paris as Nazi Stukas strafe the highway, recreating chaos and danger with as much immediacy as had *La Bataille du rail*. This film did not need to represent a novel, because, in effect, it was itself a new kind of novel, one appearing in images on screen.

Was Clément really an auteur with a caméra-stylo as Bazin suggests? Truffaut would have nothing of this; he dismissed *Jeux interdits* as a "scriptwriter's film." He was even more hostile to the director's next effort, *Monsieur Ripois*, which he reviewed at length from Cannes, just three months after implicating Clément in his tirade against that "certain tendency in French cinema." In adapting Louis Hémon's recently resurrected novel about a feckless

young man trying to make a life in London by going from one love affair to another, Clément lopped off the one affair that Truffaut (and Bazin) felt redeemed the book from cynicism. Truffaut applauded Clément for dismissing Aurenche from the project, though he still produced another fashionably cynical study of a mediocre Don Juan, denigrating his main character and the women with whom he gets involved. "When he suppressed everything that was moving in Hémon's book, Clément behaved like the pseudo-intellectuals with which French cinema is overpopulated."[68] Truffaut is a tremendously insightful, pithy critic. And he remembered what he wrote, so that when he came to adapt *Jules et Jim,* a novel that has much in common Hémon's, he avoided the pitfalls into which Clément had stepped.

Bazin also reviewed the film from Cannes, where he and Truffaut must have argued over drinks, for in Bazin's long article in *Esprit* a few months later, clear echoes of Truffaut's review are audible. He thought *Monsieur Ripois* "Clément's most important film,"[69] even if it tripped itself up. Echoing Truffaut: "My main reservation," he confesses, "being that as a work it is overly intellectual and calculated, insufficiently infused by sensibility." But where the harsh Truffaut stopped, as usual, with a summary judgment—that, having no deep feeling for the novelist, "the filmmaker was tinkering with a masterpiece"[70]—Bazin took the occasion of this ambitious work gone awry to examine Clément's "calculated" mise en scène, a cinematographic "writing" (he underlines the term) parallel to, if less successful than, Hémon's prose. Sparring with Truffaut no doubt helped him pinpoint the techniques of style he wanted to account for. Truffaut may have been the acutest critic of his generation, but Bazin's reviews led to reflections on cinema in general; he was a theorist, in this case a theorist of adaptation.

It was in this role that he identified what he believed to be the traditional novel's most distinguished and important property, the co-presence of objectivity and subjectivity. Through the alchemy of prose, novels slip from description into comprehension and vice versa, sometimes undetected, sometimes brazenly. From the silent era on, films have attempted to represent the mingling of perception and reflection, but in delivering scenes set in the world, and then representing consciousness or response to the world, they often become awkward. The aptly named "impressionist" movement of the twenties struggled to braid subjective and objective strands, as in Jean Epstein's *Fall of the House of Usher*, where ungainly knots resulted.

Bazin found that modern cinema was evolving toward solutions that suppressed special effects so as to render consciousness through perception. This is what he had admired in Wilder's *The Lost Weekend*. And this is where he believed Clément had made genuine gains. Zeroing in on one brief scene of seduction, Bazin illustrates what he means.

> The *découpage* includes a psychological commentary. The, as it were, "dramatic" or objective action, as it is determined here by the protagonists' behavior and words, unfolds indeed on the screen before our eyes; but the *découpage* (i.e., framing and camera movement) reflects not this apparent reality but rather M. Ripois' thoughts as he considers first his beautiful visitor's legs and then especially her marvelous solid gold cigarette case, slowly deciding to try to win first the former, then the latter. Obviously, the goal may not be especially original—other examples could date back even to silent cinema—but the novelty lies in the fact that the duplicity of both points of view, the objective and subjective, is throughout expressed simultaneously in the mise en scène, without any editing effects, close-ups, or superimpositions. This way of no longer *describing*, but, I want to say, *writing* ("*scribing*") the scene is

what delivers its hidden meaning, that which it has in the characters' minds. The same image that simply shows the action also comments on and analyzes it.[71]

Hémon deployed internal monologue intermittently at points when his character's thoughts come into focus. Bazin admired the way Clément followed him here by combining "voice-over commentary in an act of extreme virtuosity, with actual dialogue and direct sound … for the soundtrack continuously intermingles the two literary or verbal levels." While the monologues in *Monsieur Ripois* haven't nearly the depth we sense in *Journal d'un curé de campagne* or *Le Silence de la mer*, or even in Astruc's *Le Rideau cramoisi*, they are literary all the same, and therefore abstract in relation to the images that play alongside them.[72] Here Clément's indisputable technical skill let him mix the abstraction of a moral tale with the extreme realism of a quasi-documentary on urban life. Ripois walks through a genuine London while his thoughts drop like rain over what we see. "The moral loneliness of a poor man in the city is no longer the believable creation of the writer or scenarist; its representation coincides with our experience of it. To record it is to devise it." The voice-overs achieve even more in the film than do the introspective monologues of the novel, for they operate via "the insertion of the fictional element of the actor into a reality that ignores him." We sense this directly.

Clément's film begged for comparison with Bresson's *Journal*, which Truffaut and Bazin both supply. While neither felt he measured up, Bazin praised Clément for having reached "beyond the spectacle, [to] interest us less through the representation of events than through our comprehension of them." This is what strong novels make possible, Bazin believed, and this is what cinema was learning to provide. Because Bresson and Clément

each filmed a novel expressing the loneliness of a young man, Bazin's essays about both adaptations, taken in tandem, clarify some of the mystery of *l'écriture cinématographique.*

Bazin would have talked about these issues constantly in the office at *Cahiers du cinéma,* where his most attentive listener was Eric Rohmer, the professor of literature and former novelist who had turned to cinema as a new way to write his books. The core of Rohmer's aesthetic is summarized in Bazin's reading of the achievement of *Monsieur Ripois,* where a scripted plot, including a type of literary consciousness, comes into contact with genuine weather conditions, with oblivious buses and cars, and with real passers-by, some of whom are visibly amused by the production of a movie taking place right then and there. Rohmer must have taken notes, for almost twenty years later he repeated Clément's formula in the prologue to *L'Amour l'après-midi.* Rohmer's "moral tales," like his "comedies and proverbs" balance, in Jacques Aumont's terms, "The extraordinary and the solid," that which is scripted and that which is impossible to predict but which comes alive at the moment.[73] The entire New Wave, indeed French cinema overall, according to Arnaud Desplechin, perhaps the most important French director working directly in its legacy today, might be defined by a single aspiration: "not to be realistic as a goal, but to invent amazing fairy tales—or just tales—setting them in real life."[74]

I am not saying that the New Wave emerged from Clément's film or from Bresson's, or that it was beholden to adaptations; but the filmmakers who visibly altered cinema in the 1960s, including the former *Cahiers* critics, as well as Bazin's friends Alain Resnais, Varda, and Chris Marker, did bank on the intricate examples of *l'écriture cinématographique* that Bazin analyzed in Clément, in Bresson, and, before them, in Welles and Wyler.[75] More certainly, the

New Wave used the give-and-take between literature and cinema, within and beyond adaptation, to inflate its ambition. Cinema's literary imagination grew in Bazin's era, giving the younger art form both muscle and dexterity of expression, and providing it with an idea about how to engage and transform culture.

NOTES

1. Dudley Andrew, "The Well-Worn Muse: Adaptation in Film History and Theory," in *Narrative Strategies in Film and Prose Fiction*, ed. S. Conger and J. Welsch (Urbana: Western Illinois University, 1980), reprinted in Andrew, *Concepts in Film Theory* (Oxford, 1984), 96–106.

2. *True to the Spirit: Film Adaptation and the Question of Fidelity*, ed. Colin MacCabe, Susan Murray, and Rick Warner (New York: Oxford University Press, 2011).

3. Bazin, "William Wyler, Jansenist of Mise en Scène," in André Bazin, *Selected Writings*, trans. Timothy Barnard (Montreal: caboose Press, 2018), 67. Originally published in *La Revue du cinéma* 10 (February 1948).

4. I develop this distinction in *What Cinema Is!: Bazin's Quest and Its Charge* (Malden, MA: Wiley-Blackwell, 2010), 110–14.

5. Bazin mentions that Simenon's novels, which would seem ideal for quick translation to film, were surprisingly resistant. See chap. 35.

6. Fredric Jameson, "Periodizing the 60s," *Social Text* 9/10 (Spring–Summer 1984): 178. Jameson explicitly takes "residual" and "emergent" from Raymond Williams here, and he uses these terms frequently elsewhere.

7. André Bazin, "Is Cinema Mortal?," in *André Bazin's New Media*, ed. Dudley Andrew (Oakland: University of California Press, 2014), 313–16.

8. André Bazin, "Cinema as Digest"; see chap. 3.

9. Walter Benjamin, "The Storyteller," in *Illuminations*, ed. Hannah Arendt (New York: Harcourt Brace, 1968), 87ff.

10. See Sayed Feroz Hassan, "Surviving Politics: André Bazin and Aesthetic Bad Faith" (PhD diss., University of Michigan, Ann Arbor, 2017), 135–78.

11. See chap. 3, note 11.

12. Daniel Morgan, "Rethinking Bazin: Ontology and Realist Aesthetics," *Critical Inquiry* 32, no. 3 (2006): 443–81.

13. Literally, "living fidelity." Bazin deployed this term, which can carry a theological connotation, in his review of *Gervaise*; see chap. 56.

14. Dudley Andrew, "The Second Life of André Bazin," preface to Andrew, *André Bazin*, rev. ed. (New York: Oxford University Press, 2013), xxiv. I introduced this position in *What Cinema Is!*, 110–11.

15. André Bazin, "Roman et cinéma," *Le Parisien libéré*, no. 612, August 2, 1946; see chap. 1.

16. André Bazin, "*L'Idiot*," *Le Parisien libéré*, no. 576, June 22, 1946.

17. We can assume that Bazin, in the meantime, attended the stage version of *Of Mice and Men* at the Théâtre Hébertot, where Marcel Duhamel's French translation was used.

18. Claude-Edmonde Magny, *The Age of the American Novel*, trans. E. Hochman (New York: Ungar Press, 1972). Bazin would pull back from endorsing her thesis completely in "Pour un cinéma impur"; see chap. 62.

19. Hervé Joubert-Laurencin notes that "Bazin obviously has in mind Roger Caillois, *Puissances du roman* [Powers of the Novel] (Paris: Éditions du Sagittaire, 1942)." See *Écrits complets*, p. 114 n13.

20. André Bazin, "On William Saroyan's *The Human Comedy*"; see chap. 16.

21. André Bazin, "*The Lost Weekend*"; see chap. 17.

22. Bazin, "Cinema as Digest."

23. Bazin, "Cinema as Digest."

24. Timothy Corrigan, "Adaptations, Refractions, and Obstructions: The Prophecies of André Bazin," in *Metacinema : The Form and Content of Filmic Reference and Reflexivity*, ed. David LaRocca (New York: Oxford University Press, 2021), 56–59.

25. Alexandre Astruc, "Naissance d'une nouvelle avant-garde: la caméra-stylo," *L'Écran français* 144, no. 30 (March 1948). Translated in Peter Graham, *The New Wave* (Garden City, NY: Doubleday, 1968), 20.

26. Alexandre Astruc, "Demain le cinéma," *Combat*, June 14, 1947. Bazin and Astruc were colleagues and perhaps rivals. Astruc bragged that he and Bazin saw *Les Dames du Bois de Boulogne* together. He bravely supported it while Bazin initially found it icy and "too timeless," (*Le Parisien libéré*, September 29, 1945). Bazin changed his opinion, perhaps

upon seeing it as a film *maudit* at Biarritz. See Alexandre Astruc, "André Bazin: 'un facon d'aimer,'" *Cahiers du cinéma* 91 (January 1959).

27. André Bazin, *Orson Welles* (Paris: Chavane, 1950). See Jean-Charles Tacchella, "André Bazin from 1945–1950: The Time of Struggles and Consecration," appendix to Andrew, *André Bazin*, 227–28.

28. Astruc, "Notes sur Orson Welles," *La Table ronde* 2 (February 1948).

29. André Bazin, "The Technique of Citizen Kane," in *Bazin at Work* (London: Routledge, 1997), 236. Originally published in *Les Temps modernes*, February 1947, reprinted in *Écrits complets*, article 238, p. 240.

30. Bazin, "Technique of Citizen Kane," 237.

31. Roger Leenhardt's criticism is collected in his *Chronique du cinéma* (Paris: Editions de l'Etoile, 1986). His articles pertinent here are "Malraux et le cinéma" (June 1945), "Le Film qu'il faut voir: *Les Dames du Bois de Boulogne*" (October 1945), and "*Citizen Kane*" (July 1946).

32. See Roger Leenhardt, *Les Yeux ouverts* (Paris: Seuil, 1979). Chapter 12 recounts his impromptu evening walks in Paris with philosophers (Sartre, Maurice Merleau-Ponty), film writers (Astruc, Jacques Prévert), and novelists (Dos Passos).

33. I thank Laurent Le Forestier who, in a generous letter to the author (April 24, 2021) established that the term was much used since the 1920s, but grew substantially in the postwar period, and largely around the debate over *Citizen Kane*.

34. J. P. Sartre "*Citizen Kane*," *L'Écran français*, August 1, 1945. Sartre considered poetry frivolous after the war. But he continued to uphold the novel.

35. Bazin, "Technique of Citizen Kane," 232. Bazin's French is explicit: "Son écriture cinématographique lui appartient incontestablement."

36. André Bazin, "*Paisà* de Rossellini," in *DOC* 47, *Cahiers de documentation*, nos. 2–3 (November–December, 1947), also in *Écrits complets*, article 344, pp. 308–14, Bazin reiterates his position in his major essay on "The School of the Italian Liberation" in *Esprit*, January 1948.

37. Astruc, "L'Avenir du Cinéma," *Le Nef 48* (November 1948). This article places Renoir, Welles, and Bresson in the avant-garde, pointing the way to an abstract cinema of thought, tied to the novel rather than theater.

38. André Bazin, *Orson Welles: A Critical View* (New York: Harper and Row, 1979), 68, translated by J. Rosenbaum from the 1972 French

version (Paris: Éditions du Cerf, 1998 republication), 80. The key term appears on p. 54 in the 1950 version, where the words "semantics" and "syntax" have yet to be added, but are certainly implied.

39. The following section is elaborated at greater length in my contribution to the anthology *Understanding Barthes, Understanding Modernism*, ed. Jeffrey R. Di Leo and Zahi Zalloua (London: Bloomsbury, 2022).

40. "Le Dégré zéro de l'écriture" and "Faut-il tuer la grammaire" ("Shall We Kill the Grammar?"), *Combat*, August 1 and September 26, 1947.

41. Barthes, "Faut-il tuer la grammaire." Barthes believes Sartre turned to writing screenplays in order to broaden the social idiolect of (his) language, not to show off his own linguistic versatility, as Cocteau had been doing with his scripts. For his part, Bazin had sparred with Sartre over *Citizen Kane* and was friendly with Raymond Queneau, who became a member of Objectif 49. Bazin often praised Prévert as a screenwriter.

42. This essay came out in early Summer 1947 in *Les Temps modernes* and was collected the next year as "Qu'est-ce que la littérature" in *Situations II*. Bazin may well have taken the title of his own collected works from Sartre's rubric. In any case, he cites this piece in "Cinema as Digest." Barthes' essay, and more certainly his book, are generally taken to be his attempt to isolate a "third space" outside Sartre's binary between committed writing and bourgeois effluent. See Yue Zhou, "Commitment to Degree Zero: Barthes' First Approaches to the Neutral," *Theory, Culture, and Society* 37, no. 4 (2020): 77–95.

43. Barthes, "Le Dégré zéro de l'écriture."

44. Bazin, "William Wyler, Jansenist of Mise en Scène," 84.

45. Andy Stafford, "'L'histoire ne pourra jamais marcher contre l'histoire': Roland Barthes et l'antistalinisme, 1946–1953," *Littérature* 186 (June 2017): 20–33.

46. Philip Watts, *Roland Barthes' Cinema* (New York: Oxford University Press, 2016), 36.

47. Bazin, "Cinema as Digest."

48. André Bazin, "De la forme et du fond ou la 'crise' du cinéma," in *Almanach du théâtre et du cinéma*, ed. J. Vagne (Paris: Éditions de Flore/ La Gazette des Lettres, 1951); *Écrits complets*, article 774, 684–87.

49. Susan Sontag, "Preface," in Roland Barthes, *Writing Degree Zero and Elements of Semiology* (Boston: Beacon Press, 1968), xv–xvi.

50. Antoine de Baecque establishes the special importance of adaptation as a topic for Bazin, Truffaut, and the early *Cahiers du cinéma*. See his *Cahiers du cinéma: histoire d'un revue*, vol. 1 (Paris: Cahiers du Cinéma-Seuil, 1991), 56–110.

51. Antoine de Baecque and Serge Toubiana, *François Truffaut, a Biography*, trans. Catherine Temerson (Oakland: University of California Press, 2000), 63–80.

52. François Truffaut, *The Films in My Life*, trans. Leonard Mayhew (New York: Simon and Shuster 1978), 171.

53. Bazin, "French Cinema faces Literature," *Unifrance Film*, no. 26, August–September 1953; see chap. 60.

54. Bazin, "Stendhal's *Mina de Vanghel*, Captured beyond Fidelity"; see chap. 14.

55. Bazin, "Guy de Maupassant's *Une Vie*"; see chap. 57.

56. Bazin, "Mina de Vanghel, Captured Beyond Fidelity."

57. See Bazin, "*Journal d'un curé de campagne* and the Stylistics of Robert Bresson," chap. 61.

58. Truffaut, *The Films in My Life*, 174.

59. Bazin, "Re-reading Stendhal's *Le Rouge et le Noir* through a Camera Lens"; see chap. 12.

60. René Clément, in *Ciné-Club*, December 1947. It should be noted that when interviewed in *L'Écran français*, Fall 1947, Clément decried adaptation as a bane of French cinema, which he felt needed to become increasingly realist.

61. Emilie Bickerton, *A Short History of Cahiers du Cinéma* (London: Verso, 2009), 36–37.

62. Actually, this "special prize" was a maladroit concession offered to the film when the jury found itself locked in what was considered a bad year. See André Bazin, "Scandale à Cannes: il ne faut 'juré' de rien," *Radio-Cinéma-Télévision*, May 9 1954 (*Écrits complets*, article 1564).

63. After the film premiered, more than 40,000 copies of the novel were sold in France.

64. Bazin recapitulates the vicissitudes of the film's origins in "*Jeux Interdits*," *Esprit*, December 1952, reprinted in *Qu'est-ce que le cinéma?*, 3:15–21, translated in *Bazin at Work*, 129–36.

65. André Bazin, "*Jeux interdits:* un film admirable où s'allient le réalisme et la poésie," *Le Parisien libéré*, May 14, 1952 (*Écrits complets*, article 1037).

66. These two bookend scenes are included on the Criterion DVD of the film.

67. "Jeux Interdits," *Qu'est-ce que le cinéma?*, 3:16.

68. Truffaut, "*Monsieur Ripois*," in *The Films in My Life*, 199.

69. André Bazin, "Of Novels and Films: *M. Ripois* with or without Nemesis"; see chap. 13. Originally published in *Esprit*, August/September 1954 (*Écrits complets*, article 1580).

70. Truffaut, *The Films in My Life*, 200.

71. See chap. 13.

72. The French dialogue was supplied by Raymond Queneau, who had been responsible for initiating the project in the first place. Truffaut believed Clément made not nearly enough use of this avant-garde author, while Bazin, who knew Queneau from Objectif 49, felt that his cleverness may have made the film more superficial than the novel.

73. Jacques Aumont, "L'extraordinaire et le solide," in *L'Avant-scène du cinéma* 260 (December 1987): 3–13.

74. Arnaud Desplechin, interview in "Arnaud's Tale," featurette produced for The Criterion Collection, 2009.

75. In reprinting his essay on Wyler for his collected works, Bazin appended a note in which he concurred that Wyler had lost his edge. Still, he preferred the "cinéma-écriture" found in his best works to John Ford's spectacles and pictorial mannerism. "William Wyler, ou le janeseniste de la mise en scène," in *Qu'est-ce que le cinéma?*, vol. 1 (1958): 173n1.

Adaptation in Theory

André Bazin's complex and influential ideas about the adaptation of fiction were elaborated in greatest detail in the two pieces available in English since 1967, one on Robert Bresson's *Journal d'un curé de campagne* and the other on so-called impure, or mixed, cinema. Reprinted at the end of this volume, both were conceived during the fifteen-month hiatus, starting in January 1950, that he took from producing daily criticism to recover from tuberculosis. But he had been thinking deeply about adaptation from the outset of his career as a critic, as is emphatically demonstrated by the first selections in this section. His extended early essay on André Malraux's *Espoir* manages to honor a film and its versatile auteur, while discussing fundamental concerns about medium specificity (verbal image versus pictorial image), about the distinct audiences that adaptations address (those who have read the novel, those who know about it, and those who just wander into the theater), and about the possibility of an individual style within the constraints of the film industry. All these concerns reappear three years later in the remarkable "Cinema as Digest," where they are enriched not only by considerations of how the arts and artists have been regarded through the centuries, but also by many examples of adaptation that he had encountered in the meantime. His bold ideas (he invokes the death of the author some twenty years ahead of Roland Barthes and Michel Foucault) follow a strict logic but are carried by ingenious metaphors and analogies.

By 1948 Bazin was considered an expert on this topic, so much so that he was recruited to speak on cinema among the arts at an international congress in Geneva featuring esteemed philosophers, musicians, and art historians. Subsequently, he was asked on occasion to write about adaptation by the editors of literary journals, and in this context he reformulated certain of his cherished beliefs, covering some new ground in the process. Four of these essays directly addressing adaptation are then followed in this section by three others that go at the problem indirectly. For Bazin's literary sensibility was struck when he ran into such oddities as a full-length film of a famous long poem by Alphonse de Lamartine, and when he reviewed films by two friends and colleagues (Roger Leenhardt and Alexandre Astruc) that, without being concerned with adaptation at all, exhibit, by being novelistic, what I call cinema's literary imagination.

Part One closes with four intricate essays on knotty "film-literature" problems, occasioned by films largely forgotten today, although one of these, René Clément's *Monsieur Ripois,* received considerable attention as a prize winner at Cannes in 1953. Wanting to upgrade the stature of Clément, unfairly denigrated by François Truffaut and others at *Cahiers du cinéma,* Bazin went all out to think through this film's ambitions and shortcomings in establishing character subjectivity and interior life via strict cinematic objectivity. Naturally he referred here, as he often did, to Bresson's *Journal d'un curé de campagne,* which should be read in tandem with this piece. Even more important, in my view, are the two essays on *Mina de Vanghel,* a forty-five-minute adaptation from a little-known Stendhal novella. Perhaps because of its awkward length, this film never gained a footing in film societies or among historians, and is currently viewable only in the French archives. Yet Bazin pulls from it profound

ideas that open adaptation to new dimensions. For instance, a counterfeit off-screen voice supplements the images until the film seems to overflow the strictures of its brief running time. Like a lawyer for the defense, Bazin eloquently upholds the rights of this voice to undermine the orthodox conception of authorship in adaptation. Even if this case is eccentric, it can serve as a precedent for future scriptwriters.

Bazin's theoretical position is constituted by striking insights that seem to arise spontaneously within reviews of films like the couple just mentioned. So, take note: such insights leap from many of the reviews that are lodged in Parts Two and Three. Let me point to his appreciation of Billy Wilder's visual discretion in adapting *The Lost Weekend,* and to his complex reaction to two films which, for different reasons, were bound to cause a stir in France, *Le Rouge et le Noir* and *Le Blé en herbe.* Bazin dedicated two articles to each film. I have placed in this "theoretical" section the two in which his ideas apply to adaptation in general, but the reader may want immediately to read him further on each film, in the articles found in later sections.

1. Preview: A Postwar Renewal of Novel and Cinema

After Jean Delannoy's *La Symphonie pastorale*, starring Michèle Morgan and based on André Gide's novella, there is now talk of a *Princesse de Clèves* by Jean Cocteau and a *Candide* adapted from Voltaire by Jacques Prévert, to be filmed by Marcel Carné. The latest adaptations of Dostoevsky have already provided some sense of this peculiar tendency to prefer adaptations of canonic literary works to original screenplays. Let's await the outcome.

Yet it might be of interest to observe that in America, all the big productions are adapted from best-selling novels: *The Grapes of Wrath, Of Mice and Men, Tobacco Road, For Whom the Bell Tolls*— these are just the titles best known to the French public. The same holds true, incidentally, for successful Broadway plays.

There is nothing new, of course, in adapting novels to films, but adaptations typically took some liberties with the source. Mostly this consisted in using the subject matter rather than translating for the screen a long narrative, its style included. And that is what today's best American films seem to do, tending to double the literary work with an equivalent cinematographic one by preserving the complexity and subtlety of the novelist's art. Will they have succeeded? Soon we will surely find out.

<div align="right">

Roman et cinéma

Le Parisien libéré, no. 612, August 2, 1946

Écrits complets, 144

</div>

2. André Malraux, *Espoir*, or
Style in Cinema

A film critic ought to have a lot of trouble with his epithets. His literary counterpart is not required to account for the output of all novels. Literary classifications and hierarchies are relatively well established, and the literary chronicler deliberately ignores much of what is written, including second-rate detective stories, sentimental soap operas for the regional daily, and adventure novels sold at train stations. Nothing forces him to read these, because his public doesn't. A man of culture, he assumes a cultivated reader. More or less well stratified, a film critic works for a public that, in its vast majority, has no cinematographic culture whatsoever, for whom a film by a Jean Renoir or a Couzinet[1] is simply the movies. Let's imagine that Mr. Jean Blanzat[2] must review five or six novels of the Madame Delly or Jean de La Hire variety weekly;[3] a work by Pierre Benoît or Henry Bordeaux every two or three months;[4] and a novel by Malraux, Faulkner, Gide, or Martin du Gard no more than once or twice a year: in what style, and with what words, would he venture to address these last works? The film critic, by contrast, is constantly impugned for an imaginary bad faith merely for attempting to remain vigilant and tirelessly issue verdicts on the films he sees, judgments that the literary critic would not even deign to formulate were he to read novels of the same quality. Let me make myself absolutely clear: I am in no way speaking ill of cinema. I even think that film production in its *entirety* is ultimately superior to the *entirety* of literary production, but ancient academic habits, an intellectualist culture the critic respects and

perpetuates, is exactly what diverts us from considering litera-
ture in its entirety. In literary geography, there are only great
heights. A critic with a taste for sociology occasionally ventures
into the vast, unexplored plains where 95% of those like us live.
It's quite rare that the aesthetician deigns to follow him there.

This long preamble may not have been necessary. It does,
however, make it easier for me to discuss Malraux's film. The
reader must understand that everything that follows here
describes the artistic heights of a great literary work. I kindly ask
the reader to forget the standard range of epithets we are at times
weak enough to deploy to simply describe the films that didn't
bore us. The work I would like to discuss inhabits a realm that
the world's cinema reaches less than once in a hundred times.

Many previous reviews that have appeared rightly have
emphasized the relationship between the book and the film;
coming somewhat late, I can do little more than repeat their
evaluations of the work's substance, its intrinsic value as well as
of the rerelease that has made it so current.[5] *Espoir* is a work of
such quality, however, that it can stand up to close scrutiny. I
thus accept the nearly unanimous response of the press to the
film's release at the Max Linder and limit myself to a few
remarks on stylistics, which, in my opinion, ought to be devel-
oped much further.

It is no accident that Malraux is the contemporary writer who
has best written about cinema: there are deep affinities between
his style and the language of the screen. He was the first, I
believe, to comment on the role of ellipsis in film, and on the
ever more frequent use of this figure in the contemporary novel
(his own, in particular). However, there is a confusion in that
affinity that we might not have suspected a priori, but which
becomes apparent with time. In Malraux's film, it may be that

the ellipsis is no less effective or has any less aesthetic impact than in the book, but it penetrates the image only by doing violence to it. This unexpected resistance of cinematic expression to the transcription of an already elliptical book can, I think, shed light on an important point with regard to literary and cinematographic stylistics.

In the pages of this very journal, Claude-Edmonde Magny thoroughly analyzed the meaning of an ellipsis in contemporary literature: it destroys the possibility of meaning and introduces a void between objects and moments. The metaphysics of the ellipsis is not the same in Malraux, Camus, and Faulkner, of course. What all these contemporary novelists have in common, however, is that they want to use ellipsis to introduce temporal and spatial discontinuity in a story in such a way as to prevent us from automatically organizing reality on the basis of a particular logic of appearances, preventing us from giving it meaning. More than any other, Malraux's aesthetic develops through his choice of discontinuous moments. The story line is interrupted intentionally. Only a few broken links are scattered over the course of an action and confound even an attentive reader's efforts to reconstruct it fully.

Cinema, however, appears unable to tolerate discontinuity. For all its structure, fragmented into shots, the cinematic narrative tends increasingly to shield us from breaks. "Découpage," the professionals' term for a planned suite of shots, is a misnomer; the term used by the Americans, "continuity," is far more appropriate. In fact, the need for a flexible and resilient articulation between shots is reflected in the term continuity (*raccord*). The literary ellipsis effectively introduces a lacuna that a reader can master intellectually but that, as it turns out, is mentally painful to a viewer. I see at least two obvious reasons for this:

our passivity with respect to the image, a natural reluctance to expend intellectual effort in front of a screen, and the even unfolding of images. It is the image that should immediately set our imagination in motion, and not the mediating relay of the intellect. For no matter how determined or brave a spectator may be, the intellect is materially blocked by the spectacle's irreversibility. An [abstruse] sentence can be reread; an overly elliptical sequence is lost for good. It is as if, to work strictly on our imagination, the cinematic ellipse must remain plastic, spatial more than temporal. In cinema, a murder can be represented by a hand loosening its grip on a telephone receiver. The gesture-sign is directly connected to and simultaneous with the action it suggests; it doesn't break the continuity. True cinematographic lacunae are rarely perceived as ellipses. A man gets out of a car and enters his house. The next shot shows him going into his bedroom. The modern viewer finds it unnecessarily excessive to have watched him go up the stairs, cross the hallway, etc. But were the logic of the drama to demand it, the director could intentionally use this objective description for emotionally charged excess (if we knew, say, that at home the man will find his wife murdered).

In *Espoir,* when the disfigured pilot asks Magnin if he has a mirror, we see the captain open his briefcase as if looking for something, briefly take out a little round mirror, put it back, and say, "No." This example illustrates well the mental activity needed to reconstruct moral motives that it would be impossible to translate into visual form. In this case, of course, the ellipsis is easy to grasp no matter how intellectual it is, whereas in other cases the spectator's attention reaches its limit. Both the film's critics and its directors believe that *Espoir*'s opaqueness is the result of outside circumstances, as there were many setups that

could not be shot. Obviously the issue here is not to claim that the film would have been clearer had it been possible to follow the screenplay exactly. I believe nonetheless that lacunae, even accidental ones, ultimately play the same role as planned ellipses. Any other film would have failed under these conditions. Here, to the contrary, the lacunae contribute to a unity of style, bringing the film closer to the book, which is, in fact, just as unclear. Since they require that the mind rather than the imagination be involved, Malraux's ellipses are quite unequally comprehended. I have been to several film screenings for a relatively intellectual audience and have always been struck by how some scenes seem to be comprehensible or obscure for no apparent reason. Certain spectators understood the peasant's murder of the fascist bar owner, while others, who were no more dull-witted, still find it perplexing. It's likely that the speed of their attention, the particular psychology of their perception, got in the way of a quick enough intervention of their intellect. The *explanatory* intertitles that now accompany the film have been much criticized by those who claim that they pointlessly paraphrase the action and clarify nothing. Yet Denis Marion wrote these texts after having made surveys at the end of several showings of the film to "cultivated" viewers. That the explanations satisfied no one proved fatal, since the "obscurity" of the shots becomes eminently subjective and related to each individual's psychology. No referendum can resolve this.

This is why Malraux's film remains quite literary: not because of the copiousness or tone of the dialogue, or even because of the screenplay or psychology of the characters, but paradoxically in what should have been most cinematic, the use of a visual ellipsis in a way that preserves the intellectual structure of literary ellipsis. I am not necessarily saying that I regret this.

There is without question a positive side to the violence done to the laws of cinema. The mental tension, the sadism or aesthetic cruelty of sorts implied in this battle against the imagination, even its many obscure passages lend the work a sometimes dazzling aura. Still, these pleasures may be too intellectual—they are without a doubt valid but they don't follow in a straight line from the concept of cinematic art as *necessarily* popular. The businessmen who rejected the film would have used this as an excuse had they not also overlooked the film's most successful aspect—its grandeur and authenticity—but they are so unused to this quality that it remained unnoticed. However, I had promised to limit my remarks to style!

The ellipsis alone defines neither Malraux nor his style, of course. At a minimum, we would have to add comparison. A quick count of his syntactic vocabulary would demonstrate his frequent use of the conjunction "like," or simply his use of apposition, which is nothing but an ellipsis of the conjunction. Malraux's language is especially rich in images. His descriptions are practically nonstop comparisons. Here, for example, are two sentences from a short paragraph describing the episode of the cannon attack by Puig's car: "Behind him, in a breathless blare of trumpets and car horns, two Cadillacs sweep in, zigzagging like cars in gangster films.... Black debris amid blood stains.... a fly smashed on the wall." "The militias were shooting, it felt like an oven, their naked torsos were dappled with black spots, like panthers."

Ultimately, an analysis of the significance of comparisons in Malraux leads us to examine what, using a rather vague term, we could call a "rapprochement." Ultimately, comparison is nothing more than a rapprochement based on a resemblance between something concrete and something imagined. But for

the mind, the antithesis itself contains a subjective resemblance. Malraux uses images, whether real or imaginary, like a set designed to cast the action or the object being described in its aesthetic or metaphysical light. Whether he tells us that the militia charging into the square fell "like" hunted game, or shows us this militia driving pigeons to take flight before them, men and birds littering the ground, felled by the same machine gun bullets, the rapprochement—whether by imaginary resemblance or inscribed in reality—has the same deep significance for the writer. It is part of his mise en scène. In "Esquisse d'une psychologie du cinéma" ("Sketch for a Psychology of Cinema"), Malraux writes, "It is possible to analyze a great writer's mise en scène. Regardless of whether his object is a narrative of facts, a depiction or analysis of characters, that is, *an interrogation about the meaning of life*. Whether his talent tends toward proliferation like Proust or toward crystallization like Hemingway, he is led to recount, that is, to summarize and stage, that is, to make present. I use the term mise en scène for either the instinctive or the premeditated choice of moments to which he is attached, and the means he uses to give them a particular importance."[6]

Making present and giving meaning must for an artist be one and same action, for presence is only justified by the function of the meaning he gives it. In the work of Malraux the writer, this meaning surfaces in two important ways: the first is logical, where the characters' discourse and dialogue are often highly intellectual; in the second, which I will call aesthetic, the meaning emerges implicitly from comparisons or rapprochements. Whether imaginary or concrete, both of these have exactly the same value. For example, Malraux writes (*L'Espoir,* p. 95), "Behind Garcia, on the apostle's extended arm, machine gun belts were drying like laundry. He hung his leather vest on the outstretched index finger."[7]

The imaginary and antithetical comparison of that first sentence plays exactly the same role in the "mise en scène" as the equally antithetical but material rapprochement in the second. How can this literary staging be projected onto the visual screen? A preliminary remark: cinema knows nothing but concreteness, for its images are objectively real. The means it has at its disposal to signify the imaginary are extremely limited and of dubious aesthetic value: superimpositions, slow motion, negative/color inversion, and other optical tricks are only very rarely acceptable, and cannot possibly be used in this type of work. By contrast, the novel works only on the imaginary, since facts—whether real or thought—are transmitted by words. From this it follows that comparison in the formal and classical sense is a specifically literary figure and the conjunction "like" really has no equivalent in cinematic syntax.[8]

Its denigrators have long asserted that cinema makes our imagination passive because it has to tell everything. Were it still necessary, we could suggest another refutation here. Because he cannot formulate the image that the object he is photographing suggests to him, the cineaste must leave it to the spectator to make the effort of discovering it. But how can he be sure that the spectator will discover it, or even decide to look for it there? Here again, the technology and its psychological consequences govern aesthetics. The spectator doesn't have time to stop and think while watching a film. The image cannot make a selective appeal to intelligence. It can only turn on the smooth muscles of consciousness. The filmmaker has achieved his goal when photography spontaneously provokes the desired associations in us. I say associations, because in most cases, the image is still too involved in reality to avoid conveying a certain metaphorical polyvalence. Most often, of course, we don't usually

choose from among possible images, they do not even reach our consciousness, but their virtuality is sensed obscurely, and that is what gives the image its aesthetic density. In light of its tales, cinema is an art of ellipsis, but as a plastic reproduction of reality, it is an art of virtual metaphor.

Luckily, Malraux did not attempt to transcribe comparison literally, as he more or less did for the ellipsis, and we can say that most of his images possess precisely this obdurate density that endlessly stimulates the imagination. No doubt, these images appeal to the intellect more than in most films, but such appeal is not prohibited; it just counts that they also reach the hidden layers of consciousness. So when the dynamiters leave the grocer's shop or pharmacy, the camera's slight movement puts front and center a large enigmatic beaker with acid dripping through a funnel. The intellectual symbolism of this image can inspire long commentaries, but the drops' crystalline sound filling the dramatic silence of the room, the waves of their impact on the liquid, the only movement in the stillness deprived of men's agitation, even the object's vaguely evocative hourglass shape—these details from among which the writer could choose and which he could envelop in comparisons—are all delivered to us in their raw state, charged with meaning across metaphors' many virtualities. It doesn't matter that they only crystallize after we have had a chance to reflect on the film, and that only a subsequent meditation releases the symbols, for we had spontaneously sensed them earlier already.

Yet while literary comparison is forbidden on screen, the rapprochement of two real facts whose juxtaposition makes them particularly important is by contrast one of cinema's privileged figures. Like Malraux's book, his film is full of these concrete associations. There's the shot of the wilted sunflowers immedi-

ately following the killing of the fascist bar owner. The silence cancelled out by the noise of the cicadas after the crash of the airplane, the flight of migrating birds preceding the enemy fighters' attack; above all, the unforgettable conceit of the ant climbing across the viewfinder of the machine gun. It might even be acceptable to say that here cinematic resources serve Malraux better than literature because of the habitual choices he makes in his literary rapprochements. In Malraux's work, man is generally aligned with nature, with plants and animals, and very often with the geological or sidereal. The literary evocation therefore most certainly trails behind the concrete representation. In some domains, imagination is almost inevitably inferior to perception (as has been proved to us abundantly in war documentaries). The inhuman (you could say cosmic) counterpoint, against which Malraux always orchestrates human action, belongs among those domains; in cinema, it has found its utmost expressivity and artistic effectiveness.

Here and there, however, implicit comparisons remain that might well derive more from literary than from plastic expression. They don't harm the film, and I only mention them as examples allowing us to readily grasp the ambivalence of Malraux as a writer and a filmmaker. When one of the aerial machine gunners is wounded, his comrade yells at him to make a tourniquet and throws him the bandage box: "like a puck," says the book. Malraux was obviously obsessed by this comparison: in the film, the pharmacy box is flat and tossed horizontally, "like a puck," the spectator who has reread the book cannot help but add mentally. Had another director made this sequence on the basis of the screenplay, the dramatic interest would have remained, but he would probably not have made the effort to respect an image only a prepared viewer could grasp. As well,

on some occasions, intentions in the actors' performance aim to follow to the letter indications provided in the novel yet are too subtle to come across on the screen.

That said, the film has not incurred criticism for being "literary" in the typical, and typically pejorative, sense. The link and the close parallels between the two works have generally been considered to the film's advantage. Literature's influence on film is only blameworthy when it comes at the expense of cinematic expression. Thus, for example, when dialogue replaces visual expression, or when the director gives preference to words over characters' expressive actions, or over the meaningful use of decor and objects. For that reason, some novelists have nothing to gain from having their work adapted to film, insofar as its value cannot be separated from its language. The psychology of the characters they create, their drama, the universe they inhabit—all are defined by the means of analysis offered to an artist through writing. The French novel of analysis and introspection is one such example. In fact, we are often mistaken about the cinematic value of this or that novel: it took half a dozen films to realize that an author like Georges Simenon wasn't so easy to adapt as some had thought.

Some subjects are intrinsically literary, and their cinematic adaptations make us long for the original. This isn't true for Malraux's film. Despite its fidelity to the book for which not even the adapters of Henry Bordeaux's novels could be criticized,[9] *Espoir* remains, but for a few reservations, as deeply original as the book. This has no doubt to do with Malraux's very art, since his writerly mise en scène –with the exception of the long intellectual monologues, naturally absent from the screen— tends toward a passionate observation of men and things, a sort of partial and dramatic objectivity that lends itself to visual

expression; but here I would see the artist's relationship to his own work to be the deepest reason for this. Malraux expresses himself fully both in his film and in his book; neither precedes the other. For him, this is not an adaptation but two creations, engaging him equally. The resemblances we have emphasized are, in fact, more of a symmetry with respect to an axis of creation from which Malraux's style unfolds identically in two different forms of expression. Surely it is the experience and temperament of Malraux the writer that are at the root of what, from a cinematic vantage point, is the problematic nature of ellipses or occasional symbols; but it is precisely in its mistakes that this film conveys the impression of direct creation, one that is as personal as a novel or a painting. What we have here is a work and a style, in the fullest sense of the word.

Style is a quality less common in cinema than in the other arts for it is (after graphology) the most intimate expression of the creator's personality: intervening between the filmmaker and the work are the complications of requisite technology and a multiplicity of collaborations. The endless quarrel around who is the film's author confirms this. A collective work can have "some" style, but it is virtually impossible for the primary filmmaker to successfully impose himself on the entire team such that the work achieves "a" style as personalized as in more individualized arts. It is virtually only amateur film that attains—paradoxically, given its poor resources—the freedom of expression precluded by the heavy mechanism of the commercial film: this was also the case for silent film, less dependent on technology and where editing (an absolutely individual moment in creation) played a bigger role. Many silent films retain, in fact, an aspect of amateurism. This is quite obvious in the work of Vigo, and we may well ask if the decisive crisis in the growth of the

modern director, and how the future health of cinema is decided, isn't a function of removing amateur from commercial film. The Grémillon of *Un tour au large* (1926) all the way to *Remorques* (1941); the Carné of *Nogent, Eldorado du dimanche* (1929) to *Le Jour se lève* (1939); the René Clair of *Entr'acte* (1924) and *La Tour* (1928) to *Quatorze Juillet* (1933); the Vigo of *À propos de Nice* (1930) all the way to *L'Atalante* (1934). This decisive and often laborious molting is not as chronologically obvious as we might imagine: it advances slightly with every film, and a given director (*metteur en scène*) will have several commercial films to his name yet suddenly demonstrate that he is haunted by his youthful amateur work. This may perhaps explain the commercial failure of such superb films as *Le Crime de monsieur Lange* (1936) or *La Règle du jeu* (*Rules of the Game*, 1939). Amateurism is not obvious here in the crudeness of technical means or lack of experience, but in a certain relationship between the work and its author. While in the commercial film, the director must think of nothing but the public, in Renoir's best films some inward amusement remains for private use, an implicit understanding among pals making a film together for their own pleasure. Hence *La Règle du jeu* is still not successful outside of ciné clubs, confined there by more than mere censorship.

The current evolution of American cinema, tending toward the elimination of individual style in favor of an increasingly anonymous stylistics, proceeds in the same direction—the banishment of all traces of amateurism. In the case of Malraux, the potential problem might be to determine the degree to which *Espoir* remains a terrific amateur film even though it was shot in a studio, with professional actors and cameramen. And, to what extent its uncertain commercial success is linked to this. Will Malraux make other films? What will he yield once he has sub-

jected himself to the exigencies of all the cinematic matter that he has until now dominated and done violence to, thanks to his exceptional intuition when it comes to most of its deepest laws? Stated differently, what could Malraux contribute to Hollywood where Faulkner, Hemingway, and others already are working for cinema? We are not hoping the experiment would go that far, but we are waiting, with passionate curiosity, for Malraux to shoot in Paris, with all the necessary technical resources, without electrical outages or bombings, his *La Condition humaine (Man's Fate).*

<div align="right">

À propos de *l'Espoir* ou du style au cinéma

Poésie 45, nos. 26–27, August–September 1945

Écrits complets, 60

</div>

NOTES

The novel is entitled *L'Espoir (Man's Hope);* the film's title varies: *Espoir, L'Espoir, Man's Hope, Days of Hope,* and *Sierra de Teruel.* We use *Espoir.*

1. Émile Couzinet (1896–1964) was an idiosyncratic provincial producer/director from southwest France, whose inexpensive comedies wore thin in Paris but for a time achieved a popular following.

2. Jean Blanzat (1906–1977), a successful novelist, was the weekly literary critic for *Le Figaro* from the end of World War II until 1960.

3. Madame Delly and Jean de La Hire were pseudonyms for astoundingly prolific writers of the first half of the twentieth century. The bourgeois "improving" novels of the former and the romantic adventure tales of the latter constituted easy reading for a vast public.

4. Pierre Benoît and Henry Bordeaux were best-selling, serious novelists who were elected to the Académie française. Bazin pegs them at a lower level than the four authors he next mentions—all Nobel Prize winners except Malraux, who many think "should have gotten it."

5. *Espoir* was completed in July 1939 and screened for an invited public in August, just before the Nazi invasion of Poland on September 1. In June 1945, a print saved by sheer chance was commercially exhibited in a somewhat shorter version, expanded with a patriotic prologue pronounced by the politician Maurice Schumann.

6. André Malraux's "Esquisse d'une psychologie du cinéma" exists in many versions but came out originally in *Verve* in June 1940, which Bazin refers to in "The Ontology of the Photographic Image." Although *Verve* appeared simultaneously in English and French, the 1940 translation by Stuart Gilbert is poor, and so we translate this passage anew.

7. Bazin's rare textual citation comes from the November 1944 NRF reedition of *L'Espoir*. In the initial 1937 edition, this passage appears on pp. 114–15.

8. [Bazin's note] The claim requires some nuance. It is not absolutely impossible to translate comparisons to cinema. It is very common in Abel Gance's films, for instance. When in *Fury* Fritz Lang follows a shot of chattering gossips with a shot of chickens [in a] farmyard, the lap dissolve linking the two shots is the exact equivalent of a conjunction; still, it doesn't seem as if the real image lends itself easily to this game. Our mind spontaneously accepts the objectivity of the visual image. The transition to the imaginary is thickened, bogged down by the object's physical presence. The comparison cannot do without some emphasis, a vulgar weightiness that usually removes all its aesthetic value.

9. See note 4 above. Nine of Bordeaux's novels became films between 1922 and 1943. He wrote the dialogue for one of these, *Yamilé sous les cèdres,* which premiered in June 1939 a month before *Espoir* was completed and which, like *Espoir,* was largely shot on location with some scenes later filmed in a French studio. A mediocre novel, Bazin suggests, was nevertheless faithfully brought to the screen.

3. Cinema as Digest

The problem of digests and adaptations usually arises in the context of literature. Literature, however, is just one part of a phenomenon whose scope far exceeds it. To take painting, for example, we can righty consider a museum to already be a digest, since in it we find a *selection* of paintings *grouped* together that were destined for an entirely different architectural and decorative setting. Yet these works are still originals. What should then be said about the imaginary museum introduced by Malraux, in which, thanks to a photographic reproduction, an original is refracted into millions of facets and replaced with images of assorted sizes and colors, making them easily accessible?[1] Photography, moreover, has done nothing other than simply take up the baton from engraving, which until that point was the only approximate "adaptation" available to art lovers.[2]

We mustn't forget then that "adaptation" and the "summary" (*résumé*) of original works became part of our way of doing things quite some time ago, and on such a scale that their existence should certainly no longer be called into question. I'll take some examples from cinema.

More than one writer, more than one critic, and even more than one filmmaker has contested the aesthetic justification for adapting novels to the screen. However, given that there are no examples of those very individuals who take offense at this practice, who refuse to sell their books or to adapt others' books or to stage them when a producer insists and does so with convincing arguments, I generally find that their indictment lacks a solid

basis. Typically they invoke the unique specificity of each authentic literary work. A novel is a unique synthesis whose molecular equilibrium is fatally compromised by any attack on its form: no plot detail might be considered in essence secondary, no syntactic peculiarity that does not in reality express the work's psychological, moral, or metaphysical material.

André Gide's simple past tenses (*passés simples*) are thus, as it were, immanent to the events of *La Symphonie pastorale,* just as Albert Camus' present perfects (*passés composés*) are immanent to the metaphysical drama of *L'Etranger.*

Even posed in such complex terms, the problem of cinematic adaptation isn't fundamentally unsolvable, and the history of cinema has already proven that it has been resolved many times over, and in very different ways. To take only the unassailable examples, I cite Malraux's *Sierra de Teruel* [*Espoir*], Jean Renoir's *Partie de campagne* based on Maupassant, and the recent *Grapes of Wrath* based on Steinbeck. Yet I find it easy to defend even a more dubious success like *La Symphonie pastorale.* True, not everything in this film is equally successful, but that certainly was not due to what some consider to be the most ineffable quality in the original. I don't much care for Pierre Blanchar's acting but find, by contrast, that Michèle Morgan's eyes[3] and the leitmotif of the ever-present snow supplement Mr. Gide's simple past tenses quite precisely. The *metteur en scène* need simply possess enough imagination to create cinematic equivalences of the original's style, and the critic need only have the eyes to see it.

This thesis assumes that style not be confused with grammatical peculiarities and, more generally still, formal constants. That heresy is pervasive, and professors of French aren't, alas,

alone in spreading it. "Form" is at most only a sign, a perceptible manifestation of style, absolutely inseparable from the substance whose metaphysics, to borrow Sartre's term, it in some way constitutes.

Under these conditions, fidelity to one form, whether literary or some other, is illusory; what matters is *the equivalence in the meaning of the forms.*[4] The style of Malraux's film is strictly identical to that of his book, even though we are dealing with literature and cinema. The case of *Partie de campagne* is subtler, where fidelity to the spirit of Maupassant's work still benefits from the full genius of Renoir. What goes on here is the refraction of one work in the mind of another creator, and no one will dispute the beauty of the result. Maupassant was surely necessary for this, but so was Renoir (indeed both, Jean and Auguste).

Intransigent sorts will respond that these examples simply prove that it may not be metaphysically impossible to create a cinematic work inspired by a literary work with enough fidelity to the spirit of the original and enough aesthetic intelligence to warrant considering the film to be worth as much as the book— but that this would no longer be an "adaptation" in the sense used at the outset of our discussion. So, *Partie de campagne* on screen is just another work, equal or superior to its model, because in his art Jean Renoir is a creator of the same caliber as Maupassant, having moreover benefited from the writer's preliminary work. If we now turn to the countless American and European novels adapted to the screen every month, it will be obvious that we are dealing with an altogether different matter, with a condensation, a summary, exactly a cinematic "digest," *ad usum delphini,*[5] i.e., aesthetically indefensible films like *L'Idiot* as well as *For Whom the Bell Tolls,* and those endless Balzac "adap-

tations" that seem to have abundantly demonstrated that the author of *La Comédie humaine* is the least "cinematic" of novelists.

Granted, one must first know *to what* one is adapting—whether to the cinema or to its audience—and then realize that most adaptations are far more concerned with the latter than with the former. The problem of adapting to the public is clearer yet in radio. Unlike cinema, radio is barely an art, being first and above all a means of reproduction and transmission. The digestive phenomenon occurs only slightly in the condensation or simplification of the works, and more in the way they are consumed. The cultural interest of radio resides exactly in what scares Mr. Duhamel:[6] it allows modern man to live in a sound environment in the same way he does in the warmth of his central heating. Personally, even though I have only had a radio for a year, I feel the need to turn it on as soon as I get home. It often happens that I write or work with the radio on. At this very moment, while writing this article, I am listening to Jean Vitold's excellent daily morning show on great musicians. Just a little earlier, while I was shaving, Jean Rostand, juggling with chromosomes, taught me why only female cats can be tricolored (unless he said male cats), and I cannot now remember who it was that explained to me as I was drinking my coffee how the Aztecs used simple sand rubbing to sculpt those extraordinary polished quartz masks on display at the Musée de l'Homme. Mr. Jules Romains' sinister hoax about extraocular vision is produced on the radio in all seriousness. Radio has created a culture that is atmospheric, omnipresent like humidity in the air. For those taking the view that culture must require a major effort, the easy physical access to artworks that radio makes possible is as foreign to their nature as an attack on their form. Even

if played well and in its entirety on radio, the Fifth Symphony heard while one takes a bath is no longer a work by Beethoven; such music deserves the high mass of the concert, the sacrament of contemplation. True, we can just as easily see this as putting culture within the reach of all; physical reach being the precondition for that other [spiritual one], radio is the modern comfort of culture at all levels. It represents a gain in terms of time and effort, the very sign of our era; surely, like everyone else, Mr. Duhamel must take taxicabs to go to concerts.[7]

There is a bias that culture must require intellectual effort; this is part of a bourgeois and intellectualist reflex, the equivalent in a rationalist culture of a primitive civilization's initiation rites. While esotericism certainly is one of the grand cultural traditions—and God forbid that we attempt to banish it from ours—what is needed is to simply put it back in its place, which needn't be unlimited. There is a specific pleasure in overcoming difficulty, which is a supreme refinement of relationships with a work of art, and so much the better. But mountain climbing hasn't as yet replaced walking on level ground. The classical modes of communication, which are as much a defense of culture as a defense against displaying it, are countered by technologies and conditions of modern life, which increasingly offer a culture sized to the scale of the masses. In response to the intellectual and unconsciously aristocratic adage "No culture without effort," our civilization in the making says, "At least we've gotten this far." Insofar as progress exists, this is a case in point.

As regards cinema, my intention is not to defend the indefensible; most of the current films based on novels are indecent scams using their titles, even if a good lawyer could make a case for their indirect value. It has indeed been shown that print runs

always go up when a novel's title has been seized by the screen. Consequently, a film can only benefit the original title. For however inadequate the screen version of *The Idiot* may be, many potential Dostoevsky readers will find in its highly simplified psychology and action a kind of preliminary roughing-out that will make a rather daunting novel more accessible. The procedure resembles somewhat what Mr. De Vogüé practiced long ago:[8] contemptible in the eyes of readers comfortable with Russian novels—though neither they nor Dostoevsky have anything to lose here—yet quite useful for those who have not as yet read the novels and have everything to gain from this. Whatever the case may be, I won't venture onto this turf, for that belongs more to pedagogy than to art.

I would rather grapple with the entirely *modern* notion of the inviolability of a work of art, for which the critics are largely responsible.

It was especially the nineteenth century that anchored us in something like an idolatry of form—literary above all—which relegated to the background of our critical mind what has in fact always been the essence of literary creation: the invention of characters and situations. I can accept that a novel's heroes and events owe their aesthetic existence only to the form that expresses them and somehow gives them life in our minds. But this priority is as pointless as that question about the priority of language over thought that is regularly given to students at baccalaureate exams. It is peculiar that the very same novelists so fiercely defending the integrity of their text are also those who, on other occasions, will deluge us with confessions about the tyrannical demands of their characters. To hear them tell it, once created, their characters become uncontrollable children over whom they no longer have any authority. The novelist is a slave

to their whims, a servant of their every freedom. I do not doubt them, but in that case we must also allow that the veritable aesthetic reality of the psychological or social novel is the character or the milieu rather than what we call "style." Style serves the narrative and is, as it were, an image of it, the body but not the soul—and it is not impossible that the latter may manifest itself in a different incarnation. Such an idea is pointless and sacrilegious only if we refuse to see its many examples in the history of the arts, making it possible, in turn, to fulminate a priori against cinematic adaptations. With time, we see the phantom of a character rise clearly above the great novels. Don Quixote and Gargantua are familiar presences in the minds of millions of people who have never had any complete or direct contact with either Cervantes' or Rabelais' works. I would want to be quite sure that all those who have invoked the spirit of Fabrice or Madame Bovary have read (or reread, to do it honestly) Stendhal and Flaubert. Insofar as the style of the original was able to create and establish a character, that character takes on greater autonomy, which can occasionally even reach a quasi-transcendence of the work. Novels, as we know, are the wombs of myth.

This prickly defense of the literary work is grounded, to some degree, in aesthetics, but we must recognize that it is also based on a relatively recent individualist notion of "the author" and "the work," a conception that was not particularly rigorous in the seventeenth century even from a moral perspective, and only began to be legally defined at the end of the eighteenth. In the Middle Ages, the only known themes were those common to several arts. Adam and Eve, for example, can be found in Mystery Plays, in painting, sculpture, and in stained glass windows without anyone deciding to challenge the value of these various adaptations. And when "the loves of Daphnis and Chloe" is

assigned as the subject of the Prix de Rome in painting, what else is this other than adaptation?[9] True, no one is claiming author's rights. It would be incorrect to justify the polyvalence of medieval biblical and Christian themes by claiming that they constituted a common fund, a sort of public domain of Christian civilization; the *chansons de geste* were hardly better respected by the various scribes copying them. Rather, the work of art was not an end in itself; the only important criteria were its content and the effectiveness of its message. But at the time the balance between the needs of the public and the work of creation was such that these very conditions guaranteed the excellence of the form. It may be said that this was then, and that it would be an aesthetic misreading to anachronistically reverse the evolution in the relationship among the creator, the public, and the work. To which we might reply that, to the contrary, artists and critics may well be blind to the birth of a new aesthetic Middle Ages whose cause is the masses' rise to power (or at least their participation in it) and the emergence of an artistic technology corresponding to that rise: the cinema.

Yet even without venturing a hypothesis that would demand further arguments, it remains that cinema must recapitulate its own artistic evolution for itself, and at an extraordinarily accelerated pace, somewhat like a fetus recapitulating in a few months the entire evolution of the animal realm. However, this paradoxical evolution is contemporary with a long period of decline of a literature of individualist elites. Cinema's aesthetic Middle Age takes its myths where it can find them: close at hand, in the literature of the nineteenth and twentieth centuries. Cinema certainly had what it took to create them. And it has done so, especially in the comic films from the first French burlesques to

"American" comedies, including Sennett and, above all, Charlie Chaplin. The defenders of cinematic purity will even recall, as examples, the epics of the Westerns, of the Russian Revolution, and the great, unforgettable images of *Broken Blossoms* and *Scarface*. But so what? What can we do about it anyway? Youth passes and its grandeur with it; another subsequent grandeur may require slower conquest. In the meantime, cinema takes whatever suits it from developed, worked-through characters, already mature, honed by twenty centuries of intervening literature, adapts them and brings them into its own game. If the screenwriter and *metteur en scène* possess the requisite honesty and talent, they will also incorporate as much as possible of the character's aesthetic context. Failing that, we have all these obviously mediocre films that we quite rightly condemn, so long as we do not confuse their mediocrity with the principle of adaptation itself, which sought to simplify and condense a work from which it really only wanted to keep the central character and the main situations in which the author placed him.

If the novelist is unhappy, I certainly recognize his right to defend his work (even though he committed an act of pimping in selling it, which relieves him of many of his paternal privileges), but only because we have yet to find anything better than parents to represent the rights of underage children. This natural right is not to be taken as necessary and infallible a priori.

Instead of Kafka's *The Trial* adapted by André Gide from Alexandre Viallatte's translation, a more appropriate example for a defense of condensed adaptation would be Jacques Copeau's adaptation of *The Brothers Karamazov*.[10] Copeau did nothing other than extrapolate the characters of Dostoevsky's novel and condense the main events of the story in a few dramatic scenes, more

skillfully than Mr. Spaak did for *The Idiot*. Obviously, these theatrical examples have a slight problem in that the current theatergoing public is cultured enough to have read the novel; even without this, however, Copeau's work would still be valuable.

Apart from its pedagogical and social interest, the legitimacy of adaptation is aesthetically grounded:

· because in a certain manner the work exists independently of what is erroneously referred to as the original's "style," by confusing the style with the form.

· because the legal differentiation of the arts in the nineteenth century and the recent subjectivist idea of the author that identifies him with the work no longer correspond to an aesthetic sociology of the masses, where cinema has taken up the baton from theater and the novel (without suppressing them and even reinforcing them). The true fault lines of aesthetic splitting do not, in fact, arise between the arts but between genres; between the psychological novel and the novel of manners, for example, rather than between the psychological novel and the film based on it. But it goes without saying that adaptation to the public is inseparable from adaptation to the cinema, in that cinema is "more public" than the novel.

It was my familiarity with Radiguet's book that caused me to suffer as I watched *Le Diable au corps*. The book's spirit and "style" are in a certain sense betrayed. Yet the adaptation is about as perfect as possible, and entirely justified. Jean Vigo would have been more faithful to the original, but it is likely that the public would never have seen his film because the reality of the book would have scorched the screen. In a way, Aurenche and Bost's

work consisted of "transforming" (in the sense of an electric transformer) the novel's voltage. In the film, the aesthetic energy remains virtually intact but is distributed differently to meet the exigencies of a cinematic optic; despite Aurenche and Bost's successful transformation of the original's enormous amorality into an almost too obvious morality, the public still found it difficult to accept.

The very term "digest," which seems shameful at first, can be understood in a good way. "As the name indicates," writes Jean-Paul Sartre, it concerns literature already digested, a literary chyle."[11] But we might also understand this as literature made more accessible by cinematic adaptation, though not so much by the resulting simplifications (the film narrative of *La Symphonie pastorale* is ultimately more complicated [than Gide's novella]), but rather by the mode of expression itself, as if the consumer's mind better tolerated the aesthetic fats when they were differently emulsified. I myself do not think that the difficulty of comprehension is an a priori criterion of cultural value.

Seen this way, we can even be allowed to imagine that we are moving toward a reign of adaptation that will destroy, if not the notion of the author, then at least that of a work's uniqueness. Had the film based on *Of Mice and Men* been a success (which it could have been, far more easily than the adaptation of *The Grapes of Wrath*), a (literary?) critic[12] in the year 2050 would find himself in the presence not of a novel from which a film and a play were "drawn" but of a single work in three art forms, a sort of three-sided artistic pyramid where nothing would sanction a preference for one or the other side: the "work" would no longer be more than an ideal point at the summit of this volumetric form, itself ideal. The chronological precedence of any single

aspect would be no more an aesthetic criterion than the criterion of primogeniture in twins. Malraux thus made his film before having written *L'Espoir*; he was carrying the work within himself.

L'adaptation ou le cinéma comme Digeste
Esprit, no. 146, July 1948
Écrits complets, 457

NOTES

This was the third article in a dossier, "La Civilization du digeste," compiled for *Esprit* by Bazin's friend Chris Marker. It was preceded by Marker's own satirical piece "Sauvages blancs seulement confondre," which explicitly had the international success of *Reader's Digest* in mind. The French word "digeste" had long been used in juridical and biological senses, but its use in relation to literary works was imported from the United States at about this time, according to the 1949 *Petit Robert* dictionary. In fact, in the 1940s, *Reader's Digest* had become America's number-one selling periodical. Bazin might have encountered the French edition of this periodical, which began publishing in Montreal in 1947. In the body of Bazin's text, though not in its title, he explicitly used the American spelling "digest" rather than *digeste*.

1. Malraux had published his one-volume *La Musée imaginaire* (Paris: NRF, 1947). It would soon be incorporated within his *Les Voix du silence* (1951).

2. [Bazin's note] During a recent radio program, "French Cancan," in which Messieurs Pierre Benoît, Labarthe, and a few others competed over platitudes, you could hear Curzio Malaparte ask the moderator, as if making an irrefutable argument against the "digest," what he thought of a condensed Parthenon, for example. They couldn't find anyone who could tell him that such condensation had in fact long been around in the modeling of friezes and above all in the inexpensive photo albums of the Acropolis that you can buy from the first hawker of art reproductions to come along.

3. Known for her exceptionally beautiful eyes, Michèle Morgan plays a girl who is blind from birth but whose sight is restored in the course of the story. Morgan would entitle her 1977 autobiography, *Avec ses yeux-là* (With those eyes).

4. [Bazin's note] There may very well be other types of stylistic transfers like these simple past tenses that I don't find in *La Pastorale's* technical decoupage, meaning in the film's syntax, but rather in the eyes of an actress and in the symbolism of the snow.

5. [French editor's note] This Latin locution signifying "for the use of the Dauphin" relates to the origin of writings aimed at the education of the heir to the throne; today it is employed generally to designate a work that has been expurgated so as to be able to be put in anyone's hands.

6. [French editor's note] An allusion to the successful volume by Georges Duhamel, *Scènes de la vie future* (Paris: Mercure, de France 1930).

7. Georges Duhamel was a much-published author and member of the Académie française. After World War II he took charge of the Alliance française and was a spokesperson for French culture. An elitist who venerated classical music, he denigrated cinema. Bazin found him intolerable.

8. Eugène-Melchior de Vogüé, a nineteenth-century French diplomat to Russia, became famous with his 1876 *Roman Russe,* in which he provided vivid sketches of a number of great Russian novelists and novels, paving the way for their reception in France.

9. Not be confused with the current Rome Prize, Le Prix de Rome was established by King Louis XIV to support a promising artist for three or more years in Rome. The competition required coming up with a drawing of a given subject in an enclosed booth with only the aid of one's imagination. After the events of May 1968, André Malraux abolished the prize altogether.

10. *Le Procès* had been adapted by André Gide from Kafka's novel *The Trial* for a 1947 production staged by Louis Jouvet with sets by Christian Bérard. Jean-Louis Barrault was behind the venture. Gide used the 1933 translation by Alexandre Vialatte. Bazin may well have known Vialatte, an author who was friendly with Alexandre Astruc.

Jacques Copeau had started his career in the first decade of the century with this highly reduced but effective version of *The Brothers Karamazov*, and he reprised the production repeatedly until his death in 1949, a year after this essay. In 1946, Bazin had harshly vilified *L'Idiot*, adapted by Charles Spaak with Gérard Philipe as Prince Myshkin, for having eliminated the novel's spiritual essence in cutting its hundreds of pages to ninety-eight minutes.

11. Sartre, "Situation of the Writer in 1947," from "*What is Literature?*" *and Other Essays* (Cambridge, MA: Harvard University Press, 1988), 197. The translator uses the word "pap" for Sartre's Greek term "chyle." Bazin undoubtedly read this piece when it appeared in June 1947 in *Les Temps modernes*. It was then issued as part of *Situations II* by Gallimard Press in 1948, perhaps just before Bazin composed this article.

12. The parenthetical qualifier, with its question mark, is in the original.

4. Critical Stance: Defense of Adaptation

I confess I would find little in need of correction in my 1951 text for *Le Cinéma, un œil ouvert sur le monde*—a few additional film titles at most. The problem of adapting novels to film has barely evolved since *Journal d'un curé de campagne.* Not that cinema is less literary today than it was a decade ago. As for America, it's even the reverse that is true, in fact: most films being made right now are adaptations of famous novels. But what I wrote [in 1948] about *For Whom the Bell Tolls* applies with some few nuances to *The Sun Also Rises* and *A Farewell to Arms.*[1] There might be slightly more fidelity to the plot or to the dialogue, but there is barely any more effort to devise cinematic equivalences to the writer's style.

The essential issue may not be, in fact, that film should remain formally "faithful" to the novel. What literature can truly bring to the cinema is less a repository of interesting subjects than a certain sense of narrative. What counts is to detach the film from the *spectacle* and move it closer to the writing. From this perspective, works like *Monsieur Ripois, Le Rideau cramoisi, Mina de Vanghel,* or the recent *Bonjour Tristesse* are not stories that have been "staged for the camera" (*mises en scène*), but rather works "written" with camera and actors. Whether or not adaptation is involved, this is obviously the sense (*sens*) in which we expect and hope that cinema will pick up from the novel.[2]

Position critique: Défense de l'adaptation
La Revue des lettres modernes,
nos. 36–38, Summer 1958
Écrits complets, 2606

NOTES

This, his final statement on the topic of adaptation, was Bazin's contribution to this literary journal's special issue, "Cinéma et roman." He would pass away just three months later. The text as it appears here served as preamble to the republication in this special issue of his two major essays on the topic: "L'Adaptation ou le cinéma comme Digeste," published originally in *Esprit* in July 1948, and "Pour un cinéma impur," written in 1951. As the opening line here indicates, the latter essay appeared in *Le Cinéma, un œil ouvert sur le monde*, ed. G.M. Bovay (Lausanne: Editions Clairefontaine, 1952).

1. Ten years had passed since Bazin had judged the 1943 adaptation of Hemingway's *For Whom the Bell Tolls* to be "aesthetically indefensible" (in "The Cinema as Digest"; see chap. 3), having also denigrated it in reviewing *The Grapes of Wrath* (see chap. 20). Now, in 1958, he had experienced the newest versions of *The Sun Also Rises* and *A Farewell to Arms* (both produced in 1957), and had just reviewed the latter (see chap. 26).

2. The French "sens" in this case may refer both to "sense" (i.e., meaning) and to "direction" (as in pointing the way).

5. Cinema and Novel

Contemporary literary criticism has often pointed to the influence of cinema on the literature of these last thirty years, in particular on American literature. I am not so sure that much will remain of this commonplace, in retrospect, since the truly undeniable influences are most frequently quite external. The true novelistic revolutions of the twentieth century, those of Proust, of Joyce, of Kafka, and of Faulkner, owe nothing to the screen. As to Malraux and Dos Passos, we could of course say that their novelistic vision is related to cinema, but to which cinema? For the generalized nature of the word hardly bears up to historical analysis, and the editing effects used by the author of *The 42nd Parallel* result from a technique whose stamp we would vainly seek in today's films. Consequently, what a Malraux, a Hemingway, and a Dos Passos share is less "the cinema" than the modern sense of reportage—its photographic brutality, its objective fragmentation; and "behavioral psychology" would have developed in the same way in the novel even without the putative example of film.

By contrast, literature's influence on cinema has been unbroken since the first unfortunate avatars of Film d'Art in about 1910.[1] The general consensus in film criticism was to excuse this influence whenever the film took all the liberties it needed with the book. It hardly mattered that the cinema borrowed famous themes or popular characters from literature, so long as the film did not remain a prisoner of its model. It was, above all, about making "cinema," an art of images, essentially spectacular expressions with or without a literary alibi. Alexandre Dumas

was certainly not degraded by the American version of *La Dame aux camélias*,[2] though the play's text certainly mattered less than Garbo's presence. But other voices were raised in defense of literature to castigate filmmakers for their breach of trust, which amounted to lavishing the prestige of a title on good or bad films that couldn't in every case be taken for a faithful translation of the original. If the *Le Quai des brumes* by Marcel Carné and Jacques Prévert is a screen masterpiece, it no longer belongs to the author, Mac Orlan, except as an allusion.[3]

A critical history of French cinema of the last ten years surely ought to emphasize first a radical change in the relationship of literature to cinema. As many as two out of three of the major titles studding French postwar cinema are also the titles of novels: from *Le Diable au corps* to *Monsieur Ripois,* and including *Dieu a besoin des hommes*,[4] *Journal d'un curé de campagne,* and *Le Blé en herbe.* And about several other no less important works, such as *Les Dames du Bois de Boulogne* or *Les Dernières Vacances,* by Roger Leenhardt, we should say that they could well be the titles of novels!

What is new, however, is not the borrowing of titles and subjects, a long-standing practice as we've seen, but a phenomenon that we might date to *La Symphonie pastorale,* by Jean Delannoy: the claim to fidelity. With Aurenche and Bost, who adapted this and so many novels for cinema, a new concern emerges: respect for the original as a criterion of a film's value. While it was, in fact, possible (rightly or wrongly) to consider *Les Misérables* or *Le Comte de Monte-Cristo,* or even *Jocelyn* or *Carmen,* as pretty tales ripe to be illustrated, the moral subtleties of André Gide's narrative demanded more: a search for the delicate equivalences between literary creation and cinematic expression. In addition, it became necessary from that point on to consider, if not

respecting the text of the original, then at least remaining at its level, and above all translating into cinematic language what the writer had expressed in nuances of style.

This ambition has fairly often elicited skeptical remarks from literary critics as well as from many film critics. The former, always considering cinema with more or less unmasked condescension, claim, and with some degree of truth, that in the best cases the finesse of language, its intellectual and poetic subtleties, are untranslatable to the screen. The more benevolent critics deign to acknowledge that cinema may have considerable powers but that these are of another order: in any event, literary energy could at best be very partially converted to images, and only when at its most banal. They therefore agree with those film critics, partisans of "pure cinema," who worry about the perils to the screen posed by the temptations of the novel almost as much as those posed by the theater. Borrowing from literature is for them ultimately just a stopgap in the absence of good screenplays. The concern to not unduly strip of merit the writer being pillaged, to respect his work "as much as possible," amounts above all to a guarantee against cinema's intellectual degradation: a willingness to be strict and demanding. But this is a negative virtue because fidelity does not, in itself, ensure cinematic quality, and we gladly lauded Aurenche and Bost precisely for their ability to take great liberties with their transposition so long as these liberties did not appear to degrade the original too much.

Finally, Robert Bresson, with his well-known obvious audacity, and after several failed screenplays (including one by Jean Aurenche), dared to assert that he would bring to the screen *Journal d'un curé de campagne*, literally page by page, and if possible line

by line.[5] Since this concerned the writer Georges Bernanos, whose style cannot, in fact, be dissociated from his novelistic universe, Bresson's wager appeared crazy. We know how he kept it, annihilating with a masterly stroke the final prejudice, to wit, that not every literary truth would be good to say on screen. In the cinematic version of Bernanos' novel, Bresson, because of time constraints, had added nothing, had transposed nothing, and had at most pared things down. For the first time, perhaps, cinema was no longer providing a good illustration or a subtle, honorable transposition of a masterpiece, but rather this very novel, projected into the screen's aesthetic universe. Henceforth, Bernanos' work exists as two species: book and film. If, due to some preposterous assumption, the former were to somehow disappear, the latter would do more than merely substitute for it since, we can be permitted to say, the film is a superior modality of the novel because it incorporates it.

Bresson's infinite faith in cinema being equaled only by his faith in the literary work, his film is defined immediately by its respect for Bernanos' text, which is constantly compared with the image with which it maintains subtle relations of resonance. Ultimately, I could even say—and this paradox is not ironic as I pen it—*Journal d'un curé de campagne* could be "seen" with closed eyes: we would hear the novel. But how much more beautiful with open eyes!

If I have gone on at some length about Bresson's film, it is not because it is the sole convincing case for my argument, but only because it demonstrates more brilliantly than other films the possible existence of a *literary cinema*, where literature and cinema have nothing to lose and everything to gain. Those who do not believe in the screen's translation of the riches of language are simply forgetting that today the screen is *also* language. We

often persist in thinking about talking cinema as if it consisted of sound alone. Language there is never appreciated other than for its value as a sound image or for its dramatic effectiveness, independent of its literary value. Bresson's *Journal d'un curé de campagne,* Jean Renoir's *The River,* and *Monsieur Ripois* by René Clément and Raymond Queneau are films that line up against the last remnant of a time when it was believed that cinema was in its essence a silent art.

When André Malraux was filming *Espoir* even before writing it, when Jean Renoir was directing *La Règle du jeu,* they were consciously or not proclaiming, with a ten-year lead, the advent of a cinema that would be something other than spectacle, a cinema that more than the representation of reality is the comprehension of reality—meaning, the advent of a cinema-novel.

Cinéma et roman
Carrefour, no. 518, August 18, 1954
Écrits complets, 1584

NOTES

1. In 1908, the "Société de Film d'Art" initiated a short-lived, mainly French venture to produce films with cultural panache, drawing on prestigious plays, employing well-known theater actors, and, in the initial and most famous instance, *L'Assassinat du duc de Guise,* recruiting orchestral music by Camille Saint-Saëns. Despite tremendous publicity, the movement did not take hold.

2. *Camille,* directed by George Cukor in 1936.

3. This Carné-Prévert masterpiece took its title and characters from Pierre Mac Orlan's well-known 1927 novel, but shifted the action from Montmartre to Le Havre and otherwise altered the book.

4. [French editor's note] In fact the title changed: Henri Queffélec's 1944 novel, *Un recteur de l'île de Sein,* was adapted in 1950 by Jean Delannoy under the title *Dieu a besoin des hommes* (*God Needs Man*).

5. Six months earlier in his January 1954 *Cahiers du cinéma* fusillade against "A Certain Tendency in French Cinema," François Truffaut had targeted the scriptwriting team Aurenche and Pierre Bost, satirizing their treatment of the Bernanos novel, rejoicing that it had been rejected, after which Bresson's project was accepted.

6. Literature, is it a Trap for Cinema?

*War and Peace, Notre-Dame de Paris, Moby Dick, Gervaise—
acknowledged masterpieces of world literature have been brought to the
screen. This flowering seems remarkable and returns to the spotlight the
old problem of cinema's borrowing from literature.*

 *A. Do you believe that Feyder's proposition still applies today? "In the
current state of visual art and technology, film cannot yet definitively tear
itself from the influence, the promptings— the traps—that the other arts
in general, and literature in particular, impose on it at every step."*

 *B. Do Feyder's remarks explain cinema's persistent borrowing from
literature?*

 *C. Are there, in your opinion, other reasons for this, and if so, what are
they?*

 *D. Do you think that fidelity, an issue that is always brandished in
these circumstances, should be understood as "fidelity to the literary work"
or "fidelity to cinematic art"?*

 *E. Why do some authors, Stendhal for instance, seem to totally elude
every effort at cinematic recreation? For what reasons? Do you know of
other such examples?*

Feyder's remarks are more valid today than ever, for the tempta-
tion the other arts exercise on cinema is less technical in nature
than intellectual, or more generally cultural. Far from tending
to free itself from their influence as it evolved, cinema has been
brought back to them. Indeed, it was the earliest forms of film
that ensured its greatest freedom. The technology's rough-hewn
simplicity and the public's naïveté came together to create the

conditions for a primitive but original art of the spectacle. This was especially true for French and American burlesque comedies and for the serials of the great period (*Fantômas, Les Vampires,* etc.). In that era, what was being borrowed from literature in the Film d'Art[1] was so ridiculous it was considered of value only for the historian of the art, not for the art itself.

It was not until the talkies that the cinema could begin to aspire to a more serious translation of the refinements of the developed literary art forms—essentially theater and the novel. And yet in my opinion it took about a decade until talking cinema, particularly in the theatrical mode, stopped confusing expression and speech. From the perspective that interests us (precursors like Renoir excepted, naturally), it is roughly with *Citizen Kane* that cinema begins to be capable of incorporating techniques of novelistic writing, not only in screenplays but also in cinematographic writing itself. This didn't mean that spoken language was therefore losing importance; on the contrary, it was now entering into a complex dialectic with visual writing. The most daring instance to date of this literature-cinema amalgam certainly remains Robert Bresson's *Journal d'un curé de campagne.*

It goes without saying that these reasons that are of a strictly aesthetic order are multiplied by strictly commercial factors. Lo Duca lays these out quite clearly; I won't revisit them.[2]

FIDELITY

I fear getting myself trapped in a false dilemma here. It goes without saying, of course, that the fidelity that counts is fidelity to cinema. One could not claim to be faithful to a superior literary work by producing a low-quality cinematic work, even if the

content of the original had been respected to the last detail. On the other hand, we will always forgive a *metteur en scène* for the liberties he has taken with a famous book, provided he still gives us a coherent film marked by an imposing style (e.g., Renoir's *La Bête humaine*). Inversely, a minor book can be the pretext for a major film (e.g., *The River*, by the selfsame Renoir).

Yet fidelity to a literary work seems to me to demand discipline, which is fertile insofar as fidelity is a practically unrealizable ideal. We can, in fact, consider two cases:

1. This fidelity (meaning here something more like respect) consists in neither deforming nor impoverishing the original message more than made necessary by the cinema's dimensions, its public, and its spectacular nature. This would be the case for, let's say, *War and Peace* and, to a certain degree, Aurenche and Bost's adaptations for Delannoy *(La Symphonie pastorale)* or for Autant-Lara *(Le Diable au corps, Le Blé en herbe)*. The outcome is certainly inferior to the book, but it is possible to say that a respectful and conscientious adaptation salvages enough of the original treasure to make the undertaking worth the effort. This justification is mainly negative, but it is significant from the vantage point, if not of the art form, then at least of the culture.

2. But the will to fidelity can also be creative, insofar as it offers the filmmaker not an advantage but rather an additional difficulty. For in fact the *metteur en scène* must possess greater mastery, intelligence, and inventiveness to devise the system of equivalencies needed to translate the novelist's universe to the screen than to allow himself some dubious supposedly "cinematographic"

liberties.[3] Given that this hypothesis naturally assumes a
superior talent, if not genius, this type of fidelity will
also be highly interpretive. (As in *Journal d'un curé de
campagne.*) But this is exactly what we should expect of a
good adaptation: that the light it sheds on the translated
work be both critical and creative, that it be faithful to
the original while enriching it through the vision of
another artist.

Seen this way, the situation of truly great novels is not funda-
mentally different from that of musical or theatrical works. They
can lend themselves to many interpretations and be enriched by
the best of them.

In sum, generally speaking, the right to be unfaithful to a lit-
erary work exists only if, at the very least, the cinematic work
that results is superior to the one that would correspond to the
first hypothesis (conscientious respect).

Above this level (which already assumes considerable
requirements), the *metteur en scène* is entitled to take liberties
with literature that are to cinema's advantage. Even in this
hypothesis, however, fidelity still appears to me to be an excel-
lent, if not the best, creative discipline.

There would be a third hypothesis yet, where fidelity is
imposed a priori by the nature or fame of the work. For example,
classics of the theater impose the rigid framework of their texts,
making it quite difficult to arrogate to oneself the right to adapt
them. Similarly, it seems to me that one can only propose bring-
ing Stendhal, Balzac, or Dostoevsky to the screen on the condi-
tion that one fundamentally aims to be faithful to the spirit of
the characters and the action, though perhaps not absolutely to
the letter of the plot.

While question E is relevant, I will nonetheless pass on providing examples, because I have not sufficiently firmed up my idea about the relationship between the authors who come to mind and the cinema. Indeed, we tend to think that certain writers are a priori especially unadaptable—Stendhal or Proust, for instance, albeit for opposite reasons. But isn't it simply that they have yet to inspire a masterpiece?[4]

Of course, there is also the case of writers capable of expressing themselves in cinema: Malraux, Cocteau.... But for them, there is no problem: they have all the rights, including that of being faithful to themselves.

<div style="text-align: right;">

La littérature est-elle un
piège pour le cinéma?
L'Actualité littéraire, no. 34, April 1957
Écrits complets, 2273

</div>

NOTES

The editors of this monthly review, published from 1954 to 1960 by the Association of French Book Clubs, used this particular issue to give Bazin and other critics five initial prompts to elicit their views. Alexandre Astruc's responses followed Bazin's.

1. In 1908, the "Société de Film d'Art" initiated a short-lived, mainly French venture to produce films with cultural panache, drawing on prestigious plays and novels, and employing well-known theater actors. Despite tremendous publicity, the movement did not take hold.

2. [French editor's note] On page 30 of this issue of *L'Actualité littéraire*, Lo Duca explains that a literary adaptation is above all a financial "motive" for the producer ("A major title is commercial"), providing as it does an a priori guarantee of publicity for the film.

3. [Bazin's note] The cases of *Moby Dick* and *Gervaise* seem to me intermediary between this hypothesis and the previous one. Conscientious fidelity and renovating a text interfere with and paralyze one

other. *Moby Dick* (1955) is a far more respectable film than *War and Peace* (1956), but nonetheless a failure at the highest level, where it sought to address that difficulty.

4. [Bazin's note] *Mina de Vanghel* seems to me the most interesting interpretation to date of Stendhal. In it, Clavel proved, in any case, that it was not impossible to transpose Stendhal's style to the screen.

7. A Question on the Baccalaureate Exam: The Film-Novel Problem

[Subject:] "A contemporary writer has stated, 'Bringing a novel to the screen is a profound mistake.' Do you agree?"

[Student André Bazin, Answer the question]

The question above, one of three choices for students taking the Baccalaureate [in 1956], was startlingly modern. Some were outraged by it. I won't scrutinize the pedagogical opportunity it provides, but it seems impossible to deny, at least in the absolute, the interest and value of a question intended to encourage students to think about what comprises the essential in literature and in cinema. Isn't comparative criticism the most enlightening of all? One evening newspaper did ask, "Should future graduates be turned into critics?" But wouldn't this be precisely at least half the goal of education!

Allow one critic at least to become an exam taker and to offer his answer. Here is roughly what he would have written.

A TREASURE TO PROFIT FROM

Before getting to the heart of the issue, it might not be a bad idea to ask why novels are so often adapted to the screen. There are crass reasons for this, such as producers betting on the popularity or on the slightly scandalous notoriety of a title. But beyond this crudely commercial guarantee, there might also be the somewhat more respectable consideration of using a developed subject that has already faced the public.

For the scriptwriter-adapter, this concern turns into the advantage of working with substantial characters and situations endowed with a psychological and moral depth that original screenplays can rarely achieve. The novel is capital, a treasure, and cinema would be quite wrong not to profit from this.

To which one could respond, of course, that this is a solution born of laziness, and that even if cinema inadvertently gains from it, literature has everything to lose in such pillaging.

INFLUENCE AND ADAPTATION ARE NOTHING NEW

Let's start by noting that our severe attitude vis-à-vis imitation, copying, and even plagiarism is entirely modern. Influence and adaptation are, to the contrary, the rule in the history of the arts, which for centuries saw no shame in taking their goods wherever they found them. They didn't make out too badly, either. Monumental cathedral tympana or capitals atop columns were copied from Byzantine miniatures. Was such adaptation to be condemned in the name of "sculptural specificity"?[1] And, to stick to literary examples, what is *La Princesse de Clèves* if not the novelistic adaptation of Racine's dramatic universe?[2]

In addition to the historical argument, we can point out that each cinematic adaptation of a novel has multiplied its sales tenfold. In this sense, even the worst adaptation benefits literature incomparably, opening a printed work to a new public.

Granted, this purely quantitative consideration is not aesthetic in its nature. So let's now look at what art in general, and literature and cinema specifically, stand to lose or gain in this game.

The risk is lesser for minor novels. Where is the profound mistake spoken of by our contemporary writer? First off, he no

doubt believes that going from a book to a film can only be a process of betrayal and degradation, for which literature, not cinema, pays the price. There is a clear intellectual and moral prejudice here in presenting this process as if it were the equivalent of a falsified, impoverished translation of a high-quality work.

So we must concede to our censor that it is the minor novels that make the most satisfying adaptations, if not the best films. First, because they surely stand a better chance of being improved in the process. It is a given that Delannoy's *La Symphonie pastorale* can only disappoint, whereas Renoir's *The River* is better than the original.[3] There is obviously more reason to be concerned for masterpieces, and in any case more reason to be demanding. The very perfection of the originals bars us from thinking that they would be "improved" by the film. What's more, language clearly possesses subtleties and resources prohibited to the image as such, and conversely, the power of the image may occasionally be greater than that of writing. But did cinema acquire speech for nothing? It is retrograde to imagine that cinema is only the art of the image. Dialogue or voice-over commentary can contribute what the image cannot express, and on the other hand, from the shock, counterpoint, or parallelism between language and image new beauty can emerge, like a brilliant arc flashing between electrodes. Take Robert Bresson's *Journal d'un curé de campagne.*

ONE MAY DO IT WHEN ONE KNOWS HOW TO DO IT

This admirable film invites us to answer a perilous question. Isn't adaptation justified or excused strictly on grounds of fidelity?

Here I believe the result is all that counts. A certain prejudice in favor of fidelity seems to me not only a priori a moral guarantee of quality, but also the most reliable way of engaging creativity and originality: it takes more talent and creativity to imagine exact equivalences between a novel and a film than it does to take liberties in the name of some imagined necessity. Once again, Bresson's great lesson is decisive. But some directors (*réalisateurs*) can allow themselves every license their temperament needs, on one condition—that the results are worthy of the model and of the pretext. When Van Gogh copies Millet's *L'Angelus,* he is obviously making a Van Gogh. Renoir adopting Flaubert creates a Renoir.[4] We would not criticize him, for here even his relative infidelity pays tribute to the model, and from that betrayal we learn to appreciate it even more. I know no better way to conclude than with Bertolt Brecht's answer to a French journalist worrying about the freedoms that the great man of German theater intended to take with a Shakespeare play: "Do we have the right to abridge or even to adapt the classics?" To which Brecht calmly answers: "One may do it when one knows how to do it." I'll give a similar answer to the question: may one bring literary masterpieces to the screen? Certainly, if one shows oneself worthy of doing so.

<div style="text-align: right">

Les candidats au bac devant
le problème film-roman
Radio-Cinéma-Télévision,
no. 338, July 8, 1956
Écrits complets, 2088

</div>

NOTES

1. Bazin mocks strict adherence to a prevailing notion of pure "cinematic specificity."

2. *La Princesse de Clèves*, taken to be the first French novel with psychologically realistic characters, was published in 1678, a year after the first staging of Racine's most famous play. Both works deal with the moral vacillation of a female aristocrat.

3. André Gide won the Nobel prize the year after the adaptation of his *La Symphonie pastorale* appeared. Bazin considered Rumer Godden a mediocre novelist whom Renoir transcended in adapting her work; Renoir had great respect for her.

4. In 1880 a young Vincent van Gogh produced "The Angelus (after Millet)"; in 1933 Jean Renoir directed *Madame Bovary*, from Flaubert.

8. Lamartine, *Jocelyn:* Should you Scrupulously Adapt such a Poem?

I don't count myself among those who think that the cinema has something to lose a priori by borrowing its subjects from literature, whether novelistic or theatrical. On the contrary, it seems to me that the screen is probably on the verge of exhausting themes that might be considered specific to cinematic expression. Should others be born, it would take only a few years to run through them as well, as occurred, for example, with the American comedy. Given this, it is inevitable and natural—so long as the Stendhals, the Balzacs, or the Gides of the 1950s don't choose to express themselves directly on film, the way Malraux attempted to and as Roger Leenhardt did in *Les Dernières Vacances* (an adaptation of a novel he had not authored)—it is natural and inevitable, I say, that cinema should borrow its goods from two earlier and adjacent arts: the theater and the novel. I am not unaware of the objection by purists that the means of literature are not the same as those of film, and that a work's excellence is precisely inseparable from its means. What would be left of *Madame Bovary* without Flaubert's imperfect verbs, or of *Alissa* without Gide's simple past tense.[1]

Conversely, what could cinema gain by giving up the themes specific to it, or at least those to which it is best suited, attempting to copy works that have already found their ideal form in another material?

Such objections would seem to be backed by common sense, or at any rate by the favored opinion of modern criticism, be it

literary or cinematic. It might perhaps suffice to say that they are belied by the facts: *Espoir, Les Parents terribles, Henry V, Journal d'un curé de campagne....* Yet refuting them is worth the effort. It isn't possible to accomplish that within the scope of this column. I will limit myself to pointing out that specificity in art is a relatively recent concept and that on the contrary, in historical hindsight, adaptation—plain plagiarism, even—is the rule. Because of its young age, cinema thus brings us back virtually to the earliest stages of art history when all that initially mattered was to reproduce a theme in as many technical media as possible:[2] a Byzantine miniature, for example, in the stone of a capital.

But even were we in our rights to condemn adaptation, we would still have to recognize its many actual advantages. First, the basics: the literary heritage is composed of celebrated and thoroughly elaborated works; even when cinema only uses it as primary material and treats it with a degree of casualness, it already starts from a much higher level than most commercial screenplays. If cinema betrays the original, that is because there was something to betray, even as to the form itself! For it is only when cinema resigns itself to lazily pillaging the novel and the theater, with no concern for fidelity, that it degrades cinematic expression. Quite to the contrary, it is Robert Bresson's respect for each word that led to his remarkable cinematic style in the *Journal.* Bad filmed theater dishonors cinema only insofar as it betrays the theater. The paradox of a faithful adaptation is that it demands a more intimate comprehension and respect for the two means of expression on which it draws. The double existence of *Les Enfants terribles* demonstrates this well enough. Even were we to conclude—which I do not—that the recourse to literature is a stopgap for inventing original scripts directly for the

screen, rational thinking and experience should force us to recognize that, on the whole, the growing number of adaptations is to the benefit of cinema's progress.

This long preamble was meant to justify a priori the undertaking of Mr. Casembroot, who, having first had a go at three or four others, attacked the *mise-en-film* of *Jocelyn*.[3]

I emphasize a priori. Because for once I will be reproaching a director for his literary piety and his fidelity.

Let me first quite simply reproach him for having filmed *Jocelyn* at all. Not that Lamartine's poem is particularly unadaptable, but because I don't see the point of doing it. Who besides literature professors reads *Jocelyn* (and I'd even want to double check that). Whereas we still read *Les Misérables*. It is true that we could thank Mr. Casembroot for having spared us the effort. We might have imagined that Lamartine's 8,000 lines had become unreadable as a whole, but that some residual beauty warranted their adaptation for a broad modern public, as happens in the theater with this or that overwrought Elizabethan or Spanish work. But I find even this suggestion dubious. *Jocelyn* belongs irremediably to a superannuated part of the romantic canon, practically inaccessible to a contemporary sensibility. In 1952, its sentimental naïveté and implausible story can't count on any audience complicity whatsoever; they barely avoid complete ridicule.

So why then has this novelistic poem been filmed three or four times in the last twenty-five years? This is indeed a peculiar problem. I am inclined to think that, with regard to the general public familiar with the plot only, *Jocelyn* has the advantage of its slightly equivocal renown. What screenwriter would dare suggest such a salacious story to a producer? *Jocelyn* couples the

excuse of a schoolgirl's book with the prestige of literary suc-
cess, but ultimately what the spectator is waiting for is the semi-
nary student to unbutton the blouse.

In this regard, as in some others, the viewer has been cheated
by Mr. Jacques de Casembroot, who took his job awfully seri-
ously. No one can doubt that this adaptation is entirely faithful.
The director, author of *Combourg, visage de pierre* and, unless I'm
mistaken, one other short, *Paysages de Lamartine*,[4] specializes in
romantic and literary documentaries. Here he succeeded in
translating nature into a more than romantic—indeed, exactly a
Lamartinian—style: this betrothal of clouds to mountains, this
gray of the waterfalls, the chaos of those rocks, so terrifying and
instructive at once, are all, in fact, a satisfactory representation
of the poet's descriptions. That said, this fidelity is minor, even
if it is thought to be essential. What interests us more are the
characters. We can argue about details, but on the whole Jean
Desailly is quite good as Jocelyn, in one avatar of the various
ways we might imagine him. Simone Valère is more problem-
atic, not only because it's hard to take her for a young man,[5] but
above all because we have often seen this actress give excellent
performances, whereas she is inexplicably bad here, mistaking
romantic despair for a nervous fit. At least the blunder is not
serious enough to amount to a casting error disrupting the film's
unity.

Yet it is precisely this unity that seems to me the initial mis-
conception. If *Jocelyn* were going to be filmed, there shouldn't
have been any fear of offending some Lamartinian piety. And
isn't formal fidelity a mistake here even from an historical per-
spective? Lamartine ran afoul of the Index with this poem,
which bordered on heresy; evidently in 1836, there was worri-
some audacity with regard to morality and theology in a story

that seems so boring today.[6] I am told that the odd changes imposed on some of the plot details (the priest's ordination does not take place in a prison) correspond to early drafts of Lamartine's manuscript. Such erudition in a filmmaker would be a pleasant surprise were the result not questionable, because these variations tend precisely toward orthodoxy. Had just a small germ of heresy and scandal survived in *Jocelyn,* it would have allowed a few green shoots to flourish.

When it comes to romanticism, each era has its own. For the little seamstress of 1952, it's the film star. Today's starry-eyed young girls would have no trouble identifying with Laurence had Jocelyn been called Gérard Philipe. I would more readily forgive Jacques de Casembroot for being inspired by *Caroline chérie* than I would praise him for having been attentive to Lamartine's drafts in his adaptation.[7]

It seems to me then that, fruitful as it is when borrowing from contemporary literature, textual fidelity must be conditional when it comes to older works, where modern light can reveal surprising contoured reliefs. I don't mean to say that I would like to see a Jocelyn resistance fighter à la Clouzot's des Grieux;[8] there are other ways to modernize. I am, in fact, thinking of Robert Bresson basing *Les Dames du Bois de Boulogne* on *Jacques le fataliste,* with entire speeches from Diderot put into the mouths of his actors.[9] But such fidelity to an eighteenth-century text became strange in a twentieth-century context. Its stylistic effect was a paradox, the creation of a new unity of tone in a work, leaving room for a certain discordance.

Jocelyn, ou les ennuis de la fidélité

L'Observateur, no. 97, March 20, 1952

Écrits complets, 994

NOTES

1. [French editor's note] Alissa is one of the characters in André Gide's *La Porte étroite (Strait is the Gate,* 1909).

2. Bazin's term is "techniques," not his more usual "formes d'art." Perhaps he was under the influence of André Leroi-Gourhan's two-volume study *Evolution et techniques* (Paris: Albin Michel, 1943, 1945), the first part of which examines precisely the early stages of art history. Today we might use the term "media" or "technics."

3. "Mise-en-film" might be rendered "filmatization." Bazin's neologism is meant to be congruent to staging a novel, play, or screenplay, i.e., "mise en scène." He uses the phrase in *"Jane Eyre"* (see chap. 39), where "film version" seems more appropriate.

4. [French editor's note] *Lamartine, ombres et paysages* (1950).

5. In Lamartine's poem, the hero, Jocelyn, destined for the priesthood, is accompanied on a journey by a young person whom he rescues and mistakes for a boy. When Laurence's gender is revealed, the friendship turns romantic, though is repressed by Jocelyn's scruples. Later, Jocelyn discovers her living a frivolous life in Paris. He returns to the mountains, but fate brings him to encounter her again, this time at death's door. She has just time to confess her eternal love for him, and he buries her with sublime stoicism.

6. The Index was a notorious list of sinful books Catholics were forbidden to read. Initiated in the sixteenth century, it was last revised in 1948 and stood in place when this review appeared, until finally being revoked in 1966.

7. Gérard Philipe, hands down the French heartthrob of the early 1950s, would have been able to stir naïve viewers the way that *Caroline chérie* (Richard Pottier, 1951) did. Both films are love stories set during the Revolution, the latter a hugely successful mix of romance, comedy, and adventure. *Jocelyn* pales beside it, even if it is far more intellectually ambitious.

8. Des Greux is the hero of *Manon* (Henri-Georges Clouzot, 1949), also an adaptation of a literary classic. See Bazin's review of this film (chap. 47).

9. Bazin's wrote "auteurs" rather than "acteurs," surely a typographical error.

9. Roger Leenhardt has Filmed a Novel
he never Wrote

Roger Leenhardt is no longer unknown to the broad public since his recent documentary on *The Birth of Cinema*—an impeccable work of refined taste admirably allying technical intelligence with the popular sense of the marvelous, making the film accessible and delectable to audiences the world over.

Shall I now admit that when Leenhardt out of the blue agreed to make a feature film for his friend and producer Pierre Gérin, we were somewhat fearful? It was inevitable, but we had become used to Leenhardt prolonging his Kierkegaardian engagement with the camera. He had never directed actors, had no experience shooting on a set, and had never written a shooting script. What would become of him in the lion's pit of technology (*technique*), armed only with his intelligence?

Our friendship was not the only thing at stake; Leenhardt's exploit called out a principle: do talent, baby-blue eyes, and a diabolical filmic intelligence still suffice to make a film in France? There are director-auteurs, of course, but someone like Becker had behind him a long technical apprenticeship before writing screenplays. Leenhardt belongs to that type of author-director who from the outset can't help but capture technique in their stylistic net: like a Cocteau, a Malraux, or a Bresson. Yes, in truth, the failure of *Les Dernières Vacances* would have grieved us more for French cinema than for Roger Leenhardt.

But you will soon see *Les Dernières Vacances*. A careful and penetrating work that is initially appreciated only for its sub-

tlety and intelligence, but the impression it makes is so enduring that it is surely worth more even than it seems.

The initial idea of the screenplay is quite simple, quite beautiful, but quite tenuous: a subject for Giraudoux. It so happens that at around fifteen or sixteen, a girl matures psychologically more quickly than a boy; he will need several years to do the same. When a young Parisian architect arrives, charged with buying the family property, Juliette becomes brutally aware of her fate as woman, which abruptly separates her from her cousin Jacques who, in his childish jealousy, confusedly senses that Juliette is eluding him and crossing over to the side of the grown-ups, and that he will also be forced in his turn, albeit more slowly and painfully, to define his path to the country of men. During this last vacation, he has learned to distinguish the sting of a mother's last slap from a woman's first slap.

Leenhardt also succeeded in intimately linking the theme of the end of childhood with that of the end of a particular bourgeois society after the Great War. Both adventures occupy a common ground: the family property in Torrigne, which has become too burdensome for the heirs, who have gathered there one last time for a final summer vacation.

The park, already as beautiful as a memory, where Jacques and Juliette have their first lesson in love, is also the childhood they must relinquish. But with its monkey puzzle trees, its weeping blue cedars, its southern magnolias, its bamboo-lined alleyway, and a rock fountain in which three generations of summering schoolchildren have splashed during the same oppressive southern heat, the Torrigne property is as outmoded and out of place in the arid scrubland dotted by Roman ruins as Venetian lace dresses and Aunt Delie's beaded embroideries. It is the symbol of a bourgeoisie whose ultimate charm, if not grandeur, lay

in its ability to create a style of living and a style of property at one and the same time. Hasn't this marvelous bourgeois world become even more anachronistic in parental worries than in the children's games?

It is curious to note that with the exception of Jean Renoir in *La Règle du jeu*, French cinema has virtually ignored the theme of "the family property" to which literature, after all, owes works such as *Dominique, Le Grand Meaulnes* (*The Lost Estate*), and *Isabelle*, not to mention many second-tier novels such as those by Lacretelle and Émile Clermont.[1] But it is even more curious that the French novel from Balzac to Marcel Proust, François Mauriac, and André Gide, has provided such rich accounts of the life and death of the bourgeoisie and that, from *Un chapeau de paille d'Italie* (*The Italian Straw Hat*) to *Le Diable au corps* (*Devil in the Flesh*), we can only point in cinema to the perennial, marvelous, *La Règle du jeu*. This alone would earn *Les Dernières Vacances* a place in the intellectual history of French cinema. And, in addition, I would like to emphasize how much more Leenhardt complicated his task by setting his screenplay between 1925 and 1930, a period too close to ours to avoid the risk of ridiculous costumes, and forgoing the support of any important literary reference.

The author put himself in an even more difficult situation with his choice of main characters. In cinema, fifteen is an eminently unappealing age. It is no longer possible to count on childhood's fully animal grace, but how to find actors with sufficiently professional skills? Leenhardt's audacity was rewarded. If Michel François, not an unknown on screen, is excellent, the young Odile Versois is simply perfect.

In its tone of probing sincerity and the quality of its emotions, the film reminds us of Vigo and Radiguet (the writer). But

in contrast to the heroes of *Zéro de conduite* (*Zero for Conduct*) and *Le Diable au corps*, those in *Les Dernières Vacances* will recover from their childhood. For Leenhardt's realism does not, in fact, exclude a clear, lucid optimism, giving the lie to—at least in its cinematic extension—Gide's famous remark about nice feelings and bad literature. For in addition to being the work of a psychologist, this is also the work of a moralist in the noble sense of the term, as our best novelists have been since the seventeenth century, from Madame de La Fayette to Albert Camus.

Yet intelligence and subtle observation, psychological and social, only acquire their full meaning and value within a style. Willingly ignoring the "rules" of *découpage,* Roger Leenhardt went straight for his style. His cinematic phrasing has a subtly personal rhythm and syntax. His clarity runs the risk of obscuring his originality. With his admirable sense of a scene's inherent continuity, Leenhardt knows how to make a detail meaningful without in any way giving up on connections to the whole. His best sequences possess the luminous clarity of an etching. The counterparts to the dance beneath the garden lanterns, for instance, or the love scene in the little boat, are only to be found in Renoir (and for rather similar technical reasons). There, Leenhardt discovers exactly what it was during these last ten years that has made Renoir, Malraux, Rossellini, and Orson Welles the real cinematic avant-garde, and so he prepares a new stylistics of *découpage.*

But the specific originality of the sentence by Leenhardt, a writer of cinema, lies in his ability still to detach himself in time from the grip of reality (for example, through a transition "on the axis" to a close-up)[2] before it reaches the limits of its charm. Cinematic writing rediscovers here naturally, through its own means, the paradoxical agreement of clarity with the truth of

concrete observation, this syntax of lucidity that also typifies French novelistic classicism.

I don't want to crush with excessive literary references this restrained work, whose construction does have its failings. Still, for all the problems of its last section, *Les Dernières Vacances* is a work in possession of a tone and a style. Something like that is sufficiently rare to warrant being pointed out. Just as uncommon is Roger Leenhardt's audacity in not only taking full responsibility for his work, with his first film and on a very small budget, but also in tackling this challenge at every level of his screenplay. While he did not conquer it equally well on every single point, his film nonetheless conveys the rare flavor of a cinematic work written directly in its style. However beautiful *Le Diable au corps* may be, it is still a translation, lacking what is most intimate in a work: what we might call style's nascent state. By contrast, Leenhardt gives us the sense of having made a film of the novel he could have written.

> Roger Leenhardt a filmé le roman qu'il n'a
> pas écrit; *Les Dernières Vacances,* une
> peinture de la bourgeoisie provinciale, un
> drame aigu de l'adolescence. Un style
> *L'Écran français,* no. 135, 27 January 1948
> *Écrits complets,* 376

NOTES

Roger Leenhardt, Bazin's close friend and mentor, preceded him as film critic at *Esprit.* He published essays on cinema, literature, and philosophy, while making unique documentary films. *Les Dernières Vacances* was the first of his two features.

1. Eugène Fromentin, *Dominique,* 1863; Alain-Fournier, *Le Grand Meaulnes,* 1913; André Gide, *Isabelle,* 1911. Jacques de Lacretelle's prolific

career included numerous novels of provincial decadence written in the 1930s. Émile Clermont was much lauded for *Laure* (1913), a novel set in grand provincial homes.

2. To "cut on the axis" is to put the camera closer to or further from the subject without changing its angle.

10. Alexandre Astruc's *Les Mauvaises Rencontres* (*Bad Liaisons*): Better than a Novel

It is permissible to have reservations about *Les Mauvaises Rencontres;* it is acceptable to be irritated by its subject or even to hate it—let me say right away that this doesn't apply to me—but it seems impossible to be "against" this film, in other words to ignore at one and the same time its beauty, its nobility, and its novelty. The few possible criticisms of the film can only be minor in light of the ambition of the enterprise and the considerable contribution of Alexandre Astruc to French cinema.

Astruc is one of the few young people in his generation who chose cinema not because the profession appealed to them, but because they saw in it the most modern and thus most fertile of artistic activities.

For the auteur of *Les Mauvaises Rencontres,* "it's even better" to make a film than to write a novel, or, if you will, it is the only way worthy of our era to be faithful to Balzac, Dostoevsky, or Stendhal. Alexandre Astruc's ambition is to express everything he could say by the already archaic form of the novel, supplemented with the specifically modern dimension of the cinema.[1] Meaning, he is not one of those for whom making a film assumes compromises and concessions, albeit with the best intentions in the world. Cinema for him must not "simplify" anything or "make things accessible" to an imaginary public (not even to a Ministry of Cinema):[2] such a notion is absurd if film is, rather, capable of saying more than all the arts that came before, and saying it better. So before delving into the specifics of the critique and, moreover, acclaiming the film, we must identify the

legitimate ambition of *Les Mauvaises Rencontres* and avoid confusing Alexandre Astruc's intentions with those of run-of-the-mill successful filmmakers.

My point is not to "critique" the film, or even to say why I like it—Paule Sengissen and Jean d'Yvoire do so on their own account elsewhere in this issue of our journal—but simply to offer a few objective reasons for my admiration.

Starting from a clever but only barely interesting crime novel,[3] Astruc sought an entirely different subject and knew how to address it: the moral confusion of a particular set of postwar intellectual youth. If the crime plot seems somewhat muddled, it is because we can discern it only through the moral consistency of the characters and as if refracted by their conscience. Basically nothing occurs in *Les Mauvaises Rencontres* that is merely picturesque, spectacular, or dramatic; every event is implicitly judged, set in a moral light. For Astruc, mise en scène is an ethic, and it is no accident that the film's most beautiful sequence, where Blaise Walter and Catherine Racan meet in a nightclub, centers, in fact, on a theological discussion. But let's allow Astruc to speak: "I wanted to make a very novelistic film.... what interests me is the situation of the characters with respect to something they don't know.... To keep to the Balzacian realm, let's say that this is a little like *Illusions perdues* (*Lost Illusions*). My heroine changes in different settings and looks around her. In terms of mise en scène, it's a close up that judges the establishing shots." We understand what Alexandre Astruc means: a conscience that judges a past.

I know full well that *Les Mauvaises Rencontres* will be accused of being too intellectual and literary, and I'm not saying that the criticism is not partially justified, but we must first see that the truth of the characters demanded this. Perhaps Astruc should

have known how to be simpler, leaner, but neither less "intellectual" nor less "literary." He will surely learn from the experience to better distinguish the essential from the incidental, though not, we hope, to relinquish depth and intelligence. On the contrary, may he remain worthy of his masters: Griffith, Murnau, Hitchcock, Balzac, Fritz Lang, Dostoevsky, Renoir In the meantime, *Les Mauvaises Rencontres* is one of these all too rare films that guarantee cinema's powers and their nobility.

> *Les Mauvaises Rencontres;*
> Mieux qu'un roman
> *Radio-Cinéma-Télévision,*
> no. 303, November 6, 1955
> *Écrits complets,* 1899

NOTES

1. An ambitious and precocious intellectual, smitten by Sartre during the Occupation, Astruc published a successful first novel in 1945 and then turned to cinema with "La Caméra-stylo," a manifesto of sorts for a new literary cinema that he would pursue. He worked closely with Bazin in the late forties.

2. Though selected for Venice, the film was refused a license to represent the country from the Ministry of Industry because it concerned abortion. Thanks to Astruc's personal connections, the film was screened anyway, Astruc even taking an award, though he was shunned by the French contingent.

3. The author of the source novel, Jacques Laurent, was an outspoken, rather flamboyant, member of the literary group known as *Les Hussards.* He frequently appeared in the journal *Arts* and, under a pen name, Cécil Saint-Laurent, wrote sensational popular novels like the *Caroline chérie* series and *Une sacrée salade,* the source of Astruc's film. Bazin may betray his feelings by not mentioning his name.

11. Colette, *Le Blé en herbe:*
Uncertain Fidelity

If literary adaptation is what typifies French postwar production, Autant-Lara's latest film, anticipated for more than five years, is particularly representative of the tendency. Let us recall briefly—for we have often discussed the matter in these pages—that ever since, roughly speaking, *La Symphonie pastorale* and *Les Dames du Bois de Boulogne*,[1] the major French filmmakers no longer consider adaptation in the same terms as they did before the war. Up to that point, with some very rare exceptions, a novel provided the director and the screenwriter with only a theme (when it wasn't just a title), a few characters, a place, and a period; and so directors considered themselves virtually free to do whatever they wanted, for reasons vulgar or respectable but only very tangentially wedded to the novelist's concerns. The thinking was that, the "optic of the cinema"[2] and its means of expression being completely distinct, fidelity to the letter was nothing more than a lure, if not a danger and a sign of impotence. There is no question that Aurenche and Bost, and perhaps Melville in *Le Silence de la mer,* introduced the notion of fidelity as something positive. I am well aware that François Truffaut disagrees with them on this score,[3] but he is wrong, at least insofar as the liberties the screenwriters take with *La Symphonie pastorale* are limited to a fairly narrow framework of equivalences they thought necessary. It matters less whether they were right or wrong in thinking that a straight line isn't always the most direct path between two points than it does that identity was acknowledged at all. In short, as hypocrisy is to virtue, so their very infidelities still remain tributes to fidelity.

It would certainly be ridiculous to posit as a principle that fidelity has become henceforth a requirement of literary cinema. There is no reason why intelligent freedom cannot occasionally produce equally good or even better results in some cases, as happened before the war, for instance, with Renoir's *Partie de campagne.* But this can only apply insofar as the director's universe can claim to compete with that of the writer—a rare thing for all too obvious reasons. To the contrary, it is perfectly clear that there is nothing to lose in taking fidelity as an ideal when it comes to a great literary work, for cinema cannot as yet claim to do better in this case than a writer. As for the objection that cinema should look to do something else, we will leave that to Mr. Cécil Saint-Laurent,[4] knowing to the contrary that the practice of fidelity is a much more effective creative requirement than is freedom, from the perspective of cinematic form alone.

The adaptation of *Blé en herbe* was a priori part of this tendency in French cinema, and in decisive ways. First, the literary value of the source and especially the originality of its tone and style, its relative popularity, as well, made the comparison between the film and the book more than ever necessary. Next, Autant-Lara had chosen a typically novelistic subject, whose plot and peripeties seem insignificant compared to the novel's strictly psychological and moral focus. In the dramatic sense of the term, practically nothing *happened.* For the director this challenge was going to be harder yet to meet, given that the age of his protagonists—unless he wanted to cheat—meant that he could not cast experienced actors (as was the case in *Le Diable au corps).*[5] What's more, the subject called for the candid immediacy of impressionistic acting. Not only would the viewer be deprived of any spectacular event or solidly constructed drama, any and all psychological analysis would be absent, as would the pains-

takingly explanatory unfolding of the characters' development that could in a certain way substitute for them. True, Autant-Lara could have aimed to compensate for these deficiencies with some of the more racy elements of the story, but as we shall see, he absolutely forbade himself this option—almost, I would say, to a point of excess.

Certainly, Aurenche and Bost did not entirely refrain from making a few additions. The sort of jaunty and dramatic prologue, for a start, in which a storm washes a half-dead, stark-naked Phil up on the beach where the young ladies of the Sacré-Cœur go for their annual dip. Here we cannot help but recognize our authors' unmistakable penchant for the small anti-clerical outrage[6]—but they have had worse ideas; this episode, invented from whole cloth, quite ingeniously establishes the fundamental themes that the film will develop. First, a flurry of picturesque details identifies the period to which it barely returns, so as to focus exclusively on the characters. Next, the dramatic nature of the situation makes it easy to quickly grasp the emotional relationship between Phil and Vinca. Finally, the boy's nudity introduces indirectly but plausibly the work's carnal theme in its ambiguity, serious and light. My only criticism of Autant-Lara for having deviated from the book is that he did not resist the satiric impulse, the slightly sneering bitterness, which places this introduction on the lower level of a satire of manners—something the film subsequently dispenses with altogether. By contrast, in terms of the mise en scène, this is the film's best moment, especially the unforgettable camera angle skimming the water's surface, giving us, perhaps for the first time ever in cinema, the physical sensation of drowning.

Less successfully, an epilogue extends the book, which, as we know, ends on the morning of the decisive night. I see no

justification for this other than the entirely contingent need to stretch the sauce. True, the version screened for us apparently underwent a last-minute change to avoid the "bad ending" of the initial treatment. But I'm quite afraid, first off, that the pessimistic denouement, induced by parental prejudice, would have further betrayed the book, which has little interest in railing against bourgeois morality. Which is why we will see the parents kept in the background throughout the film. Except that the absence of a denouement is even worse; after fifteen minutes of emotional hesitation, we are left at the same point at which Colette takes leave of her characters. Everything is said in the morning by Vinca's near-indifferent gaiety and the boy's worried regret. I can see that Aurenche and Bost thought that an explanation was needed, but I don't see that they have made anything clearer; indeed, to the contrary, they merely danced around a psychological investigation that remains unresolved. From there on, the film drags, finally getting bogged down, dare I say, on a sandy beach.

More noteworthy than the screenwriters' inventions however, is their clear concern to hew as closely as possible to the book. It is as if Aurenche and Bost had adopted a principle opposed to the one that had guided their adaptation of *Le Diable au corps*. The most striking example are the parents, who remain in the background, in gray shadows, barely more fleshed out than they are in the book, whereas in the adaptation of Radiguet's novel they had played a decisive role. However, while a novelist can easily blur characters even while they remain implicitly present, a filmmaker has to contend with the spectator's interest and curiosity, his need for logic. Colette more or less ignores the families because she adopts the perspective of Phil and Vinca, for whom nothing really exists outside of themselves; but the

camera is external to them, its eye sees the parents just as clearly. To prevent them from taking on the psychological prominence that this presence calls for, the screenwriters and the *metteur en scène* had to run the risk of frustrating the spectator while also trying to get him to forget this frustration, to make it as painless as possible. They did so quite successfully, without making the parents conventional. Indeed, each parent is remarkably individualized, down to the detail of the physical resemblance between the two sisters. Phil's mother even intervenes once or twice, discreetly yet substantially, and enough so that we can in any case imagine her personality and thoughts; however, she immediately recedes into the shadow. Only Phil and Vinca dwell in the spotlight from start to finish.

The initial adaptation, the one submitted to the precensure commission, apparently introduced a dramatic and psychological element nowhere present in the book: Mrs. Dalleray was more or less a lesbian; this beautiful seductress initiates Phil, their affair doubling the young couple's relationship. If it is indeed the case that Autant-Lara was advised to cut this episode, then it would be bad form on his part to complain since, had he kept it, it would have completely upended the film's structure, disrupting or breaking the melodic line of a story whose entire charm resides in being based on three notes.

In any case, it is not the critic's place to pass judgment on intentions. In its final form, the film is, in fact, evidence of a uniquely intelligent treatment of the Mrs. Dalleray character. It was hardly possible this time to keep this important role in the same discreet shadow as the parents. True, Colette only affords her a few precise yet succinct sentences, which define a type of woman rather than an individual. The viewer would not have understood such detached discretion, especially since they

concern Edwige Feuillère.[7] Yet while Aurenche and Bost were rightly led to create a better-defined character, Mrs. Dalleray nonetheless remains in the background, in a secondary, subordinate position. We might even say that in exchange for making the role clearer, the film makes the role less colorful. Had Autant-Lara dealt with Mrs. Dalleray in the way Colette indicated, our censors of "psychological realism" would have seen there the satirical vulgarity that so offends them. In Colette, Phil's seductress has the traits almost of a conventional casino Messalina,[8] and we can be grateful to the director for having avoided, for instance, the gastronomic and vaguely orientalist preliminaries described by the novelist: "Mrs. Dalleray did not appear to have waited for him and was reading, but the salon's studied shadows, the nearly invisible table from which wafted the scents of late-season peaches, of red Cyprus melon cut into star-shaped crescents and the black coffee poured over shaved ice made it clear to him . . .," and somewhat further, "His hostess served him nonetheless and from the little silver scoop he breathed in the scent of the melon's red flesh sugared and steeped in a delicate anise liqueur." Let's agree that this scene and its description are far more conventional than what Autant-Lara put in its place.

But it is the dialogue that makes the commitment to novelistic fidelity even more evident. With the exception, of course, of the invented episodes, or those far too radically adapted (although Aurenche and Bost often try to transplant the original dialogue into them), the authors respected as much as possible Colette's text. I could provide any number of citations, which are all the more significant than many of the dialogue-heavy scenes, which have no dramatic significance other than to provide novelistic color.

So, does this fidelity to the letter of the work, more than to its spirit, fully bear the hoped-for fruits? I certainly would not say that the film betrays the book or even that it is "inferior" to it. In no way do we feel the disappointment or regret stirred by great literary works when traduced by a film, a positive observation that already makes for considerable praise. I will even say that, all things considered, I prefer the film to the novel, for the simple but profound reason that the portrayal of the main characters satisfies me, and their reality now fills my imagination to the point of overriding Colette's evocation of them. Yet this again is belied by the idiotic prejudice according to which the novel has an advantage over the cinema thanks to its virtuality: the reader's individual imagination would always complete a novel's character, which as a result is richer than any of the options among which the screen's reality chooses. But, first off, this virtuality is completely theoretical, relative only to the number of readers. Were there 100,000 readers, the novelist may have suggested that many images, yet still each reader has only a single one, worthy of his imagination; so why would it be better than the one chosen by the filmmaker? What's more, is this problem so different from that of the theater? Should we give up playing Phèdre and Hamlet on the claim that these grand characters should remain ambiguous? The important thing is to agree with the choice made by the *metteur en scène,* and to believe in the actors until they crystallize, like the lover finally meeting the woman of his dreams.[9] Even though Nicole Berger does not physically entirely match Colette's Vinca (who is more of the coltish type, nervous, leggy, long-limbed, with a young, barely developed bosom), she is a perfect substitute. I am aware that the casting of Pierre-Michel Beck hasn't met with the same enthusiasm. Yes, he is more uneven, but his charm, combining

worry and pig-headedness, his nervous vivacity that doesn't preclude a youthful virility—all correspond perfectly, in my view, to the book's character. After all, in truth, Colette has no more than a middling concern for the details of her characters. She barely develops their psychology: they are simply young people of their age, and their adventure is the experience of adolescence, barely specific. It was inevitable and natural that the film would require more precision; what Nicole Berger and Pierre-Michel Beck bring goes further than Colette but respects the general shape of the novel.

It is thus not in the essential and decisive domain of acting where the film's fidelity disappoints me. Which is why, even while I grant it a kind of superiority, something is missing. A careful reading of the novel may provide the key. My first, very general comment bears on the spirit: the enormous proportion in the text—not counting the dialogue—of tactile and olfactory substantives and epithets; as to visuals, two times out of three, they have to do with color. Which means—since the dialogue is almost never descriptive—that even were Autant-Lara's film a calque of the book, it would still be just Colette's universe minus the odors, tastes, touches, and colors. Certainly, the suggestiveness of the black and white image does indirectly restore some of these sensory realities, but I am afraid first of all that Autant-Lara is not the man for the job here; if his mise en scène suggests something beyond its contents, it is certainly not in this or that particular sense or rather in … all those senses. But even if he were as talented in restoring them as Renoir was in *La Règle du jeu*, I would still wonder whether cinema can claim to evoke a novel's complete reality, given that image and dialogue are its only means. Beyond even the sensorial realms prohibited by the uniquely distressing congenital infirmity of the cinematic image, here it is still mostly

impossible to suggest, working only with the author's directions and the scene's layout, the psychological and moral commentary a novelist can sometimes express in a single sentence, and which is often essential for a true understanding of the situation or even the dialogue. I am not saying that the direct style is necessarily prohibited to the cinema aiming to be novelistic—we have sufficient examples to the contrary—but I do believe that when it comes to faithful adaptation, and at least for certain groupings of novels, the mediation of voice-over commentary is almost unavoidable. Remember the beginning of *Double Indemnity,* when Fred MacMurray returns for the first time to Barbara Stanwyck's home: the image simply shows a man driving his car in the suburban countryside, but his voice comments on this memory: "It was a summer sunset, I will never forget the scent of the honeysuckle,"[10] and these few words were enough to lay out the sensorial, psychological, and moral dimensions of the shot. This intervention of a recitative voice may be quite discreet, merely a murmur the viewer almost forgets, as in Renoir's *The River,* but it is enough to slant an entire sequence, define its perspective, its intellectual precision. Indeed, isn't this what the novelist himself does in placing himself in God's perspective?

<div align="right">

Les incertitudes de la fidélité;

Le Blé en herbe

Cahiers du cinéma, no. 32, February 1954

Écrits complets, 1520

</div>

NOTES

The Game of Love is the English title of the 1953 film *Le Blé en herbe,* adapted from Colette's popular 1923 novel. The novel was titled *The Ripening Seed* when its English translation came out in 1956.

1. These two key examples of adaptation point to two different directions French cinema was to follow after the war. *La Symphonie pastorale*, scripted by Jean Aurenche and Pierre Bost for Jean Delannoy in 1946, solidified the "Tradition of Quality," while *Les Dames du Bois de Boulogne*, directed by Robert Bresson in 1945 with Jean Cocteau providing dialogue, helped initiate a modernist tendency.

2. This English term fails to fully render a noun that the French often use for the "perspective" or "standpoint" of something. "L'optique du cinéma" plays with the term's ocular connotation.

3. [French editor's note] Bazin is directly responding to "A Certain Tendency of French Cinema," young François Truffaut's pamphlet against the old guard of literary screenwriters, starting with Aurenche. Drafted in summer 1953, it was delayed by the rewrites requested by Bazin and Jacques Doniol-Valcroze and finally published in *Cahiers du cinéma*, no. 31 (January 1954): 15–29, a month before this article by Bazin.

4. Cécil Saint-Laurent was the pen name of Jacques Laurent, a prolific member of the Hussard literary group. Under this pen name, he wrote popular historical fiction, including *Caroline chérie*, the source of a series of hit films in the early 1950s. He also wrote *Lola Montès* (the novel and script) for Max Ophüls and *Les Mauvaises Rencontres* (*Bad Liaisons*) for Alexandre Astruc (see Bazin's review, chap. 10).

5. The same director and scriptwriters had made the most talked-about French film of 1947, *Le Diable au corps*, from Raymond Radiguet's sensational 1923 novel about a teenager's adulterous affair. Colette's similarly sensational novel also was published in 1923.

6. François Truffaut had maligned Aurenche, Bost, and Claude Autant-Lara for a compulsive anti-clericalism that flaunted their "advanced" ideas. See note 3 above.

7. Edwige Feuillère brought a lengthy career and large fan base to the role of Mrs. Dalleray, having acted in dozens of films from 1931 on. Equally respected for her work in the theater (with Cocteau and Paul Claudel), she lent her gravitas to every role.

8. Messalina, the wife of Emperor Claudius, is famous in Pliny's account for her voracious sexual appetite.

9. A reference to Stendhal's 1822 theory of crystallization as posited in *De L'Amour*: "What I call 'crystallization' is the operation of the mind that draws from all that presents itself the discovery that the loved

object has some new perfections." Stendhal, *On Love* (Mount Vernon, NY: Peter Pauper Press, 1950), 14.

10. Bazin's memory or the French subtitles were slightly off: "It was mid-afternoon, and it's funny, I can still remember the smell of the honey-suckle all along that block."

12. Rereading Stendhal's *Le Rouge et le Noir* (*The Red and the Black*) through a Camera Lens

I admit right off the bat, with no more arrogance than false shame, that I am not what you might call a Stendhalian. I always had to force myself to read *La Chartreuse* and *Le Rouge et le Noir*. I will even go so far as to admit that I never managed to take in more than some sections of the latter. I know that more than one reader will be appalled by this admission, and I am not particularly proud of it, but even should it compromise part of my reputation, that seems necessary for what comes next: it is thanks to cinema that I have come to reconsider my feelings toward Stendhal, and to have returned to him if not enthusiastically—as I have seen many others do—than at least with an active interest, compelling me to overcome my first impressions. Two films have forced my hand in this: *Mina de Vanghel* and *Le Rouge et le Noir*.

I have deliberately excluded Christian-Jaque's *La Chartreuse de Parme*¹ from this set, for it is to him that I instead owe a decisive confirmation of my prejudices, and it is therefore precisely with him in view that I'd like to resolve a confusion. It has often been noted—and I don't blame myself for it personally—that in adapting masterpieces, no matter how awkwardly, cinema rendered service to literature. The proof is statistical, in the number of reprints. I don't know how many people read *La Symphonie pastorale* in 1945, but I'm willing to bet what I get paid for this article that that number went up at least tenfold after Delannoy's film. Ditto for Christian-Jaque's *La Chartreuse*. Seen this way, every novel's adaptation benefits literature. But still, we should explain how exactly: quite simply by the formidable publicity the film

gives the book. Had [Éditions] Gallimard budgeted the approximately 150 million that is the equivalent of today's cost of making the film to market a reprint of *La Symphonie pastorale,* the result would have probably been the same. So from a strictly sociological perspective, we may congratulate Christian-Jaque's film on behalf of literature, but, bypassing that quantitative argument, we'll simply have to accept ashes on our head if we also concern ourselves somewhat with Stendhal and cinema.

Yet something bothers me in the harshness of some reactions to Autant-Lara's film that I see among the right-minded and most qualified: to hear them tell it, there is merely an insignificant difference between his infidelities and those of *La Chartreuse de Parme.* I find it necessary to protest against this. Christian-Jaque (against whom I have nothing in particular, but he is an obvious example, and a handy one) delivered a purely mechanical reading of Stendhal's novel, incapable as he is, despite Aragon's efforts, to contribute toward making it more beloved or understood.[2] I can even state that for a viewer already disinclined to like Stendhal, he made the aversion worse, like that margarine commercial that seemed to have been paid for by the union of cooperative dairies.[3] In short, had it depended on Christian-Jaque only, I would have held on to this prejudice even longer, as it hadn't cost me too much. That said, I am perfectly happy to see *Le Rouge et le Noir* be criticized as harshly as anyone might want to with regard to the literary original, and even with regard to the ideal adaptation—which anyone can imagine however they'd like—as long as the account of what it is missing doesn't make us ultimately forget what the film *does* give us. As a viewer and as a Beyle specialist, Martineau has a perfect right to describe what he finds painful, and to point out the film's infidelities,[4] but I simply think that when one is a film critic and

not a literary critic, one's judgments should be *relative* to the current cinematic situation. Not just in absolute terms related strictly to the novel, but also comparing it to what has been done before, and to what could be done today.

I am far from claiming, of course, that it was impossible to do better and am critical of Autant-Lara and his screenwriters on several counts. Their decisions as to what to cut and what to keep seem to me often arbitrary (on top of which the Mathilde character is then eliminated after the arrest, whereas the role of a grotesque, hateful preacher on whom Stendhal spends less than a page has been carefully kept, at least in the long version).[5] Granted, a close examination done in good faith shows that many "condensations" are perfectly justifiable, but why then, if so much had to be sacrificed, was it necessary to expand simple allusions (the episode in the seminary refectory, for instance, also fortunately cut from the release version). One sequence was almost unanimously acclaimed even and especially by Beyle experts who were no doubt surely all too happy to pay secondary homage to a bit of "pure cinema" that corresponds to no text at all, and here I am talking about Mme. de Renal's coming and going from her bedroom to Julien's. True, the idea is fine, but what lack of imagination in the mise en scène! Not a single gesture surprises us, dramatic intention included. We need only compare it to the lovers' movements in the apartments in *Le Rideau cramoisi*.[6]

But when all this has been said along with a few other complaints, we must finally address the film's merit, which is considerable. I ask that someone make me a list of films adapted from novels, including novels as subtle as this one, which succeed in getting us interested in the characters' moral reality as this one does. The arguments around how much they conform to their

models that everyone claims to be deciding with passionate certainty (and with all the resulting contradictions) prove my point. To think that Gérard Philipe also embodied Fabrice, but this wasn't even a Fanfan la Tulipe!⁷ If the film's characters warrant discussion and disagreement, it is because they have at least an existence on the screen, and that this life is sufficiently filled with consciousness and ambiguity to captivate us by its mere presence. As well, the film's interest doesn't ever rest simply on its dramatic turns or on the unfolding of the action as such: it is always and only to the characters that we are attached, to getting to know them and seeing them evolve, or, to put it better, seeing them mature. Nothing of what happens to them interests us as much as their reaction to some blow that unmasks and reveals them. Autant-Lara may make many mistakes in the details, but his errors don't undo this essential fidelity to the novelistic approach. It is in this way that his film captivates us, in this way that—I repeat—I have been brought closer to Stendhal. Rereading now *Le Rouge et le Noir,* I certainly see that the Beyle experts are correct theoretically (although not always, the proof being that they contradict one another here and there), that the dialectic of romantic honor and cynicism in Julien is more delicate than it appears in Gérard Philipe, and that Stendhal's Mathilde de La Mole has none of the "seductress" aspect she was given in the film. Yet I also note that these very differences help me understand the novel in that they create intellectual diffractions in its density. Of the agreement or else conflict between my memory and my imagination is born a new understanding of the characters. However, this active comparison between the book and the film is only helpful and creative insofar as the film can hold up to the reference ("you only lean," Mr. de La Mole remarks, "on that which resists"). The film is

certainly not the equivalent of the novel—but how could it have
ever been! It may not even be the best film that could have been
made under the prevailing conditions, but it provides a genuine
opening onto Stendhal, bringing us effectively some knowledge
of the characters, not descriptively and dramatically as happens
in nine of ten adaptations, but through the interest and curiosity
that their existence sparks. It was this curiosity, prompted by the
film, which sent me back to the book with an appetite my first
direct efforts never awakened. It seems to me that this is more
than enough to justify a film, and if not enough to make of it a
masterpiece, then enough at least to compel a little admiration
and a lot of respect for such an arduous undertaking.

<div align="right">

Des caractères; *Le Rouge et le Noir*

Cahiers du cinéma, no. 41, December 1954

Écrits complets, 1634

</div>

NOTES

1. See Bazin's review (chap. 49) of the 1948 *La Chartreuse de Parme*
(*The Charterhouse of Parma*).

2. Bazin had heard, or heard about, a lecture Louis Aragon had
delivered just days before at the École centrale du Parti communiste
français, entitled "Stendhal in an hour and a quarter," later published
in *La Nouvelle Critique* 7 (April 1955). Aragon had also recently published
La Lumière de Stendhal (Paris: Denoël, 1954).

3. [French editor's note] At this very moment, an advertising cam-
paign for Astra margarine (that begins by denigrating the product to
better sell its benefits afterwards) was analyzed as a mechanism to pre-
serve order by Roland Barthes in "L'opération Astra," *Lettres nouvelles*
22 (December 1954): 948; reprinted in *Mythologies* (Paris: Le Seuil, 1957).

4. [French editor's note] Henri Martineau, "*Le Rouge et le Noir* à
l'écran," *Le Figaro littéraire*, November 6, 1954. Stendhal is the pen name
of Marie-Henri Beyle.

5. [Bazin's note] Luckily this episode was cut, but the new ending is worse still, for other reasons.

6. Bazin supported *Le Rideau cramoisi* (*The Crimson Curtain*, 1953), adapted by his friend Alexandre Astruc from the nineteenth-century romantic novel by Barbey D'Aurevilly. Bazin never reviewed this film directly, but he referred to it again and again. See *Mina de Vanghel*, chap. 15.

7. Bazin had found Gérard Philipe's role as Fabrice in Christian-Jaque's *La Chartreuse de Parme* thin, compared to his more complex Julien Sorel in *Le Rouge et le Noir*. Between these two roles, Philipe starred in *FanFan la Tulipe*, an historical adventure film without literary pretensions.

13. Of Novels and Films: *M. Ripois* with or without Nemesis

I have already had occasion to speak in *Esprit* of René Clément's importance to French postwar cinema, in particular with regard to *Jeux interdits* (*Forbidden Games*). Alongside Robert Bresson and Jacques Becker, he is one of the three pillars of the new French school (four, if we add Henri-Georges Clouzot, who, in some ways, mostly belongs to the prewar era). And if he isn't the most valued (Bresson is, for my taste), he certainly is the most solid. This solidity in boldness has also been recognized by many festivals since the first one, in Cannes in 1946, where *La Bataille du rail* won the laurels. Yet now for the first time a great Clément film, and doubtlessly his most brilliant, has been "trounced" at the most recent Cannes Festival. For the consolation prize awarded Clément at the last minute, and under conditions that created a buzz, amounted obviously to a public insult. The class ace accustomed to taking the honors in the national university entrance exams couldn't possibly find it an honor to receive an "honorable mention." My aim here is not to debate the decisions of the Cannes jury. Everyone agrees that the recovery operation, whether necessary or not, added nothing to the festival's prestige in general, or to that of the jury in particular. What remains to be seen, however—for that is the decision several critics wanted to force on the judges—is whether *M. Ripois* rather than *Gate of Hell* should have received the Grand Prize.

I personally consider *M. Ripois* to be a very important film (perhaps even René Clément's most important), remarkable in many ways but not the masterpiece many want to make it, my

main reservation being that as a work it is overly intellectual and calculated, insufficiently infused by sensibility. By which I naturally mean the author's sensibility, that of the hero being another issue to which I will also turn.

Perhaps even more than its most ardent supporters claim, *M. Ripois* is above all important because of its unusual and powerful solution to the problem of novelistic adaptation. If, as I have often expounded in these pages, this problem is the key issue in the aesthetic development of postwar cinema, *M. Ripois* makes a decisive contribution to its evolution. Films that we found in their time courageous and admirable, such as *La Symphonie pastorale* or *Le Diable au corps,* now seem labored and timid. We can readily see that Aurenche and Bost's talent was above all deployed toward transposing plot and characters from the novel's universe of language to the screen's dramatic language, with an intelligence and taste still uncommon on screen. They certainly should be honored for making fidelity their prime concern. The literary work would no longer simply provide a pretext for a screenplay or the prestige of a title, which is what the older adaptations had reduced it to. Whatever changes Aurenche and Bost made to the design of the original, that is, to its characters and plot, were limited to what they considered necessary, in a sincere belief that they were giving us a film that respected its model and was worthy of it. The history of cinema owes them thanks for changing course, insisting as they did on the idea that cinema could compete with the novel on its own ground, no matter how loosely the concept of fidelity was applied. However, while they may not have been aware of it, they nonetheless held on to a reactionary and harmful assumption in their work, namely, that there is an irreducible difference between the novel's literary reality and the "optic of the screen." They

steadfastly held to the conviction that exact translation was impossible, and that the screenwriter's mission in adapting a novel was to transpose its substance from one system to the other. We won't hold it against them that this working hypothesis became an excuse to introduce their homegrown inventions and make themselves into something like the novelist's co-authors: it doesn't matter that fidelity is reduced to a novel's material and characters. But today we can see quite clearly that, in their conviction that they were making a true cinematic reconstitution of the novel, Aurenche and Bost acted like Viollet-le-Duc,[1] who was less an archaeologist than a romantic—albeit the precursor of modern archaeology—in preferring to leave new cut stone unpolished rather than to copy ancient sculptures, even if exactly.

The honor for demolishing these last preconceptions goes to Robert Bresson. His respect for literature equaled only by his utter confidence in cinema, he right off provided for us in *Journal d'un curé de campagne* an example of complete fidelity, no longer only to plot and characters but to everything in a novel that may seem to be the essential reserve of language. A fidelity that nonetheless is creative (so much more than that of Jean Delannoy or Claude Autant-Lara!),[2] for it is based not in adapting literature to cinema but rather in the reaction of the one to the other, in the relationship between word and image. Objectively, and let's now for a moment forget about the book, we can see that the film's value is *also*, if not *first of all*, literary, and that it is likely that here we find the essence of its profound cinematic originality.

In *Journal d'un curé de campagne*, Bresson carried out something of a *reductio ad absurdum* of cinema's novelistic possibilities. I am thinking specifically of the final white screen where, at the

height of its dramatic intensity, the image is effaced behind the word, the pure verb of the writer, who out of this blinding of the senses extracts a surfeit of solemnity and spiritual value. But whereas it is a good thing for an art to renounce its powers precisely in order to prove their existence and fullness, it would be absurd for it to forgo their use systematically. The case of Bernanos's book was thus rather unique, if only because of the death of its author,[3] and the exceptional importance of style in expressing his message. Beyond this limit case, fidelity can, in fact, cease to be advanced as the highest ideal of adaptation. What from now on matters to us more than fidelity is to know whether film can integrate the powers of the novel (let's contain ourselves: of the classical novel, at least) and engage us, beyond the spectacle, less by representing the events than by their internal logic (intelligence).

Consequently, I won't criticize René Clément simply for the liberties he took with Louis Hémon's novel and will only later discuss his uses of them. But in whatever direction the comparison between the novel and the film goes, we must give credit to the *metteur en scène* for a stunning invention, which precisely and with great intelligence manages to harmonize the conditions of the spectacle with those of novelistic insight. I will exemplify my point through one of the most brilliant scenes, the French lesson that makes M. Ripois decide to seduce his future wife. Although the action is in principle implied as having taken place in the past, the narration remains in the present and the camera is giving us an ostensibly objective view of the event. But the *découpage* includes in this case a psychological commentary. The, as it were, "dramatic" or objective action, as it is determined here by the protagonists' behavior and words, unfolds indeed on the screen before our eyes; but the *découpage* (i.e., framing and

camera movement) reflects not this apparent reality but rather M. Ripois' thoughts as he considers first his beautiful visitor's legs and then especially her marvelous solid gold cigarette case, slowly deciding to try to win first the former, then the latter. Obviously, the goal may not be especially original—other examples could date back even to silent cinema—but the novelty lies in the fact that the duplicity of both points of view, the objective and subjective, is throughout expressed simultaneously in the mise en scène, without any editing effects, close-ups, or superimpositions. This way of no longer *describing,* but, I want to say, *writing* [*"scribing"*][4] the scene is what delivers its hidden meaning, that which it has in the characters' minds. The same image that simply shows the action also comments on and analyzes it.

What's more, Clément does not deprive himself of access to voice-over commentary, which he combines brilliantly with real dialogue and direct sound. One must pay very close attention to identify the moment when the scene goes mute and commentary begins, with the soundtrack constantly interlacing these two literary levels, to which is added that of music, which in itself is always crucial.

Of course, the commentary and dialogue by Raymond Queneau are not actually "written," like those for *Journal d'un curé de campagne,* but their literary character is obvious, and one would not be fooled by their realism here any more than in a novel by the same author.

Such ingenuity of stylization may well find its most original form in the combination of raw reality with the acted mise en scène. In *M. Ripois,* René Clément radically updates the "neorealist" protocol for filming in the street. I put "neorealist" in quotation marks to signal that, as far as I'm concerned, this

technique does not define neorealism, though Italian directors have fortunately begun to deploy it again, for it dates far back and has been used quite often—though never, it seems to me, in the way Clément did. Dziga Vertov, and Jean Vigo in *À propos de Nice*, filmed unwitting passersby and the result was amusing or else outrageous, very often revealing a human reality to which we unconsciously adapt our eye or, more often still, to which our eye adapts itself. The implacably objective eye of the camera concealed in a hatbox breaks the relationship of "being-for-others" that shapes our perception perhaps as much as it shapes the behavior of one who knows he is being watched.[5] The case of the Italians is different, however (except, it appears, in a recent film, *Italians Stare*):[6] they don't try to reveal the humanity of street life with the objectivity of a voyeur, but rather blend their characters into it, so that we no longer even think about distinguishing the film's action from the reality we encounter every day. They accomplish this not by hiding the camera. Rather, the passersby become the extras, more or less voluntary but always aware of what is going on; the theatrical genius of the Italian people does the rest, the Italian street being a theater where every individual constantly improvises their commedia dell'arte; we can doubt as to whether the "camera in the hatbox" would have recorded anything very different at all. The same couldn't be said of London, and I like to point out that Jean Vigo, even a propos of Nice, did his spying on exactly the "Promenade des Anglais."[7] It would be interesting to account for—though it would take too long here— how René Clément managed to film his actors in the street without passersby realizing it as they went about their business "as if nothing were happening." A supply truck, portable cameras hidden inside newspapers, a whole team of assistants acting as lookouts, and above all a battle plan prepared as if for a bomb attack,

with the bus traffic and a host of other foreseeable possibilities figured out, allowed Clément to show us Gérard Philipe and Joan Greenwood in a London crowd, playing their roles in the midst of daily life, and on the same level of reality. Some anecdotes are even more significant than they are delectable: for instance, the passerby at once shocked and delighted to see two lovers kiss in the street, these being Gérard Philipe and his partner, or the young girl who, on a fluke, recognized and strode over to the French actor to request his autograph thinking that he was just out for a stroll. Without breaking stride, Gérard Philipe gestured to her which way to go. I don't know whether Clément ever considered turning these incidents into a montage short to accompany his feature, but it would have made for an interesting "Journal de *M. Ripois.*"[8] In any case, these interferences of raw reality and the film perfectly illustrate Clément's point, as well as his success. For what seems to me to be the first time, a *metteur en scène* has brought social reality into the *découpage,* a bit of color so to speak, preserving its absolutely objective character even while also subjecting it to the demands of the action and story.

A comparison borrowed from cinematic technique will help me make myself better understood. It is common for a love scene set on the street to use a special effect called "rear projection," in which the street is filmed first and then the scene is acted in the studio in front of an enormous polished glass screen on which the street shot is projected. It is easy to understand that no matter what, the protagonists are condemned to remain *in front of* the objects and people. To a trained eye, the special effect is indicated by a variety of details: unevenness of lighting, a slight flutter of the backdrop, its more apparent grain. Even were these slight imperfections removed and the initial shot filmed without the passersby being aware of the filming, the very principle of

the procedure would still depend on the two universes remaining unintegrated. The *performed* action floats atop the raw reality like a cork in the sea. But Clément makes the cork enter the sea by managing both to avoid dissolving his novelistic creation into reality and also rejecting their total differentiation. Social reality is respected as it is, revealed objectively in its brute nature while at the same time subject to narrative and deployed in the service of a novelistic reaction. Another example will express this better: M. Ripois has lost his job, has no money, is about to become homeless, and has nearly no food. Rumpled, ill shaven, and hungry, he wanders the streets peering into store windows, especially those serving fast food, where hurried people seated at bar counters face the street while eating. For those close to him or whom he watches through the window, Philipe is as he appears: a near-bum, a starving man, yet the people in the restaurant do not so much as glance at him. Reduced to the appearance of his misery, the actor is equally reduced to the solitude of a man abandoned by society. We see how much power this kind of situation draws from its mise en scène. "Reconstituted" as usual, with extras actually taken "from the street" but instructed to *appear* indifferent, the action would be nothing more than imagined and represented. But if a fictional element, that is, an actor, is inserted into a reality that pays him no heed, the scene is virtually lived. The moral isolation of the poor man in the city is no longer just a plausible-enough statement of the writer or the screenwriter: representing it coincides with putting it to the test. To express it is to experience it.

While René Clément moved away from Louis Hémon's book on practically every important point, here he did better than be faithful to it: the film's cinematic expression of London so prominently depicted in the novel is no less effective here. In

addition to the restaurant scene just discussed, a remarkable passage in the book describes hunger: "M. Ripois bought two portions of pudding at a penny each, to eat as he paced a dark street, stuffing the pudding deep in his pocket, taking large voracious bites directly from the wrapper, chewing slowly but stopping abruptly, jaws frozen, when meeting someone." Not every shame is to be found at the bottom of a glass, sometimes it can be eaten!

The film should also be credited with other achievements, secondary but possibly even more unusual. I am thinking specifically about the bilingualism inherent in the coproduction. *M. Ripois* is certainly the first coproduction that works without camouflaging its origins. Up until now, this usually catastrophic dependency could at most make itself ignored, with greater or lesser success. The film's very subject, the life of a Frenchman in London, called for a coproduction and bilingualism. However, the same version couldn't be used for the two countries, since a few words in French would be enough to make the English exotic, and vice versa. Having seen both versions a few weeks apart, I found it hard to track their differences very precisely, so adroit and convincing were the insertions, in varying proportions, of the lines in one language or the other. The flipped nationalities of the lark and the horse seemed to me to always compete for the same paté.[9] Such dexterity was largely made possible by the film's novelistic style, its freedom, and the suppleness of its writing; the constant passing from a fact to its understanding. Realism and abstraction thus no longer contradict each other and instead stand in an always-resolved dialectical tension—the very realism of language becoming relative. Something comparable could, in fact, also be noticed in the evolution of Italian neorealism. The best version of *Stazione Termini* was without a doubt the American one,[10] and I was stunned to

acknowledge that the English version of *Europe '51* was better than the Italian, even though it was unbelievable to hear Ingrid Bergman speak the language of Shakespeare to the *sciuscia*s, the little shoeshine boys. For plausibility was less important than truth, and there was more truth in having Ingrid Bergman speak English than in having her be dubbed in Italian. Once that truth was established, the social implausibility of the language spoken by the minor characters turned into a simple narrative convention. Of course, this transmutation could only function when it was harmonized with a mise en scène whose very principle was the constant transmutation into style of the most immediate and direct reality, but we can see that, at least for someone like Rossellini, neorealism—among whose earliest signatures was its respect for languages (Paisà!)—reveals its latent abstraction sufficiently today so as to use it freely when it comes to this detail. But make no mistake: what we have here is a convention made legitimate by first being integrated into social realism—the complete opposite of the convention in prewar films, where the Tower of Babel was overlooked.

The positive remarks I just made about *M. Ripois* will suffice, I think, to show the high regard in which I hold René Clément's film. But it is true that this regard bears above all on what can be said about the work in general rather than on the singular reality of the work itself. In this film I admire the invention of new aesthetic tools, the procedures of mise en scène and narrative, which enrich cinema's novelistic resources, yet I think that what we have is a failed cinematic novel. Whereas Louis Hémon's novel wasn't a failure. I don't know whether to attribute this disappointment to his excessive concern with formal issues or, negatively, to Clément's lack of sensitivity toward his hero. We might suspect that under his shiny armor, Clément's most

vulnerable spot is not the heart. His temptation is the exercise of style.[11] There is something in him of the classroom ace, the ivy leaguer of mise en scène, better at solving difficult cases *(Le Châ-teau de verre)* than at touching us, not wanting to risk a misstep. His two most "sensitive" films, *La Bataille du rail* and *Jeux inter-dits,* are also in a way the least "well made," in that both began as medium-length films that were extended to features. Moreover, he was profoundly moved by the themes of the then quite recent Resistance and of childhood, where he quite obviously exhibits a unique sensitivity. But it could also be that all those accidental or unforeseen things that occurred in the course of these two projects shielded Clément from the excesses of his talent, as if by a hand of God.

Be that as it may, Clément and Queneau's André Ripois is very different from Louis Hémon's Amédée Ripois, and in my opinion the only win of the former is in certain psychological improbabilities. Louis Hémon's Ripois has a solid existence, and his psychological parameters are clear. He is not a Don Juan, not even a second-rate one, but rather a "womanizer." That he has so many women owes nothing to his natural seduction (at the most, occasionally, to a Frenchman's reputation in England for gal-lantry) but rather to his pursuit of them with the stubbornness of an obsessive. Some of them inevitably fall into his trap because he baits them shamelessly and without remorse. This man is small, a cheap social climber who is, above all, heartless. We would be hard put to define the film's Ripois psychologically and socially. Even with Gérard Philipe's "French" charm, it is hard to believe that a beautiful, wealthy bluestocking like Cath-erine could find him seductive once he has pitifully revealed his extraordinary lack of culture. Amédée Ripois was not very intelligent, but he was sufficiently astute to force himself to

finally read a few good books he could discuss with Aurora so as to seduce her with great literature. That such a radically vulgar young man adapts with such ease to the life of an English aristocrat can't be reasonably explained by his mere physical fitness and resolute epicurean tastes. There is something incoherent, or rather nonexistent, in this character that leaves us uncomfortable. And do not pin this on ambiguities, because ambiguity is itself a psychological reality, whereas here it never enters the character, remaining always external, strictly on the level of behavior. The only ambiguity is Clément's view of Ripois. I fully understand that psychology is not the ultimate authority, and that the heroes of *Kind Hearts and Coronets* (1949) or *Monsieur Verdoux* (1947)—to which we can't help but refer—couldn't be analyzed in psychological terms without being misinterpreted; but they *can* be justified in another aesthetic mode of being. The novel is explicitly based on the metaphysics of the character, whereas in the film it is all too visibly based on Gérard Philipe's physical presence. Moreover, the moral plausibility of Louis Hémon's hero isn't imprisoned in any novelistic naturalism. The beauty of this short novel (said to be partially autobiographical) is in its natural transition to tragedy. Having honorably eliminated "Nemesis" from the title, René Clément did not find a way to replace it in his film. For it is amply clear that, when André Ripois' accidental paralysis delivers him up, helpless, to insipid feminine compassion, this can't be mistaken for the revenge of Venus. Amédée Ripois, for his part, remains entirely of a piece: simply, inexplicably, horribly, on the occasion of the death of a woman that he caused, he grows a heart. Or rather, this organ of the soul, unfeeling until then, begins to hurt, as if it were a wisdom tooth. Propelled by inertia, Ripois hadn't taken the time to wonder whether he loved Ella. Was he even capable of it? But

little by little, as other failures mount, Ella's memory blossoms in his mind, and Ripois believes that he need only retrace his steps to get her back, that she will forgive him the way, foolishly, pitifully, the others did. Except that Ella is dead, and Amédée Ripois will then find himself alone with her indelible memory. Oh! This is not remorse, but simply the birth of a heart, and Ripois returns to France more miserable than when he left, "having understood that a being in whom a soul awakens can't ever be happy again." We see that there is some distance between the novel's simple, sincere moral—to which the character's literary originality restores life and truth—and the entomological desiccation of the film's André Ripois, whose soul, as well as destiny, eludes us.

Clément's film is thus a comedy. When I said earlier that the proportion of languages wouldn't alter the taste of the dish, I was wrong, at least insofar as the English version had given me the impression of a dramatic film that became a comedy in the French. Surely that mistake was caused by my not understanding the English too well! For want of the sensory perception of the dialogue, and when only read and seen, *M. Ripois* naturally went back to the Nemesis of the novel. But Queneau's dialogue eliminates this misunderstanding once and for all. Without advocating a hierarchy of genres, we can be allowed to regret this shift to comedy, for it is far more difficult for a work to succeed when its heartless hero doesn't require a heart even of the public.

<div align="right">

Des romans et des films: M. Ripois
avec ou sans Némésis

Esprit, nos. 217–18, August–September 1954

Écrits complets, 1580

</div>

NOTES

[French editor's note] This article's title refers to the Louis Hémon's novel *Monsieur Ripois et la Némésis* (1950), but also probably to François Truffaut's article, "M. Ripois without the Nemesis," *La Parisienne*, no. 19, July 1954. [This book's editor continues] The film's French version carries the brief title *Monsieur Ripois* (often "Monsieur" is shortened to "M." in reference to both the film's title and main character), while in English it came out as *Knave of Hearts* (UK) and *Lovers, Happy Lovers!* (USA). Hémon, who died young in 1913, was posthumously world famous for *Maria Chapdelaine*. However, *Monsieur Ripois et la Némésis* was withheld from the French public until 1950 because of its tawdry subject matter. It then immediately gained a significant following, among whom were Truffaut and Bazin. Curiously, an English translation had appeared in 1925.

1. Bazin had compared these scriptwriters to the controversial nineteenth-century restorer of medieval architectural monuments Eugène Viollet-le-Duc, in the memorable final sentence of his "*Journal d'un curé de campagne* and the Stylistics of Robert Bresson," chap. 61 in this volume (originally published in *Cahiers du cinéma*, no. 3, June 1951). Just like Viollet-le-Duc, the scriptwriters update a masterpiece in a fashion that accords with their public's taste for an idealized style.

2. The directors of, respectively, *La Symphonie pastorale* and *Le Diable au corps*, which Bazin had just mentioned.

3. Georges Bernanos died in 1948 shortly after rejecting Pierre Bost's scripted version of his acclaimed 1936 novel. Bresson was chosen for the project by Bernanos' literary executor, Albert Béguin, a friend of Bazin and editor of *Esprit*, where this article appeared.

4. Bazin's homophonic pun, "non plus *décrire* mais ... *d'écrire*," might be rendered "no longer describing but ... scribing."

5. Bazin puts "pour autrui" in quotation marks no doubt to signal his indebtedness to a central concept in Sartre's *Being and Nothingness* (*L'Etre et le néant*, 1943).

6. [French editor's note] "Gli italiani si voltano," one of the episodes, signed by Alberto Lattuada, of the omnibus film *Amore in città* (*Love in the City*, 1953).

7. Bazin cleverly incorporates the title of Vigo's city symphony, *À propos de Nice,* in making this aside about the name of that city's most famous street, known for its abundance of British tourists.

8. While proposing this *Journal de M. Ripois* ("Making of…"), Bazin continues to play with the comparison to *Journal d'un curé de campagne.*

9. Bazin's condensed metaphor involves an idiomatic expression "Paté d'alouette et de cheval," in which vastly unequal amounts (1 horse, 1 lark) are used in a recipe but then go unnoticed. In this case, regardless of whether English is the horse or the lark (depending on which version is exhibited), both languages contribute to make the film taste the same, since the ingredients are flipped in the same proportions.

10. *Stazione Termini* (Vittorio De Sica, 1953) was released in the United States in 1954 as *Indiscretion of an American Wife,* after producer David O. Selznick trimmed its neorealist social observations to focus exclusively on the scandalous erotic affair. See "What is neorealism?," Kogonada's well-known 2013 video essay, maintained online by the British Film Institute.

11. In French, "Exercise de style" repeats the title of the well-known and exquisitely clever 1947 literary work by the film's scriptwriter, Raymond Queneau.

14. Stendhal's *Mina de Vanghel*, Captured beyond Fidelity

Last year, right around this time, I wrote that French cinema had nothing to be proud of when it came to its young directors. An Yves Ciampi, a Henri Verneuil, a Guy Lefranc, all those first assistants now given full control of a film, turned out to be concerned above all with cunningly adapting the recipes learned from the most commercial among their elders, from Berthomieu to Christian-Jaque. We would have looked in vain in such fare for some aesthetic restlessness, some awkward fervor, some echo of admiration for the masters of cinema, living or dead. Ah! They lost no sleep over Murnau's "cinematic space," nor did "the Renoir *découpage*" keep them from signing any contracts! The angelic stubbornness, the persistent and distracted patience of a Robert Bresson were certainly not their way. Their very first films already concealed all the concessions, all the subterfuges of their success, dexterous but shoddy. What to expect from this generation other than a confirmation of all that is most detestable in a certain French cinema "of quality."

At long last, here are two films and two young people worthy of the art they exemplify with fervor and intelligence. I will let Doniol-Valcroze tell you about Alexandre Astruc's *Le Rideau cramoisi* (*The Crimson Curtain*), which he admires as much as I do.[1] Maurice Clavel (assisted by Maurice Barry) adapted and directed Stendhal's little-known novella, "Mina de Vanghel." He did so with a brilliant and penetrating intelligence, rejecting even the most justifiable shortcuts.

What I want to say of this adaptation is that in a way it places itself beyond fidelity. Let's be clear. It is a commonplace to recognize a filmmaker's right to take liberties with the literary work that has provided him a scenario, so long as he puts them to good use: Carné with *Le Quai des brumes*, Renoir with *La Bête humaine* or *Partie de campagne*. Before them, Murnau, shooting *Tartuffe* and *Faust*, only retained from the originals the myth of their characters. Tartuffe became a monstrous staging of the lie.

With the exception of special cases justified by the director's personality, it does seem, however, that the era of free adaptation is a thing of the past. In the last decade or so, literary fidelity has become a cinematic value. For various reasons having to do with the evolution of cinema itself, *translation* has shown itself to be a positive attainment, the most creative form of adaptation. Jean Aurenche and Pierre Bost are the two most illustrious representatives of that tendency, which culminated with *La Symphonie pastorale* and *Le Diable au corps*. Essentially their work consisted of translating the novel's narrative into spoken scenes. The film tended to be the display of the action told by the novel. But [Jean-Pierre] Melville was already opposing this concept in his *Le Silence de la mer*, which profoundly changed the notion of fidelity by preserving the original text. Lastly, in his *Journal d'un curé de campagne*, Robert Bresson was establishing scrupulous respect for Bernanos' text along with his own scholarly pleonasm of the image, as the very principle of the cinematic recreation of the novel.[2]

In *Mina de Vanghel*, Maurice Clavel seems in turn to partially revisit the problem of adaptation by restoring the director's broad liberty, but a liberty regained beyond fidelity and that

incorporates it. If the film features significant differences vis-à-vis the novella, it is certainly not because Clavel asked Stendhal only for the starting point of his screenplay, what the film credits call "an idea." So those opening credits begin proudly with *"Mina de Vanghel* by Stendhal." An adapter's job is not to "extract" a story or an action from the literary work, no matter how faithful it might be to the events and characters, but rather to replace the original with a total equivalent, a new aesthetic microcosm in which the action proper and even the protagonists' psychology enter only in an almost secondary role in the same way as do the clouds, the sounds of men or animals, or the appearance of things—as the coordinates of a metaphysics.

Some might say that any adaptation worthy of the name also presumes more than a linear description of an action, an organization of a system of references giving the plot twists their moral dimensions. Yet it is precisely from the dramatic and psychological skeleton of the events and the characters that this anatomy is constructed. Here, by contrast, the mise en scène doesn't go from simple to composite. From the start, it is offered as the total complex of an aesthetic reality; it is only given to us as a synthesis. If the action follows from this, it does so only virtually, and only if we want to distill it through an intellectual operation of analysis. Clavel never started from "what happens" in the novella, but rather directly from the metaphysical structures of the novelistic universe into which these heroes are inserted. His adaptation does not concern itself, for instance, with reducing several episodes into one, retaining some characters or inventing others. If it does, this is incidental. But at its core, his adaptation is the creation of a romantic necessity, the construction of a world such as the heroes see and live it.

Whence a mise en scène arranged entirely in a thickened perspective where the shots are superposed like the pages of a book printed on transparent material that must be deciphered without turning them. Signs hide and reveal themselves in the screen's fictive density. Events don't take place on the screen so much as explode on it like a storm when the distribution of electric charges dictates.

But to get to that point, Clavel had to give himself over to paradoxical work. Repositioning itself, so to speak, at the source of the literary or cinematic creation, his adaptation bore on Stendhal's text itself. Here he had not merely to transform this episode or that character, eliminate this or that plot twist. Because his mise en scène is predicated on the constant and rigorous cross referral of image and text, the text itself could no longer avoid adaptation. It is Stendhal speaking on the soundtrack, though the text isn't one he ever wrote. For this universe where everything fits, Stendhal would have had to write "Mina de Vanghel" differently. Clavel did it for him, with tranquil audacity. What is left of Stendhal's story? Almost nothing. By which I mean: everything.

Au-delà de la fidélité; *Mina de Vanghel*
L'Observateur, no. 149, March 12, 1953
Écrits complets, 1272

NOTES

1. *Le Rideau cramoisi* and *Mina de Vanghel*, each forty-five-minutes long, were distributed as a pair under the title *Les Crimes de l'amour* (*Two Love Crimes*). Bazin and Jacques Doniol-Valcroze, sharing the film criticism duty at *L'Observateur*, decided to split the job of reviewing this two-part film.

2. The actors in *Le Silence de la mer* (1949) are seldom heard; instead, during much of the film, the text of the book is spoken in voice-over, principally by one character, as we see the scenes described. Bresson took this process a step further, multiplying the registers by showing the *curé* literally writing in a "journal" a text that he delivers in voice-over, straight from the Bernanos novel, and which is supplemented, almost illustrated, as in a pleonasm, by the images Bresson staged and shot.

15. *Mina de Vanghel:* More Stendhalian
than Stendhal

Mina de Vanghel raises and resolves the problem of literary adaptation to the screen in surprising ways.

Let's say it right away and unambiguously: Maurice Clavel took such liberties with the narrative that, unless we referred to the original novella, we would never have suspected the film's authority, its stylistic confidence, and the importance of the text. We have often seen directors retain nothing from a work except a pretext or a theme, transposing plots and characters from one period and place to another. Renoir did this in *Les Bas-fonds* (*The Lower Depths*), and is about to do it again in *Premier amour* after having taken Mérimée for a ride.[1] But the extraordinary weave of fidelity and transposition that make up the fabric of Clavel's film is certainly unprecedented. We get some idea of this, knowing that Michel Bouquet's spoken commentary, with its great dramatic and psychological significance, borrows only three or four sentences from the novella. Maurice Clavel rewrote an imaginary text by Stendhal that is more Stendhalian than the real thing; not even the most astute mind could discern the original fragments in it. But not in an updated style: rather, it was written as if Stendhal were Clavel's scriptwriter. A devilish skill that frees the director by securing him the fidelity ... of the writer—a freedom not given to everyone, of course, and we would find it hard to imagine anyone other than Maurice Clavel who could make use of its advantages.

The film only retains the novella's general theme and the plot's main thread—Mina's disguise as a servant to seduce Mad-

ame de Larçay's husband—while sidestepping practically all the plot's twists and replacing them with others, entirely invented. As for the characters, almost all are profoundly transformed. In Stendhal's description, Madame de Larçay is intelligent and beautiful, but her role remains passive; she is nothing except the wife of M. de Larçay, whom—Mina briefly dreams—he will divorce. The jealousy, and, though much less, the vengeance and challenge ("I will eclipse that woman!") that Clavel establishes from the film's outset and that tracks Mina's amorous conquest are practically absent in Stendhal. In the novel the ignoble Ruppert agrees to serve Mina's awful machination against her rival, but in the film a strange moral flirtation makes him instead, against his better interest, an ally of Madame de Larçay. Nor is Mr. de Larçay a simple, upright, good, courageous fellow whose love for his wife is the only measure of his passion for Mina. He is fundamentally a not very romantic being, who will return to his wife like a good bourgeois, wearied of a too compromising adventure, having rather odiously used the machinations through which Mina lost herself in order to conquer him. After all, Stendhal's Mina is, at least at the beginning, more novelistic than romantic; her disguise is initially just a means of living in the shadow of the man whom she has decided to love. Only step by step does the deceit turn into a machination, and Mina, caught in her own trap, and—granted—too romantic to ever back down, will end up losing herself.

The many disturbances in the economy of Stendhal's story are not gratuitous. We could, of course, argue that they are not strictly necessary to the film's logic. Clavel did effectively eliminate almost all dramatic development, pushing from the very start the relationships among his characters to their paroxysm: Mina's romantic love, her jealousy, her decision to win by telling

the most impudent of lies—all contain from the beginning the seed of the events, none of which could truly surprise us. Essentially, nothing is created; everything just becomes more explicit until the heroine's inevitable death. But this reconstruction of the narrative is justified as a whole if we accept that Clavel has sacrificed Stendhal to Mina and, in Mina, the novelistic to romanticism. In other words, the adaptation arises strictly not from the plot but from a vision of this Stendhalian microcosm through the main element of its components: German romanticism. I like to imagine that in future classes, Maurice Clavel's film will teach more in forty-five minutes about this spiritual and literary movement than three months of textual analyses. What's more, *Le Rideau cramoisi*[2] would be on hand for a comparison with French romanticism.

Literary adaptation for the screen ordinarily tends toward simplification (when it doesn't tend toward the facile). Granted, a novel says more than the screen is capable of translating in the time frame of a movie. For the conscientious adapter, the problem is pruning without betraying; requiring at the very least that the narrative be winnowed, to detach its psychological, moral, and metaphysical moorings, to reduce it to a clear, simple, dramatic plot. Crafty adapters add a bit of rhetoric, a certain tone that may be somewhat analogous to a minor quality in the original, just to give critics a reason to decide that the author was capable of translating the style by adapting the story to the requirements of the screen. That leads to Mr. Christian-Jaque's *La Chartreuse de Parme* or Henri Decoin's *Les Amants de Tolède*, of which Étienne Lalou declares with lovely simplicity that "it gives full justice to the deep spirit of the 'Spanish adventure' entitled *Le Coffre et le revenant*, from which it draws quite freely."[3] God knows that Henri Decoin took fewer obvious liberties with

Stendhal than did Clavel; the latter's liberty consisted precisely in abandoning everything that Decoin kept, in disdaining plot turns in order to devote himself to enriching the work's most intimate substance through intellectual crystallization, to lend its literary content greater density. A paradoxical process, this, and whether or not the film might have suffered in some way from it is, of course, uncertain. At least none of the possible criticisms imply that the film adopts easy solutions.

There can be no real argument that the ninety minutes of a commercial film correspond better to the dimensions of a novella—let's say a fifty-page story—than to a novel. But *Mina de Vanghel* is not a real novella. It is only by accident that its material is contained in about sixty pages; as is often the case in Stendhal, it is merely an unevenly summarized novel. If it would have been hard to say everything in an hour and a half, it was a priori about four times harder in forty-five minutes. But rather than simplify, Clavel enhanced the original even further, made the characters and their relationships even more complex, and put himself in a position to say far more in forty-five minutes than it would have been reasonable to ask of a feature-length film.

I will not claim that this situation is the direct cause of the bias Clavel adopts with regard to mise en scène. Nor is he an author to settle for such immediate justification, and I can see a relationship between his *découpage* and an existential vision of the events compatible with that of German romanticism. But a fact of mise en scène must satisfy several demands at once, the most obvious being that Clavel could only say so many things by lining them up in multiple planes or, so to speak, layers. In place of what at first appears to be the linearity of Stendhal's narrative, Clavel had to substitute a series of "scenes" constructed in relation to references with several meanings. That said, the term

"scenes" isn't adequate for these cinematic blocks in which reality reveals its meaning through a series of internal refractions and reflections. The influence of Orson Welles seems fairly obvious to me here, especially the Orson Welles of *Ambersons*. But if Clavel is indebted to him for this synthetic conception of narrative where abstraction is born of the simultaneous confrontation of the greatest number of realities a shot can contain, or, if you will, from accidental events, he does not exactly draw the same consequences. In Welles, spectacular realism is the principle determining the depth of field and the sequence shot.[4] Realism here is just one element of the mise en scène, its cement, the invisible glue holding together the complex play of prisms and lenses through which the author's ideas travel. Hence, the dialogue spoken in German, of which there naturally is no trace in Stendhal, and which wouldn't have been required even for the film's historical verisimilitude. To describe this mise en scène requires explaining that it is analytical only in the third dimension, in the sense of a perpendicular slice of the screen—in other words, along the axis of our attention. There, elements superpose themselves in perspective. Thereby, perhaps, reconciling two contradictory demands in Stendhal's style, which only appears to be analytical. For Stendhal sets facts in a linear succession, readily giving the illusion of an analysis—yet in reality the succession is merely descriptive and not causal, since its logical and psychological discontinuity is precisely the equivalent of the realism of a *découpage* that superposes the facts. On screen, the book is presented on its fore edge.[5]

In Welles, again, the realism of the sequence shot required an even more abstract narrative technique in order to translate duration. The imperfect tense, the frequentative form, are expressed in *Citizen Kane* by a succession of superimpositions.

Having rejected the narrative, its splendors and peripeties, Clavel did not need to seek a symbolism for temporal duration. And yet in *Mina de Vanghel* we find, between the "dramatic" sequences, certain images of transition—say, shots of clouds or water—yet these don't ever translate the passage of time, just the meaning of events we aren't shown: their metaphysics.

Should we nevertheless unreservedly praise Maurice Clavel for his decision to construct his adaptation and mise en scène on what others naturally ignored, which is to say, on what is essential, at the cost of the peripeties whose importance is certainly only secondary but from which Stendhal, after all, didn't abstain? If almost all adaptation presupposes sacrifices, it is certainly better to sacrifice that which is superfluous. He should beware, however, of the facility with which an author like him can challenge facility. It is good—indeed, comforting—to see a young director posit the problems of adaptation as of his very first film, and in the most demanding and austere terms. But we should be concerned about the excess in Clavel of what in others we deplore to be lacking. I was about to say that he has too much respect for the cinema. But let's be clear: for him the real development will be to integrate what he also disdains or fears, and to be just as capable of excelling at that. In *Cinémonde* he wrote, "After a first adaptation I had to get rid of a whole machination of the *Dangerous liaisons* variety, one of these psycho-dramatic clockworks that make us imagine when reading it that 'the film is already there.'" Yet doubtless the most difficult solution was to be faithful to the letter *and* to the spirit. Clavel preferred to serve the spirit (by rewriting what is, after all, an apocryphal text) rather than risk its betrayal by respecting appearances. We would only think of congratulating him on this had he not at the same time proved that we can expect of him even more: this total creative liberty

that is the prerogative of the best, and where fidelity to the letter of the work may also take the most paradoxical form.

Mina ... Trop Beyle: *Mina de Vanghel*
Cahiers du cinéma, no. 21, March 1953
Écrits complets, 1258

NOTES

1. *Premier amour* refers to a 1953 draft of a film project by Jean Renoir that was never made. Like *Les Bas-fonds*, it would have transposed a literary classic (Turgenev, this time) from the original Russian setting to France. The phrase "take Mérimée for a ride" alludes to Renoir's *Le Carrosse d'or (The Golden Coach*, 1953), based on Prosper Mérimée's novel *Le Carrosse du Saint Sacrement*, which Renoir relocated to Peru.

2. Alexandre Astruc's first film, *Le Rideau cramoisi (The Crimson Curtain)* is a forty-five-minute adaptation of a nineteenth-century romantic novella by Jules Barbey d'Aurevilly. It was paired with *Mina de Vanghel* and released in 1953 by Anatole Dauman's Argos films as *Les Deux Crimes de l'amour (Two Love Crimes)*.

3. Both films mentioned here are adaptations from Stendhal. For *La Chartreuse de Parme* (1948), see Bazin's critique, chap. 49. *Les Amants de Tolède (The Lovers of Toledo)*, which had just come out in February 1953, was taken from "Le Coffre et le revenant," a short story Stendhal composed in the same year he wrote "Mina de Vanghel." Two weeks earlier, Bazin subjected Decoin's adaptation to a merciless attack.

4. Bazin is known as the critic who most forcefully established "plan-sequence" (sequence shot) as a term to describe scenes that a director covers in a single long take; he did so pointedly in his short book *Orson Welles* (Paris: Chavane, 1950), 54.

5. [Translators' note] A book's fore edge is any exposed side of the volume, most commonly the one opposite the spine. When closed, the pages offer a surface on which designs could be inscribed. The practice dates back to the tenth century, but became more common between the late eighteenth and late nineteenth centuries, with landscape motifs as special favorites.

Adapting Contemporary Fiction

Until recently, and with some justification, film scholars in the English-speaking world deemed the study of adaptation to be a largely dispensable appendage dragging down more urgent issues in the field. It was considered conservative and academic, a low-energy repository of mainly case studies by literature professors exercising their enthusiasm for the movies. Bazin's case is entirely different, however, and not just because France fostered more sophisticated reflections. The fact is that he could not imagine addressing the question "What is Cinema?" without asking about, and delving into, adaptation. For here he could sense a new art form taking shape in relation to the system of the arts. Here he could distinguish both its aesthetic and its social possibilities.

Part Two displays the results of Bazin's vigilance as a workaday critic. Even had he not been disposed to adaptation as a topic, he could scarcely have avoided it, since the Liberation saw the screens of Paris immediately colonized by Hollywood's vast output, a large slice of which came from novels whose titles or authors preadvertised them. Bazin could feel that cinema was maturing by close contact with the most exciting fiction of the day. And so he often measured how tightly films adhered to their sources. One principle recurs: by adjusting or abandoning its habits in an effort to be worthy of the style of a significant novel—particularly a current one—the younger medium was adding to its muscle and agility.

This is the conclusion of his early article on *The Human Comedy* that opens this part, though Bazin doesn't reach that conclusion straightaway. He first excoriates American cinema for its pernicious ideology. Only in paragraph three does William Saroyan, the famous writer, arrive on the scene. Coming from outside Hollywood, Saroyan's worldview can be taken as more sincere than Hollywood's blithe ideology, even if it accords rather conveniently with it. But how can a director who comes from within the industry deliver a cinematic equivalent of the Saroyan sensibility? In this piece and even more incisively in the following one on *The Lost Weekend,* Bazin saluted the maturity of Hollywood in forgoing displays of technical prowess, as it trusted instead the resourcefulness of directors Clarence Brown and Billy Wilder, who slyly matched, even exceeded, the particular expressiveness of the novels they adapted. Both these films exhibit the largely matter-of-fact style of much interwar American fiction, like that of Hemingway. And, as this section shows, Hemingway was unavoidable, both for the cinema and for Bazin, who returned to him as the occasion offered, thirty times in all. Graham Greene was another cinematic novelist he keenly followed, as Greene was Catholic and had been a film critic himself. Dividing his writings into serious novels and what he called "entertainments," Greene showed in *The Third Man* that he understood what a writer might do in cinema, telling Bazin that this would be the best adaptation of his work. But *The Third Man* wasn't really an adaptation, and for that reason Bazin's review, brief but rapturous, is not included here. Still, its creators, Carol Reed and Orson Welles, not just Greene, exhibited a literary instinct that Bazin believed could improve the cinema of his time. All three aimed to produce popular, "best seller" films that nevertheless were rich in moral and philosoph-

ical resonance, just like demanding fiction. They believed that in both art forms style was the only way to achieve anything distinguished. Reed carried this creed into his adaptation of *Outcast of the Islands,* a novel by Joseph Conrad, whom Greene and Welles both claimed as a forebear.

Far less subject to censorship than cinema, tacitly permitted to ignore or attack social norms, literature widened cinema's repertoire during its most conservative period. Scandalous works like *Lady Chatterley's Lover* or *Tobacco Road,* when brought to the screen, even in mercilessly expurgated form, could claw through the genteel veneer of middle-brow culture. The corrosiveness of so much twentieth-century fiction goaded many screenwriters, indirectly spurring them to take risks in psychological portrayal or social critique. Reviewing Henri-Georges Clouzot's *Les Espions,* Bazin could only think of Kafka, though the film's source came from a different Czech author altogether. Never mind that; for Bazin believed that Kafka had been lurking about, just waiting to find expression on the screen, even uncredited as in this case. While *Les Espions* failed to deliver a truly Kafkaesque universe, perhaps it, or Bazin's review, contributed five years later to Welles' *The Trial.*

Part Two concludes with French cinema's attempts to keep up with its own national literature. Bazin sensed a shift right after the war toward more mature adaptations when well-received films of André Gide's *La Symphonie pastorale* and Raymond Radiguet's *Le Diable au corps* led to Robert Bresson's austere version of Georges Bernanos' *Journal d'un curé de campagne.* That film memorialized a great writer who had just died, as did Marc Allégret's 1951 documentary on Gide, his lifelong friend. And Colette was buried shortly before her scandalous novel of young love, *Le Blé en herbe,* finally made it to the screen after

thirty years. Bazin contributed to keeping these authors vibrant by detailing what they offered cineastes. He also had his ears open for new voices producers were banking on, most of whom, such as François Boyer (*Jeux interdits [Forbidden Games]*) and Louise de Vilmorin (*Madam de ...* and *Julietta*) proved thinner than hoped for. But two female novelists emerged in the fifties, Marguerite Duras and Françoise Sagan, who, with diametrically divergent styles, spoke to him and thousands of other readers eager to see their fiction on screen. The year he passed away, Bazin reviewed the first adaptations of their work. If only he had lived another few months to react to *Hiroshima mon amour*! He would doubtless have seen it as the creation of a new being, the novelist-filmmaker, something he had predicted and hoped would arrive to advance the evolution not just of cinema, but of literature and culture.

A. Best Sellers from Abroad

16. On William Saroyan's
The Human Comedy

I hope the reader will forgive me for the paragraph in my last article where I quite rashly prejudged the quality of the American films that were going to be unfurled on our screens.[1] This was an underestimation of the commercial wisdom of those responsible for their distribution. The [French] public was politely notified, thanks to the efforts of the offices in charge, that, given France's mental condition after its recent emotions, the films of John Ford, William Wyler, King Vidor, Preston Sturges, and Charlie Chaplin were going to be made available to it only at some point in the future. No *Gone with The Wind*, no *Rebecca; Of Mice and Men* is too dark a story and *The Grapes of Wrath* would make us gnash our teeth. Instead, we were going to be provided some nice little cheerful and sentimental comedies ... plus, of course, a few war and propaganda films. We aren't unaware of the economic problems currently posed by uncertain distribution channels and limited access to electricity. We understand that it wouldn't make good commercial sense in the still unrecovered French market to squander titles whose highest earnings are only expected later, but this can't prevent us from being disappointed while waiting, or from deceiving ourselves about the true reasons for these stalling tactics. That said, let's nonetheless talk about what we have seen on the screens of the boulevard cinemas: a lot of war films; documentaries, whether pure or fictionalized (that give us no respite from our emotions); a few sentimental comedies of the classical sort, some of which are good, like *It Started with Eve*, but more often bad,

like *My Sister Eileen* or *Mr. & Mrs. Smith*; and, above all, propaganda comedies for an America at war. For what characterizes recent Hollywood production seems to us to lie in its tremendous mobilization of psychology. The pragmatic genius of the Americans has naturally put cinema to use as a powerful didactic and public relations tool. Ultimately, this is more a matter of public relations than of propaganda, insofar as PR is the liberal form of political persuasion. It consists of orienting, with no material constraints, an individual's entire intellectual, moral, and sentimental life. Its aim is less to trample wills than to create habits, to generate beliefs perceived as being freely chosen. If the outcomes are the same, the means for reaching them derive, in fact, from two very different social psychologies.

Pedagogy and PR—these are American propaganda's two teats. This fact is, of course, not really new. The most informed among critics have been pointing out for quite some time that American films defend a certain social order, are a disguised apology for a system that is not only economic but also political and, indeed, moral and religious. We know specifically that some of Hollywood's finest comedies are not altogether strangers to internal American politics—thus, for instance, *Mr. Deeds Goes to Town*, about which it is worth knowing that it served President Roosevelt's agricultural policy at a particular moment. And it could even be that it was precisely when the producers or directors weren't consciously aiming for propaganda or pedagogy that they produced its best examples. American cinema as a whole reflects profoundly the civilization whose fundamental art it is. Where historical criticism comes to a halt, social psychoanalysis may still have a lot more to say. Yet this constant tendency, which, in fact, bears witness to a cinema's vitality, remained incomplete, unacknowledged, and occasionally con-

tradictory, as demonstrated by the struggle against censorship. Never before had American cinema experienced such a powerful spiritual mobilization on behalf of a war to wage and win.

An enormous number of didactic films intended for civilian as well as for military use was produced these last three years under specific directions of the official psychology and propaganda services. They address all possible topics, from the black market for cigarettes in France (a factor in the devaluation of the dollar) to military strategy by way of instructions for food safety. Walt Disney's Donald Duck explains to Detroit's steelworkers why they have to pay their taxes. The current American cinema should be understood as an enormous undertaking of civic publicity, of which Hollywood is merely the principal commercial branch. Not all film production is devoted to propaganda, of course, and some of the major productions avoid it, we are told, but of the dozen or so works we have seen thus far,[2] the one we find most interesting, may still be a propaganda film—monstrous and seductive, unacceptable and irritating—yet one we would nonetheless like to see a second time.

The Human Comedy was directed by a major *metteur en scène*, Clarence Brown, from a screenplay and dialogue written by a major novelist, Saroyan. Among its stars is Mickey Rooney. These names deserve some consideration a priori, and Saroyan, in particular, being the first American writer whose work we will have seen on film.

Let's state right off that, however important the director's role was here, this film bears unquestionably the signature of the writer.

It is no easy task to recount this nonexistent story. But in itself this absence already offers an entry into Saroyan's aesthetic universe, letting us rediscover the technique he uses in his novels and in his two plays: characters, no plot, and yet action.

From the heavens, a voice speaks to us: "I died two years ago and yet I live on in those who haven't forgotten me, I live on in my children, in the youngest whose name is Homer." And that is how we are introduced to the life of a small-town American family. The father is dead, the eldest son is a soldier, the youngest splits his time between school and a job at the telegraph office. The two daughters are pretty, well-behaved, and good house-keepers; the youngest brother contents himself with living and looking at things, animals, people. He has freckles and remark-able blue eyes. We won't be able to forget this kid when we reread Saroyan. In the post office, there is also the old, drunken, likable telegraph operator and a young quarterback who enlists in the Marines the day after his wedding. At school, the teacher is an elderly spinster, very strict and very exacting, but ultimately very kind, who knows when to choose the spirit over the letter of the law. The pupils are pleasant brats who set out after school to try stealing some apricots while an indulgent and understanding farmer looks on. There's also a town librarian, soldiers on leave, a guy who plays saxophone, a black man who sings on a passing train, and the shadow of the dad who once in a while descends from the Elysian Fields to explain things to us. All these people live before our eyes, live and talk. The characters are all good; their defects, which are mutable, are simply a sympathetic verso or an imprint of their deeper qualities. They split into two cate-gories: those who explain to the others how to live, and those who listen with gratitude and benefit from the lessons. Life itself, for that matter, is a perpetual lesson about things, sometimes reaching the level of an elementary school vocabulary lesson, as when the little boy learns what it means to be afraid: ("I am afraid," "I am afraid").[3] Not a single one of the film's images does not contain a symbol; not one word does not seek to teach the

viewer what to think about God, death, love, family, culture, art, work, politics, and the war, so as to be a decent person and experience happiness by fulfilling all duties incumbent upon a citizen of the free American democracy.

The paradox of this film is that, brought to such a systematic degree of precision, propaganda achieves a kind of poetry: each lesson is understood individually, divided carefully, like a sermon, so that nothing is misunderstood, and this naïve didacticism irritates for a long while until, little by little, through repetition, it weakens our defenses and makes a mockery of our criticism by confirming it. What is the point of calling out something that quite clearly makes no effort to hide itself? And even though we are constantly aware of it, these many symbols end up organizing themselves into a familiar mythology;[4] the sermons soothe us like a song that might well be that of a civilization. From this jolly and athletic puritanism, this morality tempered by ordinary America's humor, emerges an enveloping and gentle wisdom, brave yet resigned at one and the same time.

Certainly, however, this pedagogy wouldn't have reached the level of an incantation had the director's art not succeeded in inserting it into a style. In his first article for *Les Lettres françaises,* Roger Leenhardt wrote that the novelist was on the way to becoming the real star of American cinema. This may be something of an exaggeration or, at the very least, a somewhat premature judgment. Let's wait to see the films shot from screenplays written by Faulkner, Caldwell, and Steinbeck, as the reality is likely to be less organized, with results ultimately depending on the quality of the director and on the nature of his collaboration with the writer. But what *The Human Comedy* lets us already glimpse is a clear concern for the mise en scène to adapt itself to the writer's style and worldview.

Until now, the fidelity of an adaptation (when it was of any concern at all) was generally limited to the plot and the characters' psychology. At the very most, it extended to what is conventionally referred to as "atmosphere." Fidelity tends to penetrate even further today, it seems, going so far as to give us a complete equivalent, in its form and substance, of the written novel. This was an entirely natural development from a sociological perspective. Roger Caillois[5] perceived it very clearly when he pointed out that cinema is something of a functional relay of the novel. But it's interesting to point to the relatively recent shift from a simple sociological equivalence[6] to a specifically artistic one. In a film like William Wyler's *Jezebel* (1938), currently in rerun in neighborhood movie theaters, we can already observe the construction by chapter, the skilled erasure of an entire style in the service of a typically novelistic psychological analysis, and above all an aesthetic duration very clearly related to that of the novel (rather than to the short story, as is the case with most films). But the book from which this film was drawn raised hardly any technical problems. We know, by contrast, how important these problems were for modern American writers. To get beyond this final stage, it was perhaps necessary that the specifically cinematic technique should achieve the tremendous impersonal flexibility toward which the Americans definitively seem to be pushing it. Surely it was only this a priori absence of style that could have made the novel's spirit and form completely available. Whatever the case, Clarence Brown's art wasn't applied here only so that the *découpage* would retain Saroyan's descriptive impressionism; in his selection and enhancement of the actors, and through the plasticity of his cinematography, he was also able to recreate the novelist's aesthetic universe.

This powerful skill is not alien to the film's effectiveness as a piece of propaganda, provided we are able to intellectually dissociate the heavy-handed didacticism from the poetry of images and of situations. This analysis does not hold up, however; the thesis is too intimately embedded in poetry, which can only shine upon it. We cannot rid our mind of the ideas, given how much the images obsess us. If it were possible to doubt Saroyan's sincerity (something I would prefer not to adjudicate), we would have on our hands one of the cleverest swindles of beauty provided to us in a cinematic example.

À propos de *Human Comedy*
Poésie 45, no. 23, February–March 1945
Écrits complets, 43

NOTES

1. A reference to "Examen de conscience ou Réflexions pour une veillée d'armes," Bazin's previous contribution to *Poésie* (no. 20, the July–Oct. "Liberation of Paris" issue). At the conclusion of a summary of French cinema's position at the outset of the Liberation, Bazin warns that at the current historic moment, because the French industry cannot turn out any films due to the lack of electricity, "We cannot stand up against the gust of grandeur, violence, hate, tenderness and hope that will sweep over us with the American cinema." This article was translated by Stanley Hochman as "Reflections for a Vigil of Arms" in *French Cinema of the Occupation and Resistance* (NY: Frederick Ungar Publishing, 1981), 95–100. Bazin now says that Hollywood has not, in fact, overwhelmed France with strong emotions, ironically congratulating this marketing plan which must withhold until later its strongest films, as if the French public, emotionally exhausted by its grim struggle to defeat the Nazis and to bring collaborators to justice, weren't up to coping with these.

2. [Bazin's note] This article was written before the screening of a series of remarkable propaganda films by Frank Capra, *Why We Fight*.

3. [Translators' note] The quote is given in English.

4. [Bazin's note] It's no accident that the city is called Ithaca and that the boys are named Ulysses and Homer. It would also be worth analyzing especially the myth of paradise or, if we want, the Elysian Fields in American mythology. For a people at war, the problem of individual survival is naturally primordial.

5. [French editor's note] *Sociology of the novel.* Bazin obviously has in mind Roger Caillois, *Puissances du roman* (*Powers of the Novel*) (Paris and Marseille: Éditions du Sagittaire, 1942).

6. [Bazin's note] In the circulation and genesis of myths, for example.

17. Billy Wilder, *The Lost Weekend*

The Lost Weekend arrived from America preceded by a glowing reputation. Frankly speaking, the fact that the film picked up four Oscars (the awards given by the Academy of Motion Picture Arts and Sciences) didn't seem to us to be proof of very much: we know from experience that these awards are often bestowed more for commercial than for aesthetic values. This time, however, we were proven wrong: *The Lost Weekend* absolutely warranted being named the best film of 1945. Ray Milland, Charles Brackett, and Billy Wilder were certainly worthy of their awards for best male actor, best cinematic adaptation, and best director, respectively.

Alcoholism has its precedents in cinema, not to mention literature. Zecca understood well the dramatic potential of the "evils of alcoholism."[1] A drunk is as popular a character in a social tragicomedy as a cuckold. Just as we laugh at the husband's woes, so we generally prefer to laugh at the woes of drink, especially when the two happen to coincide, as in the famous monologue of the plastered Raimu in *La Femme du boulanger* (*The Baker's Wife*).

The Lost Weekend does something new by taking this thing seriously, tragically almost. We don't feel like laughing at this Don Birnam, a young writer potentially full of promise, slowly destroyed by his passion for whiskey despite the patient efforts of his younger brother and his fiancée. The hero of this adventure remains sufficiently aware, retaining enough moral and artistic sense to take the measure of his downfall. His cowardice

in front of alcohol, which one night lands him in the hospital; pushes him to pay with a kiss the few dollars he has begged from a bar floozy; and try and filch the purse of the woman sitting beside him at the bar, then later take his fiancée's fur coat to pawn it, does not succeed in making him an irredeemable scoundrel. Don Birnam retains some sort of aristocratic seduction that demands our sympathy and pity.[2] The role's difficulty lies in the subtle ambiguity of the character Ray Milland so admirably embodies. It is rare to see this degree of identification between an actor and his character. A Cary Grant, a Gary Cooper in America, a Gabin in France, always more or less absorbs his role. It may be because we don't know Ray Milland too well, but it's impossible to say whether he resembles Don Birnam, or Don Birnam him. On screen for two hours without ever being eclipsed, Ray Milland manages throughout to remain plausible in this role of acrobatic difficulty. The viewer experiences a hallucinatory sense of familiarity with the actor. It wouldn't take much and one would leave the movie theater staggering....

But *The Lost Weekend* is first and foremost a cinematic tour de force, a technical and artistic feat. Billy Wilder obviously sought a challenge in choosing to adapt to the screen a novel of analysis and introspection. Charles Jackson's book, which the film made famous in America and whose French publisher had the clever courtesy to provide a copy to every Parisian critic two weeks ahead of the film's release, is a rather deft work, seemingly as anti-cinematic as possible, and which at the same time contains both clinical observation and interior monologue. The action is completely psychological and coincides exactly with what happens in the hero's head, muscles, nerves, and guts.

As if it were still needed, *The Lost Weekend* gives us the dazzling proof that cinema's power of psychological analysis in no

way lags behind that of literature. It was by superficially and hastily assimilating technique to aesthetics that attempts had been made to link the camera's objectivity to some sort of artistic "behaviorism," thus limiting its psychological possibilities to the—necessarily external—observation of characters' behavior.

I will go even further. Billy Wilder not only managed to save nearly all the book's material: he also enriched it. Everything is there, and more besides. To make us understand what goes on inside his hero without reaching for crude procedures of superimposition or lap dissolves onto imaginary action, the director draws on no other resources than the actor's performance and the camera's point of view, skillfully coordinated. In making tangible certain relationships between the character and the outside world, the camera makes it possible to deduce his feelings much as radar detects the position of an invisible transmitter. So in the brilliant bar scene where Don Birnam swipes his neighbor's handbag to pilfer enough to cover his drinks, no nuance escapes us, from his decision all the way to his shame, at once flippant and despairing.

We blush along with him. However, in this game of reflection through which Billy Wilder succeeds in revealing Don Birnam's feelings to the point of making us experience them ourselves, he has had to make recourse to the set, the objects in the bar, the other customers. The director finds himself needing to reveal the inner world through its echo in the outer world, and that allows him to add the former to the latter. From a psychological study the novel thus evolves into a stunning social document in which New York's physical presence, its streets, its bars, its Jewish pawn shops, its liquor stores and hospital lobbies, is so exact and intense that it makes up a part of the analysis of the character. The glass of liquor, the wet rings it leaves on the counter, the

typewriter, the hundred other objects present in Don Birnam's mind, take on a hallucinatory importance in the film they do not have in the novel.

What next should be discussed is the directing, Billy Wilder's fabled, icy skill of *découpage*. *Double Indemnity* already manifested the Racinian purity of this cinematic language. In *The Lost Weekend*, the style's simplicity achieves the perfection of the invisible.

Given all this, need we add that the Oscar awarded to *The Lost Weekend* for the best American film of the year requires no further commentary?

The Lost Weekend (Le Poison);
Le drame de l'alcool
L'Écran français, no. 86,
February 18, 1947
Écrits complets, 244

NOTES

1. In 1902, Ferdinand Zecca, legendary pioneer of French cinema, made "Victims of Alcohol," a four-minute adaptation of Émile Zola's *L'Assommoir.*

2. [Bazin's note] Truth be told, the screenplay seems a bit lame given its implausible happy ending, which Billy Wilder basically begs us to disbelieve. It wouldn't surprise had the Misters Hays-Johnston been its godfathers! [English editor's note] Bazin refers to Will Hays, the initiator of the censorship guidelines known as the Hays Code, and Eric Johnston, president of the Motion Picture Association of America, 1947–63.

18. Hollywood Can Translate Faulkner, Hemingway, and Caldwell

My low opinion of most American screenplays is equaled only by my enthusiasm for their mise en scène. The myth is finished of a standardized Hollywood, where anonymous technical teams pre-chewed the work of a director who was unable to express himself in his own style. Hollywood's formidable machinery seems finally to have achieved a degree of perfection that frees the artist from the constraints of technology. Today a film director thinks in cinema with a variety and precision of syntax and vocabulary that no longer have anything to envy the medium of writing. Consequently, we see in the credits an ever-growing number of directors whose names are worth noting. I'm not talking only about an Orson Welles or a Preston Sturges who, having figured out how to write their own scripts, escape our broad condemnation of American screenplays, but also about a Billy Wilder, an Alfred Hitchcock, an Otto Preminger, a Clifford Odets, and even a Robert Siodmak or George Stevens who, we had thought, were doomed only to generic productions. Alongside the five or six older greats (Ford, Capra, Wyler, etc.), there are about fifteen names we must know today to orient ourselves in Hollywood's production. With respect to their subject matter, the films shown in Cannes were disappointing overall (with the exception of *The Lost Weekend* and *Wonder Man*), but we could not blame them as being formally monotonous. Their styles were certainly as different as those of a half dozen novels by strong personalities.

Furthermore, if we consider the increasing influence of the book on American film production, the growing number of

adaptations of novels, and the almost complete disappearance of original screenplays, we come to this conclusion: that cinema is in the sociological and aesthetic position of producing for the screen the equivalent of the book. Not that the book is going extinct—on the contrary; it is simply that a novelistic work is now tending naturally to be reduplicated in cinema (and partly in theater as well). Let's take, for example, *Of Mice and Men;* supposing that the film is as good as the novel, is it a play, a book, or a film? I no longer see anything more than an aesthetic trinity, a single work in three arts. Once the cinematic culture of the writer becomes sufficiently broadened, nothing, tomorrow, will in theory prevent the novelist from writing his works at the same time in cinema and in literature, as Malraux did with *L'Espoir.* But there is still something of a (marvelous) amateur awkwardness in *Espoir* the film.[1] Hollywood, by contrast, is able to provide the exact cinematic equivalent of a paragraph by Faulkner, Hemingway, or Caldwell. For the last several years, we have thus been witnessing the puberty of the American cinematic enterprise.

Unfortunately, this young art continues to be protected by a vigilant censorship against the bad company that the other muses dare to frequent. If it does receive permission to read the same stories, it is only after, *ad usum delphini,* any *amour* has been replaced by *tambour.*[2] So we continue to see this major and perfectly constructed art dumbed down into screenplays that it has outgrown. Luckily on occasion it happens that Orson Welles, William Wyler, Preston Sturges, and recently Clifford Odets make cinema speak a language worthy of it—that a screenplay seeks, and finds, its form, rather than a pointlessly original form seeking, without finding, a screenplay suitable for it (as in most of Hitchcock's films, for example). Might we hope that the day

will come when the moral and economic minders, who alone are preserving American cinema in an artificially infantile state, will sufficiently relax their grip? At that point we might, perhaps, witness the birth of a cinematic output worthy in every way of America's literary output.

> Après le Festival de Cannes:
> Hollywood peut traduire Faulkner,
> Hemingway ou Caldwell
> *Le Courrier de l'étudiant,*
> no. 33, November 13, 1946
> *Écrits complets,* 197

NOTES

This is the second part of Bazin's report on the very first Cannes festival (1946) for an education journal. In the first part he had distinguished European entries as realist from American films criticized as "irréaliste," especially in the handling of death, blaming censorship for infantilizing the public.

1. Concerning the proper title of this Malraux work, see Bazin's essay on *Espoir,* chap. 2, unnumbered note.

2. "For the use of the dauphin" is a reference to expurgated classical Latin texts produced for Louis XIV's heir. The bowdlerization in this case eliminated references to love, hence *amour* (i.e., eroticism) replaced by the rhyming *tambour* (i.e., military drum).

19. John Ford, *How Green Was My Valley*

July will have been a month fertile in cinematic emotions. *Citizen Kane, The Little Foxes, Il était une petite fille, Stormy Weather* form an artistic ensemble of a quality we are no longer accustomed to. And now yet another famous film by John Ford joins them.[1]

We have seen only two films since the war by the auteur of *Stagecoach: Drums Along the Mohawk,* an honest commercial film in Technicolor, and *The Long Voyage Home,* unusual as much for the bold social realism of its subject (the life of sailors on a cargo ship carrying munitions) as for a style as "noir" as the story itself.[2] While that film enjoyed little more than a "respectful" success in France, *How Green Was My Valley* seems to me, by contrast, to be slated for a success as popular as it is warranted.

In order to better understand this film, it's good to know that it exemplifies an increasingly widespread tendency in American cinema of adapting grand novels. Directors no longer restrict themselves to borrowing a more or less adapted screenplay from the book; they are intent to furnish a truly cinematic translation of the novel. This explains, moreover, that some films such as *Gone With the Wind* are so significantly extended that they require four hours of projection time. So *How Green Was My Valley* was taken from an English novel by Richard Llewellyn, a hefty tome of some six hundred pages whose great qualities of observation and genuine poetry do not exclude its slightly mawkish sentimentality. The narrative is told in the past tense by the book's hero, describing the hardscrabble life of a family of Welsh

miners. This harsh subject presents men of somewhat old-fashioned behavior, enamored of their village and their jobs—men of a robust and clearly defined psychology. It must have appealed to the auteur of *The Informer.*[3]

John Ford deals with the story in the style of his heyday. His cinematic understanding is beyond admirable. Served by very great actors, Ford really knows how to direct them with magisterial assurance, such that even their smallest gestures convey maximum meaning. No angle of any shot, no framing that is not worthy of a lengthy narrative. John Ford clearly tends toward eloquence, which the austere William Wyler willingly forgoes in *The Little Foxes;* yet even in its bits of bravura, Ford's style retains its magnificent purity.

I will, however, criticize him for having rather exaggerated the novel's sentimentality and simplified the personalities of some characters. Perhaps he was unable to limit to two hours all the material of this little family epic. On several occasions, we get the impression that major pieces of the story were cut or else summarized in an almost symbolic scene.

But these shortcomings do not seriously subtract from the film's abounding beauties.

<div style="text-align: right;">

Le film de la semaine
Le Parisien libéré, no. 612, August 2, 1946
Écrits complets, 143

</div>

NOTES

1. Bazin had indeed just seen and written about the Welles and the Wyler masterpieces for the first time. They became crucial to him. He also had just praised in two separate reviews the Soviet *Zhila-byla devochka* (released as *Il était une petite fille* in France and *Once there was a Girl*

in the United States). He did not review *Stormy Weather*, the 1943 African American revue with Lena Horne and Bill Robinson, but clearly found it a quality production from Twentieth Century Fox.

2. Bazin would soon review two other films Ford made just before *How Green Was My Valley: Tobacco Road* and *The Grapes of Wrath* (likewise from a grand 1939 novel). They were released in France in 1947 and 1948, respectively.

3. Ford adapted *The Informer* in 1935 from a story by Liam O'Flaherty, a prominent Irish Gaelic novelist, who wrote of the hard lives of common people.

20. John Ford, *The Grapes of Wrath*, from Steinbeck

Seven out of ten American films are adaptations of novels, and yet we have seen just about nothing from American literature on our screens, by which I mean nothing of what's essential: style. Only James Cain, an interesting but second-tier writer, found somewhat faithful translators in Billy Wilder for *Double Indemnity* and Michael Curtiz for *Mildred Pierce*, what with Tay Garnett having betrayed *The Postman Always Rings Twice*. If we add Billy Wilder's *The Lost Weekend* and two or three good detective films, we'll have more or less exhausted the list of American novels adequately transcribed for cinema, and we can see that these are no masterpieces. *For Whom the Bell Tolls* will certainly not prove me wrong, although its plot was conscientiously followed by Sam Wood; even John Ford, who just filmed Dudley Nichols' adaptation of *The Fugitive*, based on Graham Greene's *The Power and the Glory*, betrayed the spirit of the book horribly.

Which is why I find the success of *The Grapes of Wrath* to be as unequivocal as it is incomprehensible. The film is not absolutely perfect. Some of the best scenes of the novel have been omitted, yet by and large it is faithful not only to the letter but also to the spirit of the novel.

The film's realism is not noticeably inferior to that of the book, the characters are no less unique or powerful, its social and political message is exactly that of Steinbeck. As for the style, while we might have imagined something different, the choices that have been made surpass all hopes.

What is most surprising, in my view, is not that a producer dared to commission such a damning critique of certain aspects of American capitalism. Contrary to what is normally thought because of a partisan mindset or our general lack of reflection, American cinema is, among national cinemas, far and away the most satirical about the established political order (which, granted, is hardly a model). No, in truth, this defense of the labor strike seems entirely normal to me. What surprises me far more is that the aesthetic resources were up to the project. Were I asked, for example, whether in Hollywood it is easier to make a pro-Stalin film or a film without music, I would answer right off: an apologia for orthodox Communism. Still, evidence must be considered. There is barely any music in *The Grapes of Wrath:* during nine-tenths of the film realistic sound is the only accompaniment. This is a detail, but a significant one. It is as if the authors quite simply did what needed to be done. The truck is a real wreck of a truck, the characters' clothes are real rags that don't seem to have been designed for the occasion, the landscapes aren't "rear projections." The actors are directed properly. We thus have proof that Hollywood technicians are perfectly capable of seeing what needs to be done to adapt a novel accurately. If they don't, it is because a whole jurisprudence of conventions prevents them. From time to time—and we don't really know why—they are left alone to do what they want. Luck? Some smart producer's intervention? Or maybe, quite simply, the fortuitous interference of a series of accidental demands that cancel each other out, leaving these filmmakers free to do what they want.

Whatever the explanation, while *The Grapes of Wrath* may not be John Ford's "best" film, it is certainly his greatest. The only thing needed for it to be counted among the ten or twelve

greatest films of universal cinema is a more rigorous technical *découpage.* The cinematography of Gregg Toland, the cameraman of *Citizen Kane* and *The Best Years of Our Lives,* is by contrast a sheer marvel. Never self-indulgently plastic, it admirably serves the novel's grandiose and quasi-epic realism. With the exception of Tisse, Eisenstein's cameraman, Gregg Toland is, hands down, the world's best cinematographer. It is, in fact, also quite obvious that Gregg Toland was directly influenced by the Russian cinema of 1925–30 (which itself was schooled by Griffith's), so that we can say without being paradoxical that, in its spirit as well as in its aesthetic, *The Grapes of Wrath* is by far the best Russian film we have seen in the last twelve or fifteen years.

Les Raisins de la colère
Esprit, no. 143, February 1948
Écrits complets, 381

21. John Ford, *Tobacco Road*, from Erskine Caldwell

With *The Grapes of Wrath* John Ford had given us evidence that, when necessary, he knew how to be faithful to the style and the spirit of a great American novel. This comparison would surely justify our being even stricter regarding *Tobacco Road*, where Caldwell is less well served than Steinbeck had been.[1] The celebrated novelist's outrageous realism and black humor are here somewhat watered down. It is true that a play whose adaptation already "rearranged" the novel is now wedged between the novel and the film.[2] This unbelievable family of farmers, reduced by destitution to degenerate brutes clinging to their sterile land, would have by dint of Steinbeck's realism reached a kind of comic noir. Ford's film appears to respect rather faithfully the material givens of Caldwell's story, but black humor here becomes simply humor, as in a Capra comedy.

Despite these reservations, the fact remains that, if we are willing to forget the Caldwell factor, the film is not unworthy of its director, and the pleasure we take in it is one cinema rarely provides.

La route au tabac
Le Parisien libéré, no. 1412, March 30, 1949
Écrits complets, 570

NOTES

1. John Ford adapted these two best-selling depression era novels in 1940 and 1941, respectively. Bazin had reviewed *The Grapes of Wrath* a year before. See chap. 20.

2. Jack Kirkland adapted Caldwell's 1932 best seller the following year into a Broadway hit that was still running in 1941 when Nunnally Johnson transformed it into a screenplay for Ford.

22. Theodore Dreiser's *An American Tragedy* becomes *A Place in the Sun*

Black Sun

Theodore Dreiser's famed novel *An American Tragedy* was nearly made into a film by the Soviet filmmaker S. M. Eisenstein during his 1931 trip to Hollywood. Eisenstein's resolutely social vision in this adaptation frightened the producers, and the project was abandoned. The film was later made by Josef von Sternberg, who, contrary to Eisenstein, reduced the story to a purely sentimental affair. Returning now to Dreiser's theme, George Stevens has similarly preferred the drama of passion to the complex, dense social analysis of Dreiser's novel. No doubt the film loses something this way, but it was quite difficult to retain Dreiser's perspective, which, in fact, wasn't altogether eliminated by Georges Stevens. The story we are told is not quite the same, but remains very beautiful and moving and would still warrant the original title, *An American Tragedy*.

George Eastman is a poor nephew in a wealthy business family. Placed in a lowly position in his uncle's factory, he falls in love with Alice, a young worker in the same workshop. Their idyll would no doubt have continued smoothly had not George, singled out by his uncle, risen in the ranks and been introduced into the city's high society, where he meets the rich, pretty heiress, Angela; for both of them, it is love at first sight. True love and great wealth are both within George's grasp. But Alice is pregnant, and after a failed attempt to abort, she demands that George marry her and threatens him with scandal. Panicked and faltering, George concocts the criminal plan of a boat ride with Alice: an accident would take care of everything. But, in

fact, the weak-willed man is quite incapable of such a bold act. Alice does indeed drown but in a genuine accident, but this in no way helps George. Everything points to him; the jury will not accept the coincidence, and he will go to the electric chair. His final consolation will be to keep until the very end, all facts notwithstanding, Angela's enduring love.

The greatness of this script is evident; the dilemma torment-ing the hero has the purity of a tragic situation: whichever way he turns, he is trapped by his passion, social prejudice, and above all his own weakness, which twists the door screws on fate's cage. He could escape only by renouncing happiness, which is precisely what he is incapable of doing. The scriptwriter can be reproached, as we have said, solely for his hesitation about the fundamental cause of George's acts. It could simply be that he loves Angela, but it could also be that through her (as was true for Dreiser) he loves only social success. By wanting to have it both ways, the film loses some of its psychological truth.

Whatever the case, this is one of the most important works of American postwar cinema. We appreciate the remarkable sobri-ety of the mise en scène, which to an untrained viewer will seem classical. In fact, George Stevens is a director of such intelligence that only his honesty makes it so understated. Unfairly ignored, his name is overshadowed by the few endlessly cited greats.

Montgomery Clift and Shelley Winters deliver admirably true and sober performances. That of Elizabeth Taylor is no less so. Add to this her charm, and that may explain the hero's irre-sistible bewitchment.

Une place au soleil; Soleil noir
Le Parisien libéré, no. 2364, April 19, 1952
Écrits complets, 1019

23. D. H. Lawrence, *Lady Chatterley's Lover*

Faithlessly Faithful

It is only too obvious that the scandal of the celebrity of D. H. Lawrence's book has something to do with a producer's decision to choose it. This title is, as they say, worth its weight in gold. Let's give Marc Allégret his due right away, for while the title remains, his mise en scène works from start to finish to disappoint those viewers who would come to see on screen even a small part of what gave the book its equivocal reputation. Which is not to say, however, that the spectacle is harmless: what isn't shown is suggested and if, as we shall see, Lawrence's message was not exactly respected, one certainly cannot say that it was watered down. In the realm of morality, therefore, the problem goes unresolved. But we are happy to note that the reasons for this are entirely honorable.

Let's rehearse the summary: Constance Chatterley is married to a rich, puritanical intellectual, who becomes an invalid. Her experience of love has been altogether disappointing, until she meets the gamekeeper of her castle's forest. He becomes her lover and reveals to her, better even than the pleasures she had never known, their profound impact on the spiritual unity of being. In reacting against puritan sociology, Lawrence constructed in his novel—at once realistic and poetic—something like a mystique of sensuality and, we might almost say, of pan-erotic religion. There is nothing murky or impure, by the way, in this questionable philosophy. But the extreme audacity of the situations and the frankness of their evocation, even draped in metaphors, amply justify the book's salacious reputation.

Under these conditions, bringing such a book to the screen was obviously inconceivable without making a scandalous film, and thereby betraying Lawrence's undisputed intentions (even had they used a mere hundredth of the book's realities). All that remained was the part Allégret adopted, which had the paradoxical effect of turning Lawrence's torrential apologia of heart and body into an allusive, chatty work as intellectual finally as the morality it condemns. Fidelity and respect required formal austerity, but austerity contradicted the Lawrencian message!

There were still other adaptation problems: the action was set in England around 1925. For many reasons, it was inconceivable in France. Allégret took a conventional, ingenious, but slightly disappointing approach. The setting is obviously a castle in the area around Tours where everyone speaks French, yet Lord Chatterley (played, incidentally, by the English actor Leo Genn) is the only one with a British accent, which therefore becomes oddly identified with his moral stance. The idea was good but cannot offset the film's vague but obvious implausibility, stemming from the absent Anglo-Saxon social context.

> *L'Amant de Lady Chatterley;*
> Infidèlement fidèle
> *Radio-Cinéma-Télévision,* no. 311,
> January 1, 1956
> *Écrits complets,* 1943

NOTE

With legendary Danielle Darrieux in the titular role, this French adaptation, the first of this notorious novel, is based on a recent play

scripted by Baron Philippe de Rothschild who owned the theatrical rights, though he may never have staged it. The film premiered in Paris in December 1955, while its planned, concurrent U.S. release was blocked by the State of New York for moral reasons, until that was overturned by a 1959 Supreme Court ruling.

24. Has Hemingway influenced Cinema?

The work of Ernest Hemingway, the great American novelist and recent Nobel Prize winner, might have seemed particularly suited to cinematic adaptation. Indeed, his writing illustrates one of the major tendencies of the modern novel, and most particularly the American modern novel, in the most significant way—a tendency that could be defined negatively, on the one hand, by contrast to the classical psychological novel inherited from the seventeenth and eighteenth centuries, and positively on the other hand, as a literary promotion of journalistic reportage.

Let's now confront theory with facts. Hollywood has brought six Hemingway novels and short stories to the screen. The 1931 *A Farewell to Arms* with Gary Cooper. *For Whom the Bell Tolls* in 1943, with Gary Cooper and Ingrid Bergman, directed by Sam Wood. *To Have and Have Not* in 1945 with Humphrey Bogart and Lauren Bacall, adapted by William Faulkner who also wrote the dialogue, and directed by Howard Hawks. *The Killers* in 1947, directed by Robert Siodmak, with Burt Lancaster and Ava Gardner, based on the eponymous short story. We also have the 1948 *Macomber Affair*, based on yet another short story, with Gregory Peck and Joan Bennett. Finally, in 1952, *The Snows of Kilimanjaro* with Gregory Peck and Ava Gardner, directed by King Vidor.[1] Although it takes off from a short story, this film is, in fact, something of a *digest* of Hemingway's work and life. The screenwriter arranged things so as to include an American novelist in Montparnasse during the Spanish Civil War, a bullfight enthusiast, who eventually hunts big game in Africa. Only swordfishing

was left out, but then *The Old Man and the Sea* had not yet been published. It, too, will doubtless be turned into a film.[2]

THE ADAPTATIONS DISAPPOINT. . . .

But what are these adaptations worth in and of themselves, and with respect to their models? Very little, we really have to admit; the best of these six films are surely the least ambitious: *The Killers*, brilliantly directed but whose superb detective ambiance probably owed almost nothing to Hemingway any more, and *The Macomber Affair*, which, despite its rather meager mise en scène, conveyed something of the connections Hemingway knew how to draw between love and the gratuitous risks of big game hunting. Howard Hawks' fans would criticize me for not putting *To Have and Have Not* at the top of the list. But despite Faulkner's work on it, the film was a remarkable betrayal of the excellent short novel on which it was based. In any case, the least satisfying of these six films are, in fact, the most ambitious of them, and especially Sam Wood's quite unforgivable *For Whom the Bell Tolls*.

HEMINGWAY COULD HAVE WRITTEN *PAISÀ*

So we see, in fact, that in Hemingway, cinema does not seem to have tried to be faithful to those properties that would appear a priori best suited to the screen. This is hardly surprising when we also consider how Hollywood has typically treated its great contemporary writers: *The Grapes of Wrath* being one of the rare noteworthy exceptions. But perhaps we should be looking for Hemingway's true influence in films that theoretically owe him nothing—those of Huston, for example (the end of *Key Largo* is, in fact, the end of the novel, *To Have and Have Not*)—[3] so that it

surely is no exaggeration to say that the best American films over the last fifteen years would not be quite the same had the directors or screenwriters not read Hemingway.

And yet we will not draw our ultimate "Hemingwayesque" example from America but rather from Italy. At least two episodes of *Paisà* are the perfect cinematic transcription of short stories that war correspondent Ernest Hemingway "could have authored." I am thinking of the liberation of Florence, and especially of the final episode about the partisans in the marshes of the Po River.[4] It was up to neorealism—incidentally itself indirectly influenced by the American novel via certain contemporary Italian writers—to elevate to the dignity of a major art the technique of reportage as Hemingway knew to how do in the domain of the novel.

<div align="right">

Hemingway a-t-il influencé le cinéma?
Radio-Cinéma-Télévision, no. 253,
November 21, 1954
Écrits complets, 1631

</div>

NOTES

1. [French editor's note] Henry King in fact; Bazin corrected this misattribution a month later.

2. Warner Brothers would release *The Old Man and the Sea* in October 1958, a month before Bazin passed away.

3. Bazin here uses "En avoir ou pas," which is how the novel is titled in French, rather than *La Porte de l'angoisse,* as the film was known in French, and which he used in the previous paragraph.

4. These are episodes four and six, respectively, of Rossellini's *Paisà* (1946). In one of his longest and most important essays, "Le Réalisme cinématographique et l'école italienne de la Libération," published in *Esprit* in January 1947, Bazin had developed the relation of the modern American novel, and specifically of Hemingway, to neorealism, using these two episodes as extended examples.

25. Ernest Hemingway, *The Snows of Kilimanjaro*

Where are the snows of yesteryear?

We hesitate somewhat to nitpick about a film whose screenplay signals an obvious intellectual and artistic ambition. American cinema frequently borrows its subjects from detective and adventure literature, but rarely does it take on a work of this quality. "The Snows of Kilimanjaro" is one of Hemingway's best short stories, among the best displays of his style. Casey Robinson (who wrote the dialogue) and Henry King (who directed) adapted it more scrupulously and intelligently than did Sam Wood in *For Whom the Bell Tolls* (1943).

A man lies dying in a tent in the African bush at the foot of the Kilimanjaro. Here to hunt wild animals with his young wife, he has hurt himself on a nasty thorn, his leg is gangrenous. Vultures and hyenas are already sniffing the impending death. The man is a celebrated writer, known for his success with women no less than for his writing. As much because of the fever as for striving for lucidity in the face of death, he recalls the main episodes in his moral and amorous life. Three women were at its center. He may well have loved only one of them, the beautiful Cynthia Green, whom he met in a Montparnasse studio, with whom he lived for a time and then reunited, only to watch her die among the international brigades in the Spanish Civil War. The beautiful, semi-frigid German countess he later meets on the Riviera can't console him for Cynthia's death. Does the woman watching over him today, as he lies dying, warrant his survival? The book said no, but cinema, especially American

cinema, dreads pessimistic endings, and so the film strains to make us believe in a happy resolution, which is defied by the logic of the story. We know the central role of the Spanish Civil War, of bullfights, and of big game hunting in Hemingway's work. Stretching the bounds of the story, King made in *The Snows of Kilimanjaro* a sort of "digest" of all these elements in the novelist's work.

This presented problems for the mise en scène, handled relatively well by King thanks to an exceptionally adroit use of "transparencies" [rear projections], that is, a mixture of studio shots and documentary footage taken in Africa, Spain, or Paris.

What results is no doubt a relatively appealing and surprising film, whose subject matter provides, by virtue of its nobility and complexity, a welcome respite from the eternal sentimental melodramas—yet which, from another vantage point, is barely more than a caricature of the original. We can praise or criticize it depending on where we stand. Still, even the most demanding of viewers won't be bored, if for no other reason than for the impact and the spectacular realism of some of the episodes— the Spanish war, or the hippo and rhino hunts, for example.

Gregory Peck's interpretation of the novelist's character is monotonous and rather disappointing. With her beauty and the accuracy of her acting, Ava Gardner outshines her rivals, Susan Hayward and Hildegard Knef.

Unfortunately, the film was shot in Technicolor. I say unfortunately not because the quality is particularly bad, but because it seems a fact that certain more intellectual subjects have everything to lose in color. *The African Queen* is one instance, and it's all the more the case here. A spare, crisp, less unctuous black and white would have been far more suitable. My point will be

clear if I say that, had *Le Salaire de la peur* been shot in color, half of its effect would have been lost.[1]

Les Neiges du Kilimandjaro;
Mais où sont les neiges d'antan?
Le Parisien libéré, no. 2689, May 7, 1953
Écrits complets, 1333

NOTE

The Snows of Kilimanjaro was a major release by Twentieth Century Fox, with many scenes shot on location, including in Paris. It premiered on Christmas day 1952 in Mexico City.

1. Bazin could expect his readers to recognize this reference to Henri-Georges Clouzot's masterpiece *Le Salaire de la peur (The Wages of Fear)*, since he had reviewed it in the same newspaper just three days before.

26. Ernest Hemingway, *A Farewell to Arms*

Two Ernest Hemingway novels have just been brought to the screen, one on the heels of the other,[1] *The Sun Also Rises* and *A Farewell to Arms*. They are not the first adaptations; we have also seen those of *For Whom the Bell Tolls*, "The Short Happy Life of Francis Macomber" (*The Macomber Affair*), "The Killers," *To Have and to Have Not*, and "The Snows of Kilimanjaro." Moreover, we know that *The Old Man and the Sea* has also been made, cast with Spencer Tracy. In truth, none of these has led to a cinematic masterpiece. The least disappointing may have been *The Macomber Affair* and *To Have and Have Not*, directed by Howard Hawks, but the first was based on a novella and the second on a rather short narrative for which adaptation is easier than for proper novels.

With *A Farewell to Arms*, the filmmaker was, in fact, dealing with one of these proper novels. Its action is no doubt simpler and without many peripeties, but the story's technique presupposes and spurs what we might call the third novelistic dimension.[2] The love affair between Lieutenant Henry and Catherine Barkley, the pretty English nurse, is drawn against the historical background of the war, without, however, depending directly on it, as the war merely assists or thwarts them in entirely accidental ways. The two heroes make love and war, yet the two actions never meld in their consciousness until the moment when, forced to make a choice, they will flee the war that had never really concerned them, to shelter their love in Switzerland. There, however, death catches up with them. Catherine dies in childbirth. The beauty of the novel—a beauty occasionally

accompanied by an overly sensitive writing technique—resides in this counterpoint between love and war, death being the go-between. To which we might also add the tone of the story, recounted in the first person but, in fact, cynically objective. The hero is not given to soul-searching and rarely reflects on anything. What he describes for us are actions, pleasures, desires, or setbacks. Even love is nothing but a desire that endures, a pleasure more intense and more serious than others.

What remains of all that in Charles Vidor's film? Both a little and a lot!

Little, because there is no doubt that, for all the fidelity to the letter, we do not find much of Hemingway's tone, of the dry observational nonchalance, the penchant for dealing with all feelings on the same level, differentiating them only by their intensity. Cinema transforms this narrative, a kind of series of discontinuous notations like so many hatch marks in an etching, into a story with a traditional structure, modeled on the print. Above all it brings to the dramatic level two elements of different densities: war and love. *A Farewell to Arms* becomes interchangeably a love story upended by war or a war film bolstered by a sentimental plot. The novel's specific interest, which lay precisely in its sustained distinction between these two orders of events, disappears in this procedure. There is also a considerable shift in emphasis toward the war. The different means of expression explain this: the novelist is always allowed to describe just what he wants and to obliterate virtually the rest of the world.

When he writes nothing more than "meanwhile the battle was raging," he says a great deal in a very understated phrase. But to translate it, the filmmaker must recreate a universe necessarily more present to our eyes than the words are to our mind. Not that a *metteur en scène* can't in theory create equivalences to the

literary process, but this requires an exceptional imagination and capacity for abnegation. A producer doesn't mobilize an army of extras merely to give a fleeting glimpse of them. In other words, *A Farewell to Arms* has become "a war film." But if we consider it as such and forget about the comparison with the novel, our reservations give way to a certain admiration. Let's first note the interest and originality of the historical reconstruction. The ambiance of the Italian front in 1917, the debacle of Caporetto, everything merited being recalled precisely and honestly. This seems to have been done here. Charles Vidor (assisted perhaps in this by John Huston's preparations for the film) admirably restored the period for us as much in the details as in the whole. With the enormous cast of extras, he also provided a palpable and legible sense of the physiognomy and structure of military events both in the early scene of the troops' advance on the mountain front and, later, in the nightmarish retreat from Caporetto. That alone makes *A Farewell to Arms* an interesting film and one worth seeing.

So it is doubly disappointing that the sentimental action is less convincing. Perhaps the failure here lies more with the casting than with the script. Neither Rock Hudson nor—especially—Jennifer Jones corresponds to Hemingway's heroes as we might have imagined them. But isn't there also an essential, nearly insurmountable, contradiction here between this author's idea of the characters and the psychological schemata that every well-known actor brings along a priori?

L'Adieu aux armes
L'Éducation nationale 14, no. 14,
April 17, 1958
Écrits complets, 2539

NOTES

1. Bazin uses the first paragraph of this review to update the Hemingway filmography he began in his 1954 article "Has Hemingway Influenced Cinema?" (see chap. 24).

2. Bazin's analogy to 3D, a technology he had studied carefully and recently, seems here to evoke the novel's use of two overlapping lenses or filters, love and war, to produce a voluminous or multiplane representation of a situation.

27. Graham Greene's *The Power and the Glory* becomes John Ford's *The Fugitive*

It is, of course, without pleasure and with a heavy heart that I cannot express my admiration for this film, even though it brings together prestigious names and obviously shows significant technical effort. Joining the regular crew of director John Ford, scriptwriter Dudley Nichols, and actor Henry Fonda is celebrated novelist Graham Greene, whose book *The Power and the Glory* provided the film's subject. Lastly, the great delight is the participation of Mexican cinema's top technician (cameraman [Gabriel] Figueroa). Dolores del Rio and Pedro Armendáriz are also part of the team. So many talents assembled under the direction of the auteur of *Stagecoach* should have worked wonders.

In a certain sense they did, but this may be why the film misses the mark. Figueroa, whose spectacular photography we have enjoyed in most recent Mexican films, has outdone himself in *The Fugitive*. Never have we seen more sumptuous chiaroscuro or better shaped clouds on a landscape delicately sketched even in its smallest details. But cinema is not to be confused, alas, with picturesque cinematography. It may even happen that, as is the case here, plastic beauty deflects dangerously from the genuine dramatic and human interest. But Graham Greene's subject was both grandiose and delicate. For this Catholic novelist, the sacrament stamps a man as irremediably as destiny does a tragic hero. In nineteenth-century revolutionary Mexico, priests were murdered and hunted. One of these priests hides to escape the massacre. Cowardly and scarcely pious, he would have, deep down, willingly adjusted to his return to secular life

with its advantages. But the sacrament remains, and little by little it recalls him, obliges him to fulfill his priestly duty almost despite himself, and ultimately leads him to martyrdom so that God may continue.

In the film, however, while the schema is largely respected, no one dared or was able to make the character be the priest of the novel, where duty wins out over sin. Henry Fonda is just a pitiful, well-meaning guy whose sole—forgivable—fault is that he is weak. Because of this, we understand that the drama's meaning and scope are changed profoundly. An authentically Catholic work has been turned into an edifying story.

That said, a John Ford film is never bland. Even his misinterpretations are more interesting than many other directors' successes. Reason enough to take the trouble to go and see this film.

<div align="right">

Dieu est mort
Le Parisiene libéré, no. 1287,
3 November 1948
Écrits complets, 507

</div>

NOTE

John Ford's *The Fugitive* is a 1947 adaptation of Graham Greene's *The Power and the Glory*, published in 1940 in London, though initially titled *The Labyrinthine Ways* in the United States. The incident on which it was based took place in the late 1920s, not in the nineteenth century as Bazin mistakenly asserts.

28. Graham Greene, *Brighton Rock*

The title that the French distributors believed they needed to use to replace that of Graham Greene's novel *Brighton Rock*[1] is not one that, in my opinion, points to the exceptional qualities of this film, which is, moreover, also ill-served by the execrable print I saw. Still, I cannot recommend it highly enough to those who go to the cinema for more than an after-dinner outing. In fact, this is the first adaptation of the celebrated British novelist where the filmmakers were visibly concerned with being faithful to their author. Is it because Graham Greene himself worked on the film? Whatever the reason, we would be wrong to confuse this *Brighton Rock* with just any so-so gangster film. If the plot initially seems to closely resemble that of most American noir crime films, its spiritual, and we might even say metaphysical, backdrop make it something far more serious. For however appalling, cowardly, or cruel the heroes of this gang— dominated by the strange authority of an eighteen-year-old kid—might be, they maintain some sort of invisible relationship to heaven and hell, to death and to fate, that lends their actions a disconcerting gravity. God is far more present in this gang than in John Ford's *The Fugitive*, also drawn from Graham Greene.[2] Granted, the mise en scène lacks the slick luster of American films; by contrast, for all their clumsiness, the English crew of *Brighton Rock* knew how to bring to life the beach where the story is set, with a strange documentary intensity. As for the acting, which warrants our unmitigated

praise, we should mention the astonishing character created by Richard Attenborough.

Le Gang des tueurs
Le Parisien libéré, no. 1382,
February 23, 1949
Écrits complets, 554

NOTES

1. Graham Greene co-scripted this adaptation of his 1938 novel for director John Boulting. The film appeared in December 1947 in the United Kingdom and in Fall 1948 in France, poorly titled *Les Gang des tuers* (The Gang of Killers). Its U.S. premiere came only in 1951, under the title *Young Scarface.*

2. *The Power and the Glory* (1940), published in the United States as *The Labyrinthine Ways,* was, and remains, one of Graham Greene's most discussed novels. Bazin had quite recently made no secret that he thought Ford's adaptation, titled *The Fugitive* in English and *Dieu est mort* in French, missed the subtlety of Greene's moral ambiguity. See his review of *The Fugitive,* chap. 27.

29. Graham Greene and Carol Reed, *The Fallen Idol*

An exceptional film that betrays neither literature nor cinema

Once again it is from England that we receive, in *The Fallen Idol*, the best adaptation of novelist Graham Greene. Behind an original detective plot, unfolding as it does inside an ambassador's apartments, an even more original action takes place, its hero being an eight-year-old child. The proposition of the film is to show us the events through the psychology of this kid who obviously can't interpret them in the same way a grown-up would. Without really understanding it but with a child's intuition of the sort that would make a psychoanalyst's day, he looks on at the timid idyll developing between the embassy's majordomo and a typist. An idyll that provokes the accidental death of the majordomo's wife and the start of the crime plot.

To achieve this, the director—Carol Reed—did not need to resort to the sort of vain technical prowess that led Robert Montgomery to the "sinister" *Lady in the Lake*.[1] The camera does not occupy the child's place, yet the director nonetheless presents the facts in such a way that we know nothing beyond what the young hero does.

The originality of this script is not just praiseworthy in itself. It gives us proof that directors who betray novels have no one to blame but themselves. Neither the cinema nor the public are to be faulted if the screen so rarely manages to equal the novelist for psychological interest and depth; filmmakers' lack of imagination is at fault.

Enough has been said recently about the film's star, the young Bobby Henrey, so no further laurels are needed. That said, we must admit that next to him our dear Michèle Morgan[2] appears quite colorless. Ralph Richardson, by contrast, is a character actor with whom no fault can be found.

Première Désillusion; Un film
exceptionnel qui ne trahit ni la
littérature ... ni le cinéma
Le Parisien libéré, no. 1492, July 1, 1949
Écrits complets, 624

NOTES

1. *Lady in the Lake* (1946) notoriously deploys the camera as the optical point of view of the detective-narrator throughout, revealing his body only when he looks in a mirror, or when his hand moves toward his mouth with a cigarette, etc.

2. Michèle Morgan was one of France's most beloved stars when she left for Hollywood during the war, returning for *La Symphonie pastorale* in 1946. She appeared in several British films in the late 1940s, *The Fallen Idol* among them.

30. Graham Greene, *The Heart of the Matter*

Fidelity May Sometimes Betray

A film adaptation of a Graham Greene novel is always an event worth paying attention to, if for no other reason than the notoriety of some earlier efforts, in particular *The Fugitive*[1] and *The Third Man.* And, more profoundly, because Graham Greene is a novelist who knew how to combine, in original and surprising ways, the classical attractions of the detective genre with his subjects' moral, and even metaphysical, seriousness. We know that this Anglican convert to Catholicism tried in all his novels to convey a sort of tragic sense of Christianism, somewhat like our Pascalian tradition, if you will. But as with Simenon, so too with Graham Greene: the apparent affinities between his work and cinema often proved illusory or disappointing. In fact, it isn't the most famous of the films inspired by his work that are the best, and anyone who sets value on fidelity to the author's intentions may be permitted to prefer *Brighton Rock* and especially the delicate, intelligent *Fallen Idol,* in which Carol Reed did not as yet venerate the spectacular baroque of *The Third Man.*

But *The Heart of the Matter* is without a doubt one of Greene's best and most appealing novels. It recounts the fall of a high-level British detective from Sierra Leone. A scrupulous man, who is "too good" and whose moral rectitude paradoxically leads him to fear that he might make others suffer—first and foremost his wife, whom he no longer loves—arranges to let himself get caught up in the unforgiving gears of compromise and scandal. Becoming the lover of a young shipwrecked woman

(this is a wartime story), he falls into the naïve yet horrible blackmail plot of a Syrian businessman trafficking South African diamonds. And so this man of integrity, a model of civic and private virtue, entrapped less by love than by pity, is damned by his own goodness. The only way out to salvage his honor at least: suicide, which his religion forbids and which would seal his temporal fall for all eternity. Entangled in a brawl among drunken blacks, he is, in a sort of ultimate moment of grace, saved from dying by his own hand.

Such an intensely dramatic subject would seem to provide wonderful possibilities both for casting and for the mise en scène. The novel's readers can only be bitterly disappointed. The film is gray and lacking in style. It is timidly and laboriously faithful to the book, yet this fidelity—so cautious when it comes to the "heart" of the problem—never plays to the film's advantage. It may be that shooting in a studio, then inserting a few shots from Africa through a process known as "traveling matte,"[2] made it impossible to create any atmosphere. But these complaints are merely relative: its shortcomings notwithstanding, *The Heart of the Matter* remains a film of an uncommon dramatic and intellectual tenor, and in any case, those who haven't read the book will appreciate its qualities more than its faults. Finally, the cast attests to the customary solidity of British cinema. Trevor Howard is excellent. Elizabeth Allan may be a bit theatrical, but the young Maria Schell makes for a most endearing creation, worthy in every way of the novel.

Le Fond du problème; La
fidélité trahit parfois
Le Parisien libéré, no. 2919,
January 30, 1954
Écrits complets, 1518

NOTES

1. See Bazin's reviews of *The Fugitive* (John Ford, 1947), *Brighton Rock* (John Boulting, 1948), and *The Fallen Idol* (Carol Reed, 1948), chaps. 27–29.

2. [French editor's note] A traveling matte is a special effect more frequent in color film, used to insert characters or objects into a separately filmed setting. Bazin may in this case be confusing rear projection (or another special effect) with a traveling matte.

31. Joseph Conrad, *Outcast of the Islands,* filmed by Carol Reed

Islands and Illusions

Carol Reed, to whom we owe three of the best British postwar films—*Odd Man Out, The Fallen Idol,* and *The Third Man*—has taken up an even more ambitious film with *Outcast of the Islands.* Here he leaves Graham Greene for Joseph Conrad, and the Vienna of 1948 for nineteenth-century Malaysia.

Unfortunately, for all its spectacular assets, *Outcast of the Islands* fails to demonstrate the unity of style and magisterial assuredness of plot that has seemed to characterize Carol Reed's art.

The first reason for this may lie in Joseph Conrad's novel; it lacks the cinematic affinities that Greene's work possesses. And yet Willems' moral decay is a great story—that of the failed adventurer on whom an old captain takes pity and tries to regenerate by ensconcing him in one of his Malaysian trading posts. But in the Edenic, oppressive climate, Willems only grows ever more spineless and lazy. Moreover, this paradise on earth has its demon: Aïssa, the daughter of a tribal chief opposed to the captain's commercial interests. As beautiful as a pagan statue, Aïssa will serve as the lure for Willems to betray his protector's trust. But the very object of the sin contains its punishment Willems soon becomes little more than a poor wretch, unable to tear himself away from this Aïssa, who no doubt satisfies through him her race's hatred of the white man and her sex's hatred for the male.

The site of this adventure is certainly not foreign to the beauty of Conrad's novel, but that beauty is first and foremost moral: the story of the damnation of a soul incapable of wanting

its own salvation. Carol Reed was similarly unable to choose between good and evil: the mise en scène's picturesque exoticism and its true, strictly spiritual subject. Such that his film wavers between the style of an adventure story with a grand mise en scène, and scenes of lengthy dialogue between actors shot in close-up, consequently never finding the law for their dramatic unity or poetic synthesis. The meaning of the events is confused, and the character's motives no less so.

We see the same indecision in the acting. All the local actors are admirable; the ambiguity of the faces, the nude bodies, ultimately translate through their mystery and beauty the script's intentions better than the do the European actors made up to look like locals and whose performance is, by comparison, insufferably artificial. Kerima as Aïssa is the only one cast successfully; Carol Reed had skill enough to keep her from uttering a word, and she manages to bring together the perversion of Western eroticism and the primitive beauty of a pagan Eve. Trevor Howard vainly labors in a role that makes us wonder at times what Le Vigan[1] might have done with it. Still, we can enjoy Ralph Richardson as the charming, well-tempered Jules Verne-style navigator.

Le Banni des îles; îles et illusions
Le Parisien libéré, no. 2322, March 1, 1952
Écrits complets, 982

NOTE

1. Robert Le Vigan (1900–1972) was known for his often maniacal performances, such as the suicidal painter in Marcel Carné's *Le Quai des brumes* or the half-crazed "Tonkin" in Jacques Becker's *Goupi mains rouges.*

32. Arthur Miller's *The Crucible* and Nikos Kazantzakis' *He Who Must Die* are now Two Great French Films

LES SORCIÈRES DE SALEM (THE CRUCIBLE)

We occasionally hear current French cinema reproached for settling for conventional or meaningless subjects, which is to say, for shunning the major concerns of contemporary national life and any deep, serious themes. Today, for example, the Jean Renoir of *La Grande Illusion* is making *French Cancan* (1955) and *Elena et les hommes* (1956), and even Jacques Becker, who, in *Rendez-vous de juillet* (1949) examined the ideals of French youth, is now settling for *Touchez pas au Grisbi* (1954) and *Arsène Lupin* (1957). Bresson alone continues single-mindedly on the austere path taking him from *Journal d'un curé de campagne* to *Un condamné à mort s'est échappé* (*A Man Escaped*, 1956).

This spring of 1957 ought to rebut the moralists condemning the triviality of French filmmakers. Indeed, *Les Sorcières de Salem* (*The Crucible*) and *Celui qui doit mourir* (*He Who Must Die*) are two of the most "serious" and audacious films of postwar world cinema.

Les Sorcières de Salem is an adaptation by Jean-Paul Sartre of Arthur Miller's famous play directed by Raymond Rouleau, who had also staged Marcel Aymé's adaptation at the Sarah Bernhardt Theater.[1] Given how well known the work is, I need only mention that it concerns a painful moment in late seventeenth-century American history when religious fanaticism ignited and fueled incidents of collective hysteria. Moreover, we certainly know what the social symbolism in contemporary America of this old witch hunt could mean!

As we would expect, Jean-Paul Sartre made this more stark than did Arthur Miller, but it would not be right to speak about his adaptation as a betrayal or as lacking in fidelity. It may be more in relation to the very structures of action, I think, that the author of *Huis clos* and *La P ... respectueuse* appears to have deemed it necessary to take some liberties.[2] Yet again, the problem of filmed theater has been resolved by adding "exterior" episodes, by scattering and "spacing" the action. I am prepared to believe that Raymond Rouleau, a man of the theater making an effort to "adapt" to cinema, approved or requested this approach. The flaws of this lovely film, which are quite minor, seem to me to result from this prejudice—the film's theatrical origins are consequently both emphasized and contradicted by new "cinematic" elements. It would surely have been better to dare to remain embedded in theater, or else to push the transposition of the structures further yet, so as to draw even more consequences from it. But the fact remains that Raymond Rouleau's work is conscientious, and Yves Montand and Simone Signoret are admirable.

CELUI QUI DOIT MOURIR (HE WHO MUST DIE)

In *Celui qui doit mourir,* Jules Dassin clearly had more freedom in adapting Kazantzakis' great novel *Christ Recrucified.*[3] This time around, the director of *Rififi* had the good fortune to be able to make a film about a subject of his own choosing, no longer beholden in any way to the film industry's commercial conventions and prejudices. Far be it from me, of course, to regret this, and I absolutely believe that a film like *Celui qui doit mourir* is worth three *Rififi*s. It goes without saying that I respect him as much as I admire him. On the other hand, the film leaves me relatively unsatisfied, for which I blame Dassin, whereas I had

credited him with—and marveled at—the generosity of spirit, the humanity, and the lyricism that transformed a script derived from the worst *série noire*[4] into a small epic of friendship and paternal tenderness. Obviously, Dassin wasn't completely successful with *Celui qui doit mourir*, because he was on unknown terrain with this unusual undertaking and had to create from scratch, so to speak, a new genre along with a suitable style. To transform this recent but not quite contemporary story and set it in the rustic wilds of a Greek island[5] with a cast comprising half local peasants and half well-known French actors was bound to generate some stylistic contradictions. Insofar as they were perceived and resolved, these contradictions make for the originality and grandeur of the enterprise.

Deux grands films français
L'Éducation nationale 13,
no. 19, March 23, 1957
Écrits complets, 2301

NOTES

1. Marcel Aymé's four-act French adaptation of Arthur Miller's *The Crucible* premiered on December 16, 1954, at the Sarah Bernhardt Theater. Its leading actors, Simone Signoret and Yves Montand, would star in the film.

2. Before working on *Les Sorcières de Salem*, Sartre had a hand in scripting the adaptations of two of his most popular plays, "Huis clos" ("No Exit"), written in 1943 and filmed in 1954, and "La P … Respectueuse" ("The Respectful Prostitute"), written in 1946 and filmed in 1952.

3. Nikos Kazantzakis published this novel in 1948; in 1954 it was staged as a play in France.

4. French publishing imprint founded in 1945.

5. Kazantzakis set his novel in a village of central Anatolia.

33. Franz Kafka on Screen: Clouzot's *Les Espions (The Spies)*

It is legitimate to judge a film by the measure of its ambitions. So, even though they didn't bother to let us know about it beforehand, Cayatte and Clouzot couldn't deny the relatively elevated goal they set in their latest films. If I compare *Œil pour œil* (*An Eye for an Eye*) and *Les Espions*,[1] it isn't because the talents of their two *metteurs en scène* are especially comparable, but because it makes the similarities between the two films even more striking and significant. The law of series couldn't apply here any better than it does to railroad accidents. Sure, we clearly see why, in a given year, four out of five French producers began producing noir series: they hoped that by doing so they could follow in the tracks of one or two remarkable successes. Yet every year at the festivals I observe that a noticeable share of films from all over the world suggest within the framework of the general program the shape of an overarching theme. An apparently inexplicable phenomenon.

But to bring our chickens back into the coop, if I may use this image apropos the auteur of *Le Corbeau*,[2] it is striking that in a given year both Cayatte and Clouzot would for various reasons turn their backs on their previous inspirations and start making films with comparable ambitions in their principle and content.

I say in principle, because I could almost hear word-for-word Cayatte's remarks to me in Venice,[3] when Clouzot was saying to me the other day, "It's about knowing whether cinema is an adult art"—intending by that, I suppose, whether it can rival

literature specifically in intelligence and import. Cayatte, too, wanted to treat the spectator as a sensible adult.

KAFKA, FREELY TRANSLATED

But the comparison goes further than authorial intentions and touches on the foundations of the screenplay itself. More diffusely and indirectly for the *metteur en scène* of *Œil pour œil*, and slightly more explicitly and directly for Clouzot, the "challenge" is to bring to the screen, if not Kafka, then at least a free translation of the Kafkaesque universe. *Les Espions* is quite clearly a syncretic transposition of *The Castle* and *The Trial*. In Cayatte, this is less exact and perhaps less conscious, but his moral theme of guilt is quite obviously entwined with the spatial theme of a labyrinthine universe, replete with ambushes at every turn.

That Kafka flourishes in cinema today is unsurprising, of course, first because he has long been common ground for literary and more generally intellectual sensibilities, and then because the idea of adapting him to the screen is not new.[4] But what surprises me in light of this is how late this turn comes and that, subsequent to the great postwar vogue, Kafka has, in fact, lost some of his relative popularity. Given the lag between literary and cinematic modes, and especially the coincidences that lead to one film rather than another being produced, there was, let's say, one chance in ten that the first Kafkaesque film would be made in 1957, but only one in a hundred that—for no obvious historical reason, and given that the producer faces the biggest risks because of the choice—we would see *two* films inspired by Kafka made in the same season. I suggest that the reader ponder this: beyond superficial associations of ideas and influences, was it

pure luck or a profound conjunction that predestined this 1957 for Kafka?

ATOMIC AGE SPIES

Whatever the answer, I didn't make the comparison merely to reflect on the question but also because it seems interesting from the critic's perspective. In fact, both films seem to me to have missed their mark, albeit to rather different degrees and for rather different reasons.

I will in no way reproach Clouzot for having wanted to make a Kafka without Kafka. I even freely acknowledge that Kafka is what is best and most intelligent in the enterprise. Kafka is today much more a vision of the world than one or another of his unfinished novels—a structural myth, I dare say, rather than a hero involved in particular situations. For that matter, Mr. K. would lead to confusion. The only thing Clouzot kept of *The Castle* and *The Trial* was the adjective "Kafkaesque," and he had the ingenious idea of setting his film in the international espionage milieu of the atomic age.

What the revelations about intelligence activities during the last war taught anyone uninformed was that, at a certain level of responsibility, espionage had only a very distant relationship to the Manichaeism of armies at war; a certain ambiguity regarding affiliation and service seems to be consubstantial with modern espionage. What can be said about this situation once the atomic bomb is at stake? One way or another, science's internationalism leads scholars more or less in the same direction. The notion of patriotism and loyalty seems distinctly relative when, beyond societies and nations, the destiny of humanity itself is at stake. Traditional "treason" then turns into a case of

conscience. Mata Hari is quite out of style in the era of Fuchs and Maclean.[5]

Let's imagine a naïve individual caught up in this incomprehensible network where those pulling the strings are both unknown and interchangeable, where one is always at once someone's spy and double agent and someone else's traitor. Let's allow that this naïve person—you or I—is a second-rate psychiatrist in financial difficulty, whose clinic is as pathetic as the private school in *Les Diaboliques*.[6] Someone offers him five million for a guaranteed job with neither risk nor dishonor. All that's needed is to simply admit as a patient, then shelter for as long as necessary, someone who will be sent to him. The naïve individual accepts the deal to save his clinic; and so there he is—even before the arrival of the mysterious Alex—a focus of international counterespionage agents, watched, spied on, monitored, manipulated without knowing it, and condemned to go wrong if not to perpetual guilt.

WHERE IS THE LOGIC?

Why then, given these ingenious premises, does it still seem to me that Clouzot has more or less missed his mark? There are two main reasons. One has to do with the screenplay, and the other with the style.

Starting with the pretext and the look of a spy film, which draws on a traditional genre, Clouzot aspired to make it undergo an intellectual mutation that somehow elevated it to the level of metaphysics. We must not criticize him a priori (even if that were possible for an individual case) for the liberties he takes with psychological or material plausibility. He made no mistake there. Yet everything seems to have happened as if Clouzot, con-

cerned for his audience in light of the liberties he had taken, wanted in the second half of the film to provide his spectator with the logical explanations of a real spy film. He reveals the identities of the characters and their motives, and from *The Trial* and *The Castle* we lapse into the story and the morals of the nuclear scientist of Berlanga's *Calabuig* (*The Rocket from Calabuch*).[7] Except that, having already gotten himself involved in relationships far too complicated and unrealistic, Clouzot can no longer make his story hold water and avoid implausibility—something that becomes more serious once we have been invited to make sense of the situation.

A TRIAL TO BE REOPENED

However, the film's greatest handicap lies in its style. The director of *Les Diaboliques* pushed his hard-hitting technique, his violent and razor-sharp mise en scène, even further than usual. He may well have hoped that the effects of shock and surprise would compensate for the audacity of his story. But while these strategies were wonderfully effective in *Les Diaboliques,* because perfectly adequate to the subject, here they contradict the work's ambition rather painfully. The malaise Kafka creates is not visceral but cerebral, not the sort that hits us in the gut or solar plexus. Clouzot wanted to make an intelligent and even intellectual film in a style where his mastery is more than ever undisputed, yet its effectiveness remains simplistic.

The specific causes for Cayatte's failure were different. Certainly his direction of actors in particular left much to be desired, whereas Clouzot knows how to get exactly what he wants from his cast (Séty, among others, is perfect and Curt Jurgens himself is viable). But these two audacious, ambitious (and,

it goes without saying, highly respectable) undertakings both fail overall for a general, shared reason. Greater intelligence and more audacity yet were required—but an intelligence that is better integrated, that is, not an add-on but consubstantial with the cinematic form. This *Trial* is to be reopened.

<div align="right">

Les Espions

France Observateur, no. 388, October 17, 1957

Écrits complets, 2416

</div>

NOTES

This article's original title is simply *"Les Espions,"* but it is far more than a review of Henri-Georges Clouzot's *Les Espions*. Bazin does not mention that its immediate source was not Kafka but a novel by Egon Hostovský, who was, like Kafka, a Czechoslovak Jew whose life was indeed Kafkaesque as he was in flight first from the Nazis and then, after the war, having returned to Prague, from the communists.

1. André Cayatte's *Œil pour œil* was adapted from the 1955 novel of the same title by Vahé Katcha, a noted Armenian French author.

2. [Translators' note] Bazin's "Revenons à nos moutons (sheep)," a French idiom meaning "Lets get back to the subject at hand," contains an allusion to the sheep in the rural setting of *Le Corbeau,* Clouzot's most famous film. We substitute "chickens" to provide a nearly equivalent idiom.

3. [French editor's note] Bazin did not publish an interview with Cayatte, but he did meet him at the Venice Film Festival and said that Cayatte had alluded to his article "The Cybernetics of André Cayatte" during a press conference. [English editor addition] This important article (*Cahiers du Cinéma,* June 1954) explicitly rejected the moral superiority of Cayatte's approach. Bazin had also just written a key essay on Clouzot's *Le Mystère Picasso* (1956), which, on the contrary, was full of praise.

4. Here Bazin gets ahead of himself. In fact, the first feature film taken directly from Kafka would be Orson Welles' *The Trial* (1962). There had been but two shorts (one Cuban, one British) before that,

plus an episode of a Canadian television series dramatizing classic literature.

5. [French editor's note] Donald Maclean and Klaus Fuchs were two spies living in the United Kingdom and working for the Soviet Union. Recruited in the 1930s, they were exposed in the early 1950s. Maclean, a diplomat, worked for MI5; Fuchs was a physicist. They purportedly transmitted valuable information about atomic energy procedures and policies.

6. *Les Diaboliques* (1955) was Clouzot's most recent and most popular film, a crime thriller set in a crumbling boy's school.

7. Bazin saw Luis Berlanga's *Calabuig* at the 1956 Venice Festival, where it was nominated for the Golden Lion and won a minor prize. This comedy puts an American scientist into the midst of a sleepy Spanish seacoast village, where he hides after abandoning experiments he could see would benefit military ends.

B. Fiction from France

34. *Avec André Gide,* by Marc Allégret

One can speak for or against Marc Allégret's *Gide,* calling it either the best or the worst, depending on whether one appreciates it absolutely or judges it relatively with respect to the ideal film it points to.

Let's consider the claim. It can be formulated from two vantage points. First, with respect to Gide himself, Marc Allégret obviously presents an image that can at the very least be said to be incomplete, partial, and sugar-coated. The author of *Corydon, Si le grain ne meurt (If It Die),* and *Les Nourritures terrestres (Fruits of the Earth)* appears above all as a good bourgeois humanist, very much the artist who cultivates the art of being a grandfather. Whatever needed to be said about this has already been said in various places. It would be pointless to deny it. At the film's opening gala, an enthusiastic Vincent Auriol was apparently heard asking whether, once the film had finished its commercial run, multiple copies could be distributed and projected in every high school in France. If this isn't true, it might as well be. The anecdote conveys the tone of the undertaking: *ad usum delphini.*[1] I admit that I am disinclined to be terribly indignant, for two reasons. First, it's natural that on the first anniversary of Gide's death a film about him would take the shape of a tribute. The Nobel Prize was not awarded to the seducer of young Arab boys. If Gide has not been considered scandalous for quite some time, it is not because he reneged on his initial precepts but rather because his thinking had sufficiently imbued his era to come to appear classical, exemplary almost. In hindsight, Victor Hugo

did not retrospectively lose the battle of *Hernani* because he received a state burial.[2] In this sense, Marc Allégret hasn't betrayed Gide. He shows him as the times have changed him.[3] It is, moreover, untrue to claim that he remains silent on the role of sexuality in Gide's moral development. The few images concerning Gide's trip to North Africa are sufficiently eloquent, and I really don't see that the filmmaker could have gone further. Granted, they do imply that the spectator knows enough about things to understand. But this is where we must consider the means of expression: cinema does not equal book. The limits of modesty do not pass through the same kinds of images: here, far more needs to be left to the imagination. Wouldn't it be even less true to Gide's memory were the spectator made to feel uncomfortable or indignant—something that less allusive images would surely cause—for ultimately homosexuality does not interest us for itself, but only insofar as it represented the place of pleasure in Gide's moral life. It isn't *Corydon* that is important but *Les Nourritures terrestres.*[4]

Granted, I only defend Marc Allégret's reverent modesty insofar as he seems to have wanted to side with the homage and apologetics. His film assumes an already glorious, triumphant Gide. We might also imagine that the film dramatically recreates Gide's spiritual journey for us, that it would start with *Les Cahiers d'André Walter* without assuming implicitly that *Les Caves* were staged at the Comédie-Française.[5] Throughout Carl Dreyer's *La Passion de Jeanne d'Arc* we keep hoping that Joan will be saved. Limiting oneself to describing Gide's biography in light of his triumph amounts to depriving it of his perspective and the sense of his freedom.

But we must now consider the key factor that determined the shape of Allégret's film and its lacunae. I'm referring to the obvious shortage of cinematic documents. For we come to see that

even a professional filmmaker as talented and intelligent as Marc Allégret, who was lucky enough to have lived inside Gide's world, behaved ultimately like all amateur filmmakers everywhere, shooting primarily little domestic scenes. If the film gives pride of place to the grandfather, it is simply because of the disproportionate quantity of family documents. Allégret must have surely regretted his lack of foresight or his negligence. But can we imagine filming the life of a famous man before he had altogether become one? Who might personally possess the enormous amount of patience to do this other than at most someone taking the somewhat naïve perspective of an amateur filmmaker? When it comes to public figures, the newsreels of the last forty years are an enormous flea market, offering a chance of finding what one is looking for. But artists have only a few opportunities to appear in newsreels. Why doesn't the government take charge of founding its own film library of public personalities and keep it up to date? There would, of course, be errors and oversights: Lautréamont and Van Gogh would not be included, while Henry Bordeaux or Jean-Gabriel Domergue would be.[6] But to return to Gide, had the cinematic documents gone back only to the creation of the N.R.F.,[7] and had there been just one per year, we'd be quite content. In any case, the arbitrariness of this choice would be better than the randomness of newsreel documents.

For no matter what we might think of the image of Gide that Allégret has given us, it has the priceless merit of existing. The moment has come when we are rediscovering the raw representational value of cinema. The famous aesthetic judgment by Malraux that cinema as an art begins with editing was fertile for a time, but its merits have faded. The chief aesthetic emotion owed to cinema is surely what made the spectators of the Grand

Café exclaim, "The leaves are moving." Gide lived, and this simple spectacle satisfies us, whether he is attempting to amuse his grandchildren with a box of matches or explaining a Chopin scherzo to a young woman pianist. This last sequence, which goes on at some length, and seemed to me to run an entire reel with no break in the take and virtually no editing (even though it was clearly made with two cameras, basically following television's method), achieves an extraordinary power of enchantment. Duration itself becomes, in a way, the object of the image. The emotion we are experiencing can't have been born of the dramatic structure of the event, which is amorphous if not banal. Drop by drop, second by second, it accumulates until it becomes deliciously unbearable, time's summation in the subject's living duration. Time does not flow. It accumulates within the image until it is charged by some formidable potential, whose discharge we await with something like anxiety. Allégret understood this quite clearly when deciding to not cut the last second of the shot, in which Gide abruptly looks at the camera and lets out an exasperated "cut!" At which point everyone in the auditorium exhales. Each person stirs in their seat; the storm has passed.

André Gide

L'Observateur, no. 96, March 14, 1952

Écrits complets, 991

NOTES

Avec André Gide is the full title of Allégret's feature length documentary, produced by Pierre Braunberger for his company, Panthéon Films, and premiering in February 1952, exactly a year after the death of its illustrious subject.

1. This Latin locution signifies "for the use of the Dauphin," referring originally to salacious texts cleaned up so as to be used in the

education of the heir to the throne. Today it designates works that are bowdlerized.

2. Like Gide, Victor Hugo shocked the establishment in his youth. His play *Hernani* (1830) caused an uproar, yet at his death fifty-five years later he was honored as a national hero. So Gide's homosexuality made him a pariah in 1900, but when he died in 1951, he was a national treasure.

3. Bazin's formulation in French ("tel qu'en lui-même les temps l'ont changé") mimics the famous line of Mallarmé—one that he frequently echoed—that concludes his "Le Tombeau d'Edgar Poe": "*Tel qu'*en lui-même enfin l'éternité le change." Although, as the French editor notes, Bazin altered this for publication in *Qu'est-ce que le cinéma* to "tel que le temps l'a fait," diminishing the echo.

4. Gide considered his 1920 *Corydon*, which defends homosexuality, his best book. Bazin differs, arguing that the 1897 *Fruits of the Earth* uses homosexuality as one element (pleasure) among others (duty, tradition, creativity) in the hero's complex life.

5. Gide's very first publication of 1891 went unnoticed, but, Bazin writes, the film viewer would know that almost sixty years later, he would triumph with the theatrical version of one of his most famous works, *Les Caves du Vatican,* playing just before his death at the Comédie-Française.

6. Henry Bordeaux, an established, if middlebrow Catholic novelist and a member of the Académie française, was born in 1870, the year that the scandalously amoral Lautréamont died at age twenty-four, needing fifty years to be discovered by the Surrealists. Similarly, Van Gogh died virtually unrecognized in 1890, the year after Domergue, a high-society portrait painter and fashion designer, was born. Bordeaux and Domergue died in the early 1960s, and so were alive when Bazin denigrated them here in this clever comparison.

7. *La Nouvelle revue française,* the twentieth century's most powerful French literary magazine (and publishing house), was founded in 1909 by André Gide, Jacques Copeau, and Jean Schlumberger.

35. The Universe of Marcel Aymé on Screen: *La Belle Image*

Will Marcel Aymé become as "cinematic" as Simenon?[1] If so, one worries that adaptation, in his case, will not ultimately be any easier than for the novels of his colleague, whose detective stories have often proven to be cinema's "false friends." In any case, film directors would be mistaken to imagine that they can exploit the ingenious situations imagined by Marcel Aymé without expending much effort.

A man who suddenly changes heads—to his advantage—is clearly an uncommon event, and its consequences are worth the telling. Unrecognized thereafter by anyone, separated from his job and his home, he must adopt all manner of wily ruses to get back into his office and become ... his wife's lover. As we can guess, he will learn quite a bit about life in general and about himself in particular, and, having miraculously found his old head, use it to go on and manage to be somewhat happier.

But a novel lends itself more easily to mixing fantasy and reality than does a film. The written word doesn't require the same rigor of verisimilitude. It's easier to hint at something impossible, at least if one has Marcel Aymé's poetic talent, which is something director Claude Heymann unfortunately lacks.

While the latter may have managed to acquit himself passably in his adaptation of the story, nothing in his mise en scène contributes to suggesting the equivocal necessity of Marcel Aymé's universe. If we sometimes believe it and enjoy ourselves, it is largely thanks to the merits of the actors, first among them Frank Villard, who reconfirms his talent in each new film. Françoise

Christophe is quite charming when she cheats on her husband with himself. Suzanne Flon has always the same intelligent way of being pretty. Larquey is ... Larquey[2] and Robert Dalban would prove to us, were it necessary, that he is a classy comedian.

La Belle Image; L'univers de
Marcel Aymé à l'écran
Le Parisien libéré, no. 2064, June 1, 1951
Écrits complets, 799

NOTES

1. Marcel Aymé (born 1902) and Georges Simenon (born 1903) were both prolific and successful authors with fine critical reputations. In mid-1951, *La Belle Image* became the fourth of Aymé's works to be adapted. The number would ultimately reach twenty-five; he also wrote ten screenplays. Simenon has had eighty-five films made from his novels; the number stood at eighteen when Bazin made this comparison.

2. Pierre Larquey was a mainstay of classical French cinema, often playing secondary roles memorably. *La Belle Image* was his 175th appearance.

36. Colette, *Le Blé en herbe: The Ripening Seed* . . . has Matured!

It was not easy for Claude Autant-Lara to realize his long-standing project to film Colette's admirable short novel. Let us first toast the director of *Le Diable au corps* for finally reaching his goal. Such undertakings are not very common, unfortunately, for the ratio of "commercial" films, even when camouflaged beneath the deceptive appearances of technical quality, is getting to be out of all proportion in French film production, which is ever more divided between cheap ersatz of the worst Palais-Royal kitsch[1] and luxurious clones of *Caroline chérie*.[2]

But we couldn't help worrying either. After an overly long silence, Claude Autant-Lara, with *Le Bon Dieu sans confession*, delivered a film that was quite respectable, of course, but in some respects a failure, indicative above all of a strange internal imbalance, a lack of critical sense that is troubling in a man of such experience and talent.[3]

Luckily, we can rest assured. Though *Le Blé en herbe* isn't flawless, at least we recognize in it again the command and penetrating sharpness of *Le Diable au corps*.[4]

The adaptation faced multiple challenges. First, the relatively daring subject: the sentimental education and, to not mince words, the sexual initiation of the two sixteen- and fifteen-year-old adolescents, posed delicate problems for the director if he were to avoid bad taste and unbearable moral indecency. For a filmmaker must, by nature, show rather than describe, and the words of his language are a direct reflection of life. Moreover, the age of his protagonists made the task even more difficult, for

while it's possible to have children do things that they don't understand, and to have professional actors play roles they understand too well to confuse with real life, adolescence, by contrast, is a fleeting transition from innocence to awareness, so a theatrical simulation of those most serious of actions seems just about impossible. In this regard, Claude Autant-Lara's success was complete, and even though the film was utterly frank—no less so than the book—it made sense that the censure committee saw no need to prohibit the film to those under sixteen.

The second difficulty: the tenuousness of the plot. If the book were not to be betrayed, the task was to hold the viewers' interest exclusively through successive emotional situations, the affective relationship between young Phil, who initiates his cousin Vinca after having himself been introduced into manhood by a beautiful summer visitor. Here the success is less than perfect. But we must first applaud Aurenche and Bost for having refused to give in to the easy solutions a freer adaptation might have opened. They had been less restrained in *Le Diable au corps*. More scrupulous here, they absolutely never shift the focal point, which remains on Phil and Vinca, Vinca and Phil. On the other hand, it seems to me that they did not figure out entirely how to justify the postscript they added to Colette's novel, which simply ends on the morning after the crucial night. A sort of emotional hesitation, it brings the film to an evasive end, repeating pointlessly what we already know and courting boredom. On the other hand, it is certainly true that the prologue is unusually deft, a tribute as much to the screenwriters as to the director (*metteur en scène*).

Finally, the imponderable remains: Colette's inimitable style, the tone of sensuality turned intelligence. I won't reprimand Claude Autant-Lara for not having adopted it exactly, since

adaptation authorizes, even demands, transposition. What is required is simply that the director's moral universe—the gaze he insists we train on the world he has borrowed from the novelist— be validated through discernment and inherent logic. We can surely be allowed to recognize what we lose in the bargain— unless we gain something from it! All I will regret here is the sourness, the slightly inappropriate taste for satire, the suggestion of caricature that mars the tone of certain otherwise excellent passages. Bitterness does not always make wise counsel!

Acting here has a decisive role. We could hardly argue with the felicitous choice of Nicole Berger, whom we had already watched with pleasure in *Julietta*.[5] That of Pierre-Michel Beck may seem more questionable. Yet despite some unevenness, I find him excellent. As for Edwige Feuillère, she couldn't disappoint in a role that seems tailor-made for her.

> *Le Blé en herbe*; A poussé dru!
> *Le Parisien libéré*, no. 2915,
> January 25, 1954
> *Écrits complets*, 1516

NOTES

The Game of Love is the English title of the 1953 film *Le Blé en herbe*. See Bazin's other essay on this film, chap. 11, unnumbered note.

1. [Paris's] Théâtre du Palais-Royal (not to be confused with the seventeenth-century theater of the same name that was home to Moliere's company) was known in the mid-twentieth century for comedies and "burlesque." Coincidentally, Colette was closely associated with the Palais-Royal area where she lived.

2. *Caroline chérie* (Richard Pottier, 1951), a comedy set in prerevolutionary France, was an enormous box office success despite reviews that questioned its tawdriness. In the title role, Martine Carol became

France's sex symbol before ceding that position to Brigitte Bardot, who played Caroline in a 1954 sequel, one of many.

3. After a string of hits, *Le Bon Dieu sans confession* was Autant-Lara's least successful film and was never distributed in English-speaking countries. It came out in France in 1953. The title (literally, "The Good Lord without Confession"), is taken from an idiom used to denigrate a cold person for whom nothing is good enough.

4. This 1947 adaptation of Raymond Radiguet's novel has much in common with *Le Blé en herbe.* Both are about the sexual initiation of teenagers; both were published in 1923; both were adapted by the team of Jean Aurenche and Pierre Bost for Autant-Lara, then vilified by François Truffaut in his notorious article "A Certain Tendency in French Cinema," which appeared in January 1954, the same month as did this review.

5. Nicole Berger (1934–1967) got her start in *Jocelyn* (see Bazin's review, chap. 8). *Julietta* (Marc Allégret, 1953), another upper-class romantic comedy, was adapted from a novel by Louise de Vilmorin, whose *Madame de …* (Max Ophüls, 1953) premiered three months before *Le Blé en herbe.*

37. Marguerite Duras, *Barrage contre la Pacifique*, adapted by René Clément

When a director of René Clément's stature takes on a book of the caliber of *The Sea Wall (Un barrage contre le Pacifique)*, we have the right to expect a masterpiece. Is this what this is? Certainly not; still, the film seems to me to be exceptionally interesting and, while it may not be René Clément's "best," it is surely, along with *Monsieur Ripois*, among the "most powerful" films he has directed.

The limits of the undertaking were determined by the contingencies of the production. *The Sea Wall* is a French novel, even though its plot is set in the Far East; yet the film is "American." By this I mean economically, in terms of its financing, and in particular in its casting. What Clément set out to do was conquer the international market and, first in line, the U.S. market. That was his clear and deliberate bet, and since half the actors were American and the original version would be in English, it made sense to conceive the adaptation and the mise en scène in terms of an American aesthetic. From which follow, in my opinion, most of the film's weaknesses but also its qualities.

A weakness, of course, because the transposition could not help but betray, to a degree, the spirit of Marguerite Duras's novel. In its intimacy if not its form, the book is autobiographical and clearly tells a personal adventure, the story of a family: a mother and her two children left to fend for themselves in natural surroundings whose hostility takes the specific form of water and salty mud that regularly destroy crops. Nonetheless, the author sets the story historically and politically rather precisely.

A corrupt, venal administration operating with Kafkaesque methods forms the social and metaphysical backdrop to this struggle with the angel. Now, it may have been possible to depoliticize the script somewhat and find some acceptable but more international equivalents of a particular crisis in the Indochina of 1925–30. Instead, Irwin Shaw, the novel's adapter, thoroughly deformed its moral positions, reducing the forces of evil to a vague and general "capitalist" exploitation. In so doing, some of the novel's roots were irremediably cut. Their sap is absent in the characters—a sap that even René Clément, infusing as he does his subtle intentions into the mise en scène, cannot entirely replace. More insidiously yet, I think it is the American influence that is responsible for the most serious transformation, that of the denouement—pessimistic in the novel, optimistic in the film—as well as several other minor shifts in details. Surprisingly, the book itself was not devoid of American influences, but those were of the prewar American novel: Caldwell, Steinbeck. Everything in the film happens, however, as if it had been reconceived and rewritten in the American spirit of those "intelligent" postwar best sellers, specifically those by Irwin Shaw.[1]

That said, it is true that an Irwin Shaw novel is not a negligible work, and that American cinema is nowhere near this level, even when it does make a deliberate attempt, as in *The Young Lions* (1958).[2] This is all the more palpable today because of Hollywood's tendency to adapt best sellers. I would thus say that I am giving a rather exact summary of the relative qualities of *The Sea Wall* in saying that it is the ideal American film that Americans don't know how to make. Or rather, that this is the ideal American film that Americans should have made, were it not that their production system, its bad habits, and a kind of gutlessness have condemned them most often to betray their initial

intentions. Or, to put it another way yet, the intelligence and style of Clément's film aren't inferior to the virtual novel that inspired it.

I said virtual novel, since this novel is only partially related to that by Marguerite Duras; rather—just as with those imaginary numbers eliminated at the end of an equation—it is more of an unwritten American novel, one that could have been penned by Irwin Shaw.

From a certain point of view, this is no small compliment to René Clément's work. It takes a considerable talent to match and at times even surpass Kazan and Huston. But why put this talent in the service of an undertaking so perverted in its principle? Admiration is mixed with irritation, enthusiasm with regret. There is much to take in and to take from this film, for and against a certain cinema. Clément surely understood all this, for he dreams of making his next film in the style of *Les Jeux interdits* (*Forbidden Games*, 1952).

<div style="text-align: right">

Barrage contre le Pacifique
L'Éducation nationale 14, no. 23,
June 19, 1958
Écrits complets, 2601

</div>

NOTES

Marguerite Duras' novel, written in 1950, was translated two years later into English as *The Sea Wall*. This was the official worldwide title of the film adaptation, produced in Italy by Dino De Laurentis, although it appeared in France as *Barrage contre le Pacifique* (without the indefinite article) and in the United States, when distributed by Columbia Pictures, as *This Angry Age*. It stars Silvana Mangano, Anthony Perkins, and Jo Van Fleet.

1. Following Claude-Edmonde Magny's argument in *The Age of the American Novel*, Bazin suggests that Duras, like other contemporary French authors, was deeply affected by prewar American novelists. Clément's film, on the other hand, seems indebted to postwar American fiction, which Bazin finds middlebrow. Steinbeck and Caldwell, of course, continued writing fiction after World War II, but their mark had been made in the 1930s.

2. *The Young Lions* was Irwin Shaw's first and most successful novel. He adapted it for the screen himself at the moment he was adapting the Duras novel for Clément. The films came out in Paris within a month of each other in 1958. Shaw was living mainly in Paris in the 1950s, after having been blacklisted in the United States in 1951.

38. Françoise Sagan, *Bonjour Tristesse,*
adapted by Otto Preminger

Having seen *Bonjour Tristesse* several days after it came out, I had time to read the first, generally negative reviews, and confess that their arguments seemed rather convincing. I was therefore expecting a superficial film that had, from among the book's various qualities, kept only a minor, slightly scandalous plot with picturesque French vocabulary for American use. So I was greatly surprised to find a work whose mise en scène is admirably intelligent, unfaithful perhaps to some of the book's charms, but by and large compensating for this offense through specific cinematic qualities as rare as they are prized in international film production.

Yet Preminger's film has everything going against it. First, the novel's outsized notoriety, which practically makes it a national institution,[1] whereas we would demand far less of a Balzac or a Maupassant adaptation; next, its foreign production, which increases our reluctance and severity, for it goes without saying that American cinema is too vulgar to translate our French mores; and finally the publicity, which takes its cue from both. Thus, we awaited this film, more or less consciously, blunderbuss at the ready. But it seems to me that for once the powder blows back to hit the hunter in the face and leave the reviewers blackened, or blinded, in any case, by the prejudices with which they had loaded their guns and which concealed from them the beauties of a film on which they would have heaped praise had it not been based on a novel by Françoise Sagan.

Let's forget for a moment that source. What do we see? An admirably pared down work, a small, almost silent, discreet, and yet pitiless contemporary tragedy of sorts, whose purely inner action consists of nothing but wishes and glances. One woman half-consciously pushes another woman to her death without quite understanding the extent of the harm she is inflicting, yet with the accumulated cruelty of femininity and of childhood. Once she realizes the consequences of her machination, she is driven from happiness, thrown if not into hell then at least to the very limits of distress, which in color films is usually translated by the image lapsing into black and white. I don't know that we have seen anything more abstract on screen since *Les Dames du Bois de Boulogne,* or a more perfect translation into images of the moral and mental relationships between beings, or action more independent of external events. Here, nothing other than faces confronting one another, hiding or revealing their truth until that moment when the amassed lie kills more surely than a dagger.

What stays with us of this color film shot in CinemaScope on the Côte d'Azur? The quality of the air and of the water which are inscribed on these faces. Bodies, too, not for their shape or sensuality, but for what they convey about a being: a physical style, a way of walking, an elegance! Their dash or their languor remain in our mind as if etched by a quick linear stroke. The young actress Jean Seberg is at once a marvelously modern feminine type, a brilliant portrait of a young woman, and the embodiment of a moral attitude in its pure state.

Nothing, from start to finish, disrupts or obscures the purity of the melodic line. This film is written in vivid, unfailingly supple sentences stretched toward their object, clear and effective.

Some will say that this was also, or already, in the novel. That may be, but these qualities are far more common in literature than in cinema, and it would be unfair not to acknowledge the boldness of their presence on screen. Yet it is the purely cinematic originality of this purity of writing that is important to discern. The line of the film is as simple as that of the book, but not as a faithful translation: Preminger constructs his mise en scène with specifically cinematic material. It is no exaggeration to say that the heroine's physical appearance is already the symbol of the whole mise en scène, the crystal around which is organized the entire form of the action, its movement and its style.

And this, I fear, is the source of many misunderstandings. It is no doubt true that Preminger did not translate certain important aspects of the book, especially perhaps its sociological backdrop. I grant that his Côte d'Azur is relatively conventional though not false in and of itself, merely limited, reduced to its moral value, like that of the courts for tragic princes: a dramatic condition, at once servitude and freedom.

It is fair and prudent to not lose sight of what cinema jettisons from literature, on condition that we recognize that talented filmmakers occasionally grandstand by making concessions that impoverish them only to enrich us with a form of new knowledge. We can keep our eyes on the falling ballast, but isn't it better to keep our gaze fixed on the basket of the balloon as it launches toward the azure?

Bonjour Tristesse
L'Éducation nationale 14, no. 12,
March 20, 1958
Écrits complets, 2515

NOTE

1. Published in 1953 when Françoise Sagan was just eighteen years old, *Bonjour tristesse* was an astounding popular success and provoked fierce critical debate. The book's French title "tristesse" is rendered in lower case, according to French conventions, but the film, which is an American production, uses uppercase.

Adapting the Classics

Part Three groups Bazin's responses to a staple of the film industry, the sturdy genre of adaptations from grand—mainly nineteenth-century—novels that everyone has heard about and a great many read in school. His reviews of such films only occasionally rise to the level of general speculation that is the rule in Part One and often apparent in Part Two. An important exception is his scrutiny of *The Red Badge of Courage*, where John Huston dared to enter into, though not match, the dialectic established by Stephen Crane between the spectacle of war and the interiority of the main character. Generally, however, when dealing with literary monuments, neither the Classic Hollywood Cinema nor the French Tradition of Quality were adventuresome. Even a big-budget, four-hour rendering could seem little more than a "digest" of a tome in which Tolstoy or Hugo or Stendhal had magisterially woven the inner lives of several characters into the flow of history, gathering all under the ruminations of a narrator. While admitting the vainness of such ventures, Bazin made room for his readers to enjoy the plots, characters, and themes represented on the screen, as these would surely be far more substantial and intricate than what standard genre films generally offer. With so many of his readers familiar with outsized characters like Anna Karenina, Jean Valjean, and Captain Ahab, Bazin made sure to comment on casting. He was also particularly attuned to the settings that were built (or found) to constitute the "world" of Dostoevsky,

Gogol, Dickens. Nor was he automatically opposed to updating or relocating a novel if the resultant film brought out something new and truthful about the original, or if it delivered a stunning cinematic experience. Moreover, thanks to the publicity surrounding major adaptations, even out-and-out failures boosted both sales and discussions of the original literary sources.

To a certain extent, Bazin's concern with fidelity rebukes today's tendency to demote this criterion in favor of promiscuous remediation. At the same time, his frequent invocation of the term "myth" suggests that certain characters and situations transcend even the novels that brought them into the world, so that they are available in the culture at large, ready to play their roles again under new circumstances and in new media. After all, Bazin famously promoted not just "mixed cinema" but all sorts of artistic interchange, as this is evidence of a vibrant culture. And so more than an instinct for journalism led him to dwell on, say, the previous roles and fame of performers, or how mores have changed across the past few centuries. In his mind, just as in the film world, sociological investigation went hand in hand with aesthetics. You need to understand both the rapport between the entertainment business and a mythology that it both purveys and to which it is subject. He recognized the lavish productions of literary monuments to be spectacles, often ludicrous ones, but always indicators of prevailing cultural values that it was his mission and his pleasure to delineate.

Bazin knew French society as a native does, and he had received an advanced degree in French literature; so naturally his writings on adaptations of the nation's classic fiction are especially probing and well-informed. The fourteen pieces in this section, together with the five articles on "Fiction from France" of Part Two and the several pieces on individual films at

the end of Part One, amount to a survey of 240 years of French fiction (1718 to 1958) as refracted on screen. From first to last, from *Manon* (whose conclusion was relocated to Palestine in the turbulent war of 1948) to *Bonjour Tristesse* (whose American director might teach the French something about their own youth culture), Bazin dwelt on the cultural impact of stylistic choices. The novelists whose names give distinction to all these adaptations provide in each case a stylistic measure against which the filmmakers calculate their choices of actors, décor, mise en scène, and other registers, including music, voice-over, and visual tone. As the final piece in this collection intimates, Bazin believed in an evolution of what he once referred to as the "technology of adaptation." Believing in the progress of cinematic prowess, he urged us to expect, and certainly to demand, that more recent treatments of the classics demonstrate what had been learned from the adaptations about which he wrote. And today, looking back at French filmmaking since Bazin's death, we do indeed see topics addressed that previously only novelists would have considered expressing or creating. Thanks to its friendly competition with the novel—thanks even to its often failed and servile commercial exploitation of literature— the cinema has grown up, matured, and now stands alongside the literary realm that has inspired it to be ambitious.

A. The Nineteenth-Century Novel from Abroad

39. Charlotte Brontë, *Jane Eyre*

It figures that English-language filmmakers find the characteristic atmosphere of the Brontë sisters' novels tempting. More sensuous than literature, cinema, which is the art of the image, seems to lend itself to the evocation of this world in which divine curse relentlessly saturates the melancholia of lugubrious landscapes, the eyes of animals, and the blackish moss on the rocks, and is also well suited for the somber faces of the characters struggling in it.

What, then, explains that the adaptations made until now are semi-failures? *Wuthering Heights* (1939) was certainly not Wyler's best film. *Jane Eyre* disappoints as well.

The influence of literature is decidedly gaining ground in Hollywood. Not only do adaptations of novels account for more than three-quarters of all current production, it also seems that films try, as much as possible, to point to their novelistic origins. Thus, from the opening to the closing credits, *Jane Eyre* presents itself as the "filmed version"[1] of the book's main chapters; the transitions, or certain passages of lesser dramatic interest, are simply written out, with the printed page itself shown on the screen.

And yet the film is not an illustration of the novel. The adapted parts are true cinema: their dramatic constructions and their mise en scène are skillful. However, the no doubt intentionally stylized decor and the many studio-built exteriors, while ensuring a greater unity of dramatic atmosphere, also often put us in mind of a dark, animated engraving, as if the

director had sought to create a middle world between cinema's absolute realism and literature's imaginary universe.

It isn't this decision that makes the film disappointing: for all its value, it rarely offers more than a coldly clever use of resources, where genius would have been called for. The overwhelming performance of Orson Welles offsets the film's limitations all the more.

Jane Eyre
Le Parisien libéré, no. 654,
September 20, 1946
Écrits complets, 161

NOTE

Aldous Huxley turned Charlotte Brontë's *Jane Eyre* into a screenplay for this big-budget Twentieth Century Fox production, which premiered on Christmas 1943 in London. Largely because of this film, British director Robert Stephenson would gain entry to Hollywood and crest at Walt Disney Studios. Bazin mentions Orson Welles but not Joan Fontaine, the titular character.

1. Bazin's term, "mise en film," is a neologism he first used in this review. See chap 8, note 3. It appears in his writings on just three other occasions.

40. Charles Dickens,
Oliver Twist

It may simply be that I just do not like Dickens much, or else that David Lean's film accentuates more than it should the somewhat perverse side of this tale of a child martyr. The English novel, and thereby the British cinema, seem to me to have a decidedly distinct taste for mental cruelty and, to be frank, a slight tendency toward sadism. I understand full well that Dickens' genius, like that of Balzac, was knowing how to use the sentimental factors of the popular novel to create a prodigious world, a teeming social universe, and unforgettable characters; but if we simplify and stylize this creation just a bit, what surfaces is the serial novel and its rudimentary sensibility. David Lean, to whom we owe *Great Expectations* in addition to *Brief Encounter,* has surely produced one of the most erudite, refined stagings a novel has ever offered cinema—but not without a distinct dryness and a kind of elegant cruelty that strip Dickens of his novelistic abundance. I would even say that I sense an undue complacency toward the sadism I have already mentioned. So much so that something like anxiety takes hold of the theater, from which, fortunately, the comforting ending relieves it.

I have considerable qualms in uttering these reservations about a film so admirable in so many ways, and which in Venice unfailingly withstood the comparison to *Hamlet.*[1] The sets, the lighting, the photography, the acting—all bear witness to a skill and vision that would doubtless make David Lean one of world cinema's great directorial hopes, were it not for that slightly

worrying dryness and his penchant for a beauty too often sensual and decorative, something we had not yet discerned in *Brief Encounter.*

Oliver Twist
Le Parisien libéré, no. 1275, October 20, 1948
Écrits complets, 501

NOTE

1. For his film *Hamlet,* Laurence Olivier had just taken the Grand International Award at the August 1948 Venice Film Festival, besting David Lean, who had been nominated for *Oliver Twist.*

41. Nikolai Gogol,
The Overcoat

One of the lesser scandals of current film distribution in France is how Italian films are treated. Not a single month passes that does not see the release in a first-run theater, occasionally at least, of some idiotic film of the cape-and-sword, bel canto, or detective melodrama variety, whereas important films have to wait for no good reason, not even from a commercial perspective, to be shown to the French public. This is all the more irritating, as Italian production lacks films of intermediate quality: what isn't in some way good is generally awful, without even the technical and sociological perfection that saves many American B films. To take just one current example: why have we in France not seen *The White Sheik*, a witty, poetic, and charming film that would certainly be a hit, in first-run theaters at least? We are soon supposed to see *I vitelloni*, the second film by the same screenwriter and *metteur en scène*.[1] Bravo. But why not the first film, which is already two years old?

Of all the great Italian *metteurs en scène*, Lattuada may be the one to suffer most at the hands of French distributors. His last two films, *La lupa* and *La spiaggia*, have yet to be released in France.[2] In particular, it is only thanks to the art houses[3] that we were able to see the admirable *The Mill on the Po* (*Il mulino del Po*, 1949) and now also *The Overcoat*, this director's masterpiece, being screened with a two-year lag time. Though it is true that there was no delay in releasing *Anna* (1951), a strictly commercial film that Lattuada only made to pay the bills, but whose worldwide success beat the record earnings of *Bitter Rice*.[4]

The Overcoat is a peculiar adaptation of Gogol's folktale, peculiar in the sense that Lattuada kept not only the basic elements of the plot but also in a certain sense its specifically Slav "fantastique social,"[5] even while the action is set in Italy and in a mise en scène that in no way differs from Italian neorealism. We might note in passing that Italian cinema has always had a paradoxical penchant for Russian authors and has generally managed quite adroitly the transposition of the Slavic world to the Mediterranean. Be that as it may, the synthesis that Lattuada succeeded in achieving—the strange realistic stylization he offers us of a freezing and snowy Italy, which, though not ceasing to be Italy still also remains Gogol's universe, and with just as much accuracy—is a great cinematic success. It attests to his mastery, something we already were aware of, but which in his earlier films was also accompanied by a certain aridity. In this case, Lattuada's calculating rigor, which had been his limitation, is surpassed by a poetry born doubtless of the precision and the complete effectiveness of his resources, but which, by the same token, definitively justifies them.

Finally, to embody his unfortunate protagonist, Lattuada found an actor who until that point had only been successful in music hall buffooneries: Renato Rascel. His extremely endearing persona allows in all seriousness a comparison to Charlie Chaplin.

<div align="right">

Le Manteau
L'Observateur d'aujourd'hui, no. 203, April 1954
Écrits complets, 1552

</div>

NOTES

The Overcoat (Il cappotto) was released in Italy in 1952 and in the United States in 1953. This famous tale has been frequently adapted, with Lattuada's version arguably the finest.

1. Federico Fellini directed *The White Sheik (Lo sceicco bianco)* in 1952 and *I vitelloni* in 1953.

2. Both films were released in the United States in 1954, the first titled *She Wolf* (alternatively, *The Devil Is a Woman*) the second, *Riviera*. *La spiaggia* actually came out in Paris just days after this review, under the title *La Pensionnaire*.

3. "Cinéma d'Essai" is the French term. See "Stephen Crane, *The Red Badge of Courage,*" chap. 43, note 1.

4. *Bitter Rice (Riso Amaro,* 1949) directed by Giuseppi De Santis and starring Silvana Mangano, has generally been taken to be the biggest neorealist hit.

5. Bazin takes the term "fantastique social" from novelist Pierre Mac Orlan who preferred it to "poetic realism" to characterize his fiction and the French films of the 1930s with which he was associated.

42. Herman Melville, *Moby Dick*

There is little doubt that John Huston's adaptation of Herman Melville's sublime masterpiece is a failure, yet that says nothing specific about its value or about the merits of its director. For if we take it as a failure that the film recreates but a small portion of the original poetry and that it doesn't succeed in sparing us tedium (without having, however, dared to translate the book's monumental dimensions, if only proportionally), then fairness and due consideration require that we also measure, alongside the undertaking's difficulties, all that Huston was nonetheless able to preserve. Yet first it behooves us to pay the *metteur en scène* this sizable tribute: he did not betray Melville's message.

In a letter to Nathaniel Hawthorne, the author of *Moby Dick* declared, "I wrote a 'wicked' book."[1] Huston, for his part, can rightfully declare, "I made an intelligent film." For he tried at least to safeguard the essence of what was not understood in Melville's day but what matters to us today in his visionary and calculated novel: the close interweaving, the indissoluble alliance of the event and its metaphysical symbolism. Something which was fortunately accomplished by not severing that symbolism from its physical support (that is, reducing the action to a philosophical metaphor and thereby turning Melville's admirable parable into a bad thesis novel), but by preserving its immanence and ambiguities.

No one can ignore any longer *Moby Dick*'s full debt to what we might call a civilization of the Bible and, through it, an entire implicit metaphysics whose genius is to nevertheless remain on

the level of the image and analogy. This adventure novel is thus itself adventuresome, a veritable theological and moral *summa.* Moby Dick, the invincible white whale, is surely all at once the eternal Leviathan with its hellish maw engulfing humanity mired in sin, and at the same time the instrument of divine justice, whence its immaculate whiteness. As for Ahab, we see from that moment on what the new quest for the Holy Grail becomes—Luciferian and Promethean, demonic and mystical.

Huston thus fully understood that a worthwhile adaptation of *Moby Dick* had to be built simultaneously on the event and on the symbolic. For obvious reasons, it was necessary to condense and simplify, often even to transform; and [so] I don't think we can ever catch Huston being flagrantly uninformed or deceitful. Ray Bradbury[2] (the best science fiction writer whose works are, in fact, a modern form of the Melvillian fantastic) surely advised Huston well, and I believe we can admire almost every clever idea the adaptors dared to substitute or add to the original. For example, when Ahab identifies the spot where the "Pequod" is supposed to encounter Moby Dick, the maritime map shows us the Bikini Atoll.[3] Huston's purely personal initiative fits perfectly the prophetic spirit of the original novel. Similarly, at the end of the film, when contingencies of the special effects compound other adaptation problems, we find remarkable inventions. I am thinking about Ahab's corpse entangled in the harpoon lines attached to Moby Dick's body and whose dead arm, whenever the monster bucks, seems to beckon his companions toward the depths. In the same vein, Starbuck, the second in command, having opposed his captain's obsession throughout the entire film, has a change of heart and abruptly adopts the legacy of his madness. This theatrical moment is not in the book; however, nothing forbade it, and we like to think that

Melville would have thought of it himself had he adapted his work to the screen.

So why, in light of all this, should Huston's film be considered a failure? Because as everything proves, fidelity to Melville's intellectual message was unfortunately not enough to preserve and at the same time transpose the book's novelistic genius. Far longer, wordier, packed with digressions, Melville's *Moby Dick* is never boring. In the film, only the introduction and denouement manage to captivate us. And even at that, the latter is handicapped by having to resort to special effects, which, however deft, can't go unnoticed. Between these two dramatic half hours, there stretches a long story; only the character of Ahab, had he been fascinating, could have compensated for a lack of decisive plot turns. Here, however, Huston made a serious error. Theatrical and superficial, Gregory Peck is an Ahab devoid of mystery. But who could have filled the vastness of this character? Orson Welles, in all likelihood—and his all too brief appearance at the film's beginning makes us cruelly regret his subsequent absence!

A failed film, therefore, yet John Huston's *Moby Dick* is not unworthy of its model. Where so many adaptations of literary masterpieces retain only the most external anecdotes, the failure here is in no way due to stupidity. The point needed to be made.

Finally, I can't conclude without alluding to Huston's experiment with color. The critics have declared their disappointment. I admit to being surprised by such severity. With a few exceptions, which can generally be attributed to the special effects, the stylized color, created by superimposition of black and white photography onto a dominant sepia, produces a remarkable impression of "realistic unreality," very appropriate to the work's feeling. In any case, *Moby Dick* signals in this regard an interest-

ing phase in the development of color; we have already been able to discern through several signs *(Le Mystère Picasso, Nuit et brouillard [Night and Fog])* its tendency toward reabsorbing black and white, which thus ceases to stand in opposition to color and becomes a convention of choice within photographic realism.

Moby Dick
L'Éducation nationale 12,
no. 35, December 13, 1956
Écrits complets, 2182

NOTES

1. Bazin provides this English original in a parenthesis following his French version of the sentence, where he adds quotation marks around "malin" (wicked).

2. Bazin puts "science fiction" in quotation marks, because in his day this genre was less codified in French literature. By the time Ray Bradbury scripted *Moby Dick,* his most popular books, *The Illustrated Man, The Martian Chronicles,* and *Fahrenheit 451,* had been translated into French.

3. [French editor's note] From 1946 to 1958 Bikini island was the site of American nuclear tests. In 1954 an H bomb, a thousand times more powerful than the bomb dropped on Hiroshima, was tested there, obliterating three of the atolls.

43. Stephen Crane, *The Red Badge of Courage*

A cinematic triumph!

This is a great, a truly great film, which brings glory to art house cinema;[1] one regrets only that the theater did not choose a better moment to bring it, at long last, to the Parisian public. Even in Hollywood there are accursed films.[2] *The Red Badge of Courage* is one of these. Based on Stephen Crane's great novel, the film was directed by John Huston, one of the two or three most brilliant directors to have emerged in postwar America, and to whom we owe *The Treasure of the Sierra Madre* (1948) and *The African Queen* (1951). Yet both these excellent films are small stuff compared to the ambition, determination, and rigor John Huston brings to *The Red Badge of Courage.* It is most rare that the screen adaptation of a book is of a quality truly comparable to the original. This was the case for *Journal d'un curé de campagne*, and we come away with the same impression from *The Red Badge of Courage.*

This also explains the many vicissitudes the film has suffered, and why we might not have seen it had it not been for the art house circuit. The film describes the moral experience of a young soldier in the Civil War who, frightened by his baptism by fire, runs from the battle. Soon, however, he gets a grip on himself; deeply ashamed, he learns that his comrades believe him dead or wounded, rejoins his regiment, and takes part in the next attack during which, in a sort of reaction against his fear, driven by an almost morbid need to reassert himself and indifferent to danger, he repeatedly hurls himself into the rage of action, nearly leading to victory.

The viewer, who above all wants to be told a story, may wonder what the film wants to prove here. But the complexity and originality of this work lie in its taking liberties with the novel's character study. Surely Huston wants to prove nothing other than the ambiguity, the profoundly equivocal dimension, of human behavior, and that heroism may merely be a paradoxical form of cowardice. Or better yet, that cowardice and heroism, like so many other virtues and weaknesses, are eminently relative categories, and that the only reality is man.

But through his hero and beyond his individual problem, John Huston also presents us with a vision of war that is of grand depth. The relativity that Huston reveals in his hero's soul serves as the response to the fundamental ambiguity of battles. Fabrice at Waterloo comes to mind.[3] There, though, Fabrice is at the center of a battle whose order or outcome may not even be grasped by the commanders who had conceived and are leading it. Not exactly absurd but on a scale beyond that of the conscience of the soldier dying in that battle.

What is admirable here is that John Huston succeeded in making this sort of metaphysics of war comprehensible through mise en scène—not through abstractions or symbols but on the contrary, through the power of realism, through the sometimes hallucinatory respect for the truth of the detail. We certainly haven't seen anything more perfect in this genre since 1914 [*sic*], in D. W. Griffith's *Birth of a Nation.*

So we can perhaps better understand now why this film, in which there are no women, which lacks a "story" and a happy end, spooked its producers who forced it to undergo some significant mutilations and then added an "explanatory" commentary. And why, even under these conditions, they are barely daring to screen it. For this is one of the most intelligent films of the last ten years!

A detail indicative of the director's determination: the role of the hapless hero is played by Audie Murphy, the most decorated soldier of World War II.

La Charge victorieus; Une victoire du cinéma!

Le Parisien libéré, no. 2758, July 27, 1953

Écrits complets, 1398

NOTES

1. "Art house" is the common English translation of Bazin's term "Cinéma d'Essai" (later "Cinémas d'Art et d'Essai"). Theaters meeting certain standards are given this legal designation that brings with it tax breaks and other benefits to allow them to compete in the entertainment sector.

2. Echoing an epithet applied to Rimbaud, le poète maudit, "film maudit" (accursed film) was applied by postwar cinephiles to works they admired but that had been rejected by the establishment. In July 1949 Bazin organized a "Festival du film maudit" in Biarritz, a foundational event for the New Wave that would break out a decade later.

3. Allusion to Stendhal's novel *The Charterhouse of Parma* and its protagonist Fabrice del Dongo. Believing himself to have the soul of a hero, he goes in search of Napoleon but ends up lost in the midst of the battle at Waterloo, of which he barely understands anything.

44. Leo Tolstoy, *Anna Karenina*

A Beautiful Film with No Soul

It is hard to see how this new version of *Anna Karenina,* undoubtedly the most faithful of the two latest adaptations of Tolstoy's book, can be criticized.

Gathering this enormous novel into a normal-length film was no easy task. Jean Anouilh was quite skillful in his fidelity to it and was able to avoid reducing the film to a series of book illustrations; long chapters are skillfully condensed into a single scene or an exchange of dialogue. As for Julien Duvivier, he gives us here his mise en scène at its most polished. Thanks to what were undoubtedly considerable means put at his disposal for this English production, we never for a moment feel that he is uncomfortable reconstituting the historical and social milieu. This material ease is reconfirmed by the calm, confident, and precise mise en scène.

So what are we complaining about? It is uncomfortable to say. For ultimately, let's be frank: this beautiful film is boring. Everything is here, but something essential is missing, which might well be ... Anna Karenina. Great novelistic characters are not defined by their stories. They exist above them; they inhabit us even when we have forgotten the plot twists. The novelist can take as much time as he wants to haunt our imagination, page after page. However, a film cannot be reread and so must act more rapidly and more powerfully through the actor's mysterious radiance. The spectator could not care less about fidelity to the book if he is unable to profoundly love its hero. But Vivien Leigh, whose acting is excellent, unfortunately does not possess the superhuman *aura* that made for Garbo's charm and that renders

unforgettable the image of an actor who then forever remains identified with her character. The rest of the cast, from which we did not expect the same brio, is, as usual in England, perfect. Naturally, the great Ralph Richardson will be singled out.

Anna Karénine; Un beau film qui
manque d'âme
Le Parisien libéré, no. 1465, May 31, 1949
Écrits complets, 606

NOTE

Alexander Korda's 1947 British production was the eleventh of the many adaptations of *Anna Karenina.* The previous one, directed by Clarence Brown in 1935, had starred Greta Garbo with whom Vivien Leigh would inevitably be compared, and to her detriment. Although the prolific and well-known French playwright Jean Anouilh wrote the initial script for Duvivier, Korda, a powerful producer, found his existentialist slant too distant from Tolstoy and replaced him with a younger writer. This expensive and much publicized film fared poorly with the critics and the public alike.

45. Fyodor Dostoevsky, *The Brothers Karamazov*

A Worthy Adaptation

I will borrow a good definition of the difficulties of his undertaking directly from this film's adapter and director, Richard Brooks: "Dostoevsky's *Brothers Karamazov* brings together the characteristics of a crime tale, a passionate love story, a psychological thriller, a novel about religion on the Oedipal theme, Russian mores in the late 19th century, the revolt of the Russian peasantry, the emergence of a Russian middle class, the birth of Russian nationalism Putting all of *The Brothers Karamazov* into a single film would require a ten-hour screening. How can such an extraordinary story be told in 90 minutes? What had to be kept? What could be omitted? Compressed? Telescoped? Which characters would we keep?"

Richard Brooks made an effort to answer all these questions honestly and with a lively intelligence; it would be churlish not to acknowledge this, for starters. He didn't limit himself to turning Dostoevsky's enormous novel into a superficial and therefore dishonest "digest."[1]

We sense how thoughtful and skillful his work is despite the inevitable criticism about keeping this or that scene rather than another: yet he had to cut to the quick!

If, however, the spectator who remembers Dostoevsky is not satisfied, it is doubtless because he could not be satisfied in the first place, the very best adaptation being in this case just a poor substitute, given such a full and rich work. Yet it could also be that Brooks' very honesty and intelligence do a disservice to the undertaking. He wanted to keep too much. Things had to be

simplified, but an acceptable vantage point for simplifying was also needed. Jacques Copeau's stage adaptation was successful in this regard,[2] but Brooks pruned both too much and too little, finally retaining neither the benefit of simplification nor fidelity.

Having expressed these reservations, I must say that I was rather favorably surprised at something that might well have been worse: the film is respectable and warrants being seen, even if we still remember the book. It may be that the mise en scène was worked out with greater insistence than grace, but it does have some power. Yul Brynner is an excellent Dmitri but Maria Schell a very disappointing Grushenka. No question that this is the film's most egregious error. It makes us long for Marilyn Monroe.

<div style="text-align:right">

Les Frères Karamazov: Une adaptation
digne d'estime
Le Parisien libéré, no. 4262, May 26, 1958
Écrits complets, 2575

</div>

NOTES

1. Bazin brings back this term to which ten years earlier he had dedicated an entire article. See "Cinema as Digest," chap. 3, unnumbered note.

2. Jacques Copeau launched his career as an important theater director (and actor) in 1910 with his adaptation of *The Brothers Karamazov*. He revived this production frequently right up to his death in 1949.

46. Dostoevsky, *Crime and Punishment*, alongside Tolstoy, *War and Peace*

The law of series operates in cinema just as it does in rail and air disasters. No cause-effect connection optimally ties together the almost simultaneous releases in Paris cinemas, just after *Moby Dick*, of four adaptations of celebrated novels: *Crime and Punishment, War and Peace, Notre-Dame de Paris,* and *Michel Strogoff* (moreover, Laurence Olivier's adaptation of *Richard III*, another literary, albeit theatrical, classic soon followed).[1] Still, the coincidence demands reflection, and invites us to make a comparative critique.

This whole review, however, would be quite inadequate for an analysis of even one of these four films, with our reasons for praise or condemnation. You will have to forgive me in advance for these necessarily concise briefs.

CRIME AND PUNISHMENT

First, since we have been given two Russian novels, let's group them together and judge them. *Crime and Punishment* was adapted by Georges Lampin, who had already adapted *The Idiot* (1946), starring Gérard Philipe. Let's recall that Pierre Chenal had already adapted Dostoevsky's famous novel in 1936, with Pierre Blanchar playing Raskolnikov.[2] As the critics have been unanimous in panning this newest version, I have fewer qualms about withholding my own detailed reasons for criticizing it and will merely note that this is an example of an ambitious but failed adaptation. We would not automatically hold it against Georges

Lampin and [scenarist] Charles Spaak for wanting to update the novel's events and characters. Dostoevsky was Raskolnikov's contemporary and compatriot, after all. Unfortunately, in this case, the operation was inconceivable. *Crime and Punishment* is a metaphysical novel: forces larger than psychological determinism drive the characters' motives, but even so, they are expressed through the psychology of a people and a society. We would have to misunderstand this link to believe that we could transport the metaphysics of *Crime and Punishment* wholesale into the conditions of postwar France by turning Raskolnikov into a vaguely existentialist student. Wanting to preserve the characters' religious sensibility in particular leads to something ridiculous. *Crime and Punishment* is thus brought down to the level of a French "film noir," whose conventions of "wretchedness" would add to the intellectual pretensions of an utterly implausible screenplay.

WAR AND PEACE

Tolstoy's monumental *War and Peace* seems by definition to be far more difficult to turn into a film than Dostoevsky's novel, and the millions of dollars that King Vidor spent in Italy to trump *Gone with the Wind* (1939) did not make for a reassuring guarantee. However, having seen the film twice, I'll take a chance and say that more talent and, especially, more personality could have been brought to bear on the mise en scène and more finesse on the syntheses required to reduce a three- or four-thousand-page novel to a three-and-a-half-hour film, but it was difficult to avoid the pitfalls of the undertaking even with more honesty and intelligence. There are two complementary criticisms to be made of *War and Peace*. Cinematically, the film

lacks inventiveness, or more exactly, personality. Vidor's lyricism doesn't resonate, and anyone with Vidor's authority and experience could have made the film. But such anonymity is the price of the enormity of this undertaking. Given such monstrous finances, cinema is the producer's business, not the auteur's. Too many imponderable (or ponderable) contingencies come into play. Then again, American cinema is probably alone among the world's cinemas in possessing an anonymous style, borne in equal measures of experience and first-rate organization. King Vidor's role was clearly and above all to supervise. But the monument stands erect: it is solid, square, and balanced, and if it doesn't reflect King Vidor's personal qualities, it does possess at least the qualities of American cinema as such, especially clear in the admirable direction of the actors.

Still, it would be all too easy to criticize, this time by comparison with literature, the adaptation's inevitable schematization compared to the inexhaustible wealth of the novelistic material. And, of course, we would do best not to reread any chapters of *War and Peace* before going to see the film. But with the exception of a few unfortunate details (the Napoleon character, in particular), we cannot brand the film's simplifications as betrayals. We can even say that King Vidor was able, after all, to accurately preserve the Tolstoian equilibrium in the characters' destinies between historical and social causality, on one side, and personal factors, on the other. The importance given to reenacting the battles is not simply an excuse for spectacle but bears on the very essence of the narrative. It seems to me that the film *War and Peace* could only irritate those for whom Tolstoy's novel is vividly present. For the viewer who doesn't know the novel, or who has only a dim memory of it, this adaptation is a very worthwhile condensation, lacking genius, perhaps, but

brimming with the anonymous talent of conscientious crafts-men. In any case, I believe that the film is an acceptable approxi-mation of a novel that will attract hundreds of thousands of new readers thanks to King Vidor.

Next week, we will discuss whether we believe that *Notre-Dame de Paris* and *Michel Strogoff* warrant the same degree of respect or indulgence.[3]

Quatre romans, quatre films. I.
Dostoïevski—Tolstoï
L'Éducation nationale 13,
no. 1, January 3, 1957
Écrits complets, 2200

NOTES

1. John Huston's *Moby Dick* opened in Paris on November 14, 1956; Bazin reviewed it immediately (see chap. 42). All four films under scrutiny here came out in December.

2. Pierre Chenal's striking "poetic realist" version was actually released in 1935, just ahead of Josef von Sternberg's, in which Peter Lorre starred.

3. See chap. 52 for the second installment of the two-part article, which Bazin entitled "Quatre romans, quatre films."

B. French Classics on the French Screen

47. Abbé Prévost, *Manon Lescaut,* adapted by Clouzot

By making Abbé Prévost's famous novel as contemporary as possible, Henri-Georges Clouzot undertook something not unlike what Prévert did in his *Les Amants de Vérone.*[1] He also had to deal with several pitfalls typical of the genre, but overall, *Manon* stands out as a grand success.

No summary can improve on Clouzot's own remark: "I let myself get caught up in the game of wondering what a Manon, what a des Grieux, or what a Lescaut would be and would act like today, and more exactly, in 1944 immediately after the Liberation."[2] The film is his answer. Manon is a little country tramp saved by [Robert] des Grieux at the very last moment from having her head shaved by the villagers; des Grieux is a young resistance fighter who escapes with Manon in a stolen jeep, and [her brother, Léon] Lescaut is a vile black market dealer. The couple's adventure will come to an end in Palestine, with the massacre of the convoy of Jews that they had joined.

It takes all the talent and power of Clouzot's mise en scène to carry off this wager, for the charm of this legendary couple lies in the irreducible purity of their passion despite the many dishonest compromises into which Manon's fecklessness drags them. It's the resurgence of the old Tristan and Isolde myth in a period of revolutionary decadence; it's Manon's declaration that "when you love one another, nothing is disgusting." I simply wonder whether it is possible to transpose the portrait of manners that serves as the novel's backdrop into something so contemporary and close to us without compromising the viewer's necessary sympathy: after all,

a modern spectator's interest in current social events is entirely different from that of the eighteenth-century reader. The contradiction is painfully palpable at the end of the film, when Manon and des Grieux follow the Jews in their exodus. Will we pity the lovers or the unfortunate people who will die at the border of the Promised Land? Clouzot would surely like his characters to elicit our sympathy despite their (guilty?) indifference toward the social tragedy in which they accidentally participate. Yet he must respect the ancient dramatic law of unity of interest and pity. After Buchenwald, after *La Dernière Chance*,[3] after the Resistance, the film cannot be both about Jews and about Manon Lescaut. The spectator weeps at the death of the little whore, yet the awful massacre of a hundred Jews should also draw tears.

That said, I already fault these observations for being overly subtle and denying me my pleasure. For these weak reactions cannot withstand the torrent of images in Clouzot's mise en scène, in which violence sweeps everything away; the exodus episode is precisely one of the film's most beautiful moments. If it makes us think of John Ford or of the Lindtberg of *La Dernière Chance*, it is because Clouzot is the only French director today who can sustain such crushing comparisons.

As for Cécile Aubry, what is there to say other than that her face has already replaced Manon Lescaut's name in our memories.

Manon
Le Parisien libéré, no. 1400, March16, 1949
Écrits complets, 563

NOTES

1. In two reviews he had just penned, Bazin expressed reservations about André Cayatte's *Les Amants de Vérone* (*The Lovers of Verona*),

a cleverly updated version of *Romeo and Juliet* written by Jacques Prévert.

2. At the opening of Abbé Prévost's canonical novel, the heroine, Manon, is caught up in the scurrilous world of her brother, who prostitutes her, until she is rescued by the noble, idealistic, and passionate Robert des Grieux, with whom she runs off and then drags down morally.

3. *La Dernière Chance* (*The Last Chance,* Leopold Lindtberg, 1945) recounts a desperate trip made by a motley group of refugees (including Jews) toward the safety of Switzerland during World War II. It won Grand Prize at the first Cannes festival in Autumn 1946.

48. Honoré de Balzac,
Eugénie Grandet

We could put our heads in the sand, of course, and be outraged that a novel as famous as Balzac's *Eugénie Grandet* should have been filmed by an Italian director, on sets that clearly have nothing to do, at least geographically, with Balzac's region around Tours. But to do that, for purposes of comparison, we would have to come up with at least one good example of a French film based on Balzac. Italian cinema doesn't run the risk of betraying Balzac any more than French cinema has done until now. And when all is said and done, this *Eugénie Grandet* is not all that foreign to Balzac's heroine. In the absence of authentic landscapes, Mario Soldati recreated a rather artificial Saumur in the studio, and so we often sense the stucco and the "wings" of painted sets, but given the novel's fundamentally psychological nature, the film may gain from them a somewhat theatrical emphasis, which is not always to its disadvantage.

<div align="right">

Eugénie Grandet
Le Parisien libéré, no. 1281, October 27, 1948
Écrits complets, 504

</div>

NOTE

Alida Valli plays the title character in *Eugenia Grandet* (Italian title), which premiered at the Venice Film Festival in September 1946. She had become famous alongside Mario Soldati, a playwright and literary scholar, when he directed *Piccolo mondo antico* in 1941. Valli soon would star in Hitchcock's *The Paradine Case* and Carol Reed's *The Third Man*.

49. Stendhal, *La Chartreuse de Parme* (The Charterhouse of Parma)

It would certainly be unfair to judge *La Chartreuse de Parme* by Christian-Jaque, Pierre Véry, and Pierre Jarry solely on the basis of its relationship to Stendhal's novel.[1] In this respect, the film is clearly a betrayal in more ways than one. Even if we acknowledge the simplifications required to make the film comprehensible, which don't work well with the novel's thousand detours and overly numerous characters, the adapters were no more than relatively faithful to the very spirit of the book. Stendhal's characters do not love like that. Their passions are woven with greater subtlety into the fabric of a society whose mores are cruel and liberal, anachronistic and decadent. And then there is the Stendhalian psychology, the famous "crystallization" that slowly constructs love on the basis of a word, a shape, a look: in the film, the birth of the mutual feelings between Clélia and Fabrice is virtually unintelligible.[2] The two young people barely saw one another through the chink in the prison wall. For these characters to work on screen, Christian-Jaque had to emphasize their primary qualities, sometimes with practically intolerable caricatures and in any case very un-Stendhalian ones, for example, Salou as the cowardly, perverse, tyrannical prince, and Coëdel in the role of chief of police.

But I believe that condemning the screen version of *La Chartreuse de Parme* by comparing it with Stendhal would be not only an injustice but also a mistake.

If we consider the great majority of spectators who will not have read or reread the novel, and forget this inaccessible model,

we have to agree that we are in the presence of a rather sensational film, not only for its dimensions and the well-thought-out luxury of the sets, perfectly integrated into both the action and the exteriors, and the prestige of an exceptional cast, but even more and above all for the interesting characters. It's fair to say that they are poor with respect to those of Stendhal, but they are also far richer than those we normally see at the cinema.

Louis Salou and Coëdel lack nuance in their vulgarity. Renée Faure is a rather unimpressive Clélia, but Maria Casarès' brilliant authority manages to make us forget that she probably lacks Sanseverina's physique. And if Gérard Philipe is not altogether Fabrice del Dongo, we cannot hold it against him, nor even regret it, given that he plays this novelistic hero with as much ease and grace as the script requires.

La Chartreuse de Parme
Le Parisien libéré, no. 1149, May 26, 1948
Écrits complets, 435

NOTES

1. One of the most influential French novels of the nineteenth century, *La Chartreuse de Parme* follows the adventures of Fabrice del Dongo over the first third of that century. From the fall of Napoleon at Waterloo to court intrigues in Parma, where Fabrice eventually is appointed a church vicar, he becomes involved in love affairs, assassinations, and prison escapes.

2. Stendhal elaborated his notion of "crystallization" in *De l'Amour* (1822); see chap. ii, note 9.

50. *Le Rouge et le Noir (The Red and the Black)*: Tastes and Colors

We could—and will always be able to—quibble with Autant-Lara and his screenwriters about their adaptation of Stendhal's masterpiece. But can we hold them responsible for the habits of commercial cinema, which is what forced them to reduce to three hours of screen time novelistic material that could still be mined at three or four times that length? Still, even these three hours upend the usual conditions of film exhibition. Rather than bitterly compute what Aurenche and Bost sliced off of Stendhal, wisdom and fairness dictate that we first praise them for what they were able to salvage for our pleasure from this dense and admirable book.

Le Rouge et le Noir is not difficult to summarize: the short life of a young man from the provinces, from modest origins but with enormous ambition, who, in the Restoration's mediocre bourgeois or aristocratic society adopts as the guiding principle for his personal life, if you will, a sense of risk and glory, an echo of nostalgia for the faded empire.

Julien Sorel's every act and even his every passion display this ambiguity between the youthful fierceness of a fiery temperament and the calculating cynicism of a lucid but not vile ambition. Intelligent and handsome, Julien Sorel benefits rather easily from the exceedingly favorable prejudices of his well-born employers, and in rapid succession wins the hearts of two women, as seductive as they are different in character, Madame de Rênal and Mathilde de la Mole. He would have succeeded in marrying the latter, had the former not revealed their previous liaison.

Out of anger and spite (or perhaps out of love?), Julien twice shoots and gravely wounds Madame de Rênal during Mass. Condemned to death, he will retain his disdainful insolence of refusing a reprieve despite the forgiveness and supplications of his two lovely mistresses, and elegantly ascend the gallows.

But what no summary could possibly convey is the picture Stendhal paints of Parisian and provincial society during the Restoration, a rendering unparalleled in the rigorous precision of its elements and its critical judgment, whether explicit or implied.

A whole world arises in our imagination as we read the novel, a world more exact and vivid than any depicted by even the most talented historian. But this also goes, doubly even, for the personalities and the characters, drawn with such vitality and obsessive precision that a filmmaker could neither dull them nor turn them from their original meaning without incurring our severest objection.

Clearly this entailed heavy responsibilities, surely heavier even than those so recklessly betrayed in Christian-Jaque's adaptation of *La Chartreuse de Parme*.

Let's say right off that, to their credit, Autant-Lara and his screenwriters seem to have aced the essentials. Rarely has cinema put in front of our eyes and our thoughts such well-grounded characters, whose existence comes through with such incontestable evidence, yet who are so rich in nuance, so fluid in their thoughts and feelings, and—to summarize in a word—so authentically novelistic.

It was to Gérard Philipe—obviously—that the formidable honor fell of embodying Julien Sorel. The role suited him a priori so well that one could be justified in anticipating disappointment. He is perfect here. And we can easily gauge both the actor's progress and the second film's superiority by recalling

that the Fabrice of *La Chartreuse de Parme* was merely a Fanfan la Tulipe *avant la lettre.*[1]

Danielle Darrieux's prowess might be more surprising still, for while Julien Sorel's role seems to have been written for Gérard Philipe, this choice for Madame de Rênal might have been questionable. It now confirms Danielle Darrieux as a magnificent actress, here with a flawless performance and faultless tone. Antonella Lualdi's performance is no doubt somewhat more problematic, but it may also be that Mathilde's character was clearly more difficult. At least her incarnation of the character is seductive and avoids mischaracterization.

If, however, by way of conclusion, we must choose some reservation from among the many that such an undertaking must inevitably elicit, it would perhaps be a regret that the historical or social aspects of the adaptation are not always as satisfying as its psychological aspects (although there certainly are some good moments). But choices had no doubt to be made, and perhaps Autant-Lara was ill served by the resources at his disposal, especially the inadequate sets. The color may be excellent at times, but at others, alas, it betrayed him disagreeably....

> *Le Rouge et le Noir,* Des goûts et des couleurs
> *Le Parisien libéré,* no. 3156, November 4, 1954
> *Écrits complets,* 1617

NOTE

1. *Fanfan la Tulipe* (1952) was Gérard Philipe's biggest box-office success in a career of many hits. Christian-Jaque cast him as the dashing title character in this swashbuckler, after having directed him, Bazin implies, in rather the same lightweight manner in Stendhal's *La Chartreuse de Parme (The Charterhouse of Parma)* in 1948, where he played the hero, Fabrice. See Bazin's review of the latter film, chap. 49.

51. Victor Hugo, *Les Misérables*

We know that Victor Hugo's famous novel may be the book most often adapted for cinema anywhere in the world. American, Italian, Soviet, Indian, and Japanese versions exist, based on all or some parts of the narrative. France has seen three noteworthy adaptations: Capellani's, in four episodes (1912); Henri Fescourt's in 1925 with Gabriel Gabrio; and eventually the first sound version made by Raymond Bernard in 1934, at no fewer than 9,000 meters of film divided into three episodes. Its shortened two-episode version starring Harry Baur, Charles Vanel, Charles Dullin, Jean Servais, Max Dearly, Florelle, etc., could still be seen during and even after the war.[1] We agree to remember it fondly. The effort may have lacked genius, but at least it was directed conscientiously, by a director for whom Pathé spared no expense on technical resources.

And still we had to wait nearly twenty-five years for a new "French" version. I put "French" in quotation marks, as most of the film was, in fact, shot in East Berlin. No French producer today would want to shoulder such a risk on his own. The nature of this popular scenario effectively demands, beyond significant historical reproductions, a film whose length is barely compatible with cinema's commercial habits; not that exceptions can't be made, but one must then be quite sure the undertaking will succeed.

However, success does not depend on technical resources alone; there is also the matter of the style to be adopted, and this is no doubt where the danger is greatest. This, in any case, is what Le Chanois wasn't able to avoid.[2]

We can debate whether it still is possible to translate the style of a novel like *Les Misérables* to the screen, and if so, by what adjustments. In reading the novel, we accept its melodramatic quality, its lyrical outbursts, its "I swear on my mother's grave" devices, its serial-novel Manichaeism enhanced by the Hugolian antithesis, but making these elements work in cinema as it has evolved—at least in France—is difficult. For film is not a neutral, endlessly malleable means of expression: it has its specific development. In the early sound film era, the general style was still quite compatible with melodramatic conventions of both acting and plot. Since then, realism and neorealism have accustomed us to other demands. We need only compare the thoroughly expressive acting of a Harry Baur with Jean Gabin's formula of magisterial sobriety;[3] admirable, certainly, but can *Les Misérables* be remade in a sober register? Meaning that, lacking the particular genius of an Abel Gance, for instance, this type of subject is no longer supported by contemporary cinema the way it was during Raymond Bernard's years.

Still, genius being absent, perhaps the enterprise might still be justified by taste. I wonder, for example, whether melodramatic stylization, removed from the acting and the plot, couldn't have been transposed into the plasticity of the image and—since the film was a color production—an equivalent (or an evocation) of Épinal-type imagery[4] might have been sought. But this film is as short on taste as it is on genius, and I doubt that we have seen uglier or, in any case, less successfully stylized colors on the screen for some time.

As for the adaptation, it is faithful, yes, but absurd, for everything unfolds as if Le Chanois, embarrassed by the excesses of his subject, had labored hard to avoid them. What he shows us on screen are the "connecting shots" preceding or following the

"obligatory" scene. It might be said that this is exactly because such scenes could no longer be done in a respectable manner. But then, why make *Les Misérables?* Nor do I understand why, having decided, with René Barjavel,[5] to include voice-over commentary for the deleted episodes, were they so ashamed of their approach that they used only a few of Victor Hugo's sentences? Then the film recovers immediately, we listen up: at last a powerful wind fills this slack sail laboriously dragging our boredom. And we find ourselves imagining that the spectator might at least have been granted the pleasure of listening, in the absence of the pleasure of seeing.

Les Misérables
L'Éducation nationale 14,
no. 13, March 27, 1958
Écrits complets, 2522

NOTES

1. Raymond Bernard's much-lauded 1934 version initially played in three ninety-minute installments in France (and later in Japan), but by summer 1934 it was shortened to the two-part version Bazin here recalls. For its 1936 American release, the original was cut by two hours but still ran 160 minutes. The full version became available on DVD in 2012.

2. Jean-Paul Le Chanois had transformed himself from a communist director in the 1930s to a director of star-studded films in the Tradition of Quality who was demeaned by François Truffaut and his fellow critics.

3. Jean Gabin, fifty-seven-years old at the time, played Jean Valjean with inveterate self-possession.

4. "Imagerie d'Épinal" is the name of an exceedingly popular style of brightly colored nineteenth-century prints of traditionalist, naïve, and sentimental images.

5. René Barjavel (1911–1985) was a widely read novelist who, in 1944, wrote a theoretical essay, "Cinéma Total," that may well have influenced Bazin. In the 1950s he worked on more than a score of screenplays.

52. Victor Hugo, *Notre-Dame de Paris*,
alongside Jules Verne, *Michel Strogoff*

For all their differences in terms of literary merit, from the viewpoint of cinematic adaptation, the novels of Victor Hugo and Jules Verne have a lot in common. Both of them are popular works in the two senses of the word, in intention and in fact—which is not something that can be said about *Crime and Punishment* or *War and Peace*.[1] We thus have to consider that such popularity creates a double paradox for film adaptation. Moreover, the Russian novel, just like the Stendhalian, Balzacian, or Flaubertian novel, for that matter, presumes the creation of deep characters within the novel's "three-dimensional world." By contrast, the nineteenth-century's "popular novel," whether written by Hugo or by Georges Ohnet,[2] is, if I may put it this way, "flat." Its characters are little more than symbols; their existence lacks density, liberty, or ambiguity. One can, of course, posit a hierarchy between *Les Misérables* and *La Porteuse du pain* but only within a shared aesthetic.[3] Hugo's symbolism is richer, more potent, and more poetic, but his characters have little psychological existence, little ontological mystery.

It follows from this a priori that cinematic representation, which tends to simplify, schematize, and impoverish a Stendhal, Tolstoy, or André Gide, unless one is quite careful, burdens the characters of "popular" novels with an unnecessary supplement of existence. No matter how mediocre an actor's incarnation, his physical reality conveys an invitation of sorts to an existential mystery. Therefore, the challenge is the opposite of the one facing a filmmaker adapting a "three-dimensional" novel, for the

latter must preserve depth while his colleague has to figure out how to make the demands of psychological realism irrelevant. This is the paradox that explains why Jean Delannoy could make an honest *La Symphonie pastorale* (1946). All that was needed was a conscience, craft, and a minimum of intelligence: the operation still ended with a positive balance sheet. However, talent alone was not enough to bring over *Notre-Dame de Paris;* a style was needed to make us acknowledge the colossal naiveties of the original, a breath of life, a lyricism that could make the characters swirl so swiftly that we have no time to worry about their souls. In short, we were not supposed to dwell on matters of dramatic verisimilitude or psychological realism. Prévert and Aurenche's script for this adaptation combines intermittent fidelity to the letter with a betrayal by omission. As for the mise en scène, in addition to its lack of inventiveness and warmth, it also suffers a priori from two insurmountable handicaps that might well be closely related. First, the near impossibility of making the architectural presence of Notre-Dame tangible: no model or set can really convey the mineral soul of the stones. Then there is color, which to me seems contrary, if not to Victor Hugo's genius in general, then at least to the genius of his novels. What's more, black and white would have made the transposition even more romantic. Draped in rainbow hues, Hugo's famous figure of antithesis becomes ridiculous.

It's only a small step to *Michel Strogoff*! For Jules Verne's novel, the *metteur en scène* also had to satisfy respect for a tradition.[4] It would be easier to defend the broad liberties taken by Aurenche, Prévert, and Delannoy's adaptation of Hugo than to approve those that Carmine Gallone has taken with Jules Verne. What is left, really, of this type of book on screen, if we do not recognize a faithful rendering of our memories? That said, a few of the

transpositions are well done, such as changing the French and English reporters into right-wing and left-wing journalists—but on the other hand, what a dumb idea to replace the marvelous "scientific trick" of the (cooling) tears by introducing a beautiful female slave.[5] But it may simply be a mistake to adapt *Michel Strogoff* today. It was "modern" when it was published, yet now seems obsolete and naïve—which is hard to reconcile with the emotion that the heroic courier of the czar should be arousing. The best literature, therefore, is not the most difficult to adapt for film. It may well be, in fact, that popular literature is less ideally suited to the most popular of all the arts.

<div style="text-align:right">

Quatre romans, quatre films. II.
Victor Hugo—Jules Verne
L'Éducation national 13, no. 2, January 10, 1957
Écrits complets, 2206

</div>

NOTES

1. These Russian novels were compared by Bazin in the first install-ment of an article in two parts on recent adaptations from the classics that he called "Quatre romans, quatre films." See chap. 46, note 3.

2. Georges Ohnet (1848–1918) was an exceptionally popular novelist, attuned to the tastes of the late nineteenth-century reading public, but disdained by serious critics, who found him facile.

3. Though a third its length and with none of the critical bite of *Les Misérables*, Xavier de Montépin's *La Porteuse du pain* (1884) was a tremendously successful, unalloyed melodrama. Both these novels were adapted to film in virtually every decade of the twentieth century.

4. At least thirteen screen adaptations of Jules Verne's 1876 novel exist. Carmine Gallone's was the top box office hit in France in 1956.

5. Discovered to be a spy, Michel Strogoff, a courier of the czar, is sentenced to be blinded by a white-hot sword passing in front of his

eyes. However, seeing his mother standing near, he tears up to such an extent that his corneas are protected by volatilization. As farfetched as this scientific deus ex machina may be, Bazin prefers it to this adaptation's more natural ruse involving a slave girl who sweet-talks the torturer into sparing the hero's sight.

53. Zola and Cinema: *Pour une nuit d'amour (For a Night of Love)*

Late nineteenth-century naturalism obviously tempts many screenwriters and directors. We have Zola and Maupassant to thank for many films, from *Nana* to *Bel-Ami* and from *Pierre et Jean* to *La Bête humaine, Naïs* even. Their works offer the filmmaker the opportunity to recreate a picturesque era, as well as the advantage of a powerful, dramatic portrait of society and exceptional characters. Ought we to consider that this literature is less easily converted to cinema than we imagine? Whatever the case, and if we exclude Renoir, who by his temperament and the legacy of his father—the painter—was predestined to cinematic naturalism, Zola has barely any more posthumous luck with the screen than Balzac. Gréville's film, *Pour une nuit d'amour,* will not disprove this.

Odette Joyeux, cast since *Le Mariage de Chiffon* and *Douce*[1] in roles of turn-of-the-century girls and in the service of perverse ingénues, plays in this film a frail adolescent fresh out of convent, whose impoverished provincial family with a dulled crest wants to marry her off to an aristocratic fop. But this child of "a good family" has long been the lover of her foster brother (both had the same wet nurse), whom she kills in a jealous scene on the day she gets engaged. To hide the evidence of her crime, she asks the taciturn postal employee (Roger Blin), who is madly in love with her, to dump the body in the river. If he wants, she will repay the favor with her self. An accomplice, therefore, to the murder, Roger Blin will naturally be suspected but, utterly unrequited in his love, will not even demand his paltry fee. On

297

the wedding day, rather than taking revenge by making a scene in the church, he silently turns himself in to the police.

Such an exceptional situation and array of psychologies demanded a lot of the actors. Neither Odette Joyeux nor Roger Blin can be faulted: each had the temperament, physique, and intelligence necessary for their roles. It's the adaptation and the mise en scène one must blame. Odette Joyeux was persuasive in *Douce* playing a character much like this one, but director Claude Autant-Lara's work was of a different order of subtlety when it came to the psychological and social details. Certainly, Edmond T. Gréville's directing does not lack for qualities: often elegant, occasionally refined in its plastic composition, but it also fails in its useless aestheticism that is too outside its subject matter. A bit more psychological verisimilitude and a tighter dramatic line would be far more satisfying.

> Zola et le cinéma:
> *Pour une nuit d'amour*
> *Le Parisien libéré*, no. 832, May 21, 1947
> *Écrits complets*, 269

NOTE

"For a Night of Love" is the title story of a collection of three that Émile Zola, a novelist not known for this genre, brought out with real success in 1883. Edmonde T. Gréville's adaptation, *Pour une nuit d'amour,* played in New York in 1948 under the title *Passionnelle.*

1. These were among the most successful films made during the Occupation. Directed by Claude Autant-Lara and scripted by Jean Aurenche, they helped establish the "Cinema of Quality."

54. Émile Zola, *Thérèse Raquin*, adapted by Marcel Carné

For the first time since we have been collaborating on the last pages of this journal, neither Doniol-Valcroze nor I could readily give up reviewing a film for the benefit of the other.[1] Each of us had too much to say. We thought that friendship should not be the deciding factor, and that after all, the work was sufficiently important to warrant being written about twice. Yet I'm afraid that in this split I have assigned myself, if not the hardest part of the task, then at least the most thankless, for my critique will seem to add nothing to Doniol-Valcroze's except reservations. Allow me, therefore, to say that I consider *Thérèse Raquin* to be a great film, certainly an admirable and salubrious work, whose nobility of intention and style is a welcome break from the "films of quality" quietly strangling today's French cinema. I admire in it the conscience of a filmmaker who never cheats with his art, and the mastery of a director whose talent may well have here reached its apex. True, if we put our minds to it, we can detect some weaknesses, but these cannot diminish the immediate magic of the images, images whose plain fullness, with their intimate and masterfully spare perfection, are reliable indicators of evolution and progress beyond the flamboyant baroque of *Les Portes de la nuit* (*Gates of the Night*, 1946) and *Les Enfants du paradis*. This is what had to be said before any "critiques," whose thrust thereby becomes entirely relative.

Yet despite everything, I can't stop myself from seeing in *Thérèse Raquin* the drama of Carné's aesthetic: rendering characters into myths.[2] So it is worth our while to analyze this unusual

adaptation! Carné was under no obligation a priori to modernize his story. If he did so, it was to get away from Zola's naturalism, the complete opposite of the "poetic realism" in which Carné feels comfortable. The social fantastic of *Les Enfants du paradis* was sanctioned by the beginning of romanticism.[3] But by being equivocal, "realism" would have fallen apart in the social context of the late nineteenth century. If the concept of fate, so dear to Carné, exists in Zola, it is purely social. Social mores make this apparent. There is nothing metaphysical about fate in the novel. Yet in the way he adapts Zola, Carné aims precisely to make fatality external to the characters, as in *Les Enfants du paradis*. That said, we should not be fooled by the personification of fate played by Jean Vilar.[4] This transcendence was already present in the prewar works, albeit less explicitly and distributed across several characters.

In Zola—Carné himself admits—the crime had a specific social cause: the impossibility of divorce. *Thérèse Raquin* is a plea for divorce. Obviously such a contingent dramatic device does not add up to a tragedy, and Carné says he wanted to pare down the story's details to heighten its tragic dignity. Yet he also needed to preserve some psychological verisimilitude, thus the invention of her scruples to explain Thérèse's attachment to her husband despite the violent desire Laurent awakens in her. I'll skip over the error of casting Simone Signoret (otherwise excellent) in this context, for how to believe the rationalizations of this solid and sensual young woman? Let's get to the more significant character of Raf Vallone.[5] Here the author's dramatic obsession is on display with a touching naïveté. A Carné hero cannot, by definition, carry out his crime willingly, because were he to do so, he would cross over to the side of *evil* and no longer be a tragic victim of fate. Yet, at the same time, he must

be personally responsible so as to be both the subject and the object of fatality. It was in Jean Gabin that Carné had both found and perfected his ideal tragic hero, as much because of Gabin's physical presence as because of the character he had created for himself from film to film. We accepted his fundamental impulsiveness, and that it was his very generosity that led to an uncontrollable, lethal anger. This—in vain—is what Carné tries to convince us of with Raf Vallone. I say in vain because nothing in this actor predisposes him to anger a priori; rather, he is the strong, gentle type, a mountain shepherd. At the very least, the adapters might have taken the trouble to create a character that would justify his rages, but this would have meant that psychology plays a role in Carné's work. Yet Gabin's fits of rage don't stem from psychology; they are the givens of his character, part of his personal mythology. It would be useless to seek a single word in Prévert's dialogue that would explain or announce them. They burst forth with the naturalness and obviousness of a storm. Yet here the dialogue tries in vain and without conviction to convey early on that Laurent is easily angered and, in the murder scene, that the victim contrives to insult and egg him on: it is obvious that these fits of rage remain as inexplicable as they are necessary for the tragic cause. They are perfect for Gabin, but it is Vallone who performs them.

As for Roland Lesaffre, he, too, is obviously just a new avatar of a character dear to Carné: the combination—rather paradoxical, to boot—of destiny and the deserter. A priori this should be the screenplay's most artificial and least forgivable invention. But in this case, this critic's logic is faulty and he is happy to acknowledge it. The character of the blackmailer-sailor is, on the contrary, one of the film's best elements, if not *the* best. It may be that, unlike the case of Vallone, who suffers by being

naïvely modeled on Gabin, we have here an endearing and original variation on an old theme. The character's concealed contradiction makes him complex. The scene in which he explains that although his blackmail succeeded, ultimately he is the victim, is absolutely fascinating. Moreover, Lesaffre embodies here a hybrid character: a sort of fate victim, for ultimately the truck that will kill him will also be his fate before becoming that of Thérèse and Laurent. There is a surprising surfeit of Carné's traditional Manicheism here.

Moving from the characters to the sets, how to account for the presence of the train, also completely invented, unless as an effort to bring back a theme dear to the novel's author? We note, in passing, that this time the train is electric. Other than the slightly discomfiting similarity with Ledoux's crime in *La Bête humaine,* this sequence is, incidentally, magisterial.[6]

I would like to conclude on this electric locomotive as the very symbol of the Carné case. The problem facing him seems to be to modernize his mythology or, if we prefer, more simply, his themes. It is quite obvious that his adaptation of *Thérèse Raquin* was conceived a priori—sometimes at the expense of the work's verisimilitude and logic—to force the material of the book into several of the dramatic molds that he had been using for the last twenty years.[7] It would be absurd to criticize him for this—since many artists, some of the greats among them, have basically done nothing but repeat themselves—were it not for the fact that cinema is an art that ages ten times faster than the others. Carné's drama may be that the themes in *Le Quai des brumes* and *Le Jour se lève* also belonged to the prewar era. For the last ten years, Carné has been struggling to rip them from their previous historical rooting.

In *Thérèse Raquin,* we can easily discern which grafts have "taken" and which have withered on the vine.

> Le nouveau film de Marcel Carné:
> *Thérèse Raquin;* Des personnages
> et des mythes
> *L'Observateur,* no. 183, November 12, 1953
> *Écrits complets,* 1458

NOTES

1. Just after founding *Cahiers du cinéma,* Bazin and Jacques Doniol-Valcroze signed on to share responsibility for the film reviews in the recently established weekly *L'Observateur politique, économique et littéraire,* which would ultimately become *La Nouvelle Observateur.*

2. Bazin had published an important essay on this director, "Carné et la désincarnation" (*Esprit,* September 1951), in which he argued that his postwar films became awkward, deliberate, and out of sync with postwar France, whereas his 1930s masterpieces maintained a perfect rapport with their era whose myths they expressed. See Dudley Andrew, "The Myth of Poetic Realism," In *Mists of Regret: Culture and Sensibility in Classic French Film* (Princeton: Princeton University Press, 1955), chap. 10.

3. "Social Fantastic" ("le fantastique social") is the name given to "poetic realism" by Pierre Mac Orlan, author of the source novel for Carné's *Le Quai des brumes* (1938). The characters and milieu of *Les Enfants du paradis* were taken from the epoch of French romanticism in about 1830.

4. Bazin is skipping across three decades of Carné's films. The famed theater actor Jean Vilar played a character named "Destin" (Fate) in *Les Portes de la nuit* in 1946, literalizing a role that was more figuratively evoked in Carné's successes of the late 1930s. Now, in 1953, Bazin finds vestiges of Carné's abstract tendency in his invention of a character who is not in the novel, a sailor who blackmails Thérèse and her lover, Laurent.

5. In this film, Raf Vallone plays Laurent, a truck driver who has a torrid and fatal affair with Thérèse Raquin.

6. In Renoir's 1938 *La Bête humaine,* Fernand Ledoux played Roubaud, the cuckolded husband who murders Grandmorin in a train car.

7. See note 2, above.

55. Émile Zola's *La Bête humaine* becomes Fritz Lang's *Human Desire*

It is obviously easy to criticize Fritz Lang's undertaking in the name of the masterpiece Jean Renoir extracted from Émile Zola's *La Bête humaine*. Americans are, as we know, accustomed to these cinematic reeditions called "remakes"[1] and have sometimes pushed the process to ridiculous lengths by trying to reproduce an original film shot by shot—or almost. This was especially the case for Julien Duvivier's *Pépé le Moko*, remade in America as *Algiers*, with Charles Boyer in the role originally played by Jean Gabin.

Still, it would be even more ridiculous for critics to try to prevent a director from readapting a tried and true subject when the talent justifies it. Fundamentally, what counts is that the new film has value in itself and is capable of moving the majority of viewers, who have few or no memories of the first film.

This, it seems to me, is the case for *Human Desire*, in which we may find many elements from Renoir's film (which it shares, moreover, with the novel) but also discern enough differences to make it impossible to claim that Fritz Lang limited himself to copying without transposing.

We no doubt remember the locomotive engineer who has inherited his parents' alcoholic lapses. Uncontrollable outbursts of murderous rage occasionally turn this upright young man into a "human beast." Engaged to a gentle, uncomplicated young girl, he takes a lover whose husband has killed for her out of jealousy. The engineer is the only witness for the prosecution, but he refuses to testify during the investigation. Their

complicity grows into passionate, sensual love for which the only obstacle soon becomes the husband, increasingly a wreck. Still, it is not so easy to kill the man, and it is ultimately on the young woman that the unfortunate lover turns his homicidal fury. Once he regains his mind, he has no other option but to kill himself.

We must, in all honesty, grant that the psychological element of hereditary homicidal tendencies so dear to Zola has aged badly. It was obviously the weak point in Renoir's film, as well, and only Gabin's personality lent it some credibility. We can't criticize Fritz Lang's decision to willingly jettison it. Lang's hero, however, returns from Korea, which, despite everything, casts an aura of fatality over him. (Think of Lesaffre in *Thérèse Raquin).*[2] This transposition is ingenious. From this point forward, it becomes absurd to have him kill his mistress who, in a more convincing solution, is murdered by her husband, allowing the brave engineer to return to the pure fiancée awaiting him. No doubt this happy ending satisfies American tastes, but the most important thing is that it does not jar with the logic of the script, for which we cannot, ultimately, fault the director.

When we remember it, of course, we miss Renoir's poetry of the railroad, overwhelming to the point of fascination. Still, Fritz Lang's electric trains with aluminum cars possess their own beauty, even if the director seems to have willingly renounced expressing their picturesque qualities so as to focus interest on the actors.

Here again, the memory of Simone Simon, Jean Gabin, or Ledoux might be unfair.[3] Lacking mystery, Glenn Ford is somewhat disappointing. But Broderick Crawford is remarkable and quite believable in Ledoux's role. Last but not least, I dare to state that the perverse charm of Gloria Grahame easily supports

a risky comparison with Simone Simon. And that is saying something.

> *Désirs humains; La Bête humaine*
> vue par Fritz Lang
> *Le Parisien libéré,* no. 3369, July 12, 1955
> *Écrits complets,* 1831

NOTES

1. Original in English.

2. See Bazin's review of *Thérèse Raquin,* chap. 54, another adaptation from Zola, which makes much of the addition of a character, played by Roland Lesaffre, returning from a Pacific war, this time Indochina.

3. These three actors made a tremendous impression in Renoir's 1938 film. Ledoux played Roubaud, the cuckolded husband of Séverine (Simone Simon), while Gabin gave one of his greatest performances as Jacques Lantier.

56. Émile Zola's *L'Assommoir* becomes René Clément's *Gervaise*

L'Assommoir posed formidable problems to screenwriters and filmmakers. Zola has been adapted to the screen several times, and he is, on the whole, one of the best-served authors. Jacques Feyder and Carné with *Thérèse Raquin*, Jean Renoir with *Nana* and *La Bête humaine*, in particular, have provided cinema with significant works that in no way offend Zola's memory. Yet all of them, up to and including the admirable *La Bête humaine*, take liberties with their model that are certainly legitimate in light of the outcomes, but that eliminate from the start the main difficulties inherent in fidelity to Zola. From this vantage point, Aurenche and Bost are the first to be concerned with the precision of the transcription. It was obviously not an option to preserve everything of the approximately six hundred pages, so they pruned the novelistic profusion around the character of Gervaise, which fully justifies the new title. As they did so, they sought to avoid betraying not only Zola's spirit but also, most especially, the novel's narrative structure, its heft, its density. Their choice, and the subsequent simplifications, never had the effect, so to speak, of reducing the action to the two dimensions of the screen, which still maintains its depth of perspectives and complexity.

More questionable, perhaps, may be the changes in accent and highlighting that the screenwriters carried out on Zola's vision of his universe. A rather mechanistic vision, perhaps, with some springs that are now rusty. But the risk had to be taken, insofar as works do not remain identical to themselves. They are

reborn in the reading of each generation. Today, for example, alcoholism would no longer be plausibly considered such an implacable fate. In Zola's time, its various aspects were different in the working class. Today, by contrast, we have some reasons for being rather more sensitive to housing issues (in the wake of Haussmann's urban renewal), the impact of which seems to us to be greater. In short, to limit our examples, a living fidelity required a profound reworking of fundamental values and structures of the form.

As for the mise en scène, I will mention of all its merits only the one I see as the greatest: René Clément's unbelievable capacity to bring a period back to life. "Resurrection" is the word, perhaps not so much for its accuracy or absence of inaccuracy, as for the impression of the fantastic to which this realism leads. The "historical" genre is flourishing in the cinema, but I don't know if we have had until now the almost oneiric feeling of a true hallucination that certain sequences in *Gervaise* produce in us—except perhaps in the extraordinary opening of *Les Jeux interdits* (*Forbidden Games*). Naturally, if this effect had been the result of a merely arithmetic accumulation of details, it would not deserve much credit, but it is the fruit of intention, intelligence, and, above all, an ability to synthesize. The only comparable work that I see in terms of ideas is Huston's *The Red Badge of Courage*, unfortunately too little known.

This admirable film, however, is not without faults, and its sin resides precisely in that it elicits, in my opinion, no other sentiment than admiration.

I have alluded to the screenwriters' remarkable work, but everything occurs as if their very intelligence could not go beyond its own limits. I mean that, having carefully dismantled

Zola's mechanics, they could not go further in the synthesis they were substituting for it, in order to reach that point where an aesthetic universe regains its sense and its unity. Some will object that this was a superhuman task, and I agree, but then the result cannot satisfy us. If *Gervaise* is the story of ... Gervaise, then we need greater psychological detail, if not about her then at least about the characters whose intimate relationships with her cause her slow, awful degradation. If we think about it, this story has the terrifying and piteous rigor of tragedy. We watch the relentless destruction of a being's resolve to save itself. But of whom or of what is Gervaise the victim? Of her devotion to her husband and the incredible moral situation in which he puts her, or of a particular social conjuncture whose psychological factors would merely be the outcome—the hovel's promiscuity, for example? It may be, as far as the authors are concerned, that the milieu explains Gervaise's moral and personal trajectory, but we just don't know, because, depending on the circumstances, our attention is divided between the linkages of psychological (or emotional) events and the social realism of some of the reconstructions, given that the *metteur en scène* makes no effort to render tangible the dynamic interaction of individual fates and the social milieu. Perhaps this dynamic interaction is implied, but the work of the adaptation was only to make it legible in the same way iron filings do the spectrum of a magnet.

But above all I think that if *Gervaise* is not a masterpiece, despite qualities that outshine those of many other major works, it is because the film's intelligence seems to have smothered its sensibility. For it lacks that which constitutes the power of films less perfect or less great, such as *La Bête humaine* or *Casque d'or*: a generosity of heart, a lucid and warm élan that urges spectators

as well as characters to look in the same direction. What is missing here, ultimately, is what Clément proved himself capable of in directing the children of *Les Jeux interdits*.

Gervaise
L'Éducation nationale 12,
no. 25, October 4, 1956
Écrits complets, 2132

NOTE

Gervaise (René Clément, 1956) was a major studio production in the quality tradition. It took best film at the British Academy Awards and was named top foreign film by the New York Film Critics, Japan's *Kinema Junpo*, and The National Board of Review. It lost the Academy Award for Best Foreign Language Film to *La Strada*.

57. Guy de Maupassant, *Une vie (A Life)*, adapted by Alexandre Astruc

In my last column, I could not talk about *Une vie* at the same time as *Les Amants* and *En cas de malheur* because of its importance.[1] I actually think Astruc's film is not the most "successful" of the three, yet it stands out for being the most richly significant and most fundamentally original with respect to the future of French cinema.

Very freely adapted from Guy de Maupassant's novel, as we shall see, *Une vie* was received rather coldly in Venice; the Parisian critics, while more nuanced, remained divided and often reticent. It seems to me, however, that neither the qualities nor the failings attributed to the film correspond accurately to its real merits and failures.

By unanimous agreement, for instance, praise was heaped on the film's color. Cinematographer Claude Renoir's images are indeed admirable, but it is unfair to deny the director any credit for them, as the critics often did. *Une vie* is a work conceived entirely in relation to color, not just in the mise en scène but also in the screenplay (seasonal colors resonating with the characters' relationships). I will go even further: I am not sure that, given his overabundant talent, the cinematographer didn't to some degree actually betray Astruc's intentions by making such frequent reference to painting (that of Courbet and the Impressionists, in particular) and in any case always to pictorial and plastic rather than dramatic criteria.

Inversely, I think the reproach that the film is cold and unfeeling derives rather from its main strengths. *Une vie* is clearly neither

a sentimental nor even a psychological film, and that is what makes it original. Astruc's work sits at the opposite end of the spectrum from "boulevard" cinema (the brilliant yet nonetheless disappointing avatars of which I glimpsed in *En cas de malheur*), consisting not in *explaining* characters but rather in *showing* them to us in action (which he does both in the dialogue as well as in the mise en scène). This does not mean, however, that this is a cinema of comportment, a behaviorist cinema, as its objectivity is integrated within a style. *Une vie* is a lyrical film, a romantic film, a film that acknowledges a particular penchant for the baroque in the aesthetic sense of the term. These adjectives are not peripheral to the film: they characterize an authentic auteur projecting his vision of the world in cinema as legitimately and as personally as does a painter or a writer. There is thus no reproaching him for any a priori "coldness," given that a certain lyrical detachment of the characters is inherent in the logic of the style.

Having established the originality and the loftiness of the undertaking, I nevertheless still have reservations, less about its intentions than about its results, which don't always correspond to its ambition.

First, as to the screenplay: never for a moment would I reproach Astruc for the extreme liberties taken with his source. Fidelity in matters of adaptation may be a fertile path (see *Journal d'un curé de campagne*), but as Astruc said so well, "nor is the filmmaker a good man whose mission it is to propagate world literature to the masses."

The classics, for that matter, never bothered about such scruples, and Astruc is right again in emphasizing that great works are sufficiently resilient to support twenty interpretations: "It isn't Stendhal who is being betrayed, it is the Stendhalians." These superb assertions warrant a commentary that I cannot

provide here, but I agree with what he says, with just a single reservation. We have the right to be more demanding when it comes to creative infidelity than we have to honest, respectful mediocrity. So, whereas I find Astruc's adaptation excellent in principle, on several points it seems awkward to me. First, it consists in a transposition of the novel's psychological and sociological levels to a purely moral dimension, fundamentally independent of the period in which the action is rooted. *Une vie* thereby acquires at once both modernity and generality. And then, by granting the man almost the same importance as the woman, Astruc makes two characters interesting. Whereas in the novel Julien is little more than the wretched dregs of a degenerating class, the issue in the film becomes the couple, the shared loneliness of an emotional woman and a sensuous man. So I blame the adaptation for its inability to rid this new character of the novel's psychological elements, making his behavior at times inconsistent or contradictory (his avarice, for example).

As for the mise en scène, some of the director's intentions fail due to their execution (especially the winter scenes, including the birth scene, which verges on the ridiculous) but also because of the film's aberrant editing (we have every reason to believe this was not the director's responsibility). A film entitled "a life" can't last just seventy-five minutes; indeed, the initial version ran closer to two hours. This new, edited version visibly cut the beginnings and endings of sequences, leaving only what is indispensable to a scene's logic. But here's the rub: *Une vie* is not a "logical" film. The "madness behind the realism" that Astruc wanted to coax from Maupassant was being readied in the first shot of the sequence, exploding at the end. Amputating the *découpage* of these images—images perhaps not useful for understanding the screenplay but necessary to achieve the style—certainly

damaged it, perhaps not fatally but at least noticeably. There was another drawback to this mutilation: it required a voice-over commentary (to fill the gaps), and this error was compounded by conceiving it in the first person singular, whereas the very subject of the film is precisely the mutual incomprehension of two characters.

Fortunately, these serious grievances do not outweigh the film's major qualities that justify our faith in Astruc despite everything, and our admiration for a film that in Venice brought great honor to the new French cinema.

Une vie
L'Education nationale 14,
no. 26, October 16, 1958
Écrits complets, 2656

NOTE

After premiering in France in September 1958, six weeks before Bazin's death, *Une vie* opened in the United Kingdom in 1961 as *Maupassant's Une Vie.* It then opened in the United States in 1962 as *The End of Desire.*

1. This article is the second installment of a report from the 1958 Venice Film Festival. Part One (October 2) focused mainly on the scandal caused by Louis Malle's *Les Amants* (*The Lovers*) and Claude Autant-Lara's *En cas de malheur* (*Love is my Profession*). *Une vie* also caused a scandal, but of a different sort, as this article explains.

58. Maupassant Stories adapted by Max Ophüls:
Le Plaisir

On the one hand, we should hail the production of a film like
Le Plaisir.[1] The work is distinguished, well made, well acted,
adapted from a worthy text, richly produced, has a serious
screenplay, and a stunning cast; in short, a film of international
class. We can't say as much for many French films, and Mr. Max
Ophüls, whose *La Ronde* was triumphantly acclaimed outside of
France, will probably continue with *Le Plaisir* to hold high in his
Austrian hand the torch of French cinema.

On the other hand, this is just the kind of useless, if not harm-
ful, film we might happily do without. God knows what wealth
of scenarios Maupassant's work and especially his tales provide.
And also how, until now, their use by cinema has been mediocre
or worse, with the exceptions being Jean Renoir's *Partie de cam-
pagne* and a little, practically unknown film by Kirsanoff based
on *Deux amis (Two Friends)*, produced in 1947 with utterly inade-
quate means; had it succeeded, Kirsanoff's film would have cer-
tainly been the most moving and satisfying of those inspired by
the theme of the Resistance.[2]

Max Ophüls brings Maupassant into the cinema through the
front gate. I don't think that's the right one.

There is something in the generous, spontaneous line of Mau-
passant's tales that make them more akin to a sketch than a paint-
ing: it is in their design rather than in their color that the story's
concept is found. Whence the paradoxical adequation to its source
tale of Renoir's *Partie de campagne*, which couldn't be completed
and so ultimately remained in the state of a sketch. In Renoir's

version of *Madame Bovary* the lacunae and weaknesses bother us, whereas in *Partie de campagne* they charm us. What matters is maintaining the alacrity of the line, the movement of its curve, even when incomplete, and the accuracy of the silhouettes rather than the resemblance of the faces. In this mode of adaptation, "the mise en scène" is secondary; we can forgive it everything except the precision of tone, the consonance with its model.

Max Ophüls, by contrast, buries this mode beneath the spurious luxury of details, the gloss of the sets, the sumptuous photography, the mastery of the *découpage,* the brio of the acting. Add to it that this accumulation can't always be taken as a sum of superfluous qualities, for it includes more than one error. The director's Viennese origins are felt not only generally, in a particular expressionist penchant that weighs down the image, but also quite precisely in incongruous details—as, for example, in "La Maison Tellier," where the set of the little church in Normandy is filled with cherubs and curlicues straight out of a Bavarian chapel. Finally, the skillful use of the camera is a good thing as long as it doesn't veer into an obsession with the traveling shot. The complicated set of "La Maison Tellier" was built so that Mr. Ophüls could link five or six different scenes, both in the street and in the "establishment," in a single shot.[3] I don't see what these acrobatics have to do with Maupassant, whereas I do see quite clearly their impact on the film's estimated cost: 250 million, I believe.[4] Things could have been done differently but equally well for half as much. In the cinema as elsewhere, there is a kind of immorality in luxury in times of poverty when the luxury is not justified by its object.

That being said, though it might seem relatively harsh, there is no reason to deprive oneself of ... *Le Plaisir*'s pleasure. The first and the last story, "Le Masque" and "Le Modèle," are much

shorter than "La Maison Tellier," which occupies the middle of the film, and they are far from being its equal. They don't give us enough time to forget about the stylistic exercise, and their plots are simply less good. "Le Modèle" is, however, worthwhile for our rediscovery in it of Simone Simon, younger and more seductive than ever. As for "La Maison Tellier," the tale's flavor, humor, and spiritual human truth give the dozen or so admirably directed actors the leisure to charm us. We must, of course, mention Jean Gabin, a perfectly natural wily type in the role of a country carpenter, and Madeleine Renaud, whose exemplary authority reigns irresistibly over the ladies. Among them, the trim and ethereal figure of Mila Parély makes us regret having seen her so infrequently since *La Règle du jeu*.

<div style="text-align:right">

Le Plaisir de Max Ophuls

L'Observateur, no. 95, March 6, 1952

Écrits complets, 984

</div>

NOTES

1. Three stories from Guy de Maupassant, adapted by Max Ophüls in 1952. Peter Ustinov provides the off-camera introduction to each story, serving as the voice of Maupassant.

2. See chap. 59, note 3.

3. This particular "maison" is a house of ill repute, which the camera approaches from the street to peer through its various windows.

4. Equivalent to about $650,000, a substantial sum for a French film in 1952.

59. Maupassant Stories adapted by André Michel: *Trois femmes*

I was in Cannes, sitting on the steps of the palace between two screenings, when a young woman from Martinique whom I immediately "recognized" crossed my path. I said hello, fretting already about remembering her name and how I knew her. She smiled and held out her hand as if indeed I did know her, when suddenly I realized: it was Zora. I had seen André Michel's film a few weeks earlier in Paris. I had never met Moune de Rivel, but she was such a delightful Zora that I had remembered the face and smile as if they were those of a close friend, someone I had known forever and whom I ran to encounter, without even realizing that the friendship was merely imaginary. Yet without any doubt the most important part of this story is that it didn't bother me in the least to explain this confusion to Moune de Rivel, for at that moment it felt entirely natural.

This little incident might just give some measure of one of the most dependable qualities of André Michel's film: the spontaneous sympathy, in the strong sense of the word, that it elicits, the familiarity we immediately feel with the characters and thus our interest in what happens to them. Rare are films, and French films, especially, that are intellectual with so light a touch, knowing how to win the viewer through friendship and cordiality, and inspiring a nearly physical pleasure at knowing the characters and therefore an immediate curiosity about their lot. Enough with those ceremonial openings; enough with the usual introduction via the intermediary of a highly stylized *découpage*. My friends' friends are my friends, and André Michel has known

his protagonists long enough that we immediately feel as comfortable as he and they do in this delightful cinematic outing.

It is pleasing and instructive that André Michel's film was made at roughly the same time as that of Max Ophüls, with which it obviously presents some points of comparison: both are based on three short stories by Maupassant, yet it would be hard to imagine more different approaches to adaptation. In place of the story's fluidity, the impressionist warmth and the direct sensuality of that naturalist writer, Ophüls offers a heavy rhetoric of *découpage*, the full toolbox of stylistic exercises. As the "Maison Tellier" seen through its slits and shutters, Maupassant is glimpsed here only through a play of mirrors as in a baroque Musée Grévin replete with wax replicas of our most famous actors.[1] André Michel's film, on the other hand, made on a relatively low budget but with pleasure, warmth, and conviction, makes us feel as though we had found Maupassant sitting in front of a nice fire, warmed by a glass of mulled wine.

Whether Maupassant is an author for the cinema is in debate. To me, the arguments for and against are equally convincing. Yet it seems to me that for filmmakers he is one of the rare if not the only novelist who could write in an aesthetic temporality less than the duration of commercial movies. By which I mean that cinema's big handicap when it comes to adapting novels is that for reasons that are entirely unrelated, it must "force grow" characters and events that cannot ripen into maturity in the ninety minutes allotted to a film screening. As if by reaction, this often leads to a paradoxical impression of slowness. Thus, the short novella *La Symphonie pastorale* came out as a film that is much more ponderous and slow, one we might think was based on a three hundred-page novel. It is this aesthetic temporality of

the novel that seems so difficult to rediscover in the film's objective time.

And this is why I think Maupassant is such a prized author for filmmakers: no more than ten, fifteen, or twenty minutes of screen time suffice to faithfully render most of his novellas, no question. And this without any remarks about lack of substance or schematically drawn characters. The most beautiful Resistance story brought to the screen was certainly Kirsanoff's adaptation of Maupassant's "Deux amis" (Two Friends). Unfortunately, its poor technical resources made marketing it quite difficult, but taken on its own merits, the film presents a most dramatic adventure in fewer than twenty minutes without requiring another foot of celluloid to flesh out a character or fine tune a detail.[2] Of course the story can be "beefed up," as Renoir did in *Partie de campagne,* but what film could have survived being edited unfinished, half filmed like that, without being at a radical disadvantage? Whereas it seems that in the Renoir, the gaps are compatible with the film's deep meaning and do not affect its true structure. In fifty minutes, Renoir had already taken more than the time required by a story whose action covers several years. Maupassant leaves a wide safety margin, something almost fatally denied to an adapter by others.

These comments are in no way meant to tarnish the value of Jean Ferry, in whom Michel found a collaborator brimming with intelligence and sensitivity, able to capture perfectly the film's tone. The problem of dialogue was delicate and Ferry solved it by seizing the moment discreetly. In fact, we know that two of the short stories, "The Inheritance" and "Mouche," deal with particularly risqué situations. A dignified, middle-class husband turns out to be sterile or impotent, yet conceives a child by a "friend of the family" with the tacit blessing of the father-in-law

in order to come into an inheritance; so much for "Coralie." Mouche is a sweet girl who floats around unnecessary moral complications, brightening the weekends of five Parisian best friends decked out in straw hats and striped vests. Mouche gets pregnant by these five fathers, but an ill-chosen swim douses these dreams, at which point Mouche discovers that she has the soul of a mother, and her five lovers, taking pity on her, promise entirely seriously to "give her another one." If the film has not been restricted for audiences under sixteen, it is because it manages in the most natural way to convey its meaning only to spectators able to understand it, without skirting the subject or making salacious jokes. We have to make a real effort to imagine, after the fact, all that could have been shocking in the film's subject.

If *Trois femmes,* much admired when shown at Cannes, was never considered for a prize, it is because its obvious merits did not include that crowning quality that makes a film dazzle. There is a tone, a sensitivity in André Michel; his personality comes through in the atmosphere with which he infuses his film and especially in his actors' behavior, although he may still lack the *je ne sais quoi* that defines style and which here surely appears only as a certain absence of rigor in *découpage*, or rather inattentiveness to his own resources. The casualness of a Renoir in *Partie de campagne* comes, in fact, from the constant inventions in his framing. It seems to me that André Michel, while rightly concerned with the tone and the internal *tempo* of his scenes, sometimes sacrifices an aspect of expressivity that could be provided by the camera. It's also quite possible, however, that his use of three different cameramen makes a fair critical evaluation of this point more difficult. In any case, we hope to know more about this in the near future, for while André Michel had to wait

nearly twenty years to make this major film, there is no doubt that he will make others.[3]

Mouche! *Trois femmes*
Cahiers du cinéma, no. 15, September 1952
Écrits complets, 1102

NOTES

Trois femmes (*Three Women*), André Michel's first feature-length film, premiered in summer 1952, six months after Max Ophüls' *Le Plaisir,* which likewise adapted three Maupassant stories. The key story of *Trois femmes* is "Mouche."

1. Opening in 1880, the Musée Grévin was (and remains) among the most famous wax museums, with the hall of mirrors and baroque architecture Bazin mentions.

2. Bazin errs here concerning the length of *Deux amis* (*Two Friends,* 1946), which is a twenty-eight-minute adaptation of one of Maupassant's most significant stories, a tale of heroes during the Franco-Prussian war who face a firing squad rather than divulge information. Dimitri Kirsanoff was a star filmmaker of the French Impressionist movement in the 1920s but found little commercial success after sound. Still, critics kept their eye on his subtle works.

3. Michel made a half dozen modest films in the fifties, then became a journeyman director of dramatic series for television.

60. French Cinema faces Literature

It is always a rather fruitless rhetorical exercise to look for any dominant characteristic of French cinema. Variety seems to be its only law, even more so in the last ten years; the famous noir realism that was its brand during the prewar years is now only intermittently deployed in a few films.[1] But should we be bent on this pursuit, it might be possible to discern a tendency shared among some of the most important films, one that appears to belong only to French postwar production, namely, equaling or outcompeting novelistic and dramatic work.

Filmmakers the world over, ever since the silents, have lacked any scruples about drawing inspiration from literary subjects, but that was merely the starting point for screenplays that were then quite freely dealt with. By contrast, when Melville brought *Le Silence de la mer* to the screen, he made fidelity to the novel its touchstone. More freely, no doubt, but always with a clear scrupulous concern for fidelity, Aurenche and Bost adapted books for Jean Delannoy and Autant-Lara that ten years earlier would have been considered untranslatable to the cinema without numerous betrayals: I am talking about *La Symphonie pastorale* and *Le Diable au corps*. Yet this audacious and brilliant undertaking now seems timid compared to the austere paradoxes Robert Bresson overcame in his *Journal d'un curé de campagne*. With this film, which exists rather like a second aesthetic mode of Bernanos' novel, can we still speak about adaptation?

Obviously, the challenge is not always pushed this far, but in films such as *Chéri, Le Crime des justes, Dieu a besoin des hommes, Le*

Plaisir, La Vérité sur Bébé Donge, Trois femmes, or *Les Enfants terribles*, we can at least recognize, to different degrees, a clear concern to preserve on screen, beyond plot elements or character outlines, the very stuff of the book and even the flavor of a style.

Need we emphasize that *Jeux interdits* is the cinematic translation of a François Boyer novel, which the film, far from betraying, further nourishes and enriches?[2]

When it comes to theater, Cocteau's treatment of *Les Parents terribles* and Claude Autant-Lara's of Georges Feydeau's *Occupe-toi d'Amélie!* are no less typical. But literature's influence naturally extends beyond this acknowledged and formal fidelity. To these adaptations, we would have to add an entire literary cinema "written" directly for the screen, such as *Les Dernières Vacances* by Roger Leenhardt in the category of the novel, and Jean Cocteau's *Orphée* in that of the poetic tale. After all, even adaptations as free as Jean Renoir's *The River* and *Le Carrosse d'or* obviously still belong to a cinema that only exists in competition with, and as if by emulation of, the literature from which it draws inspiration.

Will it therefore be said that French filmmakers are devoting their talent to subjects never quite as appropriate to the screen as to the novel, or to the novelistic or theatrical form? As far as we're concerned, the works cited above are proof of progress in cinematic intelligence. Today, the fact that French cinema, without mockery or concession, can equal an art as intellectual as the novel and do so with its own subjects does not, of course, prove that it needn't seek a better use of its powers elsewhere. However, we must first see this as proof of a maturity and mastery that make everything possible.

<div align="right">

Le Cinéma français et la littérature
Unifrance Film, no. 26, August–September 1953
Écrits complets, Varia 7

</div>

NOTES

This article came out in a special Venice Film Festival issue of *Unifrance*, the government agency whose publications promote French cinema abroad. English and Spanish translations of this piece were included. It is translated anew here from the French.

1. Bazin refers here to "poetic realism," the memorable style of 1930s French cinema.

2. *Jeux interdits* is given special mention here no doubt because it had won the Golden Lion at the previous year's Venice Film Festival.

Two Long Essays on Adaptation, translated by Hugh Gray

These two justly famous essays were published shortly after Bazin had recuperated from tuberculosis. Convalescence gave him more than a year to synthesize the ideas about adaptation he had been developing since the outset of his career. In fact, however, he didn't have much time to compose the intricate "*Journal d'un curé de campagne* et le stylistique de Robert Bresson," for the film premiered on February 7, 1951, and Bazin's article appeared less than four months later, in the third issue of *Cahiers du Cinéma*. It is unclear when he wrote "Pour un cinéma impur" for an anthology edited by Georges Michel Bovay, called *Cinéma, un œil ouvert sur le monde (Cinema, an Eye Open to the World)*. A luxury volume published in Switzerland in 1952, it advertises the collaboration of Jean Cocteau. Cocteau may well have solicited Bazin's participation.

Bazin lightly edited both these essays for volume 2 of *Qu'est-ce que le cinéma?*, the source Hugh Gray used for his 1967 translation. The current editor has, with some assistance, gone carefully through Gray's work to make corrections and update the vocabulary. This helps align these pieces with the others in this anthology. Indeed, anyone reading these pieces now after going through the sixty others will be gratified to recognize titles of films, names of authors, and terms and concepts already encountered. Bazin drew on his full reservoir to shape these two comprehensive, complex, yet carefully organized essays. They are magisterial.

The endnotes following each essay are limited, but they do include all of Hugh Gray's notes. This volume's editor has elected not to clutter the text, and so very few notes highlight the myriad subtle, ambiguous, or occasionally questionable terms and phrases Gray employs to capture Bazin's often more subtle or ambiguous French. Nor was there space to follow Gray's lead in glossing the names, titles, and historical facts Bazin brings up. Only in a few important instances is the reader alerted to differences from the 1951 and 1952 versions of these texts. Translations of both these early versions can be found in *The André Bazin Reader* (Montreal: caboose, 2021). The best authority is unquestionably the *Écrits complets,* which fastidiously indicates each alteration Bazin made in 1958.

61. *Journal d'un curé de campagne* and the Stylistics of Robert Bresson

IF *Diary of a Country Priest* impresses us as a masterpiece, and this with an almost physical impact, if it moves the "critic" and the uncritical alike, it is primarily because of its power to stir the emotions, rather than the intelligence, at their highest level of sensitivity. The temporary eclipse of *Les Dames du Bois de Boulogne* was for precisely the opposite reason. This film could not stir us unless we had, if not exactly analyzed, at least tested its intelligence and, so to speak, understood the rules of the game.

While the *Journal's* instantaneous success is undeniable, the aesthetic principles on which it is based are nevertheless the most paradoxical, maybe even the most complex, ever manifest in a sound film. Hence the refrain of those critics, ill-equipped to understand it but who still love it: "Paradoxical," they say, "incredible—an unprecedented success that can never be repeated." Thus they renounce any attempt at explanation and take refuge in the perfect alibi of a stroke of genius. On the other hand, among those whose aesthetic preferences are of a kind with Bresson's and whom one would have unhesitatingly thought to be his allies, there is a deep sense of disappointment in proportion as they expected greater acts of daring from him.

First embarrassed, then irritated by the realization of what the director did not do, yet too long in accord with him to be able to change their views on the spot; too caught up in his style to recapture their intellectual virginity which would have left the way open to emotion, they have neither understood nor liked the film.

Thus we find the critical field divided into two extreme groups. At one end those least equipped to grasp the *Journal* and who, by the same token, have loved it all the more without knowing why; at the other end those "happy few" who, expecting something different, have not liked it and have failed to understand it. It is the "strangers" to the cinema, the "men of letters,"[1] amazed that they could so love a film and be capable of freeing their minds of prejudice, who have understood what Bresson had in mind more clearly than anyone else.

Admittedly Bresson has done his best to cover his tracks. His avowal of fidelity to the original from the first moment that he embarked on the adaptation, his declared intention of following the book word-for-word, conditioned us to look for just that and the film only serves to prove it. Unlike Aurenche and Bost, who were preoccupied with the optics of the screen and the balance of their drama in its new form, Bresson, instead of building up the minor characters like the parents in *Le Diable au corps*, eliminated them. He prunes everything but the essentials, giving an impression as he does so of a fidelity unable to sacrifice one single word without a pucker of concern and a thousand preliminary twinges of remorse. Again this pruning is always in the interest of simplification, never of addition. It is no exaggeration to say that if Bernanos had written the screenplay he would have taken greater liberties with his novel. He had, indeed, explicitly recognized the right of the adapter to make use of his book according to the requirements of the cinema, the right, that is, "to dream his story over."

However, if we praise Bresson for his fidelity,[2] it is for the most insidious kind of fidelity, a most pervasive form of creative license. Of course, one clearly cannot adapt without transposing. In that respect, Bernanos was on the side of aesthetic common

sense. Literal translations are not the faithful ones. The changes that Aurenche and Bost made to *Le Diable au corps* are almost all entirely justified in principle. A character seen by the camera and the same character as evoked by the novelist are not identical.

Valéry condemned the novel for being obliged to record that "the Marquise had tea at five o'clock." On his side, the novelist might, in turn, pity the filmmaker for having to show the marquise actually at the table. It is for this reason, for example, that the relatives of the heroes in Radiguet, peripheral in the novel, appear important on the screen. The adapter, however, must be as concerned with the text as with the characters and with the weight of their physical presence on the balance of the story. Having transformed the narrative into visuals, the filmmaker must put the rest into dialogue, including the existing dialogue of the novel, although we expect some modification of the latter—since spoken as written, its effectiveness and even its meaning will normally evaporate.

It is here that we see the paradoxical effect of the textual fidelity of the *Journal.*

While the characters in the book are presented to the reader concretely and while their inevitably brief evocation by the pen of the *curé* of Ambricourt never gives us a feeling of frustration or of any limits being put both to their existence and to our knowledge of their existence, Bresson, in the process of showing them to us, is forever hurrying them out of sight. In place of the powerfully concrete evocations of the novelist, the film offers us an unceasingly impoverished image that escapes us because it is hidden from us and is never really developed.

The novel of Bernanos is rich in picturesque evocations, meaty, concrete, strikingly visual. For example: "The Count went

out—his excuse the rain. With every step the water oozed from his long boots. The three or four rabbits he had shot were lumped together in the bottom of his gamebag in a horrible-looking little pile of bloodstained mud and gray hair. He had hung the string bag on the wall and as he talked to me I saw fixed on me, through the intertwining cords, a still limpid and gentle eye."

Do you feel you have seen all this somewhere before? Don't bother to look where. It was probably in a Renoir film. Now compare this scene with the other in which the count brings the two rabbits to the presbytery—admittedly this comes later in the book, but the two could have profitably been combined, thus giving them a style in common—and if you still have any doubts, Bresson's own admission will remove them. Forced to throw out a third of his final cut for the exhibitor's copy, he ended, as we know, by declaring with a delicate touch of cynicism that he was delighted to have had to do so. Actually, the only image he really cared about was the blank screen at the finale, which we will discuss later.

If he had really been "faithful" to the book, Bresson would have made quite a different film. Determined though he was to add nothing to the original—already a subtle form of betrayal by omission—he might at least have chosen to sacrifice the more "literary" parts for the many passages of ready-made film material that cried out for visualization. Yet he systematically took the opposite course. When you compare the two, it is the film that is literary while the novel teems with visual material.

The way he handles the text is even more revealing. He refuses to put into dialogue (I hardly dare to say "film dialogue") those passages from the novel where the *curé* enters in his diary the report of such-and-such a conversation. Here is a first discrepancy, since Bernanos at no point guarantees that the *curé* is

giving a word-for-word report of what he heard. The odds are that he is not. In any event, supposing he *is,* and that Bresson has it in mind to preserve, along with the objective image, the subjective character of something remembered, it is still true that the mental and emotional impact of a line that is merely read is very different from that of a spoken line.

Now, not only does he not adapt the dialogue, however circumspectly, to the demands of a performance, he goes out of his way, on the contrary, whenever the text of the novel has the rhythm and balance of true dialogue, to prevent the actor from bringing out these qualities. Thus a good deal of excellent dramatic dialogue is thrown away because of the flat monotone in which the director insists that it be delivered.

Many complimentary things have been said about *Les Dames du Bois de Boulogne,* very little about the adaptation. The critics have, to all intents and purposes, treated the film as if it were made from an original screenplay. The outstanding quality of the dialogue has been attributed to Cocteau, whose reputation has little need of such praise. This is because they have not reread *Jacques le fataliste,*[3] in which they would have found if not the entire script, at least the evidence of a subtle game of hide and go seek, word-for-word, with the text of Diderot. While it did not make one feel one ought to go back to verify the fact at close quarters, the modern version left one with the impression that Bresson had taken liberties with the story and retained simply the situation and, if you like, a certain eighteenth-century flavor. Since, in addition, he had killed off two or three adapters working under him, so to speak, it was reasonable to suppose that he was that many steps away from the original. However, I recommend fans of *Les Dames du Bois de Boulogne* and aspiring

scenarists alike to take a second look at the film with these considerations in mind. Without intending in any way to detract from the decisive part played by the style of the mise en scène in the success of the film, it is important to examine very closely the foundations of this success, namely, a marvelously subtle interplay—a sort of counterpoint between faithfulness and unfaithfulness to the original.

It has been suggested in criticism of *Les Dames du Bois de Boulogne,* with equal proportions of good sense and misunderstanding, that the psychological make-up of the characters is out of key with the society in which they are shown as living. True, it is the mores of the time that, in the novel of Diderot, justify the choice of the revenge and give it its effectiveness. It is true again that this same revenge seems to the modern spectator to be something out of the blue, something beyond his experience. It is equally useless on the other hand for those who defend the film to look for any sort of social justification for the characters. Prostitution and pandering as shown in the novel are facts with a very clear and solid contemporary social context. In the film of *Les Dames* they are all the more mystifying, since they have no basic justification. The revenge of an injured mistress who forces her unfaithful lover to marry a luscious cabaret dancer seems to us to be a ridiculous gesture. Nor can the fact that the characters appear to be abstractions be explained by deliberate cuts made by the director during the filming. They are that way in the script. The reason Bresson does not tell us more about his characters is not only because he has no desire to, but because he would be hard put to do so. Racine does not describe the color of the wallpaper in the rooms to which his characters retire. To this one may answer, of course, that classical tragedy has no need of the alibis of realism, and that this is one of the basic dif-

ferences between the theater and the cinema. That is true
enough. It is also precisely why Bresson does not derive his cin-
ematographic abstraction simply from the bare episodes but
from the counterpoint that the reality of the situation sets up
with itself. In *Les Dames du Bois de Boulogne,* Bresson has taken the
risk of transferring one realistic story into the context of another.
The result is that these two examples of realism cancel one
another out, the passions displayed emerge out of the characters
as if from a chrysalis, the action from the twists and turns of
the plot, and the tragedy from the trappings of the drama. The
sound of a windshield wiper against a page of Diderot is all it
took to turn it into Racinian dialogue.

Obviously Bresson is not aiming at absolute realism. On the
other hand, his stylized treatment of it does not have the pure
abstract quality of a symbol. It is rather a structured dialectic of
the abstract and concrete, that is to say, of the reciprocal inter-
play of seemingly incompatible elements. The reality of the
rain, the murmur of a waterfall, the sound of earth pouring from
a broken pot, the hooves of a horse on the cobblestones, are not
there just as a contrast to the simplification of the sets or the
convention of the costumes, still less as a contrast to the literary
and anachronistic flavor of the dialogue. They are not needed
either for dramatic antithesis or for a contrast in decor. They are
there deliberately as neutrals, as foreign bodies, like a grain of
sand that gets into and seizes up a piece of machinery. If the
arbitrariness of their choice resembles an abstraction, it is the
abstraction of the concrete integral. They are like lines drawn
across an image to affirm its transparency, as the dust affirms the
transparency of a diamond; it is impurity at its purest.

This dialectical movement of the mise en scène is repeated in
the very midst of elements which seem at first to be completely

stylized. For example, the two apartments of the women are almost totally unfurnished, but this calculated bareness has its explanation. That the frames should be on the walls though the paintings have been sold is undoubtedly a deliberate touch of realism. The abstract whiteness of the new apartment is not intended as part of a pattern of theatrical expressionism. The apartment is white because it has just been repainted and the smell of fresh paint still hangs about. Is there any need to add to this list the elevator or the concierge's telephone, or, on the soundtrack, the tumult of male voices that follows the face-slapping of Agnès, the text for which reads totally conventionally while the sound quality of it is absolute perfection.

I have referred to *Les Dames* in discussing the *Journal* because it is important to point out the profound similarity between the mechanics of their respective adaptations.[4]

The style of the *Journal* indicates a more systematic searching, a rigor that is almost unbearable. It was made under very different technical conditions. Yet we shall see that the procedure was in each case basically the same. In both it was a matter of getting to the heart of a story or of a drama, of achieving the most rigorous form of aesthetic abstraction while avoiding expressionism by way of an interplay of literature and realism, which added to its cinematic potential while seeming to negate it. In any case, Bresson's faithfulness to his model is the alibi of liberty in chains. If he is faithful to the letter of the text this is because it serves his purpose better than taking useless liberties. Furthermore, this respect for the letter is, in the last analysis, far more than an exquisite embarrassment, it is a dialectical moment in the creation of a style.

So it is pointless to complain that paradoxically Bresson is at one and the same time the slave and the master of his text,

because it is precisely from this seeming contradiction that he gets his effects. Henri Agel, for example, describes the film "as unthinkable a thing as a page of Victor Hugo rewritten in the style of de Nerval." But surely one could imagine poetic results born of this monstrous coupling, of unexpectedly revealing flashes touched off by a translation made not just from one language into another (like Mallarmé's translation of Poe) but from one style into the style of another artist and from the material of one art into the material of another.

Let us look a little more closely now at the *Journal* and see what might not have really come off. While not wishing to praise Bresson for all his weak spots, for there are weaknesses, rare ones, which work to his disadvantage, we can say quite definitely that they are all an integral part of his style; they are simply that kind of awkwardness to which a high degree of sensibility may lead, and if Bresson has any reason here for self-congratulation, it is for having had the sense to see in that awkwardness the price he must pay for something more important.

So, even if the acting in general seems poor, except for Laydu all the time and for Nicole Ladmiral some of it, this, provided you like the film, will only appear to be a minor defect. But now we have to explain why Bresson who directed his cast so superbly in *Les Anges du péché* and *Les Dames du Bois de Boulogne* seems to handle them in this film as amateurishly as any beginner with a 16mm camera who has roped in his aunt and the family lawyer. Do people really imagine that it was easier to get Maria Casarès to tone down her temperament than to handle a group of docile amateurs? Certainly some scenes were poorly acted. It is odd however that these were by no means the least moving.

The fact is that this film is not to be measured by ordinary standards of acting. It is important to remember that the cast

were all either amateurs or simple beginners. Still, the *Journal* no more approximates to *Ladri di biciclette* than to *Entrée des artistes*. Actually the only film it can be likened to is Carl Dreyer's *Jeanne d'Arc*. The cast is not being asked to act out a text— whose literary turn makes it unplayable—not even to live it out, just to speak it. It is because of this that the passages spoken off-screen so perfectly match the passages spoken by the characters on-screen. There is no fundamental difference either in tone or style. This plan of attack not only rules out any dramatic interpretation by the actors but also any psychological touches, either. What we are asked to look for on their faces is not some fleeting reflection of the words but an uninterrupted condition of soul, the mask of a spiritual destiny.

Thus this so-called badly acted film leaves us with the feeling of having seen a gallery of portraits whose expressions could not be other than they were. In this respect the most characteristic image of all is Chantal in the confessional. Dressed in black, withdrawn into the shadows, Nicole Ladmiral allows us only a glimpse of a gray mask, half lit, half in shadow, blurred like a seal stamped on wax.

Naturally Bresson, like Dreyer, is only concerned with the countenance as flesh, which, when not involved in playing a role, is a man's true imprint, the most visible mark of his soul. It is then that the countenance takes on the dignity of a sign. He would have us be concerned here not with the psychology but with the physiology of existence. Hence the hieratic tempo of the acting, the slow ambiguous gestures, the obstinate recurrence of certain behavioral patterns, the unforgettable dreamlike slow motion. Nothing purely accidental could happen to these people—confirmed as each is in his own way of life, essentially concerned either against the influence of grace, to con-

tinue so, or, responding to grace, to throw off the deadly Nessus mantle.[5]

There is no development of character. Their inner conflicts, the various phases of their struggle as they wrestle with the angel, are never outwardly revealed. What we see is rather a concentration of suffering, the recurrent spasms of childbirth or of a snake sloughing off its skin. We can truly say that Bresson strips his characters bare.

Eschewing psychological analysis, the film in consequence lies outside the usual dramatic categories. The succession of events is not constructed according to the usual laws of dramaturgy under which the passions work towards a soul-satisfying climax. Events do indeed follow one another according to a necessary order, yet within a framework of accidental happenings. Free acts and coincidences are interwoven. Each moment in the film, each set-up, has its own due measure, alike, of freedom and of necessity. They all position themselves in the same direction, but separately like iron filings drawn to the overall spectrum of a magnet. If the word tragedy comes to one's pen, it is in an opposite sense since we can only be dealing here with a tragedy freely willed. The transcendence of the Bernanos-Bresson universe is not the transcendence of destiny as the ancients understood it, or yet the transcendence of Racinian passion, but the transcendence of Grace which is something each of us is free to refuse.

If, nevertheless, the coherence of events and the causal efficiency of the characters involved appear to operate just as rigidly as in a traditional dramatic structure, it is because they are responding to an order of prophecy (or perhaps one should say of Kierkegaardian "repetition") that is as different from fatality as causality is from analogy.[6]

The pattern of the film's unfolding is not that of tragedy in the usual sense, rather in the sense of the medieval "Passion Play," or better still, of the Way of the Cross, each sequence being a station along that road. We are given the key to this by the dialogue in the hut between the two *curés*, when the one from Ambricourt reveals that he is spiritually attracted to the Mount of Olives. "Is it not enough that Our Lord should have granted me the grace of letting me know today, through the words of my old teacher, that nothing can remove me from the place chosen by me from all eternity, that I was the prisoner of His Sacred Passion?"

Death is not the preordained end of our final agony, only its conclusion and a deliverance. Henceforth we shall know to what divine ordinance, to what spiritual rhythm the sufferings and actions of the *curé* respond. They are the outward representation of his agony. At which point we should indicate the analogies with Christ that abound toward the end of the film, or they may very well go unnoticed. For example, the two fainting fits during the night; the fall in the mud; the vomiting of wine and blood— a remarkable synthesis of powerful comparisons with the falls of Jesus, the Blood of the Passion, the sponge with vinegar, and the defiling spittle. These are not all. For the Veil of Veronica we have the cloth of Seraphita; then finally the death in the attic—a Golgotha with even a good and a bad thief.

Now let us immediately put aside these comparisons, the very enumeration of which is necessarily deceptive. Their aesthetic weight derives from their theological value, but both defy explanation. Bresson like Bernanos avoids any sort of symbolic allusion and so none of the situations, despite their obvious parallel to the Gospel, is created precisely because of that parallel. Each carries its own biographical and individual meaning. Its

Christlike resemblance comes second, through being projected onto the higher plane of analogy. In no sense is it true to say that the life of the *curé* of Ambricourt is an imitation of its divine model, rather it is a repetition and a picturing forth of that life. Each bears his own cross and each cross is different, but all are the Cross of the Passion. The sweat on the brow of the *curé* is a bloody sweat.

So, probably for the first time, the cinema gives us a film in which the only genuine incidents, the only perceptible movements, are those of the life of the spirit. Not only that, it also offers us a new dramatic form that is specifically religious—or better still, specifically theological; a phenomenology of salvation and grace.

It is worth noting that through playing down the psychological elements and keeping the dramatics to a minimum, Bresson is left to dialectically confront two kinds of pure reality. On the one hand, as we saw, we have the countenance of the actor denuded of all symbolic expression, sheer epidermis, set in a surrounding devoid of any artifice. On the other hand there is what we must call the "written reality." Indeed, Bresson's faithfulness to the text of Bernanos, his refusal, that is, not only to adapt it but also his paradoxical concern to emphasize its literary character, is part of the same approach to the direction of his actors and the selection of his settings. Bresson treats the novel as he does his characters. The novel is a cold, hard fact, a reality to be accepted as it stands. One must not attempt to adapt it to the situation in hand, or manipulate it to fit some passing need for an explanation; on the contrary, it is something to be taken absolutely as it stands. Bresson never condenses the text, he cuts it. Because what is left over is a part of the original. Like marble from a quarry the words of the film continue to be part of the

novel. Of course the deliberate emphasis on their literary char-
acter can be interpreted as a search after artistic stylization,
which is the very opposite of realism. The fact is, however, that
in this case the "reality" is not the descriptive content, moral or
intellectual, of the text—it is the very text itself, or more prop-
erly, the style. Clearly the reality at one stage removed of the
novel and that which the camera captures directly cannot fit one
inside the other or grow together or become one. On the con-
trary, the effect of their juxtaposition is to reaffirm their differ-
ences. Each plays its part, side by side, using the means at its dis-
posal, in its own setting and after its own style. But it is doubtless
by this separation of elements, which because of their resem-
blance would appear to belong together, that Bresson manages to
eliminate what is accidental. The ontological conflict between
two orders of events, occurring simultaneously, when confronted
on the screen reveals their single common measure—the soul.

Each elements says the same thing and the very disparity
between their expressions, the substance of what they say, their
style, the kind of indifference that seems to govern the relation
of actor to text, of word and visage, is the surest guarantee of
their close complicity. This language which no lips could speak
is, of necessity, from the soul.

It is unlikely that there exists anywhere in the whole of
French cinema, perhaps even in all literature, many moments of
a more intense beauty than in the medallion scene between the
curé and the countess. Its beauty does not derive from the acting
or the psychological and dramatic values of the dialogue, or
indeed its intrinsic meaning. The true dialogue that punctuates
the struggle between the inspired priest and a soul in despair is,
of its very nature, ineffable. The decisive clashes of their spirit-
ual fencing match escape us. Their words announce, or prepare

the way for, the fiery touch of grace. There is nothing here then of the flow of words that usually goes with a conversion; if the overpowering severity of the dialogue, its rising tension and its final calm leave us with the conviction that we have been the privileged witnesses of a supernatural storm, the words themselves are so much dead weight, the echo of a silence that is the true dialogue between these two souls; a hint at their secret; the opposite side of the coin, if one dare to say so, of the Divine Countenance. When later the *curé* refuses to come to his own defense by producing the letter of the countess, it is not out of humility or love of suffering. It is rather because no tangible evidence is worthy to play a part either in his defense or his indictment. Of its nature the evidence of the countess is no more challengeable than that of Chantal, and none has the right to ask God to bear witness.

The technique of Bresson's direction cannot adequately be judged except at the level of his aesthetic intention. Inadequately as we may have so far described the latter, it may yet be that the highly astonishing paradox of the film is now a little more evident. Actually the distinction of having set text over against image for the first time goes to Melville in his *Silence de la mer.* It is noteworthy that his reason was likewise a desire for fidelity. However, the structure of Vercors' book was of itself unusual. In his *Journal* Bresson has done more than justify Melville's experiment and shown how well warranted it was. He has carried it to its final conclusions.

Is the *Journal* just a silent film with spoken titles? The spoken word, as we have seen, does not enter into the image as a realistic component. Even when spoken by one of the characters, it rather resembles the recitative of an opera. At first sight the film seems to be somehow made up, on the one hand, of the

abbreviated text of the novel and illustrated, on the other hand, by images that never pretend to replace it. All that is spoken is not shown, yet nothing that is shown cannot also be spoken. At worst, critical good sense can reproach Bresson with having substituted an illustrated radiophonic montage, no less, for Bernanos' novel.

So it is from this ostensible corruption of the art of cinema that we begin if we are to grasp fully Bresson's originality and boldness.

In the first place, if Bresson "returns" to the silent film it is certainly not, despite the abundance of close-ups, because he wants to tie in again with theatrical expressionism—that fruit of an infirmity—on the contrary, it is in order to rediscover the dignity of the human countenance as understood by Stroheim and Dreyer. Now if there is one and only one quality of the silent film irreconcilable of its very nature with sound, it is the syntactical subtlety of montage and expression in the acting of the film, that is to say, that which proceeds in effect from the weakness of the silent film. But not all silent films want to be such. Nostalgia for a silence that would be the benign procreator of a visual symbolism unduly confuses the so-called primacy of the image with the true vocation of the cinema—which is the primacy of the object. The absence of a soundtrack for *Greed*, *Nosferatu*, or *La Passion de Jeanne d'Arc* means something quite other than the silence of *Caligari*, *Die Nibelungen*, or *Eldorado*. It is a frustration, not the foundation of a form of expression. The former films exist in spite of their silence not because of it. In this sense the invention of the soundtrack is just a fortuitous scientific phenomenon and not the aesthetic revolution people always say it is. The language of film, like the language of Aesop, is ambiguous, and in spite of appearances to the contrary, the

history of cinema before and after 1928 is an unbroken continuity. It is the story of the relations between expressionism and realism. Sound was to destroy expressionism for a while before adapting to it in its turn. On the other hand, it became an immediate part of the continued development of realism.

Paradoxically enough it is to the most theatrical, that is to say, to the most talkative, forms of the sound film that we must look today for a resurgence of the old symbolism while the pre-talkie realism of a Stroheim has, in fact, no following. Yet, it is evident that Bresson's undertaking is related to the work of Stroheim and Renoir. The separating of sound and of the image to which it relates cannot be understood without a searching examination of the aesthetics of realism in sound. It is just as mistaken to see it as an illustration of a text, as a commentary on an image. Their parallelism maintains that division which is present to our senses. It continues the Bressonian dialectic between abstraction and reality thanks to which we are concerned with a single reality—that of human souls. In no sense does Bresson return to the expressionism of the silent film. On the one hand he excludes one of the components of reality in order to reproduce it, deliberately stylized on a soundtrack, partially independent of the image. In other words, it is as if the final rerecording was composed of sound directly recorded with scrupulous fidelity and a text postsynchronized in monotone. But, as we have pointed out, this text is itself a second reality, a "cold aesthetic fact." Its realism is its style, while the style of the image is primarily its reality, and the style of the film is precisely the conflict between the two.

Bresson disposes once and for all that commonplace of criticism according to which image and sound should never duplicate one another. The most moving moments in the film are

those in which text and image are saying the same thing, each however in its own way. The sound never serves simply to fill out what we see. It strengthens it and multiplies it just as the echo chamber of a violin echoes and multiplies the vibrations of the strings. Yet this metaphor is not dialectical, since it is not so much a resonance that the mind perceives as something that does not match, as when a color is not properly superimposed on a drawing. It is here at the edge that the event reveals its true significance. It is because the film is entirely structured on this relationship that, toward the end, the images take on such emotional power. It would be in vain to look for its devastating beauty simply in what is explicit. I doubt if the individual frames in any other film, taken separately, are so deceptive. Their frequent lack of plastic composition, the awkwardness and static quality of the actors completely mislead one as to their value in the overall film. Moreover, this accretion of effectiveness is not due to the editing. The value of an image does not depend on what precedes or follows it. It accumulates, rather, a static energy, like the parallel plates of a capacitor. Between the image and the soundtrack differences of aesthetic potential are set up, the tension of which becomes unbearable. Thus, the image-text relationship moves toward its climax, the latter having the advantage. Thus it is that, quite naturally, at the command of an imperious logic, there is nothing more that the image has to communicate except at the very end by disappearing. The spectator has been led, step by step, toward that night of the senses, the only expression of which is a light on a blank screen.

That is where this so-called silent film and its lofty realism is headed, to the disappearance of the image and its replacement simply by the text of the novel. But here we experience irrefutable aesthetic evidence, a sublime achievement of pure cinema.

Just as the blank page of Mallarmé and the silence of Rimbaud is language at the highest state, the screen, free of images and handed back to literature, is the triumph of cinematographic realism. The black cross on the white screen, as awkwardly drawn as on the average memorial card, the only trace left by the assumption of the image, is a witness to something the reality of which is itself but a sign.

With the *Journal* cinematographic adaptation reaches a new stage. Up to now, film tended to substitute for the novel in the guise of its aesthetic translation into another language. "Fidelity" meant respect for the spirit of the novel, but it also meant a search for necessary equivalents, that is to say, it meant taking into account the dramatic requirements of spectacle or again the more direct effectiveness of the cinematographic image. Unfortunately, concern for these things will continue to be the general rule. We must remember, however, that it was through their application that *Le Diable au corps* and *La Symphonie pastorale* turned out so well. According to the best opinions, films like these are as good as the books on which they are modeled.

In the margin of this formula we might also note the existence of the free adaptation of books such as that made by Renoir for *Partie de campagne* or *Madame Bovary*. Here the problem is solved in another way. The original is just a source of inspiration. Fidelity is here the temperamental affinity between filmmaker and novelist, a deeply sympathetic understanding. Instead of presenting itself as a substitute, the film is intended to take its place alongside the book—to make a pair with it, like twin stars. This assumption, applicable only where there is genius, does not exclude the possibility that the film is a greater achievement than its literary model, as in the case of Renoir's *The River*.

The *Journal*, however, is something else again. Its dialectic between fidelity and creation is reducible, in the last analysis, to a dialectic between the cinema and literature. There is no question here of a translation, no matter how faithful or intelligent. Still less is it a question of free inspiration with the intention of making, with loving respect, a duplicate. It is a question of building a secondary work with the novel as foundation. In no sense is the film "comparable" to the novel or "worthy" of it. It is a new aesthetic creation, the novel, so to speak, multiplied by the cinema.

The only procedure in any way comparable of which we have any examples are films of paintings. Emmer or Alain Resnais are similarly faithful to the original, their raw material is the already highly developed work of the painter; the reality with which they are concerned is not the subject of the painting but the painting itself, in the same way as the text of the novel is Bresson's reality. But the fidelity of Alain Resnais to Van Gogh, which is ontologically that of photographic fidelity, is but the prior condition of a symbiosis of cinema and painting. That is why, as a rule, painters fail utterly to understand the whole procedure. If you see these films as nothing more than an intelligent, effective, and even a valuable means of popularizing painting—they certainly are that, too—you know nothing of their aesthetic biology.

This comparison with films of paintings, however, is only partially valid, since these are confined from the outset to the realm of a minor aesthetic genre. They add something to the paintings, they prolong their existence, they release them from the confines of their frames, but they can never pretend to be the paintings themselves.* The *Van Gogh* of Alain Resnais is a minor

* At least up to the time of *Le Mystère Picasso* which, as we shall see, may invalidate this criticism.

masterpiece taken from a major oeuvre which it makes use of and explains in detail but does not replace. There are two reasons for this congenital limitation. First of all, the photographic reproduction, in projection, cannot pretend to be a substitute for the original or to share its identity. If it could, then it would be the better to destroy its aesthetic autonomy, since films of paintings start off precisely as the negation of that on which this aesthetic autonomy is based, the fact that the paintings are circumscribed in space and exist outside time. It is because cinema as the art of space and time is the contrary of painting that it has something to add to it.

Such a contradiction does not exist between the novel and the film. Not only are they both narrative arts, that is to say temporal arts, but it is not even possible to maintain a priori that the cinematic image is essentially inferior to the image prompted by the written word. In all probability the opposite is the case. But this is not where the problem lies. It is enough if the novelist, like the filmmaker, is concerned with the idea of unfolding a real world. Once we accept these essential resemblances, there is nothing absurd in trying to write a novel on film. But the *Journal* has just revealed to us that it is more fruitful to speculate on their differences rather than on their resemblances, that is, for the existence of the novel to be affirmed by the film and not dissolved into it. It is hardly enough to say of this work, once removed, that it is in essence "faithful" to the original, because, to begin with, it *is* the novel. But most of all the resulting work is not, certainly, "better" (that kind of judgment is meaningless) but "more" than the book. The aesthetic pleasure we derive from Bresson's film, while the acknowledgment for it goes, essentially, to the genius of Bernanos, includes all that the novel has to offer plus, in addition, its refraction in the cinema.

After Bresson, Aurenche and Bost are but the Viollet-le-Duc of cinematographic adaptation.[7]

> *Le Journal d'un curé de campagne* et le
> stylistique de Robert Bresson
> *Cahiers du cinéma, no. 3*, June, 1951
> *Écrits complets,* 798

NOTES

Hugh Gray, the first to translate this article into English, believed it to be "the most perfectly wrought piece of film criticism" he had ever read. A fine stylist himself, Gray's translation, nonetheless, has been shown to be flawed. Some of the locutions (and spelling) in his 1967 publication betray his British education. Some of his choices at English equivalents today feel inadequate to Bazin's original. And on a few occasions he seems simply to have misunderstood Bazin's admittedly complex syntax. This current republication, then, adjusts Gray's work, though without compromising his fluent prose and consistent tone. The first alteration, in fact, comes immediately with the first word of the title, where "*The Journal*" replaces Gray's "*Le Journal*." In fact, the title of the film and the novel is simply *Journal d'un curé de campagne*. Both film and novel will subsequently be referred to as "*Journal*" or, as here in the title of Bazin's article, "the *Journal*."

1. [Hugh Gray's note] Does Bazin really mean "those happy few" sarcastically, or has his memory failed him when he actually meant "this band of brothers"? [This editor's note] Bazin uses English for "happy few" and puts in quotation marks the French words for "strangers" and "men of letters."

2. Bazin's formulation is a bit more elaborate: "However, if we praise Bresson for having been more royalist than the king, it is for the most insidious kind of fidelity."

3. [Hugh Gray's note] A novel by Diderot (1713–1784), the encyclopedist. The novel is in the line descending from Rabelais by way of Cervantes and Laurence Stern, with acknowledged borrowings from the latter's *Tristram Shandy*.

4. Bazin continues this sentence after a comma: "their respective adaptations, about which the obvious differences in the mise en scène and the greater liberties that Bresson appears to have taken with Diderot risk concealing this similarity."

5. [Hugh Gray's note] Here is a remarkable example of Bazin's capacity for compression. In one adjectival phrase he combines pagan and Christian legend. Nessus was the centaur who gave Deianira, wife of Heracles, a poisoned garment with which she unwittingly caused the death of her husband, thus avenging Nessus' own death at the hands of Heracles.

6. [Hugh Gray's note] A notion involved in Kierkegaardian religious existentialism. It involves finding what has been lost. It bears some comparison to the Platonic view of the truth as "recollection," but it is different as to the temporal perspective involved. Recollection is oriented to the past, repetition to the future.

7. [Hugh Gray's note] French architect and author (1814–1879) and restorer of ancient churches and buildings, such as Notre-Dame and La Sainte-Chapelle. His doctrine was that a building should be restored less according to the condition in which it was found than according to the architectonic principles from which its forms derived. The conclusions drawn by him and his disciples were frequently criticized less for their own sake than because their application would not allow for any alternatives.

62. In Defense of Mixed Cinema

A BACKWARD glance over the films of the past ten or fifteen years quickly reveals that one of the dominant features of their evolution is the increasingly significant extent to which they have gone for their material to the heritage of literature and the stage.

Certainly it is not only just now that the cinema is beginning to look to the novel and the play for its material. But its present approach is different. The adaptation of *Le Comte de Monte Cristo,* *Les Misérables,* or *Les Trois Mousquetaires* is not in the same category as that of *La Symphonie pastorale, Jacques le fataliste (Les Dames du Bois de Boulogne), Le Diable au corps,* or *Journal d'un curé de campagne.* Alexandre Dumas and Victor Hugo simply serve to supply the filmmaker with characters and adventures largely independent of their literary framework. Javert or D'Artagnan have become part of a mythology existing outside of the novels. They enjoy in some measure an autonomous existence of which the original works are no longer anything more than an accidental and almost superfluous manifestation. On the other hand, filmmakers continue to adapt novels that are sometimes first-rate as novels but which they feel justified in treating simply as very detailed film synopses. Filmmakers likewise go to novelists for characters, a plot, even—and this is a further stage—for atmosphere, as for example from Simenon, or the poetic climate found in Pierre Véry. But here again, one can ignore the fact that it is a book and just consider the writer a particularly prolix scenarist. This is so true that a great number of American crime novels are clearly written with a double purpose in view, namely,

with an eye on a Hollywood adaptation. Furthermore, respect for crime fiction when it shows any measure of originality is becoming more and more the rule; liberties cannot be taken with the author's text with an easy conscience. But when Robert Bresson says, before making *Journal d'un curé de campagne* into a film, that he is going to follow the book page by page, even phrase by phrase, it is clearly a question of something quite different, and new values are involved. The *cinéaste* is no longer content, as were Corneille, La Fontaine, or Molière before him, to ransack other works. His method is to transcribe for the screen virtually unaltered a work the excellence of which he recognizes a priori. And how can it be otherwise when this work derives from a form of literature so highly developed that the heroes and the meaning of their actions depend very closely on the style of the author, when they are intimately wrapped up with it as in a microcosm, the laws of which, in themselves rigorously determined, have no validity outside that world, when the novel has renounced its epic-like simplicity so that it is no longer a matrix of myths but rather a locus of subtle correlations between style, psychology, morals, or metaphysics?

In the theater the direction of this evolution is more evident still. Dramatic literature, like the novel, has always allowed itself to suffer violence at the hands of the cinema. But who would dare to compare Laurence Olivier's *Hamlet* to the, in retrospect, ludicrous borrowings that the Film d'Art made once upon a time from the repertoire of the Comédie-Française? It has always been a temptation to the filmmaker to film theater, since it is already a spectacle; but we know what comes of it. And it is with good reason that the term "filmed theater" has become a commonplace of critical opprobrium. The novel at least calls for some measure of creativity, in its transition from writing to image. The

theater by contrast is a false friend; its illusory likeness to the cinema set the latter en route to a dead end, luring it onto the slippery slope of the merely facile. If the dramatic repertory of the boulevards, however, has occasionally been the source of a goodish film, that is only because the director has taken the same kind of liberty with the play as he would with a novel, retaining, in fact, only the characters and the plot. But there again, the phenomenon is radically new, and this seems to imply respect for the theatrical character of the model as an inviolable principle.

The films we have just referred to and others the titles of which will undoubtedly be cited shortly, are both too numerous and of too high a quality to be taken as exceptions that prove the rule. On the contrary, works of this kind have for the last ten years signposted the way for one of the most fruitful trends of contemporary cinema.

"*Ça, c'est du cinéma!*" "That's really cinema!" Georges Altman long ago proclaimed on the cover of a book dedicated to the glorification of the silent film, from *The Pilgrim* to *The General Line*. Are the dogmas and hopes of the earliest film criticism that fought for the autonomy of the seventh art now to be discarded like an old hat? Is the cinema or what remains of it incapable of surviving without the twin crutches of literature and theater? Is it in process of becoming an art derived from and dependent on one of the traditional arts?

The question proposed for our consideration is not so new; first of all, it is the problem of the reciprocal influence of the arts and of adaptations in general. If the cinema were two or three thousand years old we would undoubtedly see more clearly that it does not lie outside the common laws of the evolution of the arts. But cinema is only sixty years old and already its historical perspectives are prodigiously flattened. What ordinarily extends

through one or two civilizations is here contained within the life span of a single man.

Nor is this the principal cause of error, because this accelerated evolution is in no sense contemporary with that of the other arts. The cinema is young, but literature, theater, music, and painting are as old as history. Just as the education of a child derives from imitating the adults around him, so the evolution of the cinema has been influenced by the example of the hallowed arts. Thus its history, from the beginning of the century on, is the result of determinants specific to the evolution of all art, and likewise of effects on it of the arts that have already evolved. Again, the confused pattern of this aesthetic complex is aggravated by certain sociological factors. The cinema, in fact, has come to the fore as the only popular art at a time when the theater, the social art *par excellence,* reaches only a privileged cultural or monied minority. It may be that the past twenty years of the cinema will be reckoned in its overall history as the equivalent of five centuries in literature. It is not a long history for an art, but it is for our critical sense. So let us try and narrow the field of these reflections.

First of all let it be said that adaptations which the modern critic looks upon as a shameful way out are an established feature of the history of art. Malraux has pointed out how much the painting of the Renaissance was originally indebted to Gothic sculpture. Giotto painted in full relief. Michelangelo deliberately refused any assistance he might have had from oils, the fresco being more suitable to a style of painting based on sculpture. And doubtless this was a stage quickly passed through on the way to the liberation of "pure" painting. But would you therefore say that Giotto is inferior to Rembrandt? And what is the value of such a hierarchy? Can anyone deny that fresco in

full relief was a necessary stage in the process of development and hence aesthetically justified? What again does one say about Byzantine miniatures enlarged in stone to the dimensions of a cathedral tympanum? And to turn now to the field of the novel, should one censure preclassical tragedy for adapting the pastoral novel for the stage or Madame de La Fayette for her indebtedness to Racinian dramaturgy? Again, what is true technically is even truer of themes which turn up in all kinds and varieties of expression. This is a commonplace of literary history up to the eighteenth century, when the notion of plagiarism appeared for the first time. In the Middle Ages, the great Christian themes are to be found alike in theater, painting, stained glass windows, and so on.

Doubtless what misleads us about the cinema is that, in contrast to what usually happens in the evolutionary cycle of an art, adaptation, borrowing, and imitation do not appear in the early stages. On the contrary, the autonomy of the means of expression, and the originality of subject matter, have never been greater than they were in the first twenty or thirty years of the cinema. One would expect a nascent art to try to imitate its elders and then, bit by bit, to work out its own laws and select its rightful themes. One finds it less easy to understand that it should place an increased volume of experience at the service of material foreign to its genius, as if its capacity for invention, for specific creation, was in inverse proportion to its powers of expression. From there to the position that this paradoxical evolution is a form of decadence is but a step, and one that criticism did not hesitate to take upon the advent of sound.

But this was to misunderstand the basic facts of the history of film. The fact that the cinema appeared after the novel and the theater does not mean that it falls into line behind them and on

the same plane. Cinema developed under sociological conditions very different from those in which the traditional arts exist. You might as well derive the *bal-musette* or bebop from classical choreography. The first filmmakers effectively extracted what was of use to them from the arts with which they were about to win their public, namely the circus, the itinerant theater, and the music hall, which provided slapstick films, especially, with both technique and actors. Everyone is familiar with the saying attributed to Zecca when he discovered a certain Shakespeare. "What a lot of good stuff that character passed up!" Zecca and his fellows were in no danger of being influenced by a literature that neither they nor their audience read. On the other hand, they were influenced by the popular literature of the time, to which we owe the sublime *Fantômas,* one of the masterpieces of the screen. The film gave a new life to the conditions out of which came an authentic and great popular art. It did not spurn the humbler and despised forms of the theater, fairground, or serial novel. True, the fine gentlemen of the Academy and of the Comédie-Française did make an effort to adopt this child that had been brought up in the world of stage business, but the failure of the Film d'Art only emphasized the futility of this unnatural enterprise. The misfortune of Oedipus and Hamlet meant about as much to the cinema in its early days as "our ancestors the Gauls" do to Negro elementary schoolchildren in the African bush.[1] Any interest or charm that these early films have for us is on a par with those pagan and naïve interpretations of Catholic liturgy practiced by savage tribes that have gobbled up their missionaries. If the obvious borrowings in France—Hollywood unashamedly pillaged the techniques and personnel of the Anglo-Saxon music hall— from what survived of the popular theater either in the fairgrounds or on the boulevards, did not create aesthetic disputes, it

was primarily because as yet there was no film criticism. It was likewise because such avatars of these so-called inferior arts did not shock anybody. No one felt any call to defend them except the interested parties who had more knowledge of their trade than they had of filmological preconceptions.[2]

When the cinema actually began to follow in the footsteps of the theater, a link was restored, after a century or two of evolution, with dramatic forms that had been virtually abandoned. Did those same learned historians who know everything there is to be known about farce in the sixteenth century ever make it their business to find out what a resurgence of vitality it had between 1910 and 1914 at the Pathé and Gaumont studios and under the baton of Mack Sennett?

It would be equally easy to demonstrate that the same process occurred in the case of the novel. The serial film adopting the popular technique of the feuilleton revived the old forms of the *conte*. I experienced this personally when seeing once again Feuillade's *Vampires* at one of those gatherings that Henri Langlois, the amiable director of the Cinémathèque française, knows how to organize so well. That night only one of the two projectors was working. In addition, the print had no subtitles, and I imagine that Feuillade himself would have had difficulty in trying to recognize the murderers. It was even money as to which were the good guys and which the bad. So difficult was it to tell who was which that the apparent villains of one reel turned out to be the victims in the next. The fact that the lights were turned on every ten minutes to change reels seemed to multiply the episodes. Seen under these conditions, Feuillade's *chef d'oeuvre* reveals the aesthetic principle that lies behind its charm. Every interruption evoked an "ah" of disappointment and every fresh start a sigh of hope for a solution. This story, the meaning of

which was a complete mystery to the audience, held its attention and carried it along purely and simply by the tension created in the telling. There was no question of preexisting action broken up by intervals, but of a piece unduly interrupted, an inexhaustible spring, the flow of which was blocked by a mysterious hand. Hence the unbearable tension set up by the next episode to follow and the anxious wait, not so much for the events to come as for the continuation of the telling, of the restarting of an interrupted act of creation. Feuillade himself proceeded in the same way in making his films. He had no idea what would happen next and filmed step by step as the morning's inspiration came. Both the author and the spectator were in the same situation, namely, that of the king and Scheherazade; the repeated intervals of darkness in the cinema were those of *The Thousand and One Nights*. The "to be continued" of the true feuilleton as of the old serial films is not therefore a device extrinsic to the story. If Scheherazade had told everything at one sitting, the king, cruel as any film audience, would have had her executed at dawn. Both storyteller and audience need to experience the power of this magic by way of interruption, need to savor the delicious wait for the continuation of a tale that is a substitute for everyday living which, in its turn, is but a break in the continuity of a dream. So we see that the so-called original purity of the primitive screen does not stand up under examination. The sound film does not mark the threshold of a lost paradise on the other side of which the muse of the seventh art, discovering her nakedness, would start to put back on the rags of which she had been stripped. The cinema has not escaped a universal law. It has obeyed it in its own way—the only way possible, in view of the combination of technical and sociological circumstances affecting it.

We know, of course, that it is not enough to have proved that the greater part of the early films were only either borrowed or pillaged in order to justify thereby the actual form of adaptation. Deprived of his usual stance, the champion of "pure cinema" could still argue that intercourse between the arts is easier at the primitive level. It may very well be that farce is indebted to the cinema for its rejuvenation. But its effectiveness was primarily visual and it is by way of farce, first of all, and then of the music hall, that the old traditions of mime have been preserved. The farther one penetrates into the history of genres, the more the differences become clear, just as in the evolution of animals at the extremities of the branches deriving from a common source. The original polyvalence having developed its potential, these are henceforth bound up with subtleties and complexities of form such that to attack them is to compromise the whole work. Giotto could paint under the direct influence of architectural sculpture, but Raphael and Da Vinci were already attacking Michelangelo for making painting a radically autonomous art.

There is some doubt that this objection could stand up under a detailed discussion, and that evolved forms do not continue to act on one another, but it is true that the history of art goes on developing in the direction of autonomy and specificity. The concept of pure art—pure poetry, pure painting, and so on—is not entirely without meaning; it refers to an aesthetic reality as difficult to define as it is to combat. In any case, even if a certain mixing of the arts remains possible, like the mixing of genres, it does not necessarily follow that they are all fortunate mixtures. There are fruitful crossbreedings which add to the qualities derived from the parents; there are attractive but barren hybrids and there are likewise hideous combinations that bring forth nothing but chimeras. So let us stop appealing to precedents

drawn from the origin of the cinema and let us take up again the problem as it seems to confront us today.

While critics are apt to view with regret the borrowings made by cinema from literature, the existence of a reverse process is as accepted as it is undeniable. It is, in fact, commonly agreed that the novel, and particularly the American novel, has come under the influence of the cinema. Let us leave to one side books in which the influence or direct borrowings are deliberate and so of little use for our purpose, as for example *Loin de Rueil* by Raymond Queneau. The question is whether or not the art of Dos Passos, Caldwell, Hemingway, or Malraux derives from the technique of the cinema. To tell the truth, we hardly believe it. Undoubtedly, and how could it be otherwise, the new way of seeing things provided by the screen—seeing things in close-up or by way of storytelling structures such as montage—has helped the novelist to refurbish his technical equipment. But even where the relationship to cinematic techniques is avowed, they can at the same time be challenged: they are simply an addition to the apparatus available to the writer for use in the process of building his own particular world. Even if one admits that the novel has been somewhat shaped by the aesthetic gravitational pull of the cinema, this influence of the new art has unquestionably not been greater than that of the theater on literature during the last century. The influence of a dominant neighbor on the other arts is probably a constant law. Certainly, the work of Graham Greene seems to offer undeniable proof of this. But a closer look reveals that his so-called film techniques—we must not forget that he was a film critic for a number of years—are actually never used in the cinema. So marked is this that one is constantly asking oneself as one "visualizes" the author's style why filmmakers continue to deprive themselves of a technique that could

be so useful to them. The originality of a film such as *Espoir* by Malraux lies in its capacity to show us what the cinema would be if it took its inspiration from the novels "influenced" by the cinema. What should we conclude from this? Surely that we should rather reverse the usual theory and study the influence of modern literature on filmmakers.

What do we actually mean by "cinema" in our present context? If we mean a mode of expression by means of realistic representation, by a simple registering of images, simply an exterior vision as opposed to the use of the resources of introspection or of analysis in the style of the classical novel, then it must be pointed out that the English novelists had already discovered in "behaviorism" the psychological justifications of such a technique.[3] But here the literary critic is guilty of imprudently prejudging the true nature of cinema, based on a very superficial definition of what is here meant by reality. Because its basic material is photography it does not follow that the seventh art is of its nature dedicated to the dialectic of appearances and the psychology of behavior. While it is true that it relies entirely on the outside world for its objects, it has a thousand ways of acting on the appearance of an object so as to eliminate any equivocation and to make of this outward sign one and only one inner reality. The truth is that the vast majority of images on the screen conform to the psychology of the theater or to the novel of classical analysis. They proceed from the common sense supposition that a necessary and unambiguous causal relationship exists between feelings and their outward manifestations. They postulate that all is in the consciousness and that this consciousness can be known.

If, a little more subtly, one understands by cinema the techniques of a narrative born of montage and change of camera

position, the same statement holds true. A novel by Dos Passos or Malraux is no less different from those films to which we are accustomed than it is from a novel by Fromentin or Paul Bourget. Actually, the American novel belongs not so much to the age of cinema as to a certain vision of the world, a vision influenced doubtless by man's relations with a technical civilization, but whose influence upon the cinema, which is a fruit of this civilization, has been less than on the novel, in spite of the alibis that the filmmaker can offer the novelist.

Likewise, in going to the novel the cinema has usually looked not as one might expect to works in which some have seen its influence already operating, but, in Hollywood, to Victorian literature and in France, to Henri Bordeaux and Pierre Benoît. Better ... or worse ... when an American director turns his attention on some rare occasion to a work by Hemingway, for example, *For Whom the Bell Tolls,* he treats it in the traditional style that suits each and every adventure novel.

The way things are, then, it would seem as if the cinema was fifty years behind the novel. If we maintain that the cinema influences the novel, then we must suppose that it is a question of a potential image, existing exclusively behind the magnifying glass of the critic and seen only from where he sits. We would then be talking about the influence of a nonexistent cinema, an ideal cinema, a cinema that the novelist would produce if he were a filmmaker; of an imaginary art that we are still awaiting.

And, God knows, this hypothesis is not as silly as it sounds. Let us hold on to it, at least as we do to those imaginary values which cancel one another out following on the equation that they have helped to solve.

If the apparent influence of the cinema on the novel has led the minds of some otherwise sound critics astray, it is because

the novelist now uses narrative techniques and adopts ways of laying out facts whose affinity with the methods of cinematic expression are undoubted, whether borrowed directly, or as we prefer to think, because of a certain aesthetic convergence that has simultaneously polarized several contemporary forms of expression. But in this process of influences or of resemblances, it is the novel which has proceeded furthest along the logic of style. The novel it is that has made the subtlest use of montage, for example, and of the reversal of chronology. Above all it is the novel that has discovered the way to raise to the level of an authentic metaphysical significance an inhuman, mineral-like objectivity. What camera has ever been as externally related to its object as the consciousness of the hero of Albert Camus' *L'Étranger?* The fact of the matter is that we do not know if *Manhattan Transfer* or *La Condition humaine* would have been very different without the cinema, but we are certain on the contrary that *Thomas Garner* and *Citizen Kane* would never have existed had it not been for James Joyce and Dos Passos. We are witnessing, at the point at which the cinematic avant-garde has now arrived, multiple films that dare to take their inspiration from a novel-like style one might describe as ultracinematographic. Seen from this angle, the question of borrowing is only of secondary importance. The majority of the films that we have presently in mind are not adaptations from novels, yet certain episodes of *Paisà* are much more indebted to Hemingway (the scenes in the marshes) or to Saroyan (Naples) than Sam Wood's *For Whom The Bell Tolls* is to the original. By contrast, Malraux's film is the close equivalent of certain episodes in *L'Espoir* and the best of the recent English films are adaptations of Graham Greene. In our view the most satisfactory is the modestly made *Brighton Rock,* which passed almost unnoticed while John Ford

was lost in the sumptuous falsification of *The Fugitive (The Power and the Glory)*. Let us therefore see what the best contemporary films owe to the contemporary novelists—something it would be easy to demonstrate up to the appearance especially of *Ladri di biciclette (Bicycle Thieves)*. So, far from being scandalized by adaptations, we shall see in them, if not 'alas' a certain augury for the progress of cinema, at least a possible factor in this progress, to the extent, at least, that the novelist transforms it.[4] Perhaps you may say that this is all very true about modern novels, if the cinema is simply recouping here a hundredfold what it has already lent to the novel, but what is the argument worth when the filmmaker pretends he is taking his inspiration from Gide or Stendhal? And why not from Proust or even from Madame de La Fayette?

And indeed why not? Jacques Bourgeois in an article in *La Revue du Cinéma* has made a brilliant analysis of the affinities between À *La Recherche du temps perdu* and cinematic forms of expression. Actually, the real problems to be faced in discussing the theories of such adaptations do not belong to the realm of aesthetics. They do not derive from the cinema as an art form but as a sociological and industrial fact. The drama of adaptation is the drama of popularization. A provincial publicity blurb on *La Chartreuse de Parme* described it as taken from "the famous cloak-and-dagger novel." We sometimes get the truth from film salesmen who have never read Stendhal. Shall we therefore condemn the film by Christian-Jaque? Yes, to the extent that he has been false to the essence of the novel, and wherever we feel that this betrayal was not inevitable. No, if we take into consideration first of all that this adaptation is above the average film level in quality and second that, all things considered, it provides an enchanting introduction to Stendhal's work and has certainly

increased the number of its readers. It is nonsense to become indignant about the humiliations practiced on literary works on the screen, at least in the name of literature. After all, they cannot harm the original in the eyes of those who know it, however little they approximate to it. As for those who are unacquainted with the original, one of two things may happen; either they will be satisfied with the film which is as good as most, or they will want to know the original, with the resulting gain for literature. This argument is supported by publishers' statistics that show a rise in the sale of literary works after they have been adapted to the screen. No, the truth is, that culture in general and literature in particular have nothing to lose from such an enterprise.

There now remains the cinema, and I personally feel that there is every reason to be concerned over the way it is too often used in relation to our literary capital because the filmmaker has everything to gain from fidelity. Already much more highly developed, and catering to a relatively cultured and exacting public, the novel offers the cinema characters that are much more complex and, again, as regards the relation of form and content, a firmness of treatment and a subtlety to which we are not accustomed on the screen. Obviously, if the material on which the scenarist and the director are working is in itself on an intellectual level higher than that usual in the cinema then two things can be done. Either this difference in level and the artistic prestige of the original work serve as a guarantee, a reservoir of ideas and a *cachet* for the film, as is the case with *Carmen, La Chartreuse de Parme,* or *L'Idiot,* or the filmmakers honestly attempt an integral equivalent, they try at least not simply to use the book as an inspiration, not merely to adapt it, but to translate it onto the screen as instanced in *La Symphonie pastorale, Le Diable au corps, The Fallen Idol,* or *Journal d'un curé de campagne.*

We should not throw stones at the image-makers who simplify in "adapting." Their betrayal as we have said is a relative thing, and there is no loss to literature. But the hopes for the future of the cinema are obviously pinned to the second group. When one opens the sluice, the level of the water is very little higher than that of the canal. When someone makes a film of *Madame Bovary* in Hollywood, the difference of aesthetic level between the work of Flaubert and the average American film being so great, the result is a standard American production that has only one thing wrong with it—that it is still called *Madame Bovary*. And how can it be otherwise when the literary work is brought face to face with the vast and powerful cinematographic industry: cinema is the great leveler. When, on the other hand, thanks to a happy combination of circumstances, the filmmaker plans to treat the book as something different from a run-of-the-mill scenario, it is a little as if, in that moment, the whole of cinema is raised to the level of literature. This is the case with the *Madame Bovary* and *Partie de campagne* of Jean Renoir. Actually, these are not very good examples, not because of the quality of the films but precisely because Renoir is more faithful to the spirit than the letter. What strikes us about the fidelity of Renoir is that paradoxically it is compatible with complete independence from the original. The justification for this is, of course, that the genius of Renoir is certainly as great as that of Flaubert or Maupassant. The phenomenon we face here is comparable then to the translation of Edgar Allan Poe by Baudelaire.

Certainly it would be better if all directors were men of genius; presumably then there would be no problem of adaptation. The critic is only too fortunate if he is confronted sometimes with men of talent. This is enough however on which to establish our thesis. There is nothing to prevent us from dreaming of

a *Diable au corps* directed by Jean Vigo, but let us congratulate ourselves that at least we have an adaptation by Claude Autant-Lara. Faithfulness to the work of Radiguet has not only forced the screenwriters to offer us interesting and relatively complex characters, it has incited them to flout some of the moral conventions of the cinema, to take certain risks—prudently calculated, but who can blame them for this—with public prejudices. It has widened the intellectual and moral horizons of the audience and prepared the way for other films of quality. What is more, this is not all; and it is wrong to present fidelity as if it were necessarily a negative enslavement to an alien aesthetic. Undoubtedly the novel has means of its own—language, not the image, is its material, its intimate effect on the isolated reader is not the same as that of a film on the crowd in a darkened cinema—but precisely for these reasons the differences in aesthetic structure make the search for equivalents an even more delicate matter, and thus they require all the more power of invention and imagination from the filmmaker who is truly attempting a resemblance. One might suggest that in the realm of language and style cinematic creation is in direct ratio to fidelity. For the same reasons that render a word-by-word translation worthless and a too free translation a matter for condemnation, a good adaptation should result in a restoration of the essence of the letter and the spirit. But one knows how intimate the possession of a language and of the genius proper to it is required for a good translation. For example, taking the well-known simple past tenses of André Gide as being specifically a literary effect of a style, one might consider them subtleties that can never be translated into the cinema. Yet it is not at all certain that Delannoy in his *La Symphonie pastorale* has not found the equivalent in his mise en scène. The ever-present snow carries

with it a subtle and polyvalent symbolism that insidiously modifies the action, and provides it as it were with a permanent moral coefficient the value of which is not so different after all from that which the writer was searching for by the appropriate use of tenses. Yet, the idea of surrounding this spiritual adventure with snow and of ignoring systematically the summery aspect of the countryside is a truly cinematographic discovery, to which the director may have been led by a fortunate understanding of the text. The example of Bresson in *Journal d'un curé de campagne* is even more convincing; his adaptation reaches a dizzying fidelity by way of a ceaselessly created respect for the text. Albert Béguin has rightly remarked that the violence characteristic of Bernanos could never have the same force in literature and cinema. The screen uses violence in such a customary fashion that it seems somehow like a devalued currency, which is at one and the same time provoking and conventional. Genuine fidelity to the tone set by the novelist calls thus for a kind of reversal of the violence of the text. The real equivalent of the hyperbole of Bernanos lay in the ellipsis and litotes of Robert Bresson's *découpage*. The more important and decisive the literary qualities of the work, the more the adaptation disturbs its equilibrium, the more is needed the creative talent to reconstruct a new equilibrium not indeed identical with, but the equivalent of, the old one. To pretend that the adaptation of novels is a slothful exercise from which the true cinema, "pure cinema," can have nothing to gain is critical nonsense to which all adaptations of quality give the lie. It is those who care the least for fidelity in the name of the so-called demands of the screen who betray at one and the same time both literature and the cinema.[5]

The effective fidelity of a Cocteau or Wyler is not evidence of a backward step, on the contrary, it is evidence of a development

of cinematographic intelligence. Whether it is, as with the author of *Les Parents terribles*, the astonishingly perspicacious mobility of the camera or, as with Wyler, the asceticism of his *découpage*, the austerity of the photography, the use of the fixed camera and of deep focus, their success is the result of outstanding mastery; moreover it is evidence of an inventiveness of expression which is the exact opposite of a passive recording of theater. To show respect for the theater it is not enough to photograph it. To "create theater" of any worthwhile kind is more difficult than to "create cinema," and this is what the majority of adapters were trying to do up to now.

There is a hundred times more cinema, and better cinema at that, in one fixed shot in *The Little Foxes* or *Macbeth* than in all the exterior traveling shots, in all the natural settings, in all the geographical exoticism, in all the shots of the reverse side of the set, by means of which up to now the screen has ingeniously attempted to make us forget the stage. Far from being a sign of decadence, the mastering of the theatrical repertoire by the cinema is on the contrary a proof of maturity. In short, to adapt is no longer to betray but to respect. Let us take a comparison from circumstances in the material order. In order to attain this high level of aesthetic fidelity, it was essential that the cinematographic form of expression make progress comparable to that in the field of optics. The distance separating *Hamlet* from the Film d'Art is as great as that separating the complex play of lenses of the modern *objectif* from the primitive condenser of the magic lantern. Its imposing complexity has no other purpose than to compensate for the distortions, the aberrations, the diffractions, for which the glass is responsible—that is to say, to render the camera obscura as "objective" as possible. The transition from a theatrical work to the screen demands, on the aesthetic level, a

scientific knowledge of fidelity comparable to that of a camera operator in his photographic rendering. It is the termination of an improvement and the beginning of a rebirth. If the cinema today is capable of effectively taking on the realm of the novel and the theater, it is primarily because it is sure enough of itself and master enough of its means so that it no longer need assert itself in the process. That is to say it can now aspire to fidelity— not the illusory fidelity of a replica[7]—through an intimate understanding of its own aesthetic structure, which is a prerequisite and necessary condition of respect for the works it is about to make its own. The multiplication of adaptations of literary works which are far from cinematic need not disturb the critic who is concerned about the purity of the seventh art; on the contrary, they are the guarantee of its progress.

"Why then," it will be asked by those nostalgic for cinema with a capital C, independent, specific, autonomous, free of all compromise, "should so much art be placed at the service of a cause that does not need it—why make a reduced novel when one can read the book, or *Phèdre* when all you need is to go to the Comédie-Française? No matter how satisfying the adaptations may be, you cannot argue that they are worth more than the original, especially not of a film of an equal artistic quality on a theme that is specifically cinematographic? You cite *Le Diable au corps, The Fallen Idol, Les Parents terribles,* and *Hamlet.* Well and good. I can cite in return *The Gold Rush, Potemkin, Broken Blossoms, Scarface, Stagecoach,* or even *Citizen Kane,* all masterpieces which would never have existed without the cinema, irreplaceable additions to the patrimony of art. Even if the best of adaptations are no longer naïve betrayals or an unworthy prostitution, it is still true that in them a great deal of talent has gone to waste. You speak of progress but progress which can only render the

cinema sterile in making it an annex of literature. Give to the theater and to the novel that which is theirs and to the cinema that which can never belong elsewhere."

This last objection would be valid in theory if it did not overlook historical relativity, a factor to be counted when an art is in full evolution. It is quite true that an original scenario is preferable to an adaptation, all else being equal. No one dreams of contesting this. You may call Charlie Chaplin the Molière of the cinema, but we would not sacrifice *Monsieur Verdoux* for an adaptation of *Le Misanthrope*. Let us hope, then, to have as often as possible films like *Le Jour se lève, La Règle du jeu,* or *The Best Years of Our Lives*. But these are platonic wishes, attitudes of mind that have no bearing on the actual evolution of the cinema. If the cinema turns more and more to literature—indeed, to painting or to journalism—it is a fact which we take note of and attempt to understand because it is very likely that we cannot influence it. In such a situation, if fact does not absolutely make right, it requires the critic at least to be favorably predisposed. Once more, let us not be misled here by drawing an analogy with the other arts, especially those whose evolution toward an individualistic use has made them virtually independent of the consumer. Lautréamont and Van Gogh produced their creative work while either misunderstood or ignored by their contemporaries. The cinema cannot exist without a minimum number, and it is an immense minimum, of people who frequent the cinema here and now. Even when the filmmaker affronts the public taste there is no justification for his audacity, no justification except insofar as it is possible to admit that it is the spectator who misunderstands what he should and someday will like. The only possible contemporary comparison is with architecture, since a house has no meaning except as a habitation. The cinema

is likewise a functional art. If we take another system of reference we must say of the cinema that its existence precedes its essence; even in his most adventurous extrapolations, it is this existence from which the critic must take his point of departure. As in history, and with approximately the same reservations, the verification of a change goes beyond reality and already postulates a value judgment. Those who damned the sound film at its birth were unwilling to admit precisely this, even when the sound film held the incomparable advantage over the silent film of replacing it.

Even if this critical pragmatism does not seem to the reader sufficiently well-founded, he must nevertheless admit that it justifies in us a certain humility and thoughtful prudence when faced with any sign of evolution in the cinema. It is in this frame of mind that we offer an attempt at explanation with which we would like to end this essay. The masterpieces to which we customarily refer as examples of true cinema—the cinema which owes nothing to the theater and literature because it is capable of discovering its own themes and language—these masterpieces are probably as admirable as they are inimitable. If the Soviet cinema no longer gives us the equivalent of *Potemkin* or Hollywood the equivalent of *Sunrise, Hallelujah, Scarface, It Happened One Night,* or even of *Stagecoach,* it is not because the new generation of directors is in any way inferior to the old. As a matter of fact, they are very largely the same people. Nor is it, we believe, because economic and political factors of production have rendered their inspiration sterile. It is rather that genius and talent are relative phenomena and only develop in relation to a set of historical circumstances. It would be too simple to explain the theatrical failures of Voltaire on the grounds that he had no tragic sense; it was the age that had none. Any attempt to

prolong Racinian tragedy was an incongruous undertaking in conflict with the nature of things. There is no sense in asking ourselves what the author of *Phèdre* would have written in 1740, because he whom we call Racine was not a man answering that identity, but "the-poet-who-had-written-*Phèdre*." Without *Phèdre* Racine is an anonymity, a concept of the mind. It is equally pointless in the cinema to regret that we no longer have Mack Sennett to carry on the great comic tradition. The genius of Mack Sennett was that he made his slapstick comedies at the period when this was possible. As a matter of fact, the quality of Mack Sennett productions died before he did, and certain of his pupils are still very much alive: Harold Lloyd and Buster Keaton, for example, whose rare appearances these past fifteen years have been only painful exhibitions in which nothing of the verve of yesteryear has survived. Only Chaplin has known how to span a third of a century of cinema, and this because his genius was truly exceptional. But at the price of what avatars, of what a total renewal of his inspiration, of his style and even of his character! We note here—the evidence is overwhelming— that strange acceleration of aesthetic duration which characterizes the cinema. A writer may repeat himself both in content and form over half a century. The talent of a filmmaker, if he does not evolve with his art, lasts no more than five or ten years. This is why genius, less flexible and less conscious than talent, has frequent moments of extraordinary failure; for example, Stroheim, Abel Gance, Pudovkin. Certainly the causes of these profound disagreements between the artist and his art, which cruelly age genius and reduce it to nothing more than a sum of obsessions and useless megalomania, are multiple, and we are not going to analyze them here. But we would like to take up one of them which is directly related to our purpose.

Up until about 1938 the black-and-white cinema made continuous progress. At first it was a technical progress—artificial lighting, panchromatic emulsions, traveling shots, sound—and in consequence an enriching of the means of expression—close-up, montage, parallel montage, rapid montage, ellipsis, reframing, and so on. Side by side with this rapid evolution of the language and in strict interdependence on it, filmmakers discovered original themes to which the new art gave substance. "That is cinema!" was simply a reference to this phenomenon, which dominated the first thirty years of the film as art—that marvelous accord between a new technique and an unprecedented message. This phenomenon has taken on a great variety of forms: the star, the reevaluation,[8] indeed the rebirth, of the epic, of the commedia dell'arte, and so on. But it was directly related to technical progress—it was the novelty of expression which cleared the path for new themes. For thirty years the history of cinematographic technique, in a broad sense, was bound up in practice with the development of the scenario. The great directors are first of all creators of form; if you wish, they are rhetoricians. This in no sense means that they supported the theory of art for art's sake, but simply that in the dialectic of form and content, form was then the determining factor in the same way that perspective or oils turned the pictorial world upside down.

We have only to go back ten or fifteen years to observe evidence of the aging of what was the patrimony of the art of cinema. We have noted the speedy death of certain types of film, even major ones like the slapstick comedy, but the most characteristic disappearance is undoubtedly that of the star. Certain actors have always been a commercial success with the public, but this devotion has nothing in common with the socioreligious phenomenon of which Rudolph Valentino and Greta Garbo

were the golden calves. It all seemed as if the area of cinematic themes had exhausted whatever it could have hoped for from technique. It was no longer enough to invent quick cutting or a new style of photography in order to stir people's emotions. Unaware, the cinema had passed into the age of the scenario. By this we mean a reversal of the relationship between content and form. Not that form has become a matter of indifference, quite the opposite. It had never been more rigorously determined by the content or become more necessary or a matter of greater subtlety. But all this knowledge of form tends toward its efface-ment and its transparence before a subject that we appreciate today for its own sake and concerning which we become more and more exacting. Like those rivers which have finally hol-lowed out their beds and have only the strength left to carry their waters to the sea without adding one single grain of sand to their banks, the cinema approaches its equilibrium profile. The days are gone when it was enough to "make cinema" in order to deserve well of the seventh art. While we wait until color or stereoscopy provisionally returns its primacy to form and cre-ates a new cycle of aesthetic erosion, on the surface cinema has no longer anything to conquer. There remains for it only to irri-gate its banks, to insinuate itself between the arts among which it has so swiftly carved out its valleys, subtly to invest them, to infiltrate the subsoil, in order to excavate invisible galleries. The time of resurgence of a cinema newly independent of novel and theater will perhaps return. But it may then be because novels will be written directly onto film. As it awaits the dialectic of the history of art which will restore to it this desirable and hypo-thetical autonomy, the cinema draws into itself the formidable resources of elaborated subjects amassed around it by neighbor-ing arts during the course of the centuries. It will make them its

own because it has need of them and we experience the desire to rediscover them by way of the cinema.

This being done, cinema will not be a substitute for them, rather will the opposite be true. The success of filmed theater helps the theater just as the adaptation of the novel serves the purpose of literature. *Hamlet* on the screen can only increase Shakespeare's public, and a part of this public at least will have the taste to go and hear it on the stage. The *Journal d'un curé de campagne*, as seen by Robert Bresson, increased Bernanos' readers tenfold. The truth is that there is here no competition or substitution, rather the adding of a new dimension that the arts had gradually lost from the time of the Reformation on: namely a public.

Who will complain of that?

> Pour un cinéma impur (défense de l'adaptation)
> *Cinéma, un œil ouvert sur le monde,* G.-M. Bovay
> (dir.), Lausanne, Éditions Clairefontaine, 1952
> *Écrits complets,* 923

NOTES

This republication of Hugh Gray's 1967 translation of Bazin's crucial article adjusts some of his spellings and locutions so that they accord with those employed throughout this volume. Gray's occasional errors and inconsistencies in rendering Bazin's intricate sentences and certain of his terms are rectified without sacrificing the beautiful tone of voice through which Bazin first spoke to us in English. A discrepancy occurs immediately in Gray's title for this essay, which Bazin called, "Pour un cinéma impur: défense de l'adaptation," meaning, "For an Impure Cinema: Defense of Adaptation."'

1. Bazin uses Oedipus and "The Prince of Denmark" to indicate that he's referring to characters who have an afterlife beyond the famous plays about them. "Our ancestors the Gauls" comes from Caesar's *Gallic Wars,* a reference to the origin of the French nation that would mean

little to Africans forced to learn French history. Decolonization of Africa was just beginning when Bazin wrote this piece in 1951.

2. Bazin's original 1952 publication pursues the relation of Max Linder and Chaplin to the music hall. He cut this and other elaborations [see note 5 below] when he edited his collected best articles just before his death late in 1958. The early version has been translated by Timothy Barnard in André Bazin, *The André Bazin Reader* (Montreal: caboose Press, 2021), 309–34.

3. In the 1952 version Bazin followed this sentence with "Besides, nothing would be more opposed to the cinema than the interior monologue, this pillar of the modern novel."

4. Bazin's "Tel qu'en lui-même enfin le romancier le change!" modifies the opening of Mallarmé's poem "Le Tombeau d'Edgar Poe," which begins with "Tel qu'en Lui-même enfin l'éternité le change." A literal translation of Bazin's line would be: "Such as into itself the novelist at last changes it."

5. Gray does not translate Bazin's next paragraph, which we give as follows: "But the most convincing demonstration of this paradox has been provided during the past several years by a whole series of theatrical adaptations that had come to prove, despite the variety of origins and styles, the relativity of the old critical prejudice against 'filmed theater.' Without analyzing for now the aesthetic reasons for this evolution, it suffices to state that it is closely related to the decisive progress in the language of the screen." Bazin himself then prunes the next pages (about 1,300 words) from his original 1952 article that inquired into the success of contemporary "filmed theater" from *The Little Foxes* (William Wyler, 1941) through *Rope* (Alfred Hitchcock, 1948) and *Hamlet* (Laurence Olivier, 1948). [For an English translation of this section, see *The André Bazin Reader*, 324–28.] By eliding this extended discussion of theater, Bazin's 1958 canonical version focuses more strictly on the cinema's relation to the novel.

6. Bazin uses two words for the English "lens": "le jeu complexe de lentilles d'un objectif modern," playing on the connotation of "objectif."

7. Bazin uses a more erudite word for replica, "décalcomanie."

8. In the 1952 original, Bazin wrote "the erotic re-evaluation of the female body."

Chronological List of Articles

The number preceding each item refers to its place in André Bazin, Écrits complets, *ed. Hervé Joubert-Laurencin (Paris: Éditions Macula, 2018).*

43 À propos de *Human Comedy* | *Poésie 45*, no. 23, February–March 1945

60 À propos de l'*Espoir* ou du style au cinéma | *Poésie 45*, nos. 26–27, August–September 1945

143 Le film de la semaine | *Le Parisien libéré*, no. 612, August 2, 1946

144 Roman et cinéma | *Le Parisien libéré*, no. 612, August 2, 1946

161 *Jane Eyre* | *Le Parisien libéré*, no. 654, September 20, 1946

197 Après le Festival de Cannes: Hollywood peut traduire Faulkner, Hemingway ou Caldwell | *Le Courrier de l'étudiant*, no. 33, November 13, 1946

244 *The Lost Weekend* (*Le Poison*); Le drame de l'alcool | *L'Écran français*, no. 86, February 18, 1947

269 Zola et le cinéma: *Pour une nuit d'amour* | *Le Parisien libéré*, no. 832, May 21, 1947

376 Roger Leenhardt a filmé le roman qu'il n'a pas écrit; *Les Dernières Vacances*, une peinture de la bourgeoisie provinciale, un drame aigu de l'adolescence. Un style | *L'Écran français*, no. 135, January 27, 1948

381 *Les Raisins de la colère* | *Esprit*, no. 143, February 1948

435 *La Chartreuse de Parme* | *Le Parisien libéré*, no. 1149, May 26, 1948

457 L'adaptation ou le cinéma comme Digeste | *Esprit*, no. 146, July 1948

501 *Oliver Twist* | *Le Parisien libéré*, no. 1275, October 20, 1948

504 *Eugénie Grandet* | *Le Parisien libéré*, no. 1281, October 27, 1948

507 *Dieu est mort* | *Le Parisien libéré*, no. 1287, November 3, 1948

554 *Le Gang des tueurs* | *Le Parisien libéré*, no. 1382, February 23, 1949

563 *Manon* | *Le Parisien libéré*, no. 1400, March 16, 1949

570 *La route au tabac* | *Le Parisien libéré*, no. 1412, March 30, 1949

606 *Anna Karénine;* Un beau film qui manque d'âme | *Le Parisien libéré*, no. 1465, May 31, 1949

624 *Première désillusion;* Un film exceptionnel qui ne trahit ni la littérature … ni le cinéma | *Le Parisien libéré*, no. 1492, July 1, 1949

798 Le *Journal d'un curé de campagne* et la stylistique de Robert Bresson | *Cahiers du cinéma*, no. 3, June 1951

799 *La Belle Image;* L'univers de Marcel Aymé à l'écran | *Le Parisien libéré*, no. 2064, June 1, 1951

923 Pour un cinéma impur (défense de l'adaptation) | *Cinéma, un œil ouvert sur le monde*, edited by Georges-Michel Bovay, Lausanne: Éditions Clairefontaine, 1952

982 *Le Banni des îles;* îles et illusions | *Le Parisien libéré*, no. 2322, March 1, 1952

984 *Le Plaisir* de Max Ophuls | *L'Observateur*, no. 95, March 6, 1952

991 *André Gide* | *L'Observateur*, no. 96, March 13, 1952

994 *Jocelyn*, ou les ennuis de la fidélité | *L'Observateur*, no. 97, March 20, 1952

1019 *Une place au soleil;* Soleil noir | *Le Parisien libéré*, no. 2364, April 19, 1952

1102 Mouche!; *Trois femmes* | *Cahiers du cinéma*, no. 15, September 1952

1258 Mina … Trop Beyle; *Mina de Vanghel* | *Cahiers du cinéma*, no. 21, March 1953

1272 Au-delà de la fidélité: *Mina de Vanghel* | *L'Observateur*, no. 149, March 12, 1953

1333 *Les Neiges du Kilimandjaro;* Mais où sont les neiges d'antan? | *Le Parisien libéré*, no. 2689, May 7, 1953

1398 *La Charge victorieuse;* Une victoire du cinéma! | *Le Parisien libéré*, no. 2758, July 27, 1953

Varia 7 Le cinéma français et la littérature | *Unifrance Film*, no. 26,
August–September 1953

1458 Le nouveau film de Marcel Carné: *Thérèse Raquin;* Des person-
nages et des mythes | *L'Observateur*, no. 183, November 12, 1953

1516 *Le Blé en herbe;* A poussé dru! | *Le Parisien libéré*, no. 2915, January
25, 1954

1518 *Le Fond du problème;* La fidélité trahit parfois | *Le Parisien libéré*, no.
2919, January 30, 1954

1520 Les incertitudes de la fidélité; *Le Blé en herbe* | *Cahiers du cinéma*,
no. 32, February 1954

1552 *Le Manteau* | *L'Observateur d'aujourd'hui*, no. 203, April 1, 1954

1580 Des romans et des films: *M. Ripois* avec ou sans Némésis | *Esprit*,
nos. 217–18, August–September 1954

1584 Cinéma et roman | *Carrefour*, no. 518, August 18, 1954

1617 *Le Rouge et le Noir;* Des goûts et des couleurs | *Le Parisien libéré*,
no. 3156, November 4, 1954

1631 Hemingway a-t-il influencé le cinéma ? | *Radio-Cinéma-Télévision*,
no. 253, November 21, 1954

1634 Des caractères; *Le Rouge et le Noir* | *Cahiers du cinéma*, no. 41,
December 1954

1831 *Désirs humains; La Bête humaine* vue par Fritz Lang | *Le Parisien
libéré*, no. 3369, July 12, 1955

1899 *Les Mauvaises Rencontres;* Mieux qu'un roman | *Radio-
Cinéma-Télévision*, no. 303, November 6, 1955

1943 *L'Amant de Lady Chatterley;* Infidèlement fidèle | *Radio-
Cinéma-Télévision*, no. 311, January 1, 1956

2088 Les candidats au bac devant le problème film-roman |
Radio-Cinéma-Télévision, no. 338, July 8, 1956

2132 *Gervaise* | *L'Éducation nationale* 12, no. 25, October 4, 1956

2182 *Moby Dick* | *L'Éducation nationale* 12, no. 35, December 13, 1956

2200 Quatre romans, quatre films; I. Dostoïevski—Tolstoï |
L'Éducation nationale 13, no. 1, January 3, 1957

2206 Quatre romans, quatre films; II. Victor Hugo—Jules Verne |
L'Éducation nationale 13, no. 2, January 10, 1957

2273 La littérature est-elle un piège pour le cinéma ? | *L'Actualité
littéraire*, no. 34, April 1957

2301 Deux grands films français | *L'Éducation nationale* 13, no. 19, May 23, 1957

2416 *Les Espions* | *France Observateur,* no. 388, October 17, 1957

2515 *Bonjour Tristesse* | *L'Éducation nationale* 14, no. 12, March 20, 1958

2522 *Les Misérables* | *L'Éducation nationale* 14, no. 13, March 27, 1958

2539 *L'Adieu aux armes* | *L'Éducation nationale* 14, no. 14, April 17, 1958

2575 *Les Frères Karamazov;* Une adaptation digne d'estime | *Le Parisien libéré,* no. 4262, May 26, 1958

2601 *Barrage contre le Pacifique* | *L'Éducation nationale* 14, no. 23, June 19, 1958

2606 Position critique: Défense de l'adaptation | *La Revue des lettres modernes,* nos. 36–38, Summer 1958

2656 *Une vie* | *L'Éducation nationale* 14, no. 26, October 16, 1958

Index of Films

This alphabetical index privileges the version of the title that appears throughout the translations (see "Preface"). French and Anglophone films are listed under their original title. Italian, German, Russian, Japanese, Swiss, and Spanish films are listed under their U.S. title followed by the original title—if it is different. As with titles, the dates for the most part include general release dates for France and the United States, but also for other countries if a film was neither French nor American, or if it had an earlier release date in countries other than its primary country of production. This should help evoke the tapestry of film distribution with its sometimes serendipitous delays and occasional simultaneity. Finally, page numbers followed by a lowercase "n" refer to endnotes.

A Farewell to Arms / L'Adieu aux armes (Frank Borzage, US 1932 / FR 1933): **195**

A Farewell to Arms / L'Adieu aux armes (Charles Vidor, US 1957 / FR 1958): **81, 82n1, 201–3**

A Place in the Sun / Une place au soleil (George Stevens, US 1951 / FR 1952): **190**

À propos de Nice (Jean Vigo, FR 1930): **64, 137, 147n7**

African Queen, The / L'Odyssée de l'African Queen (John Huston, US 1951 / FR 1952): **199, 268**

Algiers / Casbah (John Cromwell, US 1938 / FR 1938): **305**

Amant de Lady Chatterley, L' / *Lady Chatterley's Lover* (Marc Allégret, FR 1955 / US 1956 [banned until 1959]): **192–93**

Amants, Les / *The Lovers* (Louis Malle, FR 1958 / US 1959): **312, 315n1**

Amants de Tolède, Les / *The Lovers of Toledo* (Henri Decoin, Fernando Palacios, FR 1953 / US 1954): **154, 158n3**

Amants de Vérone, Les / *The Lovers of Verona* (André Cayatte, FR 1949 / US 1951): **281, 282n1**

Anges du péché, Les / *Angels of Sin* (Robert Bresson, FR 1943 / US 1950): **339**

Anna (Alberto Lattuada, IT 1951 / FR 1952 / US 1953): **261**

Anna Karenina / *Anna Karénine* (Julien Duvivier, UK 1948 / US 1948 / FR 1949): **271–72**

Assassinat du duc de Guise, L' / *The Assassination of the Duke de Guise* (André Calmettes, Charles Le Bargy, FR 1908 / US 1909): **87n1**

Atalante, L' (Jean Vigo, FR 1934 / US 1947): **64**

Avec André Gide (Marc Allégret, FR 1952): **14, 229–32**

Aventures d'Arsène Lupin, Les / *The Adventures of Arsène Lupin* (Jacques Becker, FR 1957): **216**

Bas-fonds, Les / *The Lower Depths* (Jean Renoir, FR 1936 / US 1937): **152, 158n1**

Bataille du rail, La / *The Battle of the Rails* (René Clément, FR 1946 / US 1949): **32, 34, 132, 142**

Battleship Potemkin, The / *Bronenosets Potyomkin* / *Le Cuirassé Potemkine* (Sergei Eisenstein, USSR 1925 / FR, US 1926): **373, 375**

Bel-Ami (Willi Forst, GE 1939 / FR 1941 / US 1947): **287**

Belle Image, La / *The Beautiful Image* (Claude Heymann, 1951): **234–35**

Best Years of Our Lives, The / *Les Plus Belles Années de notre vie* (William Wyler, US 1946 / FR 1947): **25, 187, 374**

Bête humaine, La (Jean Renoir, 1938 / US 1940): **91,148, 297, 302, 304n6, 305, 308, 310**

Bicycle Thieves / *Ladri di biciclette* / *Le Voleur de bicyclette* (Vittorio De Sica, IT 1948 / FR, US 1948): **367**

Birth of a Nation, The / *Naissance d'une nation* (D. W. Griffith, US 1915 / FR 1920): **269**

Bitter Rice / *Riso amaro* / *Riz amer* (Giuseppe De Santis, IT 1949 / FR 1949 / US 1950): **261, 263n4**

Blé en herbe, Le / *The Game of Love* (Claude Autant-Lara, FR 1954 / US 1954): **28, 30, 49, 84, 91, 115–32, 163, 236–38, 239n5**

Bon Dieu sans confession, Le (Claude Autant-Lara, FR 1953 / US 1983): **236, 239n3**

Bonjour Tristesse (Otto Preminger, US 1958 / FR 1958): **81, 244–46, 247n1, 253**

Brief Encounter / *Brève rencontre* (David Lean, UK 1945 / FR, US 1946): **259–60**

Index of Names

Martineau, Henri, 127, 130n4
Mata Hari (stage name), 222
Maupassant, Guy de, 28–29, 68–69,
 244, 297, 312–14, 315n,, 316–17,
 318n1, 320–21, 323n, 369
Mauriac, François, 108
Melville, Herman, 264–66
Melville, Jean-Pierre, 115, 148, 324,
 345
Mérimée, Prosper, 152, 158n1
Merleau-Ponty, Maurice, 41n32
Messalina, 120, 124n8
Michel, André, 319–22, 323n3
Michelangelo, 357, 362
Milestone, Lewis, 11, 14
Milland, Ray, 175–76
Miller, Arthur, 216–17, 218n1
Millet, Jean-François, 98, 99n4
Molière, 238n1, 355, 374
Monroe, Marilyn, 274
Montand, Yves, 217, 218n1
Montépin, Xavier de, 295n3
Montgomery, Robert, 209
Morgan, Daniel, 8, 40n12
Morgan, Michèle, 51, 68, 79n3, 210
Morin, Edgar, 26
Murnau, Friedrich-Wilhelm, 114,
 147–48
Murphy, Audie, 270

Napoleon, 270n3
Nerval, Gérard de, 339
Nichols, Dudley, 185, 205

Objectif 49, 19, 21, 31, 42n41, 44n72
Odets, Clifford, 179–80
O'Flaherty, Liam, 184n3
Ohnet, Georges, 293, 295n2
Olivier, Laurence, 19, 260n1, 275,
 355, 380n5
Ophüls, Max, 28, 124n4, 239n5,
 316–17, 318n1, 320, 323

Parély, Mila, 318
Peck, Gregory, 195, 199, 266
Perkins, Anthony, 242
Philipe, Gérard, 11, 16, 80n10, 104,
 105n7, 129, 131n7, 138–39, 142–43,
 275, 286, 288–89
Poe, Edgar Allan, 233n3, 339, 369,
 380n4
Pottier, Richard, 105n7, 238n2
Preminger, Otto, 179, 244–46
Prèsle, Micheline, 16
Prévert, Jacques, 23–24,
 41–42nn32,41, 51, 84, 87n3, 281,
 282n1, 294, 301
Proust, Marcel, 58, 83, 93, 108, 367
Pudovkin, Vsevolod, 376

Queffélec, Henri, 87n4
Queneau, Raymond, 23–24, 42n41,
 44n72, 87, 136, 142, 144, 146n11,
 363

Rabelais, François, 73, 352n3
Racine, Jean, 5, 96, 99n2, 336, 376
Radiguet, Raymond, 16–17, 76, 108,
 118, 124n5, 163, 239n4, 333, 370
Raphael, 362
Rascel, Renato, 262
Reed, Carol, 162–63, 209, 211, 213n1,
 214–15
Rembrandt, 357
Renaud, Madeleine, 318
Renoir, Claude, 312
Renoir, Jean, 10, 18, 22, 41n37, 52, 64,
 68–69, 87, 90–91, 97–98, 99nn3,4,
 108–9, 114, 116, 122–23, 147–48, 152,
 158n1, 216, 297, 304n6, 305–6,
 307n3, 308, 316, 321–22, 325, 334,
 347, 349, 369
Renoir, Pierre-Auguste, 69, 297
Resnais, Alain, 38, 350
Richardson, Ralph, 210, 215, 272

Index of Topics and Concepts

Founded in 1893,
UNIVERSITY OF CALIFORNIA PRESS
publishes bold, progressive books and journals
on topics in the arts, humanities, social sciences,
and natural sciences—with a focus on social
justice issues—that inspire thought and action
among readers worldwide.

The UC PRESS FOUNDATION
raises funds to uphold the press's vital role
as an independent, nonprofit publisher, and
receives philanthropic support from a wide
range of individuals and institutions—and from
committed readers like you. To learn more, visit
ucpress.edu/supportus.